culture incorporated

Mark W. Rectanus

culture incorporated

Museums, Artists, and Corporate Sponsorships

University of Minnesota Press
Minneapolis / London

Portions of chapters 3 and 4 originally appeared in "Kulturförderung und Kultursponsoring: Positionen zwischen Kulturpolitik und Marktwirtschaft," *Internationales Archiv für Sozialgeschichte der deutschen Literatur* (IASL) 19, no. 1 (1994): 75–94; reprinted with permission of Max Niemeyer Verlag, Tübingen. An earlier version of chapter 6 appeared as "New York—Bilbao—Berlin and Back: The Global Museum and Cultural Politics," *European Studies Journal* 17, no. 1 (2000): 41–66; reprinted with permission.

Published by the University of Minnesota Press
111 Third Avenue South, Suite 290
Minneapolis, MN 55401-2520
http://www.upress.umn.edu

Library of Congress Cataloging-in-Publication Data

Rectanus, Mark W.
 Culture incorporated : museums, artists, and corporate sponsorships / Mark W. Rectanus.
 p. cm.
 Includes bibliographical references and index.
 ISBN 0-8166-3851-9 (cloth : alk. paper) — ISBN 0-8166-3852-7 (pbk. : alk. paper)
 1. Art patronage. 2. Corporate sponsorship. 3. Museums—Economic aspects. 4. Arts—
Economic aspects. I. Title.
 NX710 .R43 2002
 700'.79—dc21

 2001007088

Printed in the United States of America on acid-free paper

The University of Minnesota is an equal-opportunity educator and employer.

12 11 10 09 08 07 06 05 04 03 02 10 9 8 7 6 5 4 3 2 1

Contents

Acknowledgments

I am grateful to a number of colleagues and institutions for their support throughout this project. In particular, I would like to thank Georg Jäger at the Institut für Deutsche Philologie, Ludwig-Maximilians Universität München, for his invitation to conduct research in Munich under the auspices of an Alexander von Humboldt Foundation Research Fellowship. His enthusiasm for the project, his insights during the early stages of its development, and the opportunity to share it with his students are greatly appreciated.

I would also like to specifically thank the Alexander von Humboldt Foundation for its funding of this project and its ongoing support, which made my extensive research in Germany possible. I am grateful to the foundation's outstanding staff for providing assistance during the grant, as well as for their ongoing commitment to new areas of research. My research in the United States and Europe was also funded by Iowa State University. Both a Faculty Improvement Leave and financial support from the Council on Scholarship in the Humanities at Iowa State University allowed me to expand the scope of this project and to present my research-in-progress at numerous conferences. In Berlin, the Institut für Museumskunde provided generous access to their archival materials and publications.

For their reading, comments, and suggestions on various aspects of the manuscript, I am indebted to numerous colleagues. I would particularly like to thank Gerd Gemünden, Georg Jäger, Alice Kuzniar, Burkard Hornung, and Michelle Mattson. I am grateful to Elizabeth Rectanus for her unwavering support of the project and for drawing my attention to the works of Annie Leibovitz. Neelum Chaudhry's perceptive comments on the project were of considerable help in steering the manuscript to publication. I would also like to thank Hans Haacke for his permission to use photographs of his installations, for his stimulating work (both print and visual) on corporate sponsorship, and for his interest in the book. David Yust kindly provided photographs of Christo and Jeanne-Claude's *Wrapped Reichstag*.

Finally, at the University of Minnesota Press, I would like to thank my editor Jennifer Moore for her commitment to the book project and Robin A. Moir for her able assistance with the manuscript preparation.

Abbreviations

AEC	Ars Electronic Center
AG	Aktiengesellschaft (joint stock company)
AMICO	Art Museum Image Consortium
ARD	a German public television station
ARPANET	Advanced Research Projects Agency Network
ATM	asynchronous transfer mode (a dedicated-connection switching technology)
BAM	Brooklyn Academy of Music
BCA	Business Committee for the Arts
BSE	bovine spongiform encephalopathy
CAVE	Cave Automatic Virtual Environment
CD-I	compact-disc interactive
CDU	Christlich Demokratische Union (Christian Democratic Union, a political party)
CMC	computer-mediated communications
CSU	Christlich Soziale Union (Christian Social Union, a political party)
DASA	DaimlerChrysler Aerospace
DGB	Deutsche Guggenheim Berlin
EAT	Experiments in Art in Technology
ESB	Europäische Sponsoring Börse
ETA	Euskadi ta Askatasuna/Freedom to the Basques
EU	European Union
FRG	Federal Republic of Germany
GDR	German Democratic Republic

GMB	Guggenheim Museum Bilbao
KMW	Kunstmuseum Wolfsburg
KPMG	an accounting and consulting company
LAA	local arts agencies
MAM	Milwaukee Art Museum
MBB	Messerschmitt-Bölkow-Blohm
MESL	Museum Educational Site Licensing Project
MIP	Museum Informatics Project
MOO	multi-user object-oriented programming
MSM	Munich City Museum
MTU	Motorinen- und Turbinen Union
MTV	a German television station
MUD	mixed-use development
MUKO	Mukoviszidose-Hilfe
NAFTA	North American Free Trade Agreement
NEA	National Endowment for the Arts
NEH	National Endowment for the Humanities
NLC	National Labor Committee
ORF	Austria's public television station
RTL	a German television station
SIN	Sarajevo Is Next
SMF	Sarajevo Music Forum
SPD	Sozial Demokratische Partei Deutschlands (Social Democratic Party)
SRGF	Solomon R. Guggenheim Foundation
TBWA	an advertising agency
TRS	Travel Related Services (American Express)
V&S	V & S Vin & Sprit (a Swedish distiller)
VDM	Vitra Design Museum
VVD	Volkswagen-Versicherungsdienst GmbH
VW	Volkswagen
WTO	World Trade Organization
YBAS	young British artists
ZDF	a German public television station
ZKM	Zentrum für Kunst und Medientechnologie

Part I

Corporations and Culture: The New Partnership

1. Full Disclosure

It takes art to make a company great.

There's an art to helping those in need.

—Philip Morris Companies Inc.

"Imagine using the power of the arts to help feed the hungry." This is the "modest proposal" made by Philip Morris in its campaign "Arts against Hunger: A Global Initiative . . . ," which offered discounted tickets to arts events in return for donations to food drives. This "global initiative" was undoubtedly only one component of yet another public-relations strategy designed to repair the corporation's image after successive losses in tobacco litigation during the late 1990s.[1] More important, however, the advertisement focuses our attention on three key dimensions of corporate cultural politics: corporate sponsorship of cultural programs; social sponsorships and "corporate philanthropy"; and the globalization of corporate cultural politics as practiced by multinational and transnational corporations.

As the advertisement suggests, sponsorships are now embedded in many facets of contemporary culture: cultural programs (from historic restorations to rock concerts), social sponsorships (of education, health, and environmental programs), or sports sponsorships. The borders between the social, cultural, and political, which sponsoring ostensibly maintains, dissolve in the practice of corporate cultural politics. This is underscored by the shift from separate programming for cultural and social sponsorships to new programs that integrate cultural and social projects, both locally, in the communities where corporations maintain their operations, and globally, in their promotion of products and images. Corporate cultural politics attempt to legitimize corporate interests in globalized societies—in cultural, social, economic, and political spheres—but in doing so they also expose their stake in institutional and communal discourses and values.

Not only has the corporation become accepted as a legitimate, institutionalized participant in the cultural marketplace, but corporate cultural politics also define and shape culture. Associating cultural sponsorship exclusively with "high culture" or

3

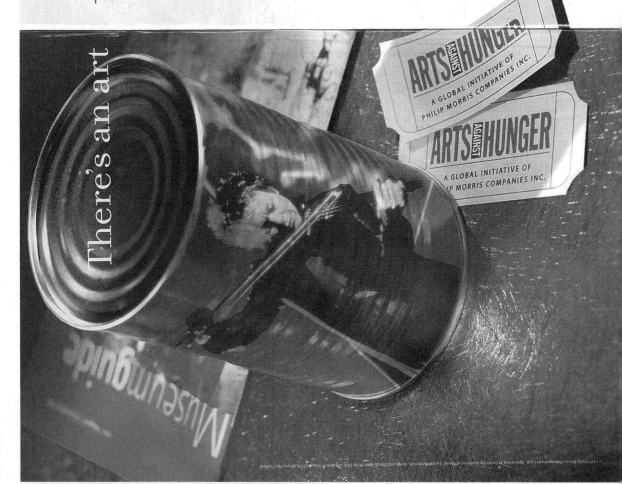

patronage masks the corporation's participation in constructing social relations and identities in a multidimensional culture of everyday life, a culture that cannot be adequately characterized as high or low. *Culture Incorporated* argues that an analysis of sponsorship, as a function of corporate cultural politics, is now more crucial than ever, precisely because sponsoring has become so ubiquitous. Sponsorships deflect attention away from the corporation's own functions as a cultural producer, promoter, or mediator by projecting the image of an institutional entity standing outside the cultural marketplace. Corporate cultural politics not only attempt to maintain social legitimation, but they also respond to dynamic social forces and public policies (e.g., alcohol and tobacco legislation, environmental issues) that the corporation can partially defuse or strategically redirect but not completely control. Culture cannot be isolated from social and political agendas. Indeed, with respect to public policy, culture's legitimacy is increasingly defined in terms of its social utility. Here, *American Canvas,* a report by the National Endowment for the Arts (NEA), recommended that arts programming be included in grants for federal funding for social services in order to position local arts projects more favorably in the increasing competition for public resources (Larson 1997, 128–29).

Postunification Germany provides a trenchant example of the intersection of public and corporate cultural politics, particularly when they are considered in the context of parliamentary debates on moving the capital from Bonn to Berlin, on Christo and Jeanne-Claude's *Wrapped Reichstag* project, or on the Holocaust Memorial.[2] Although some European Union (EU) nations, such as the United Kingdom, have integrated sponsorships into cultural policy for many decades, Germany reflects significant new trends among many EU countries, which are embracing combinations of public, corporate, and foundation funding schemes, challenging the "commonly assumed dichotomy between the market and the welfare state" in countries such as the Netherlands (Hitters 1996, 257). While we must be aware of significant differences among EU nations and the United States, recent developments in cultural politics (even in the Netherlands, with its tradition of state funding) are strikingly similar across nations. In Germany, the unification process accelerated the pace of corporate sponsorships, which had become more widespread in the 1980s, and provided an opportunity for corporations to legitimize their status as "partners" in cultural programming. The German context illustrates how the dual forces of privatization and globalization are reshaping the cultural terrain and how they have become crucial factors in actually redefining the objectives of cultural politics. A prime example of privatization, or corporatization, in the public discourse on cultural politics and globalization during the 1990s was former Foreign Minister Klaus Kinkel's redefinition of Germany's image abroad as "Corporate Germany" *(Unternehmen Deutschland)* (Kinkel 1996, 10).

Culture Incorporated traces the relations among corporations, artists, nonprofit cultural institutions, foundations, governments, and audiences in interdisciplinary and

Figure 1.1. Corporations increasingly merge cultural and social sponsorships.

contextual approaches. While this investigation is informed by a significant body of research in cultural studies, it goes beyond discrete analyses of advertising, promotion, or institutional perspectives by exploring links to the cultural politics of sociocultural programming. In addition, this book addresses positions of artists and their audiences, through case studies of artists working in collaboration with sponsors (e.g., Annie Leibovitz and American Express), working in opposition to them (e.g., Hans Haacke; Christo and Jeanne-Claude), or negotiating new positions between collaboration and resistance (Michael Clegg and Martin Guttmann). By examining the interrelationships between the sponsor and sponsored culture, *Culture Incorporated* invites readers to interrogate the interests of the corporation itself, rather than just the culture it sponsors, and to consider the potential for alternative forms of participation in the production of culture.

Overview

In Part I, I argue that global corporations (e.g. AT&T, BMW, DaimlerChrysler, IBM, Philip Morris) have institutionalized their own cultural politics, which play a pivotal role in the nexus of corporate, nonprofit, foundation, and national or regional politics. The first chapter situates corporate sponsorship in Germany and the United States within the broader contours and discourses on cultural politics and globalization. Chapter 2 traces the historical shift from corporate philanthropy and patronage (prior to the 1960s) to contractual sponsorships, which now account for a significant proportion of all corporate cultural programming. Corporate funding for culture advanced from its rather marginal role in the 1950s (in the United States) as a public relations instrument and a source for product design and packaging to its institutionalized status as a legitimate "player" in cultural policy and urban development. Simultaneously, corporate cultural politics emerged in response to dynamic social forces over which it can exert only partial, albeit significant, control. Chapter 2 also examines how corporate architecture and property development influence social policy and public space and how corporate identity is linked to artistic creativity and technology in defining the global, transnational corporation. Finally, I also investigate how artist Hans Haacke's installations deconstruct the interests embedded in corporate cultural politics by revealing the links between urban sites (e.g., Berlin), national identity, and corporations.

Part II explores sponsorships as they relate to changing definitions of culture as lifestyle and event. These studies interrogate the relations among corporate sponsors, cultural institutions, artists, and audiences. In Chapter 3, I discuss the ways that corporate cultural programming reflects the corporation's emergence as a cultural producer and mediator in its own right. Of course, corporations have a long history as producers of mass consumer culture, but sponsorships of high culture also allowed them to operate on both sides of the cultural boundary, which has been increasingly blurred by the actual uses of everyday culture since the late 1960s. Artists, such as Andy Warhol, also intentionally problematized these borders. For example, Absolut Vodka's "arts patronage" seizes upon postmodern culture's fusion of high and low, as

well as the importance of cultural identities, for its promotions. The repositioning of the corporation as a "partner" with museums, symphonies, and public entities is also a result of the emergence of what Andrew Wernick has called "promotional culture," which is a predominant, legitimized mode of communication within most aspects of society (politics, education, media) and "virtually co-extensive with our produced symbolic world" (Wernick 1991, 182). Wernick's analysis provides a useful point of departure for my investigation of the shifting signification between products and their (commodified) images. Promotional culture based on image also sets the stage for corporate "image transfer," which links the positive image values of the cultural institution with the corporation. Finally, multicultural programming (AT&T, Kodak, Philip Morris) attempts to fuse notions of ethnicity, cultural, and national identity with community partnerships by integrating both social and cultural sponsorships.

In chapter 4, I present a detailed study of Annie Leibovitz's collaboration with American Express, one that illustrates the interdependence of corporate sponsors, the media, advertising, museums, and artists. Leibovitz's aesthetic and professional practices problematize the uses of photography within postmodern media culture. For American Express, the advertising campaign and exhibit provided the opportunity to coordinate the image of their product (the American Express Card and Travel Related Services), the lifestyle orientations of their existing and potential markets, and subsequently the image of the sponsored exhibit. The mediation and representation of these images is discussed within the specific context of postunification Germany through an analysis of the media reception of the *Photographs* exhibit in Munich and Leibovitz's photographs of German celebrities (Michael Stich, Wim Wenders, Hanna Schygulla). Travel and mobility (as a function of corporate globalization) become a compensation for the loss of home and a stable locus of identity. The mediation of place and identity (e.g., in Sarajevo, the Gulf War, and Las Vegas) form the thematic focus of much of Leibovitz's work during the 1990s and reveals the tensions in her aesthetic practices.

As examples of nonsponsored culture, Woodstock and *Wrapped Reichstag, Berlin, 1971–95* (Christo and Jeanne-Claude) became lightening rods for debates over politics and culture. Chapter 5 explores the extent to which the proliferation of event culture (from the Bregenz Festival to rock concerts for charity), upon which much of corporate sponsorship is based, operates within the dimensions of attraction and entertainment, on the one hand, and critical reflection or subversion, on the other. Events play a central role in the construction of individual and collective experience, signifying a shift from sociological orientations based primarily on an *economic* semantic (the differentiation between "more" and "less") to a *psychophysical* semantic of structuring lived experiences—what sociologist Gerhard Schulze calls *"die Erlebnisgesellschaft."* Simultaneously, economic rationales have become a central orientation for legitimizing cultural politics in Germany. Schulze's extensive analysis of contemporary society provides important insights into the composition of audiences and social milieus participating in event and lifestyle culture. This dimension is related to John Urry's notion of postmodern practices of (cultural) tourism, which he calls "consuming places."

In chapter 5, I also discuss sponsors' attempts to colonize such youth-subcultural scenes as charitable concerts and festivals. Finally, I investigate Christo's *Wrapped Reichstag* project as a challenge to institutionally sponsored events, notions of public and private spaces, and cultural politics in postunification Germany.

Part III focuses on the redefinition of the museum as a privileged and contested site of cultural mediation and reception. Chapter 6 traces the convergence of the institutional interests of corporations, governments, nonprofit cultural institutions, and foundations through an examination of the museum. A significant feature of the museum is its transformation into a multiple-use cultural center (for entertainment, consumption, education, information, representation). I investigate the globalization of the Guggenheim Museum (through satellites in New York; Bilbao, Spain; and Berlin) with respect to its use of corporate globalization strategies—specifically, its politics of space (Frank Gehry's architecture), image politics (collaborations with sponsor Hugo Boss), and its role in local cultural politics. The Kunstmuseum Wolfsburg illustrates the fusion of economic, political, and corporate (Volkswagen) interests in constructing regional cultural politics and the importance of private funding for German museums. Corporate museums (the BMW Museum and the Vitra Design Museum) create narratives and spaces for corporate history and for histories of technology and culture.

Chapter 7, "Cybersponsoring," continues our investigation of the museum by exploring the emergence of meta-museums, virtual museums, and corporate cultural politics in cyberspace. The Zentrum für Kunst und Medientechnologie (ZKM), in Karlsruhe, Germany, and the Ars Electronica Center (AEC), in Linz, Austria, gained international attention by fusing art and technology and by developing multiple, hybrid museum spaces under one conceptual and administrative structure. Simultaneously, well-established museums are digitizing their collections, acquiring media art, and establishing new projects such as the Guggenheim Virtual Museum. Both meta- and virtual museums reflect a fundamental reconfiguration of the way museums' contents are mediated to publics and a heightened awareness of technology as a medium of artistic expression. I conclude chapter 7 by summarizing some of the key developments in corporate cultural politics, assessing their significance for public cultural politics, and considering the potential for audiences to assume a greater role in democratizing cultural institutions.

Cultural Politics: Investing in Social Capital

At the outset of the twenty-first century, Berlin is an ideal place to observe the forces of corporate globalization, corporate politics of space, and debates over national identity or postnational identity. Corporate representation is made literally concrete in the expansive building projects by Daimler (DaimlerChrysler) at Potsdamer Platz or in the Sony Center, reflecting the material interests of corporate real estate development. Beyond deploying their corporate images within the urban center, these projects establish the corporation's political, economic, and social interests in "real" spaces, in

Germany's new capital and in the center of the "new Europe's" crossroads between east and west.

With respect to corporate cultural politics in Germany and the United States, I will focus on many of their similarities and institutional convergences rather than delineating their differences. Of course, there are significant historical, structural, political, and sociocultural differences between the two nations (Heinrichs 1997, 132–59). Cultural institutions in Germany (museums, theaters, operas, symphonies) are primarily financed by local municipalities and state governments *(Länder)*, and there is still widespread support for the public financing of culture. However, the shift to multiple, or "mixed," forms of cultural financing, which rely on fund-raising, endowments, merchandising, and sponsorships, was and is being driven by the economic exigencies of postunification budget cuts within local governments, by European integration, and by globalization within the cultural sector (e.g., media conglomerates such as Bertelsmann or Disney). In some respects, it was inevitable that corporate globalization would also affect public cultural politics, as national economies are increasingly integrated into global networks of communication. In the German case, unification accelerated this development, which, as Werner Heinrichs points out, cannot be reversed: "Even if 'German Unification' is at some point financed and unemployment returns to 'normalcy,' everything will not be able to be just as it was in the 1970s and 1980s" (1997, v). Sociodemographic and structural factors are also contributing to this shift in public funding; such factors include a proportionally older German population, an increasing number of single households, and globalization trends that place greater pressure on the German economy to maintain (high-paying) jobs and competitive products (Heinrichs 1997, v). Heinrichs's main thesis is that the economics of funding culture are in large part driving the redefinition of cultural politics; that is, the shortage of funding will contribute to a discussion of what is funded, how it is funded, and how the projects are organized or structured (vi). Despite the differences between Germany and the United States (as well as other European nations), he suggests that Germany should look to the United Kingdom, the United States, Sweden, and France in developing a new system that will shift to multiple funding sources (public, foundation, corporate, endowment).

The studies in this book indicate that the shift to mixed funding in Germany, which began in the early 1990s, is already well under way.[3] Certainly, proposed changes in the German tax laws, changes that would encourage more charitable donations, will provide further impetus for endowments, which so many U.S. cultural institutions now rely upon. Moreover, in both nations, massive capital resources will be transferred to the baby-boom generation in the form of inheritance during the first two decades of the twenty-first century.

Yet it remains to be seen how this capital will be directed and what the impact will be for cultural institutions. If past experience in the EU and the United States is any indicator, there will be a tendency to develop new, high-profile projects. Although this may present the potential for innovative approaches and projects outside the

established institutional boundaries, existing foundations will remain major players in the cultural landscape. Indeed, the stock market boom of the 1990s provided significant capital appreciation to well-established nonprofits, such as the Ford Foundation,[4] but new foundations have also emerged from the high-tech sector.[5] In Germany, existing cultural institutions will be increasingly dependent upon their own fund-raising for establishing endowments, as well as upon new forms of promotion and merchandising, with the consequences that they will also be competing with other sites of (urban) entertainment and event culture. Although foundations, endowments, and public funding may support ongoing overhead costs, sponsorships will in all likelihood continue to perform an important function in funding a substantial percentage of new exhibitions or high-profile events, which could not occur without the sponsorships. Indeed, the Solomon R. Guggenheim Foundation report on its new museum in Bilbao stated that sponsors now fund as much as 70 percent of exhibition costs in the United States and Europe: "The benefit to corporations for sponsoring these exhibitions will be tailored to their marketing objectives as well as their client and employee needs. Support of this kind is often achieved through board-member connections or contacts within the corporation" (*Museo Guggenheim Bilbao* 1997, chapter 6, page 3).

A recurring theme of this book is that sponsorships have considerable qualitative impact in cultural politics, even when they represent a relatively small proportion of programming budgets. Corporate expenditures for culture are frequently underestimated. This is in part due to the fact that they are included within corporate marketing and promotion budgets rather than within corporate philanthropy, which is being replaced by sponsorships (Schreiber 1994, 18). The key issue here is that corporations have a disproportionate influence in shaping cultural programming. If many museums are dependent upon some form of sponsorship for even a third of their funding for exhibitions, then it is a source they can scarcely forgo. As we will see, cultural institutions, not just sponsors, profit from higher levels of visibility for the sponsored project, despite the fact that corporate funding is only one of multiple funding sources. The advantage of "corporate partners" is that they are already "wired in" to the promotional media and can mobilize their own (global) communication channels. In fact, a positive "image transfer" is precisely the point of the sponsorship, for the corporation and for the cultural institution (Bruhn 1991, 224–32).

In the United States, corporate expenditures for cultural programming make up a higher proportion of all funding for culture than in Germany, and are firmly institutionalized within the cultural marketplace. The magnitude of this support is illustrated rather dramatically by Intel Corporation's sponsorship of *The American Century: Art and Culture* at the Whitney Museum of American Art in 1998. The Whitney and Intel announced that the sponsorship was the largest ever funded for an art-museum exhibition—$6 million.[6] By comparison, actual funding for NEA grants in 2000 was only about $80 million.[7] After the "culture wars" of the 1980s and 1990s, resulting in budget cuts and threats to eliminate the NEA altogether, the NEA proposed a new di-

rection for funding in its report *American Canvas*, which would offer a new legitimacy to public culture by linking it with social programs. The report called for an increased role for the arts within everyday life in local communities, that is, collaborations between local arts associations (LAAs) and community organizations ranging from school districts to housing or social services agencies to law enforcement agencies (Larson 1997, 82–86). As I observed at the outset, this fusion of cultural and social programming, reflected in corporate programs such as Philip Morris's "Arts against Hunger" campaign, is in keeping with corporate initiatives to validate and insert their interests into local communities.

In a somewhat similar vein, Stefan Toepler has suggested using Lester Salamon's notion of "social capital" in order to reposition the debate on arts funding:

> The arts should look to the debate on civil society and social capital, defined as "the bonds of trust and norms of reciprocity that individuals develop by interacting with one another." "Looking at the arts from a social capital angle would entail a greater focus on those parts of the cultural universe that actually provide venues for citizens to participate and interact, which in turn fosters social bonds and raises the level of trust in communities." (Toepler, 1999, 2, quoting Salamon)

Toepler envisions the artist "as community convener or even as community mediator. The most fruitful area to explore is how the arts can contribute to building social capital and how arts organizations can become more effective players in a reinvigorated civil society" (2). Although I think the role of the artist and audiences in the community is a pivotal one—indeed, I argue that artists and audiences must play a vital role in (re)asserting their own diverse interests—I also believe that the participants (or so-called stakeholders) in the networks of cultural production, mediation, and reception are not positioned equally with respect to their economic, political, or cultural status. Moreover, I believe we should differentiate among forms of cultural production. That is, communities must also be willing to receive forms of culture that challenge social norms and values (see chapter 5). Historically, it has always been easier to make a case for funding the canon of "high culture" rather than the avant-garde or even popular culture.

The notion of social capital seems to imply that art, in order to be institutionally legitimized, must be reduced to its social instrumentality. Toepler's argument suggests that the existing paradigms that defend cultural funding on the grounds that they foster economic development (e.g., through product merchandising or urban marketing) be replaced (or substantially shifted) to a new social instrumentality (social development) (1999, 1). Of course, the notion of social capital is an attempt to pragmatically reposition nonprofits within a highly competitive marketplace of discourses vying for legitimacy and economic capital. However, is it not true that those nonprofits that are well positioned in terms of economic capital can purchase social or cultural capital? And is this not what sponsors actually do?

On the one hand, sponsorship practices indicate that the shift to legitimizing

culture on the basis of social capital *has already occurred, but without the equal partnership* within the system envisioned by Salamon and Toepler. On the other hand, the cultural institutions that have been the most successful in terms of their public visibility, market success, and media reception (such as the Guggenheim) have accomplished this from a basis of *economic capital* (foundation investments) and *cultural capital* (i.e., collection development and diversification; collaborations with sponsors such as Hugo Boss or Giorgio Armani; heightened institutional image) rather than by attempting to validate their legitimacy through social capital (other than museum pedagogy and outreach).[8] Thus, economic capital and cultural capital cannot be deleted from the social-capital equation.[9] Though the notion of social capital is in part based on the idea that it will be "shared" (through partnerships), there is little consensus on how the economic capital or cultural capital, which can build social capital, will be shared. More simply, not all of the partners come to the table with equal amounts of "capital" (social, economic, or cultural), nor do they necessarily have the same interests or objectives.[10] The point is not that culture should be divorced from the social context—on the contrary. Social capital obscures culture's inextricable links to *all* aspects of society, particularly the economic and the political, and functions as yet another public policy vehicle that can deflect attention from the economic and institutional interests of the participants.

Full Disclosure

The inextricable links among social, cultural, and economic capital were manifest in the recurring crises in cultural institutions during the 1980s and 1990s (e.g., the "culture wars" over funding for the NEA and exhibition policies). Such crises revealed the dissonances embedded in contemporary cultural politics while simultaneously providing an opportunity to interrogate these interests. The *Sensation* exhibition at the Brooklyn Museum of Art in 1999, featuring the works of young British artists (YBAs) from the Saatchi Collection, became a paradigmatic case of institutional and political self-interest. Ultimately, the media coverage of the exhibition focused on two issues:[11] (1) the legal actions initiated by New York City mayor Rudolph Giuliani to revoke funding for the museum in reaction to some of the works (i.e., Chris Ofili's *The Holy Virgin Mary*) and as a result of the city's specious claim that the museum had violated its lease; (2) the museum's solicitation of funding for *Sensation* from sources that could profit financially from the media exposure provided for the artists (i.e., from the Saatchi Collection and auction houses, such as Christie's, representing the artists), as well as conflict-of-interest issues relating to David Bowie's use of the *Sensation* exhibit on his Web site (at no cost to his Internet company) and a subsequent contribution to the museum.

Although Giuliani's efforts to revoke the museum's funding were rejected on First Amendment grounds, the case did generate media exposure for his political image (positive or negative). In doing so, the *Sensation* suit also reinforced boundaries that publicly funded cultural institutions carefully observe in order to maintain political

support for funding. For many museums, the sensation over *Sensation* could cut both ways. Although it had provided increased publicity for the Brooklyn Museum of Art and the exhibition, it also generated substantial negative publicity both in the representation of the exhibition itself and, perhaps more importantly, with respect to the ethics of its funding practices.[12] For publicly funded cultural institutions, the implicit threat of reduced funding and negative media coverage may lead to self-censorship. This was apparently the case when the National Gallery of Australia, Canberra, canceled *Sensation* after the controversy in New York City. The museum's director, Brian Kennedy, not only commented that the funding practices of the Brooklyn Museum cast a negative light on the exhibition but also referred to public criticism regarding the exhibition itself: "We cannot ignore what's happened in Brooklyn; we're not disconnected from the art world. We're not separate."[13] The direct impact of the Brooklyn Museum case in Australia reflects not only the globalization of the exhibition market itself but, more notably, the concrete effects on *local* cultural politics and museum practices resulting from global media coverage. Unlike the Australian case, in which the exhibition was canceled as a result of controversy in Brooklyn, the success of *Sensation* in London and Berlin had been an inducement for the Brooklyn Museum to promote it as a major exhibition. In Germany, the growing influence of collectors (such as Saatchi) in the international art market, as well as museums' willingness to accommodate them, was indeed an issue when Berlin's *Sensation* appeared at the Hamburger Bahnhof, in Berlin, although the Berlin exhibition was financed by a nonprofit organization, Friends of the National Gallery (Verein der Freunde der Nationalgalerie), for 1.7 million deutsche marks. Despite the nonprofit funding of *Sensation,* the exhibition was considered by some to be a sign of increasing dependency on commercial interests, with its consequent potential negative impact in Germany, where museums have increasingly embraced sponsorships since the late 1980s.[14]

Sensation had again raised issues of the ethical boundaries among exhibition funding, collectors, and corporate sponsors. What was at issue here was an indictment not of sponsorships per se, for they have become an integral part of museum practice, but rather of the failure to recognize and disclose these interests. This was a recurring theme in both U.S. and international press coverage. In the *New York Times,* David Barstow observes varying and eroding standards for museum ethics, referring to comments by specialists on museum ethics "that potential conflicts of interest are best handled when they are fully disclosed to the public."[15] Yet in an interview with Germany's *Süddeutsche Zeitung,* a Brooklyn Museum spokesperson asserted that because there are no clear guidelines regulating the relations between museums and sponsors, similar practices are common at other institutions; however, their potential conflicts of interest are not open to disclosure (as the court documents were in the Brooklyn case).[16]

From another perspective, full disclosure, when it actually occurs, reveals the systemic interdependencies of the participants within the complex networks of cultural production, mediation, and reception. Full disclosure of financial and contractual

agreements is therefore a first step toward ethical, open procedures. If disclosure does not inherently alter the manner in which cultural mediation occurs, it can reframe the contexts in which culture will be received by illuminating the financial and political interests of those involved. In the case of *Sensation,* one form of disclosure, that is, presentation in the cultural media, was able to focus attention on these systemic dependencies and institutional interests. Thus, the microlevel of exhibition financing and ethics are only symptomatic of wider institutional convergences, which this book will explore.

In this instance, *Sensation* represented part of what Marion Leske referred to as the "Saatchi System," that is, a microsystem of art consumption, marketing, exhibition, and speculation—both responding to and shaping forces in the macromarkets of global culture and media. Saatchi's system operated by (1) financing and sponsoring alternative art schools (e.g., YBAs at London's Goldsmith's College); (2) acquiring artworks from promising young artists based on the contacts with these schools; (3) promoting and publicizing the artists and their works at Saatchi's own galleries; (4) promoting and loaning the Saatchi collection for international exhibitions, thereby increasing the value of many works; and (5) selling some of the works at auction and donating the proceeds to art schools.[17]

Part of the new mix of cultural funding both in the United States and the EU positions nonprofit foundations as major players in the cultural landscape. Yet few nonprofit foundations or museum foundations (including those receiving significant public funding, as in the Brooklyn Museum case) practice full disclosure of their funding data and sponsorship contracts. In Germany, for example, fewer than 10 percent of the major foundations publish more than superficial reports on their finances and interests. Rupert Graf Strachwitz has pointed out that this lack of transparency regarding funding interests ultimately undermines the legitimacy of cultural foundations.[18] Corporate rhetoric promoting cultural programs as a "dialogue with audiences" may lead to greater public skepticism and cynicism when funding schemes, such as those revealed during the *Sensation* exhibition, expose the underlying self-interests of institutions, sponsors, and politicians.

Unfinished Business

Museum ethics and guidelines can only be seen as one component of a much broader institutional analysis that incorporates the interests of artists and audiences rather than relegating ethical guidelines to museums and sponsors alone. Precisely the areas of contemporary museum practice that are not as visible or overtly contested as were those involved in *Sensation* reveal shifts in the terrain of cultural politics. Another highly publicized, albeit significantly less controversial, case of conflict of interest between exhibition policies and corporate interests, the Guggenheim Museum's *Giorgio Armani* retrospective (2000), represents a historical marker in the *convergence* between museums' and corporations' interests and away from corporate interests overtly shaping museum practices. Designer Giorgio Armani's sponsorship agreement with the

Guggenheim (the museum had similar agreements with Hugo Boss), for a reported $15 million, raised the question of whether the exhibition was a quid pro quo for the sponsorship.[19] (The show itself was sponsored by Time Warner's *In Style* magazine.) Neither the Guggenheim nor Armani would confirm the amount of the donation nor the terms of the sponsorship agreement.

Thematic exhibitions on fashion and the museum as a stage for fashion events have become relatively commonplace since the 1980s (e.g., Wolfgang Joop and the Kunstmuseum Wolfsburg, Hugo Boss and the Guggenheim). Moreover, museums certainly have a role to play in examining fashion as a cultural artifact and as an integral part of everyday life and social history and in looking at its considerable influence on shaping notions of identity and the body. Of course, a key issue is *how* such exhibitions mediate diverse discourses on the functions of designs, not just those on consumption and desire. This critical perspective was certainly lacking in *Giorgio Armani,* an exhibition weighted heavily to Armani's most recent designs, that is, those still being sold or promoted.[20] The Armani exhibition did not address these links to fashion's multiple narratives in any larger sense, nor did it develop a more sophisticated representation of the impact of Armani's oeuvre in broader aesthetic and cultural contexts. The role of the exhibition as a promotional vehicle is echoed in Roberta Smith's assessment of the Armani retrospective, which she also considers in the light of a general devaluation of art itself within contemporary curatorial practices. Regarding the social and institutional conflicts embedded in the museum's role, Smith refers to David Hickey's notion that "the discourse of art is about conflict of interest," commenting that "in museums, monetary and aesthetic interests, the power of money and the value of art, are constantly and repeatedly pitted against each other."[21]

The "discourse of art" as "conflict of interest" is also a discourse embedded within the Guggenheim's own institutional history and curatorial politics. Within the context of the broader uses of full disclosure, these discourses reference real social and economic interests that were as much a part of museum politics thirty years ago as they are today (as illustrated in the Armani exhibition). Here, I am referring to the Guggenheim's cancellation of the exhibition *Hans Haacke: Systems* shortly before its opening in April 1971 as well as of his subsequent work *Solomon R. Guggenheim Museum Board of Trustees* (1974). The exhibition included a number of pieces, most notably *Shapolsky et al. Manhattan Real Estate Holdings, a Real-Time Social System, as of May 1, 1971,* that explored power and social relations between museums and corporate real estate development in New York City. With regard to *Shapolsky,* Rosalyn Deutsche writes,

> By expanding the work's context beyond the museum walls to encompass the city in which the museum is situated, Haacke did not merely extend the notion of site-specificity geographically. Neither did he simplistically attempt to surmount institutional boundaries by symbolically placing his artwork "outside" the museum and addressing "real" subject matter. Rather, he permitted the viewer to apprehend the

institutional apparatus by questioning the twin fetishisms of two, equally real, sites. Both the city, constructed in mainstream architectural and urban discourses as a strictly physical, utilitarian, or aesthetic space, and the museum, conceived in idealist art discourse as a pure aesthetic realm, appear as spatial forms marked by a political economy. (1998, 171–72)

More explicit links between the Guggenheim family and their membership on corporate boards, as well as corporate representation on the Guggenheim Museum's board, are documented in Haacke's *Solomon R. Guggenheim Museum Board of Trustees.* Yet these interlocking interests, which were certainly not unique to the Guggenheim, were not considered relevant to the museum or to any notion of the institutional role of museums. As Deutsche points out, the Guggenheim's director, Thomas Messer, re-asserted that the art museum was a sphere separate from the social and economic forces of the city and society within which it existed (1998, 191), despite the obvious contradictions in the documentation that Haacke's work itself provided. Again, the Guggenheim was certainly not unique in its insistence on separating institutional interests from artistic ones. Indeed, the social, economic, and political links between the cultural spaces of the museum and corporate interests are part of the (repressed) historical narratives of museums in social space, which have only become part of more-recent institutional memory. Some museums, such as Munich's Haus der Kunst, the site of the National Socialist *Entartete Kunst* exhibition (1937), have begun to integrate their own past into the exhibition space of the museum itself (see chapter 6).

The ongoing interrogation of the interrelations and dependencies between public space and corporate space, not only as a central issue of Haacke's works but also as a form of intervention in social spaces, is referenced in the title of his 1985 exhibition, *Hans Haacke: Unfinished Business,* at the New Museum of Contemporary Art.[22] Haacke's works not only deconstruct the institutional links of power and the aesthetics of their representation, but they also excavate their historical foundations. In this sense, his works make a contribution to the process of social disclosure that has been legally codified and defined as *a process of bringing into view by uncovering, laying bare, revealing to knowledge, freeing from secrecy or ignorance, and making known.*[23] They accomplish this through an interrogation of the representational spaces of political and corporate power within the real physical spaces of political power, for example, real estate development by Daimler-Benz at Berlin's Potsdamer Platz following German reunification. Chapter 2 explores how corporate real estate development, as one form of corporate cultural politics, frequently uses culture and artists as an investment, that is, a form of cultural capital, in order to increase property values and as a promotional vehicle to maintain social legitimacy and to position corporate interests within local communities. More recently, Haacke's installation in the Reichstag, *Der Bevölkerung,* references the building's historical and ideological functions by altering the original inscription, "To the German people" ("DEM DEUTSCHEN VOLKE"), located on the outside of the building, to one located within the walls of power of the

Reichstag itself. Thus, Haacke's work, which reads "To the Population" ("DER BE-VÖLKERUNG"), addresses the tension between the historical and spatial functions of the Reichstag as a site of power and a symbol of a divided German identity while simultaneously addressing the manner in which it constructs power relations both externally and internally.[24]

Thus, I would suggest that disclosure must be addressed in its multiple, interrelated dimensions and discourses, as historical, legal, economic, political, spatial, and institutional questions as well as fundamentally cultural and social ones. The trajectory from the Guggenheim's ban on Haacke to the *Giorgio Armani* retrospective in some sense reflects the Guggenheim Museum's own reconfiguration into a global corporate entity with numerous satellite subsidiaries. At the same time, corporations have assumed institutional roles as cultural producers, not only as a result of the products and images they disseminate globally but also by promoting themselves as "artist-entrepreneurs" (e.g., Armani) and creating their own institutionalized forms of cultural programming, which ranges from corporate museums to extensive cultural and social programming orchestrated by cultural communications, marketing, and sponsorship departments. However, these interests are not only threatened by interventions by artists and communities. A recurring theme of this book is that the expansion of corporate cultural politics is not only in itself a response to the destabilization of corporate legitimacy in public policy but also provides cultural infrastructure for corporate products, services, and images.

Finally, history and memory are an integral part of the process of disclosure, of excavating the institutional narratives of the more recent and distant past. Despite work by historians to provide further knowledge of this past, the significance of corporate histories has only recently received more attention from the public. This is, in part, a result of major lawsuits, consumer advocacy, and legal actions by state and federal representatives, as well as the attendant media coverage. Although many corporations claim that their past is general knowledge—a part of the historical record—they have been unwilling to accept responsibility for their past actions or to discuss the unwritten past. This pertains not only to their products (e.g., tobacco) but also to the implication of corporate capital and interests in political power, as was the case under National Socialism. At the end of the last decade of the twentieth century, more than half a century after the Holocaust, the role of Swiss banks during National Socialism was finally investigated, despite years of resistance from both the banks and the Swiss government. In Germany, lawsuits filed in the United States against German corporations on behalf of victims of slave and forced labor in German industry during National Socialism provided impetus for a fund (established by German corporations and the German government) to compensate the victims (Stiftungsinitiative der deutschen Wirtschaft). Even after the fund had been established, groups representing the victims asserted that the fund administrators for German industry, by delaying initial payments, were not acting in good faith—a view shared by members of the German Parliament.[25] The public's perception that corporations are unwilling to

engage in a public discussion of their past is reinforced by the belated recognition of responsibility in both of these major cases. Although this book does not address corporate histories, I argue that corporate museums—as part of corporate cultural politics— may represent an attempt to rewrite social histories of technologies as well as institutional histories. To the extent that corporate museums of art or technology have established their legitimacy as sites of education and entertainment, they also should be considered in terms of a broader process of rewriting our own collective histories.

Globalization

If, as Thomas L. Friedman argues, technology is one of the major forces driving globalization (2000, 440), then corporations are strategically positioned to assert their interests. Technology is indeed key to understanding the globalization of corporate cultural programming. Technology not only becomes a vehicle for mediating culture (e.g., in corporate museums or exhibitions such as the Guggenheim's *The Art of the Motorcycle* sponsored by BMW) (Hyde 1998, 95), but technology transfer from corporations to cultural institutions, or in reverse as "cultural software" transferred back to the corporation, are also lauded as forms of creative synergy (see chapter 7). New forms of cybersponsoring, such as Intel's Web site for the Whitney's *American Century* exhibition, "allow teachers from Omaha to Helsinki to Tokyo to incorporate the exhibition into the curriculum and take their students on virtual field trips" by utilizing audio, video, and 3-D technologies for online viewing.[26] Online rock concerts for charitable causes (e.g., Cisco Systems' sponsorship of Net Aid) also illustrate the development of virtual space for corporate promotion and globalized cultural programming that link both "real" and virtual spaces.

However, we should be cautious in considering globalization only in terms of corporate hegemony or colonizing without simultaneously recognizing forces that contest corporate politics or force their realignment—a leitmotiv of this book. Moreover, globalization involves a number of paradoxes that can only be theorized through a certain degree of differentiation and, I would argue, through a combination of macro and micro analyses. Malcolm Waters concludes that theories of globalization define it as a process of simultaneous homogenization and differentiation (1996, 136, 139). These forces emanate from relationships between social organization and territoriality that are, in turn, characterized by three central functions of exchange: *Material exchanges localize, political exchanges internationalize, and symbolic exchanges globalize* (8–9). Thus, corporations express their interests on multiple levels simultaneously. For example, transnationals develop markets in eastern Europe through their new operations in Berlin, they utilize this urban space for real estate developments in the entertainment and financial sectors (e.g., the DaimlerChrysler or Sony shopping complexes at Potsdamer Platz), they maintain close proximity to the seat of government in order to further their political interests, and they promote their products and services locally and globally. The fusion of corporate and cultural institutions such as the Deutsche Guggenheim Berlin (i.e., the Deutsche Bank AG and the Solomon R.

Figure 1.2. Corporate history in the public forum: poster for a discussion in Frankfurt am Main.

Guggenheim Museum) represents global image promotion (of the bank and the museum) within the specific local site of Berlin and the bank building (see chapter 6).

Ulrich Beck views the EU as an opportunity for an equitable reregulation of social policies (and an overhaul of the World Trade Organization) despite, or perhaps in response to, the forces of privatization and global corporatization (1998, 263). Like Joschka Fischer (foreign minister under Gerhard Schröder's red-green coalition), Beck believes that European integration provides a political opening for the reexamination of social, political, and human rights policies (263). Certainly the introduction of comprehensive, Europe-wide standards for the environment, wages, or social policies would have a decided impact on forces of corporate globalization by simultaneously setting benchmark standards for non-EU nations. I would also suggest that political responses to corporate products, for example, opposition to genetically modified organisms in processed foods (including objections based on food-safety issues resulting from the mad cow disease [bovine spongiform encephalopathy, BSE] crisis in Europe), not only have a ripple effect within transnational corporations but also resonate in public opinion in non-EU nations. Fischer's attempt to reconcile notions of national identity with a postnational federation (through an EU constitution) is based on common standards of social equity for all "citizens," but it also would allow for national diversity.[27] Here, the EU plays a significant role in dealing with the forces of globalization, rather than abdicating this leadership to the United States, as Friedman suggests.[28]

In her book *No Logo,* Naomi Klein addresses the expansion of global corporate interests through the proliferation of corporate brands embedded in the social contexts and spaces of contemporary society. Moreover, Klein points to the potential for social conflict resulting from a growing consciousness of the consequences of global corporate policies creating *"No Space," "No Choice,"* and *"No Jobs"* (emphasis in original) but also leading to a rejection of the all-pervasive corporate brands themselves, which would strike the core of corporate economic power:

> By attempting to enclose our shared culture in sanitized and controlled brand cocoons, these corporations have themselves created the surge of opposition. . . . By thirstily absorbing social critiques and political movements as sources of brand "meaning," they have radicalized that opposition still further. By abandoning their traditional role as direct, secure employers to pursue their branding dreams, they have lost the loyalty that once protected them from citizen rage. And by pounding the message of self-sufficiency into a generation of workers, they have inadvertently empowered their critics to express that rage without fear. (1999, 441–42)

Indeed, corporate proclamations of a new social partnership first articulated in the late 1980s and made concrete through the rapid growth of sociocultural programming in the 1990s, such as "Arts against Hunger," could only be legitimized through increasing interventions within the spaces of social and public policy that increasingly challenge corporate values.

Benjamin Barber sees the antidote to a corporate globalization of "McWorld" that "has threatened the autonomy of civil society and its cultural and spiritual domains, as well as of politics" in the form of "a many-sectored civil society in which the autonomy of each distinctive domain . . . is guaranteed by the sovereignty of the democratic state"(1996, 296). For Barber, the integrity of democratic institutions stands at the core of maintaining social equality with diversity (300).

With respect to the globalization of culture and society, it is therefore crucial that we reexamine our cultural institutions and their increasing convergence with corporate cultural politics, not only with an eye to how corporations shape culture, that is, their practices within and outside of the corporation, but also with respect to the way they have created a new consensus in determining institutional objectives and how the new partnership (Schreiber 1994) between corporations and communities should be structured. This involves an investigation and recognition of the economic, cultural, and social capital vested in our institutions. Beyond advertising and promotion, this book explores how corporate cultural politics reframe and restructure institutional discourses that facilitate the increasing convergence between cultural and social institutions, corporations, and nonprofit foundations. This convergence accelerates the blurring of boundaries between public and commercial interests or public and commercial space while deflecting attention away from a critical interrogation of corporations themselves. Although notions of "outside" and "within" may be useful in identifying corporate strategies and examining potential forms of resistance, we must also recognize the extent to which we are implicated individually, institutionally, or communally in these processes. Rosalyn Deutsche has argued that the notion of a clear differentiation of spatial boundaries and their representation (in this case, the boundaries between public and private, between corporate and cultural spaces) restricts a fuller analysis of social space that would "deter us from investigating the real political struggles inherent in the production of *all* spaces and from enlarging the field of struggles to make many different kinds of spaces public" (1998, 374–75n121). I hope this study will contribute to a fuller awareness of the nature of these institutional, cultural, and communal relations as a part of larger movements that are also underway to reexamine corporate politics both locally and globally.

2. Corporate Cultural Politics:
Corporate Identity and Culture

On the day the Berlin Wall fell, we decided to send a film crew to the scene immediately. . . . Our immediate concern was that something important was happening that would have a direct and immediate impact on millions of lives, and that would directly influence millions of others around the world in a positive way. We knew there would be value in that linkage for Pepsi. . . . We made a commercial that celebrated the moment and closed with the words "Peace on Earth," joined tastefully to a small Pepsi-Cola logo. A big event, and Pepsi was proud to be a small part of it.
—Alan Pottasch, in *Lifestyle and Event Marketing*

During the 1990s, mapping the terrain of cultural politics in the United States and Germany was not only a matter of registering the ongoing financial and identity crises (while developing survival strategies) but also a process of renegotiating the institutional roles of cultural producers, brokers, and audiences. Although politicians in Germany and the United States became even more aware of the potential power of culture as a two-edged sword of identity promotion (e.g., Pepsi's "current-event marketing") and representational politics (e.g., NEA controversies in the United States; Christo's *Wrapped Reichstag* in Germany), they continued to reduce funding for culture. Meanwhile, nonprofit organizations such as the Guggenheim and Getty foundations assumed more-visible and more-influential positions through their extensive acquisition and building projects (e.g., the Guggenheim Museum Bilbao (GMB), Deutsche Guggenheim Berlin, or the Getty Center in Los Angeles), transforming themselves into truly global enterprises with their own "brands" of cultural politics and image promotion.

In Germany, where many corporations are still controlled by private or family interests, new cultural foundations are emerging as major beneficiaries of these private fortunes and will be significant participants in shaping postunification cultural politics in the twenty-first century.[1] In the United States, the gaps left by budget cuts and new demands for cultural programming in the 1980s and 1990s were at least partially filled by foundations, individual donors, and corporate sponsors, as well as by many museums and performing arts centers, which transformed themselves into semicommercial

entities.[2] The collaboration of private foundations, public arts institutions, and corporations has supplanted, expanded, and redefined cultural politics. This and subsequent chapters will investigate the notion that corporations have institutionalized their own cultural politics, which play a pivotal role in the nexus of corporate, foundation, and national or regional politics. Despite their relatively small contribution to cultural funding, corporations participate in defining public and private agendas of cultural programming in at least three key respects.

First, the corporation produces consumer and media culture by defining the relations between products and images that construct the contexts and social relations of everyday life. Andrew Wernick concludes that promotion *(promotional culture)* has become the predominant, legitimized mode of communication within most aspects of society (e.g., politics, education, media) and that it is "virtually co-extensive with our produced symbolic world" (1991, 182). Gerhard Schulze argues that the actual experience of consuming the image *and* the product itself involves a complex interaction between the psychological (re)construction of the image and the physical process of consuming the product, which enables the individual to establish and replicate the gratification of consumption. This desire to find and replicate such experiences is the primary orientation of societies based on experiences and events (Schulze's *Erlebnisgesellschaft*) (1992, 252).

Second, corporate models of institutional operation and management (e.g., in search of market approval, efficiency) are increasingly accepted as legitimate by government, nonprofit, and educational institutions. Although the corporation draws on social and psychological techniques from other spheres, it adapts and redefines them in terms of corporate objectives and disseminates them for use by nonprofit institutions. In this respect, corporations have a significant impact by establishing the relations of power among institutions and by shaping the parameters of social legitimacy. In assessing this influence in the construction of culture, Avery Gordon concludes,

> Corporate culture, in the broadest sense, influences and supervises public modes of governance not simply through conventional corporate influence on state politics, or through interlocking networks of elites, or through the generalization of the commodity form . . . but as a model of cultural and social relations. Significant changes in corporate culture not only refashion the corporation, but make the social forms and identities produced there reign commonsensically in our public and private lives. In other words, corporate culture strives, particularly when it conceives of itself as a "sustainable environment," to become socially dominant. (1995, 18–19)

Third, although nonprofit institutions (e.g., museums, operas, theaters, symphonies) occupy different positions within the cultural marketplace, or in what Schulze terms the market for experiences *(Erlebnismarkt),* they share many common interests. Above all, both commercial and nonprofit institutions strive to maintain institutional survival by (1) creating legitimacy, (2) cultivating informal relations with policy makers, (3) securing a certain degree of institutional stability, (4) realizing economic success,

and (5) generating a resonance within the audiences they choose to address (Schulze 1992, 504–5). Nor can artists completely disengage themselves from or disregard these survival strategies. Artistic production is increasingly relativized within a cultural and experiential marketplace in which the artist assumes positions of collaborator or supplier of conceptual "software" for the projects (i.e., new experiences and events) offered by cultural institutions and corporations (Schulze 1992, 438, 506). Thus, commercial entities (corporations) develop their own forms and strategies of cultural politics (e.g., sponsorships) in order to maintain and expand their institutional bases and spheres of influence, while public and nonprofit institutions incrementally adopt (and modify) corporate strategies in order to guarantee public recognition and financial stability. New forms of cultural promotion and mediation, such as cultural sponsorships, have developed as a result of these *converging interests.* That is, both corporations and nonprofits seek legitimacy and audience acceptance.

Certainly, it would be a simplification to speak strictly in terms of corporate cultural hegemony. *Corporate cultural politics have emerged, in part, as a result of the corporation's response to dynamic social forces (internal and external) over which it can exert only partial, albeit significant, control.* Although much of product culture and promotion is based on recirculating and appropriating existing cultural images (Coca-Cola, the Marlboro Man, the VW Beetle), product images are also threatened by rapid obsolescence. From an audience perspective, consumption and reception can be structured and channeled but not totally programmed. Corporations recognize that the contexts of cultural production and reception are contested. They are marked by paradoxes, crises, and forms of resistance that potentially subvert the spaces occupied by corporate interests, yet this resistance may also present new venues for corporate cultural programming.[3] However, the crises of corporate legitimacy also provide an aperture for artists who reject sponsorship (e.g., Hans Haacke, Christo and Jeanne-Claude) to address corporate and public cultural politics in their work. Moreover, as some products (e.g., tobacco, alcohol, genetically modified foods) have become the target of social and public-policy agendas in the EU and the United States, the necessity of a cultural programming that operates outside of the traditionally circumscribed boundaries of material culture becomes more essential for corporations if they are to maintain their social legitimacy. Rather than valorizing either manipulation or resistance, this study examines aspects of manipulation and resistance by analyzing the specific contexts of cultural production, dissemination, and reception. It is within the site-specific production, mediation, and reception of culture that the strategies and potential for social control or resistance become visible.

As I have suggested in chapter 1, corporate cultural policy and the limits of sponsorship have assumed a central position in public-private debates on new directions in culture, both in the United States and in Germany. At the same time that a major NEA report on the arts and culture in the United States *(American Canvas)* was released, I. Michael Heyman (secretary of the Smithsonian Institution) summarized the Institution Council's discussion of corporate sponsorships:

In the past three years, corporate funding has been an important source of additional revenues for our educational efforts in research, exhibitions and national outreach. We're grateful for that help. Unlike in the past, however, corporations now ask more from us than simple acknowledgment of support. For instance, in return for a sponsor's giving to the Smithsonian a percentage of its product sales, or funding an activity or exhibition, the sponsor may ask to use the Institution logo in corporate advertising, identifying the company as "a proud supporter of the Smithsonian." (1998, 11)

The experience of the Smithsonian and the concerns of its council speak to core issues of corporate sponsorships. Heyman's observations illustrate one dimension of a much larger complex of communicative strategies employed by corporations. Here, we see several leitmotivs emerge, including (1) *the centrality of the event* as a medium that defines and structures the production of culture and the contexts of its reception, (2) *the preeminence of image promotion,* or what marketing specialists refer to as "image transfer," and (3) the importance of *shaping public and social policy* through "partnerships." In this case, the institutional image of the Smithsonian becomes an integral component of constructing and projecting corporate identity through the corporation's use of institutional spaces (exhibitions) and modes of signification (logos):

Two of our sponsors made it clear at the Council meeting that the value of the Smithsonian to corporations lies in pairing our identity (or "brand") with that of a corporation ("co-branding"). In corporate eyes, our well-known identity bespeaks "American," "integrity," "familiarity," "family," "history," "technology," "art" and similar concepts. (Heyman 1998, 11)

Whereas corporations once insisted upon the placement of their corporate logos on advertisements for sponsored projects, the institution's logo is now transferred to the corporate advertisement of cultural sponsorship as a stamp of public approval and legitimacy.[4] Conversely, the cache of public trust that this approval communicates can be rapidly spent, "especially in connection with questionable products (tobacco and alcohol, . . .), practices (such as providing substandard wages and working conditions) and occurrences (such as deleterious environmental events)" (Heyman 1998, ·11). Heyman concludes that the Smithsonian must attempt to balance corporate interests with those of public policy and its own institutional objectives. In comparison with past conflicts with the U.S. Congress (which funds the Smithsonian and appoints its Board of Regents), he suggests that corporate opposition to Smithsonian projects may seem minor. Yet the Smithsonian's discussion of sponsorship in its membership's magazine illustrates the extent to which corporations have assumed a central position in defining culture and in structuring the institutions and spaces of public cultural politics. A brief look at the evolution of corporate involvement in cultural programming in the United States reveals the gradual expansion of corporate interests in public cultural politics and the simultaneous legitimation and institutionalization of sponsorship.

Sponsoring: "The New Partnership"

In 1960, Governor Nelson Rockefeller gained legislative approval for the New York State Council on the Arts. This agency subsequently became an administrative model for state arts organizations and for the NEA and the National Endowment for the Humanities (NEH), enacted by Lyndon Johnson in 1965 (Heilbrun and Gray 1993, 229–30). During the late 1950s, large corporations like the Chase Manhattan Bank and Philip Morris were already engaged in art collecting and modest support of symphonies. The Ford Foundation had been providing grants for symphonies since the late 1950s and became a major funding source for arts projects. In 1967, David Rockefeller (chairman of the board of Chase Manhattan Bank) proposed the Business Committee for the Arts (BCA) in order to encourage other business leaders to support the arts, both nationally and regionally (Jedlicka 1989, 1). The establishment of the BCA and the political groundwork laid by Nelson Rockefeller signaled a growing consciousness within corporations that cultural promotion could be deployed as an instrument of public relations within the public-policy arena. Although David Rockefeller stressed notions of social responsibility and "good citizenship" in his speech proposing the BCA, the economic and public relations value of "the arts" (i.e., predominantly high culture) were already an integral component of developing external and internal corporate identity:

> It can provide a company with extensive publicity and advertising, a brighter public reputation, and an improved corporate image. It can build better customer relations, a readier acceptance of company products, and a superior appraisal of their quality. Promotion of the arts can improve the morale of employees and help attract qualified personnel. (Rockefeller 1966, 3)

Rockefeller's address to business leaders also refers to other forces and interests at work beyond corporate philanthropy or patronage, for example, architecture as a representation of corporate identity in urban centers and the use of culture in product design (5–7). The organization and articulation of corporate interests in "the arts" also became an instrument for maintaining and documenting social legitimacy as corporations were subject to increased scrutiny in the late 1960s. Two decades later, George Weissman, former CEO of Philip Morris, referred to the social and cultural forces that threatened the corporate infrastructure:

> Our community was changing in the late 1950's and the 1960's—turbulently and radically on many fronts at the same time—politically, socially, culturally, economically. Long established cities like Boston, Detroit, Cleveland, Atlanta, Pittsburgh . . . began to grow old and show serious signs of wear. . . . There was grave concern whether broken-down neighborhoods—entire cities—our vital communities—had the ability to repair, revive and recover. . . . Obviously, innovative approaches were needed to run our businesses, to develop new kinds of ties with the community . . . to make secure our democratic, capitalistic way of life. We are dealing here with basic, rock-bottom self-interest. (Weissman 1988, 2)

The BCA and individual corporate programs were a response to a sociopolitical climate that was perceived as challenging or undermining corporate power in local communities (e.g., corporate resistance to unionization, unregulated economic development) and threatening the corporation's political interests. We will see that corporate cultural politics is not limited to cultural programming; it also operates increasingly in the social dimension, that is, through "social sponsorships" at local and national levels.

At Philip Morris, support for the arts had become an instrument for corporate identity and market expansion: "Through audacious, original marketing campaigns, Philip Morris products began capturing ever-larger market shares in the 1950s and 1960s. This boldness and flair for innovation were reflected in the company's sponsorship of the museum exhibition Pop & Op" (*Philip Morris and the Arts* 1993, 3). By 1965, Philip Morris had already organized and sponsored the exhibition and U.S. tour of *Pop & Op,* featuring works by Roy Lichtenstein, Jasper Johns, and James Rosenquist. Corporations had long since recognized the value of aesthetics and design in marketing, as well as the public-relations value of their own participation in the mediation of contemporary culture and lifestyles. Although relatively few corporations had articulated programs for cultural programming in the 1960s, many realized the significance of the 1960s counterculture for the design, styling, and packaging of new products. Thus, manufacturers of consumer products increasingly pursued strategies of aesthetic appropriation while advancing social agendas that reinforced the legitimacy of "the capitalistic way of life," particularly with respect to corporate interests in urban centers. The emerging institutionalization of cultural programming was also a recognition of the centrality of contemporary culture as a function of the new lifestyle marketing during the early 1970s.

The attractiveness of cultural sponsorships increased dramatically as (popular) culture's status within the mass media assumed a heightened social status. In the United States, the promotional value of sponsorships as an ancillary or complementary form of addressing target markets and more-sophisticated audiences continued to expand during the 1970s and 1980s. Sports sponsorships were becoming one of the largest markets for alcohol and tobacco producers. Philip Morris simultaneously pursued support of avant-garde culture (in both visual and performing arts) and a public policy that would favor its products (especially tobacco). Although sports sponsorships were and are structurally distinct from cultural sponsorships, they provided some initial experience for subsequent marketing in cultural contexts, especially at events and festivals. Of course, sports were not considered forms of serious, high culture despite their widespread appeal even among so-called elites. Yet as the NEA observes, institutionalized forms of high culture were and are not "integrated into our daily lives in quite the same way that sports are (which is why no less than 12 of the 25 highest rated television shows of all time were sporting events)" (Larson 1997, 61). Precisely because professional sports are so embedded in most aspects of global culture—including education at all levels, leisure, and management—they have been attractive sites for the

projection and construction of identities. However, the reality of these lifestyles (e.g., health risks related to the consumption of alcohol and tobacco) also became primary objects of public policies that threatened corporate interests during the 1990s.

Although during the early 1980s many corporations continued to perceive cultural programming primarily as philanthropy (or pursued philanthropy and sponsorship), by the early 1990s financial support for culture had been integrated into corporate identity, marketing communication, and public affairs. Indeed, the quantitative significance of sponsorships (which provided corporate funding or goods and services in return for the promotional use of the event and institution) was underestimated or not even registered as "arts support" in many major studies of the arts, in part because such expenditures in marketing and advertising budgets are largely undisclosed, that is, not made available to the public (Heilbrun and Gray 1993, 236–37). Alfred Schreiber, a corporate consultant on event sponsorships, observes,

> In reality, corporate philanthropy has been almost entirely replaced by cause-related marketing.
>
> What's the difference?
>
> Simply that philanthropy was sometimes giving money away. Lifestyle marketing, of course, gives money too. But it goes beyond that. It shares values. It's an overt demonstration and statement that a company not only gives cash but shares certain attitudes and beliefs with its consumers.
>
> There is also more of a synergy to lifestyle marketing than to philanthropy. (1994, 18)

Expenditures for cultural programs were integrated into specific marketing and promotion objectives, based on profitability and a return on investment. Forms of culture that were not consonant with either product or corporate identity objectives were eliminated as unsuitable from the outset (Bruhn and Dahlhoff 1989, 62–69; Schreiber 1994, 19). Moreover, contemporary sponsorships position the corporation as a "partner" in regional or community affairs[5] and in the formulation of public policy, demanding a promotional return on investment for products and services and legitimizing corporate interests (economic incentives, labor relations, etc.).[6] Although contemporary sponsorships may reinforce multiple corporate objectives (cultural, social, economic), their programming has become more focused and, as we have seen in the case of the Smithsonian, more demanding, tending to see sponsorships in terms of specific contractual agreements rather than philanthropy:

> A company is giving some tangible asset to the entity it chooses to support, be it money, technical assistance, marketing advice, exposure, whatever. In return, the corporation expects very concrete things, which are spelled out in a plan that is jointly approved by both the sponsor and the organization that gets sponsored. (Schreiber 1994, 18)

The two-pronged objectives of cultural sponsorships—product or image promotion and public-policy impact—are reflected in the evolution of sponsoring in both

North America and Europe (Bruhn and Dahlhoff 1989, 37). On both continents, the expansion of sports sponsorships preceded cultural sponsorships. Social and environmental sponsorships did not become more widespread until the 1980s in the United States and the late 1990s in Germany. Cultural sponsorships were more prevalent in the United States and the United Kingdom than in Germany, where they only gained importance beginning in the 1990s (Bruhn 1991, 26). Financing German unification and expansive development projects during the 1980s led to budget cuts at regional and national levels in the early 1990s. Museums, operas, and theaters searched for alternative funding sources, including sponsors. This expansion of sponsorships in Germany received further impetus from the privatization of public entities (e.g., of the rail system, post office, and telecommunications), the emerging markets of the EU, and corporate globalization, which contributed to a more competitive cultural marketplace. Both at the federal and regional level, the new cultural politics embraced corporate-public "partnerships" (Heinrichs 1997, v). After initially being criticized in the media, corporate participation had become an integral part of Germany's cultural marketplace by the mid-1990s.

With the exception of sports sponsorships, some cultural and social sponsorships have merged. Rock concerts for charitable causes (e.g., for AIDS, Amnesty International), festivals, or other events became sites for cause-related fund-raising and corporate representation. Ronald McDonald Houses (for families of children being treated in nearby hospitals) signified the participation of global corporations in local social contexts (Dumrath 1992, 31–36). In the late 1990s, the NEA's *American Canvas* argued for an even greater involvement for the arts within the fabric of everyday life in U.S. communities (Larson 1997, 82–86). In chapter 3, I will examine how this fusion of various types of sponsoring reflects broader processes of cultural de-differentiation (between high and low culture) (Lash 1991, 5) or cultural hybridization (between various types of culture), processes that blur the boundaries between corporate and public interests.

Culture as Corporate Communication

The potential for sponsorship is as vast and diverse as the field of contemporary culture, ranging from support for historic restoration projects (e.g., Mercedes-Benz contributes to Margaret Mitchell's residence in Atlanta) to support for research on breast cancer (e.g., BMW makes a donation each time someone test-drives a BMW during a fund-raiser) to support of contemporary music (e.g., Volkswagen sponsors the Rolling Stones).[7] The "new partnership" (Schreiber 1994, 18–20) among corporations, cultural institutions, and communities, based on events and "cause-related marketing," attempts to engage audiences on an emotional level, not only through interaction with the product itself but by organizing and structuring selected sites of cultural production and mediation.

Cultural sponsorships have been integrated into corporate identity, communication, and management philosophy and are increasingly measured through quantitative

evaluation. Sponsoring specialist Manfred Bruhn suggests that managers begin the process of cultural sponsorship by evaluating cultural production in terms of its compatibility with the corporation's own philosophy of cultural support and corporate identity (Bruhn 1991, 208). Corporations generally base their funding decisions on three criteria: (1) whether the area of cultural activity (e.g., music, art, film, festivals) corresponds to the corporation's own target markets, (2) whether themes and events have potential for media coverage and resonance, and (3) whether individuals and groups are "promotable" (Bruhn and Dahlhoff 1989, 74). Although these factors suggest that forms of alternative or marginalized culture may be rejected out of hand, subsequent chapters in this study will show that some avant-garde artists and works may be attractive precisely because they have high visibility in the media. However, few corporations select projects that overtly criticize their politics and interests.

Schreiber recommends that corporate managers measure the success of sponsorships in relation to (1) the program's effectiveness in providing more involvement with participants and audiences ("value-added" dimensions to the actual event), (2) the project's potential to attract and engage mass media as a bridge to audiences who cannot participate in the event, and (3) the project's potential to involve the corporation's customers, sales force, distributors, or wholesalers (1994, 132). Linking popular events to products is considered "value-added" because it adds audience interaction with the corporate products or images to the promotional budget that would have been expended in any case. Concurrent media coverage of sponsored events (frequently included in news coverage) is a form of free promotion and is often more effective than advertising because it is not tuned out or turned off by viewers.

Image and product promotion are amplified by linking sponsored events to in-store promotions and sales incentives. Events become instruments for market research and tools for measuring the effectiveness of corporate communication at an event (Schreiber 1994, 134). For example, an event's organizers distribute coupons that are redeemable at fast-food restaurants, which in turn promote the event (so-called cross-promotion). Such "point-of-sale" cross-promotion was used for the Benson & Hedges Blues Festival:

> Benson & Hedges . . . places a free "on pack" cassette of music from the festival on their cartons. So the consumer who buys a carton of Benson & Hedges also gets a free cassette of blues hits. In this way, Benson & Hedges drives the overall idea that it is giving a nationwide series of musical events by giving customers a taste of it at the local level. (Schreiber 1994, 134)

Despite heightened restrictions on tobacco advertising in the EU and the United States, it remains to be seen to what extent such forms of product promotion can or will be regulated, particularly when organizers become dependent upon sponsored funding.[8]

By sponsoring a successful event, corporations gain leverage with distributors at the local or regional level. Leveraging can be used to induce or pressure reluctant retailers to offer corporate goods and services. Schreiber explains that American Express lever-

aged the Liza Minnelli, Frank Sinatra, and Sammy Davis Jr. tour Together Again by "inform[ing] theaters that they could only present the concert if they began to accept the American Express card in their future box-office operations" (1994, 19). Sponsors may actually "buy" a successful annual event (e.g., a music festival) or create their own events in order to achieve greater control over its production and communication. Events can be licensed to other cosponsors, and the corporate owners may make a profit by successfully marketing their event (Schreiber 1994, 146).

While some sponsorships are utilized as vehicles for *product* promotion, others are primarily engaged to promote product or corporate *images*. Philip Morris sponsors the tour of the Philip Morris Superband in the United States as image promotion, but it also distributes cigarettes at international art exhibitions such as the *documenta* or at the Filmfest München as product promotion. What is most significant, however, is that both of these activities are carried out within contexts signified as cultural sites. Despite structural or organizational distinctions between product sponsoring and image sponsoring (Bruhn and Dahlhoff 1989, 64–68), sponsoring practice indicates a de-differentiation of product and image. Attempts by corporations to distinguish between product (sponsoring) and image (sponsoring) reflect marketing and distribution strategies rather than the actual contexts of consumption that fuse the physical and psychological aspects of *experiencing* consumption, a fusion that Schulze has defined as *Erlebnis* (1992, 422). The development of sponsoring as an instrument of corporate communication contributes to this process of de-differentiation because it most commonly occurs on the boundaries of product and image (Wernick 1991, 184). Thus, product sponsoring invokes image sponsoring and vice versa. However, the image has gained a more important status in the signification of the product (Wernick 1991, 92–123; Stolorz 1992, 55). The mediation of product and corporate images through sponsored projects is an intrinsic feature of the cultural politics of the corporation. Because the products and images function within dynamic and volatile sociocultural and political contexts in which they are rapidly relativized, destabilized, or made obsolete, they must be recycled, reinvented, or reinscribed with meaning. The cultural politics of the corporation increasingly require it to explore, occupy, *and redefine* social boundaries in order to maintain economic, political, and social legitimacy.

Defining a Politics of Corporate Space

Corporate headquarters are the most visible locus of corporate image and power. They signify a politics of place or space, that is, of the corporation's economic, political, and cultural status, either within urban centers or as a rural campus. Not only do these buildings function as promotional signs for the corporation and the city, but they also often become synonymous with urban skylines and rural landscapes—for example, Mies van der Rohe's Seagrams Building or Philip Johnson's postmodernist AT&T Building in New York, the BMW headquarters and BMW Museum in Munich, Norman Foster's Shanghai Bank in Hong Kong, or Frank Lloyd Wright's Johnson Wax Building in Wisconsin (Roth 1989, 83–84). Architecture simultaneously externalizes and fuses corporate identity with corporate design. The representational aspects of

corporate design—from product packaging to the design of corporate environments and spaces—address both external audiences (consumers, politicians, competitors, collaborators, shareholders) and internal ones (management and employees) by mediating values and identities.

Karla Fohrbeck argues that corporate design fulfills two related social needs: (1) It reinforces the desire for social differentiation, individuality, innovation, and distinctive lifestyles while (2) providing structures and symbols that support the need for community, for shared identities and meanings (Fohrbeck and Wiesand 1989, 28). As a function of corporate identity, corporate architecture attempts to simultaneously represent innovation, distinction, creativity, and individuality while ensuring a sense of orientation, community, and partnership. Both dimensions of corporate identity and design relate to the conceptualization of cultural sponsorships and corporate cultural politics.

Corporate architecture functions as a marker for historical and spatial narratives, that is, for the way corporate buildings define and structure social interaction within the building while also shaping physical, social, and economic spaces surrounding it. IBM's founder, Thomas Watson, selected rural sites in order to isolate employees from the "temptations of urban life" that would supposedly decrease productivity (Erben 1992, 64). Of course, the idea of creating communities of workers—for example, as factory and mining towns or as social communes—is well documented in the social history of labor relations. But Watson's patriarchal attitude was also intended to geographically distance IBM and its employees from the competition by reducing the flow of information and personnel to competitors while controlling the environments within which employees lived and worked. More specifically, it was an attempt to structure "intact" external *social* environments in order to ensure a stable business environment (Erben 1992, 64–65). However, corporations recognized (particularly during the 1960s and 1970s) that attempts to control social environments, predicated on nineteenth-century notions of corporate patriarchy, were obsolete and counterproductive.

In fact, it was the corporation itself that destroyed any vestiges of intact communities by exploiting the commercial potential of the media and mass-market advertising beginning in the 1950s in the United States. However, the goal of structuring social environments in order to maintain productivity and promote local corporate interests was not abandoned but, rather, redefined as "community partnerships." At IBM, sponsoring philosophy is directly related to community partnerships that "serve to create an intact environment," for example, through sponsorships in schools near IBM's former corporate headquarters in Sindelfingen, Germany (Erben 1992, 66). Although corporations frequently claim to cultivate their own distinctive corporate culture internally, corporate identity externally asserts the corporate interest as an integral part of all communities.

Figure 2.1. IBM shapes educational policy at local levels through product technologies and community partnerships.

Reinventing Education

Computers can **make a** world of **difference** in our nation's education system.

They just can't do it on their own.

We don't just send computers to schools, we send people, too: experienced scientists and problem solvers. They help educators apply technology in ways that make profound improvements in the way schools are run. In Cincinnati, a team from IBM helped teachers design a new program that tailors courses and schedules to the unique needs of individual students, finally putting an end to "one size fits all" education. The result: better schools, smarter kids. To find out more about IBM's Reinventing Education program, visit us at www.ibm.com/IBM/IBMGives

Solutions for a small planet™

Although the site selection for corporate headquarters is still based on economic criteria (e.g., real estate prices, tax abatements), quality of life, or potential for creative synergy, corporate globalization and telecommunication have eliminated many of the differences between rural, suburban, and urban sites. Corporate headquarters attempt to create shared communal spaces (such as atria, plazas, dining areas, fitness centers, daycare facilities) and individualized spaces (particularly for management) while maintaining hierarchies of power through spatial or territorial relations (e.g., space allocation, interior design). Internally, corporate design shares a common orientation to social spaces and structuring relations between the individual and communities. In this sense, the corporate workplace is redefined as a communal living space or a community of shared values that eliminates difference. The campus architecture of high-tech corporations—enhanced by collaborative working groups and teams—*ostensibly* erased the spatial hierarchies symbolized by the corporate penthouse in an urban skyscraper. Working communities were redefined and spatially recontextualized through corporate design and corporate culture. Simultaneously, beginning in the 1970s, corporate architecture was reconceptualized in order to project a corporate image in harmony with a heightened environmental consciousness. Artist Dan Graham observes,

> While postwar use of transparent glass windows for the corporate office buildings made its function and employees visible to the public, by the seventies, two-way mirrored windows had replaced transparent windows. This new corporate facade reflected the outside environment while allowing employees the security of an unseen view outside. . . . The corporate edifice, reflecting the exterior environment, could then be identified with the sky. The building's outer skin reflected sunlight and heat, conserving energy, and the facade read and functioned as "ecological." (1995, 130–31)

In his installation *Two-Way Mirror Cylinder inside Cube and Video Salon: Rooftop Park for Dia Center for the Arts* (1991), Graham addresses the exclusion of the spectator and others represented by the two-way mirrored windows, which "do not allow visual penetration by the spectator of the interior, but give the interior viewer a transparent view of the exterior" (1995, 127). Graham's interpretation and mediation of the two-way mirrored windows define a politics of corporate space as *containment* (for those within) and *exclusion* (for those outside).

An integral component of contemporary corporate cultural politics is the attempt to make community interests synonymous, or at least compatible, with corporate interests and to manage social diversity within corporate environments. Gordon discusses the redefinition of multicultural diversity in terms of diversity management:

> The management of racial and gender identities and conflicts, or what is otherwise known as diversity management, is a core component of the new corporate culture. Contemporary corporate culture does not demand assimilationism quite as we have known it, nor does it require undifferentiated social control. Corporate culture links a vision of racial and gender *diversity* to its existing relations of ruling to produce some-

thing that might be called multicultural corporatism. This vision of corporate multi-culturalism has the potential to become an influential feature of the larger project . . . of rewriting our nation's basic social contract. (1995, 2)

Corporate architecture addresses both social policy (e.g., diversity issues) and public space by redefining the relations between the corporation and those spaces that it occupies or dominates. New headquarters buildings are promoted as part of urban or regional revitalization projects and jobs initiatives, which communicate a positive public-relations image (e.g., that the corporation has "invested" in urban projects).

Corporate buildings integrate public and social spaces by including retail spaces and entertainment venues. Rockefeller Center—with its skating rink, annual Christmas tree display, cafés, bookstores, and NBC's corporate headquarters and television studios, with public windows and street-level broadcasts—exemplifies the hybridization of corporate and public spaces and is one of the early models of "mixed-use development" (MUD) (Snedcof 1985, 13). A significant feature of this hybridization of corporate and public spaces is the integration of museums into the corporate headquarters. The main lobby of Philip Morris's corporate headquarters in New York City became the site of a branch of the Whitney Museum. Many corporate centers, like BMW's, also house company museums. Graham observes that the IBM Atrium and Museum collapses traditional images of nature, as well as distinctions between public and private spaces: "The atrium functions essentially as a lobby for the attached, underground Museum of Science and Art, and marks another moment in corporate space, when corporate sponsorship of public museums became common in New York in the seventies" (1995, 131).[9]

In a similar fashion, corporate plazas, situated on the boundary between public and corporate spaces, become venues for corporate self-promotion, including sponsored events and commissioned artworks. Artist Richard Serra refers to the difficulties of establishing a separate space for art within such sites:

> Usually you're offered places which have specific ideological connotations, from parks to corporate and public buildings and their extensions such as lawns and plazas. It's difficult to subvert those contexts. That's why you have so many corporate baubles on Sixth Avenue [New York], so much bad plaza art that smacks of IBM, signifying its cultural awareness. . . . But there is no neutral site. Every context has its frame and its ideological overtones. It's a matter of degree. There is one condition that I want, which is a density of traffic flow. (Quoted in Crimp 1993, 169)

Like Serra, Judith Baca directs our attention to the functions of commissioned art as a representation of the relations between urban spaces and communities:

> By their daily presence in our lives, these artworks intend to persuade us of the justice of the acts they represent. The power of the corporate sponsor is embodied in the sculpture standing in front of the towering office building. These grand works, like their military predecessors in the parks, inspire a sense of awe by their scale and the importance of the

artist. Here, public art is unashamed in its intention to mediate between the public and the developer. (1996, 132)

Corporate cultural politics and corporate space are reproduced through the proliferation of real estate development or MUD projects that integrate cultural programming. In Austin, Texas, developer J. Burton Casey explains that his firm utilized the arts as a promotional vehicle to create a "feeling that it was avant-garde/cutting-edge to locate in that part of the city rather than feeling as if they were moving to the slums" (1986, 6). The project provided 45,000 square feet of studio space for one hundred local artists at cost (allocated from the firm's promotion budget) and established a children's museum staffed by engineers from the aerospace corporation Lockheed (Casey 1986, 6).[10] Such projects underscore the extent to which notions of urban planning remain inherently based on a corporate politics of containment and social displacement.[11]

Many of the cultural centers within MUDs, which began to proliferate in urban areas beginning in the 1970s, were either dedicated to high culture (concert halls, theaters, and museums), with its affluent audiences and donors, or entertainment and shopping complexes (Snedcof 1985, 11–35). As corporations became institutionalized as cultural promoters and brokers rather than simply urban patrons, they acquired properties in strategic locations in order to develop their own cultural centers, heighten their image, and promote their interests in local cultural politics. Certainly, the development of "cultural real estate" in the 1990s marked a significant shift from the high-culture properties of the 1970s and 1980s to the mass-entertainment complexes operated by multinational corporations in Berlin; New York; Orlando, Florida; Las Vegas; Hollywood; and even Branson, Missouri. (Disney had ensured its own completely autonomous local government through massive land acquisitions and development plans in Orlando—including the planned community Celebration—plans that were eagerly accepted by local and state government.)[12]

Although the MUDs and cultural centers of the 1970s were not as widespread in Germany, one need look no further than the multinational development projects (e.g., by Daimler and Sony) in Berlin of the 1990s in order to gain a sense of the significance corporations attach to the utilization of local and global spaces. Indeed, Berlin's Potsdamer Platz project (opened in 1998) reflected urban redevelopment and corporate image on an enormous scale, including

> the new Marlene-Dietrich-Platz, a new 12,000 square meter water feature, 18 residential blocks, 620 apartments, 30 restaurants, cafés, and bars, in addition to a musical theater, a casino, multiplex cinemas, a Grand Hotel, 110 retail outlets, and 175,000 square feet of commercial office space. This is all Daimler-Town, the Daimler-Dream.[13]

In terms of a corporate politics of space, Potsdamer Platz was an opportunity for emerging transnational corporations (e.g., DaimlerChrysler) to physically assert their presence locally at the crossroads of eastern and western Europe and within the politi-

cal contexts of the new capital (and thus adding their own "corporate embassies" to the ranks of national representation), meanwhile validating their participation in urban life by providing venues for the production and consumption of culture.

While media and entertainment corporations, such as Disney, may be among the most visible forces in urban (e.g., Broadway and Forty-second Street development) and regional (e.g., Orlando, Florida) cultural politics in the United States, many corporations "outside" of the culture industry (e.g., DaimlerChrysler) do not only sponsor culture; they also develop and structure the physical spaces of social interaction and simultaneously employ them as an articulation and legitimation of their interests in local public policy. The Ford Motor Corporation joined the Times Square development at Broadway and Forty-second Street by establishing the Ford Center for the Performing Arts as a venue for musical attractions.[14] Such projects establish corporations, like Ford, as cultural promoters and mediators of urban tourism and demarcate corporations' territorial, cultural, and political interests beyond the domain of corporate headquarters—in this case by allying themselves with political interests that redefined the urban space in order to expel "undesirable elements" (i.e., adult video outlets, the homeless, muggers, drug addicts). Rosalyn Deutsche has studied the double bind of urban gentrification (for government and corporations) during the 1970s and 1980s, which promoted the interests of developers but also threatened to displace the pool of cheap labor within inner cities (1998, 15–16).[15]

Central to such debates is a politics of space, which, as Susan Willis observes, erases the distinctions between publicly funded spaces and private property, a difference that "fundamentally defines our social practices and relationships" (1995, 182–83). This underscores the fact that economic, social, and political interests are embedded in both "private" and "public" spaces. Deutsche problematizes the very distinctions between "public" and "space," rejecting classical dichotomies of spaces:

> For no space, insofar as it is social, is a simply given, secure, self-contained entity that precedes representation; its very identity as a space, its appearance of closure, is constituted and maintained through discursive relationships that are themselves material and spatial—differentiations, repressions, subordinations, domestications, attempted exclusions. (1998, 374–75n121)

Paul Virilio argues that "more than Venturi's Las Vegas, it is Hollywood that merits urbanist scholarship," for it is Hollywood that problematized the notion of the stable image and a sense of place through the construction of imagined environments (sets) and their transformation into the equally unstable, fleeting images of the screen (1997, 389–90).[16] Whereas Virilio, like Jean Baudrillard, theorizes the dissolution of real environments, I would argue that the virtual environments of film or cyberspace also increase the desire for physically occupying and sensing other spaces, even if they too are not real. The sense of "being there," of experiencing events and places symbolically, cognitively, *and* physically (i.e., Schulze's *erleben*) is also reflected in John Urry's notion of "consuming places" (1995, 28, 149). Moreover, such themed environments are,

as Fredric Jameson concluded in his analysis of John Portman's Bonaventure Hotel, not interchangeable (1997, 242–45). Disney has had to reexamine its concepts of themed environments, in part to compensate for the proliferation of its own and other themed environments outside of Disney World, environments that define much of everyday social reality (Waldrep 1995, 221–22).

Although corporations play a major role in structuring the environments of social interaction, these sites perform different functions for, and are experienced in multiple modes by, audiences. Marianne Conroy suggests a more differentiated reading of the contexts and functions of themed environments such as outlet malls, arguing that specific sites influence the use and meaning of the commodity in very different ways (1998, 77). These perspectives shift the emphasis to the audience and to social interaction rather than to the forces of institutional control.

As Sophie Watson and Katherine Gibson observe, postmodernist interventions have exposed the assumptions of modernist planning: "the notion that cities can be made better, that outcomes are knowable, that order and rationality should and can replace chaos and irrationality; the ideology of progress, and some notion of the better good" (1995a, 258). "Planning in a postmodernist environment" is a recognition that urban spaces are occupied by diverse and conflicting forces that should be engaged democratically rather than contained, expelled, or repressed. Deutsche also conceives of social space as inherently "produced and structured by conflicts" (1998, xxiv). But how does urban planning integrate the forces of social conflict or promote social reform without becoming a vehicle for control?

Although Watson and Gibson question the degree to which planning is possible if it is based on contingency and indeterminacy, they underscore the necessity of rethinking the manner in which spaces are conceptualized, and particularly the interplay between forces of mainstream culture and of cultures that have been marginalized within the contested territories of urban space (1995a, 259, 262–63). Baca proposes that artists (particularly those from marginalized communities) have a responsibility to become involved in "the invention of systems of 'voice giving' for those left without public venues in which to speak" (1996, 137–38). In a similar vein, artist and community activist Mary Ann Mears suggests that cultural projects be included in grant applications for federal economic development funding that the U.S. government has allocated for "empowerment zones." In doing so, artists and marginalized communities become participants in economic revitalization projects (cited in Larson 1997, 128–29).

The Globalization of Corporate Cultural Politics: Sponsoring Diversity and Creativity

The processes of de-territorialization are indicative of cultural de-differentiation and globalization. Thus, themed environments become part of everyday landscapes and vice versa; sociopolitical boundaries between public spaces and private spaces are blurred. As Waters points out, theories of globalization define it as a process of simultaneous homogenization and differentiation (1996, 136, 139). This tension between

homogenizing and differentiating tendencies is manifest in the complex relations of corporate cultural politics. Waters concludes that analyses of globalization are primarily based on relationships between social organization and territoriality, which are characterized by three central functions of exchange: material exchanges localize, political exchanges internationalize, and symbolic exchanges globalize (8–9). With respect to our discussion of corporate cultural politics, these dimensions relate to

- the dissemination of material products and the simultaneous communication of product images at local or regional sites;

- the articulation of corporate political interests (locally, nationally, and internationally) via cultural and social sponsorships;

- the communication of corporate and product images globally.

Of course, these processes, such as material and symbolic exchange, occur simultaneously on multiple levels and in multiple territories.

Sponsorships and cultural programming represent sites at which cultural, economic, and political interests converge and are negotiated. Departments of cultural programming within corporations form institutional and administrative centers for the mediation of corporate cultural politics. Rather than simply responding to funding requests from artists, nonprofit agencies, or public institutions (museums, theaters, symphonies), the corporate "Cultural Programs" departments often create their own programming concepts and seek suitable partners to develop and implement them. Public-relations firms specializing in sponsorships may also be engaged in the process of identifying projects that will meet corporate image or product objectives. The European Sponsoring Exchange *(Europäische Sponsoring-Börse, ESB)* provides seminars, information on organizations seeking sponsors, and listings for sponsors on its Web site.[17] Whereas some corporations (e.g., DaimlerChrysler) administratively separate sponsorships from product-oriented public relations, others, such as Philip Morris, tend to overlap the two functions (Grüßer 1992, 35).

Because the distinctions between product and image have become increasingly fluid, much of sponsoring is ultimately tied to public-relations and corporate-image objectives. Regardless of their designations, the departments of cultural programming have become an integral component in the articulation of corporate cultural politics. Although there are considerable differences in the forms of culture they sponsor (both high and low) and the manner in which they organize their participation (e.g., from product promotion to image transfer), these positions reflect the extensive function of corporations in the construction of image and product cultures and subcultures. Several examples of the activities of cultural programming departments illustrate the globalization of corporate cultural politics, in terms of both the homogenizing and the differentiating tendencies outlined above.

In articulating their "sponsoring philosophy," departments of cultural programming frequently refer to notions of creativity and innovation in order to define and

legitimize their participation in the cultural marketplace—both as producers and consumers. This is part of the "new partnership" (Schreiber 1994)—a new "social contract" (Gordon 1995) that inserts corporate interests into communities. Creativity and innovation provide the link between artists (or cultural institutions) and products, services, and corporate image. At DaimlerChrysler Aerospace (DASA, formerly Deutsche Aerospace), a subsidiary of DaimlerChrysler, support for young artists is linked to the firm's history, image, and corporate art collections. DASA's cultural program creates a historical narrative that is synchronized with corporate image goals:

> The history of Deutsche Aerospace has been forged by the pioneer spirit of our company's founding fathers. And visionary thinking combined with innovative capabilities are still the major elements that shape our enterprise today.
>
> It is thus in keeping with this spirit at Deutsche Aerospace that we welcome an artistic vision of our company.[18]

The text reference to "founding fathers" evokes images of a history of patriarchal tradition and individual entrepreneurship, although DASA was only created during the early 1990s to consolidate Daimler-Benz acquisitions (Dornier, MBB [Messerschmitt-Bölkow-Blohm], MTU [Motoren- und Turbinen-Union], and Telefunken Systemtechnik) under a common corporate roof. On the other hand, DASA's corporate identity as a young, dynamic, and creative corporation is underscored in the text and in the title of its initial cultural program: "A Young Corporation Supports Young Artists." The project provided stipends for artists to visit the production sites of Deutsche Aerospace subsidiaries, record their impressions in various media (e.g., painting, sculpture), and subsequently exhibit their works in the Munich headquarters.

At BMW, creativity and innovation form the core of the discursive structure of cultural programming:

> The culture of our time transports New Thinking. This culture is—at least in the various facets of it that BMW perceives, supports, and shows—open to innovation and experiment. Cultural action creates new horizons, illuminating and expanding at the very least our present perspective.[19]

Like DASA, BMW presents the development of new product technologies as an artistic endeavor:

> A spiritual affinity, indeed a community, connects us with the culture of our time, with experiment and innovation. Cultural and industrial spheres are searching for the worlds we will live in tomorrow. Thus, whenever we connect art and technology in cultural presentations, we are utilizing this affinity.[20]

This marriage of art and technology, facilitated by cultural programming, is transferred to futuristic product development and is celebrated as a new "boundary crossing."[21] Similar texts articulating the objectives and philosophies of multinational corporations are well documented in the professional literature on public relations and

corporate identity and will be examined in depth in the subsequent chapters of this study.[22] Although most corporations with established sponsorship programs (e.g., American Express, BMW, DaimlerChrysler, Philip Morris) encourage their national subsidiaries to develop their own sponsorship programs, they also reconfigure success-ful programs for foreign consumption or support projects that will be accessible to international audiences (e.g., art exhibitions). Thus, sponsoring follows the corporate mantra "Think globally, act locally."

A key feature of this globalization process is the transfer of philosophies of man-agement and corporate identity within and between multinational corporations. This has led to the dissemination of a common but by no means unified corpus of multi-national management philosophies and consulting practices. Certainly, multinational mergers and acquisitions in manufacturing, communication, and service industries (e.g., DaimlerChrysler, Bertelsmann–Random House) and increasing concentration among accounting and consulting firms (e.g., Ernst & Young, KPMG, or McKinsey) have accelerated the standardization of management and personnel philosophies as well as of evaluation and assessment practices. This process has been facilitated by (1) the identification by business consultants from academia or public relations of cul-ture and lifestyle as productive markets and (2) the professionalization of cultural pro-gramming in corporations in the United States during the early 1960s and in Ger-many at the end of the 1970s.

With respect to sponsoring, there has also been a gradual trend toward standardiza-tion of sponsoring objectives and philosophies, based on a significant body of manage-ment literature published during the early 1990s (in particular, the work of Manfred Bruhn, who established a framework for sponsoring in Germany). Within the EU and the United States, there is a general consensus on the objectives or motivations for sponsoring, including (1) image transfer, (2) social responsibility, (3) contact with cus-tomers and markets (and product promotion), (4) employee motivation (in the work-place and at special events), and (5) the personal interests of corporate executives (Bruhn 1991, 224–32; Hummel 1993, 60–64; Schreiber 1994, 102–4).

The globalization of corporate identity is, as Ulf Hannerz discusses, articulated by management gurus, such as Kenichi Ohmae, who foresee the dissolution of national and multinational corporate identities into new, transnational, collective identities (Hannerz 1996, 85–86). Again, such collective identities employ notions of creativity, visionary thinking, innovation, and the construction of new historical narratives. Re-ferring to Ohmae's transnational (versus multinational) corporation of the near future, Hannerz observes, "In the shared life and personal ties of the corporation, it is implied, cultural resonance can again be found. The corporation may even have a history, a mythology of the past, and celebrate it. More certainly, it will offer some vision for the future" (86). This is precisely what DaimlerChrysler did in order to facilitate the fusion of Daimler-Benz and Chrysler, picturing the founding fathers (Gottlieb Daimler, Carl Benz, and Walther Chrysler) on its new stock certificates and creating the motto (which appeared on employee PCs the day of the merger) "The future starts today."[23]

Like Hannerz, Pierre Bourdieu addresses the sociological dimension of global corporate culture. Highly educated and culturally sophisticated management elites, unlike the cultural philistines of the nineteenth century, find a receptive vehicle in the mass media for the articulation of their own pseudophilosophies (Bourdieu and Haacke 1995, 30):

> Today's owners are, often, very refined people, at least in terms of social strategies of manipulation, but also in the realm of art, which easily becomes part of the bourgeois style of life, even if it is the product of heretical ruptures and veritable symbolic revolutions. (Bourdieu and Haacke 1995, 41)

With the assistance of journalists and public-relations specialists, corporate leaders utilize the media in order to promote corporate interests and maintain their legitimacy (Bourdieu and Haacke 1995, 30). Management best-sellers, such as *Corporate Cultures: The Rights and Rituals of Corporate Life* (Terrence Deal and Allan Kennedy) or *In Search of Excellence* (Thomas Peters and Robert Waterman), which were widely received in Germany and the EU, contributed to the dissemination of management philosophy and influenced social policy by transferring administrative models to public and nonprofit institutions.[24] Management elites, educated in the West, also export corporate culture from the mainstream of urban economic centers (Frankfurt, London, New York, Tokyo) to the peripheries of the so-called Third World (Hannerz 1996, 139). The "new managers" cultivate a self-image of artist-entrepreneur and have also joined social milieus characterized by a greater need for self-realization and fulfillment (Schulze 1992, 313). Ulrich Wever, an executive with IBM and the Hypo-Bank in Germany, characterizes the founders and inventors of firms as nonconformists or outsiders, or what he terms "a social avant-garde" who are willing to cross established boundaries and who cannot be pigeonholed (1992, 93).

The contemporary manager is a projection of the corporation's own promotion and advertising, that is, young, active, dynamic, well educated, mobile (with experience abroad), and culturally sophisticated—as comfortable at the opening of a new art exhibition as in the office. Indeed, the managerial elite perceives itself as a contemporary patron of the arts—for example, Michel Roux's ostensible patronage of artists for the Absolut Vodka promotion. Yet creativity is also reconfigured as social control. Herbert Lachmeyer proposes that management uses "creative chaos" to increase productivity by altering administrative routines (which, paradoxically, form the basis of their own efficiency models) and by threatening to terminate those who are not sufficiently adaptable:

> Given this context, the idea that the mass of "anonymous undead" office workers can become more motivated through a bit of creativity requires the belief of the employees that the practice of their profession is simultaneously a part of their own self-realization: "corporate culture" as the apotheosis of "corporate identity." (1992, 44)

Ultimately and most importantly, however, the identity of the manager as creative artist, both privately and professionally, is as much a construct as are the products and

images he or she promotes. Such constructs also apply to the notion of corporate identity for the new transnational corporations, which rely on national historical narratives or product mythologies (as in the case of DASA and BMW).[25]

An illustration of the promotional merger of corporate professionals as managers with their personal identities as artists is provided by management consultant and business professor Gertrud Höhler, who posed for an American Express advertisement.[26] The photograph of Höhler mounted on her jumping horse was taken by "celebrity photographer" Annie Leibovitz as part of an American Express advertising campaign in Germany, "Portraits" (including photographs of German celebrities), designed to address younger, upwardly mobile customers (see chapter 4). By identifying themselves as artists—based on the notion that managerial creativity is synonymous with artistic creativity—management elites have attempted to reestablish the aura of the artist's personality and artistic genius as a function of entrepreneurship (Hans Haacke, cited in Römer 1992, 64). This aspect is completely attuned to the desire of sponsors to present themselves as cultural producers (creative artist-entrepreneurs) and associate themselves with the sponsored culture (of other artists). The attraction of culture for the sponsors resides in its representation as Other or "exotic" and in its resulting communicative potential as a medium of corporate cultural politics. However, this process is simultaneously undermined by the corporation's own promotional strategies and the proliferation of consumer products, which relativize the status of auratic art through mass production.

"Art Cars," *Five Continents,* and *Museum for the Workplace*

The globalization of corporate cultural politics is not only evident in the manner in which corporate products and services are used as components of sponsorship programs (e.g., Sony provides monitors for video-art exhibitions; Lufthansa transports art exhibitions), but also in the promotion of the product itself as a work of art. Product culture as culture per se—ostensibly breaking down the barriers between high and low under the banner of pluralism—is very much a part of corporate cultural politics (see chapter 3).

BMW's "Art Cars" project exemplifies the intersection of globalization, creativity, and technology in cultural programming. After Alexander Calder painted a BMW racing car for his friend, driver Hervé Poulain, in 1975, BMW commissioned "rolling canvases" by Frank Stella, Roy Lichtenstein, Andy Warhol, Ernst Fuchs, Robert Rauschenberg, Michael Jagamara Nelson, Ken Done, Matazo Kayama, César Manrique, A. R. Penck, Esther Mahlangu, and Sandro Chia (*BMW Art Car Collection* 1991; 1993). Almost as a disclaimer, BMW introduces the *BMW Art Car Collection* brochure with a discussion of contemporary and artistic responses to automotive technology (even including more-critical treatments, such as artist Ed Kienholz's *Back Seat Dodge* [1964] [*BMW Art Car Collection* 1991, n.p.]). According to BMW, each of the subsequent portraits of the artists and their works in the catalog "allow the observer to take a fresh, undistorted view of a key symbol of modern civilization and lifestyle" (*BMW Art Car Collection* 1991, n.p.).

Figure 2.2. The car as canvas: creativity, speed, and technology in the *BMW Art Cars Collection.*

"Art Cars" certainly draws the spectator's attention to the iconic status of the auto-
mobile by elevating the mass-produced product to a work of art endowed with its
own unique aura by virtue of the individualized treatment of the artists. However, the
works seen in the *Collection* reinforce the fetishization of the automobile as an expres-
sion of the individual, power, speed, mobility, and collecting but the project does not
simultaneously explore the critical implications of these social narratives: highway fa-
talities (there are no speed limits on the Autobahn), environmental issues, urban ex-
pansion. On the political front, the German automobile industry, including BMW
and Volkswagen (VW), continues to resist speed limits, calling them "measures from
the stone age."[27] Nor does the *Collection* address the specific historical and ideological
functions of the automobile (e.g., the history of manufacturers such as VW) and of
the Autobahn, either in terms of its development under National Socialism or later as

the material and symbolic disjuncture of two German nations (as thematized in Hans Haacke's installation *Cast Concrete* [1997]; Buchloh 1997, 414). In the *BMW Art Car Collection,* the automobile assumes the dominant position, as a canvas and filter, for individualized, artistic expressions that are thus largely reduced to a secondary, decorative function. The automobile itself becomes the canvas and medium for artistic expression while the artists' own interpretations and expressions must, ultimately, be subordinated and conform to the medium, rather than challenging or subverting it.

The designations "art" and "collection" attempt to establish the works as auratic rather than interchangeable, mass-produced products. In addition to its own BMW Museum at corporate headquarters in Munich and an extensive sponsorship program, BMW established BMW Galleries and Pavilions in key urban centers (Munich, The Hague, New York, Toronto) in order to project its corporate image through art— including displays of the latest "Art Cars." BMW defines the role of the Galleries and Pavilions:

> Again and again, at these sites it is a matter of working with art to risk something new. Artists situate the conditions of life in our world. Thus we too act, as we are called upon, to also improve our world in the sense of mobility.[28]

What is not mentioned here, however, is that the BMW Pavilions and Galleries were also promotional spaces for marketing new automobiles, located in high-density urban markets. The Munich gallery, for example, displayed cars upstairs and artworks (including art cars) on the lower level, and it is listed in the local telephone directory under "exhibition, sales, gallery." The pavilions were also transformed into sales areas for extensive BMW merchandising of its own clothing, luggage, accessories, and miniatures—all of which was sold in its own catalog, *BMW Lifestyle.*

The "Art Cars" are dually signified as artworks to be viewed for their uniqueness and as promotional symbols for all BMW products. As an articulation of local cultural politics, the pavilions define a space within which the corporation can operate in both cultural and commercial modes, indeed, merging the two but by no means allowing alternative or dissonant voices to encroach on those sites. Moreover, the "Art Cars" and galleries facilitate the globalization of this merger, both by promoting new products in international markets and by inscribing them with the aura of the "exotic" or "multicultural" through artist commissions. The paintings on a BMW 525i, painted in the tradition of the Ndebele tribe by Esther Mahlangu (born in the Middelburg district in what was then the Transvaal province of South Africa) are based on the mural paintings found in tribal huts. BMW explains that

> [Mahlangu's] transfer of tribal tradition to a modern idiom of high technology . . . [was] natural, yet challenging. Conscious of the exalted company she was joining [i.e., other well-known contemporary artists] in being invited to add to the BMW Art Car Collection, Esther Mahlangu is particularly proud of the fact she is the first woman artist in the collection BMW Art Car Collection. (*BMW Art Car Collection* 1993, n.p.)

Figure 2.3. The BMW Pavilions fuse art exhibitions and product promotion.

BMW Lifestyle.
Eine Kollektion im
individuellen Stil von BMW.

98

Figure 2.4. BMW lifestyle as product merchandising.

Unlike Western consumer products that are adapted, decorated, or modified as they merge and clash with indigenous cultures (e.g., taxis), Mahlangu's commission, like all the "Art Cars," was clearly designed as a product for cultural export, that is, one that could be employed as a promotional symbol of corporate global diversity and "exclusively a work of art . . . [that] will never be driven on the road" (*BMW Art Car Collection* 1993, n.p.). This exported culture is then sent around the world in a never-ending tour of museums (the Louvre, Centre Pompidou, Whitney Museum of American Art, Palazzo Grassi, Cultural Center Hong Kong) and BMW galleries. The international exhibits and the iconic status of the BMW cars as prestige objects further

fuse physical and economic (upward) mobility with globalization: "And they will roll on: to Toronto, Chicago, Pasadena and San Diego, to Johannesburg, Cape Town and Pretoria, to Tokyo, London, Barcelona . . . an idea travels around the globe" (*BMW Art Car Collection* 1993, n.p.).

Another dimension of corporate globalization facilitated by art is the widespread development, beginning in the 1960s, of corporate art collections and galleries (e.g., at the Hypo-Bank or Chase Manhattan Bank).[29] Apart from their utilitarian function as interior decoration for corporate buildings, art collections validate corporate participation in culture at the local or internal level. In addition to its economic value and potential public-relations functions, corporate art is frequently cited as a factor in motivating employees.[30] In fact, various forms of in-house cultural programming (e.g., artists in residence, lectures, concerts, employee workshops) are used to promote improved employee relations and heighten productivity, in some cases through rewards or incentive programs (e.g., VIP concert tickets, vacations). Cultural programs for employees compose an internal dimension of corporate cultural politics, although they perform different functions than sponsorship programs, which are directed externally to target markets. Occasionally however, the two intersect, such as when Volkswagen sponsored the Rolling Stones Voodoo Lounge tour and was able to bring the band to the VW factory parking lot for a concert.

Bettina Becker's analysis of Walter de Maria's *Five Continents* sculpture (1989), located in the main reception hall of the DaimlerChrysler (at that time Daimler-Benz) headquarters in Stuttgart-Möhringen, draws our attention to the function of art within corporate spaces by problematizing its reception among employees (1994, 131–40). The sculpture is a 125-cubic-meter steel-framework cube, with Plexiglass sections making up each of its six sides. The cube is filled with almost 250 tons of irregularly cut, hand-size, white stones quarried in Kenya, Brasil, India, Greece, and the United States. The marble and quartz crystals are reflected in the changing light of the atrium and in the spotlights directed toward the sculpture. Becker summarizes the symbolic function of the work in the context of Daimler-Benz's corporate identity:

> The stones which are joined at this location are a symbol for the unity of the earth, and stand for the surmounting of spatial and temporal distances, for change, growth, and transitory passages, as well as for the internationality of the corporation, in whose reception hall they are located. (132)

Based on her study of employee interaction with the sculpture and informal interviews, Becker concludes that most employees have either become so accustomed to the work that they disregard it, or they perceive it as an obstacle blocking traffic patterns within the main entryway. By virtue of its size and central placement in the reception hall, however, they do use it as a meeting point near the company restaurant (135–37). Many employees have a decidedly negative reaction to the artwork, which they have nicknamed "the rock pile next to the fly" (referring to a large fly that was entombed in the layered rocks during the work's composition); others call it "the cat-

litter box" *(Katzenklo)* (136–37). Becker interprets the employees' reception of *Five Continents* as (1) a reflection of a common disinterest in contemporary art among many members of society and their inability to "read the code" of contemporary art, and (2) the failure of many corporations (in this case Daimler) to provide sufficient infrastructure in mediating the significance and interpretation of art and specific artworks within the context of the headquarters building (137–38). An important conclusion of Becker's analysis is that the actual reception of corporate art within the workplace is not only differentiated but frequently very negative—a fact that is often suppressed because top-level executives are personally involved in the acquisition of major works of corporate art (183).

At other firms (e.g., Degussa AG or the Deutsche Bank), managers who perceived that art and "good taste" were being forced upon them sometimes responded by turning pictures over, by altering (but not destroying) a work using slips of paper, by surrounding it with cola cans (i.e., surrounding that which is perceived as esoteric with the banal and everyday), or by refusing to occupy the work space (Bettina Becker 1994, 67–68; Nicolaus 1990, 90–91).[31] Becker refers to corporate art as "a subversive secret weapon" (1994, 67, 174) because controversial works open the door to unexpected employee responses, which are actually directed to management. Certainly, the fact that employees feel strongly enough about a work of art to alter or remove it confirms its potential as a provocation in contexts where its function is frequently relativized or reduced to decoration. The artificial construct of the cultivated manager as artist-entrepreneur obviously collapses in the face of the everyday reality of the workplace.

I would also argue that what differentiates art in the workplace from art in public venues is that employees are, for the most part, confronted with the same works on a daily basis, whereas museum visits are voluntary and public art can be more readily circumnavigated. Hostile reactions to art in the workplace (e.g., altering or even defacing works) are of course more symptomatic of employee-employer relations than necessarily of an underlying resentment of the artwork itself. Subversive responses to corporate art are neither widespread, nor do they necessarily indicate organized social resistance to corporate power. To a limited extent, they represent mediated expressions of resistance, not against art per se but against the power structures within the corporation that impose it:[32]

> Only in the highest floors of the corporate towers is art safe from tangible critique. Here, the chairman resides and confers. Here, the watchmen are patrolling through the reserved elegance of the rooms, with pistols respectfully concealed under their jackets. Here, in the security area, the Deutsche Bank presents the rare essence of its collection: works of classical modernism on white-enameled wood walls. (Nicolaus 1990, 90, cited in Bettina Becker, 1994, 69)

At Daimler-Benz, corporate art functioned as a status symbol for the former CEO Edzard Reuter, who, with Hans J. Baumgart, acquired and commissioned works with little regard for the interests or knowledge of the employees (Bettina Becker 1994,

139–40). What is important here is *not* what Becker calls "the failure to read the code" or individual interpretations of art but management's unwillingness to engage employees in a substantive dialogue regarding the functions of art and culture both within and outside of the workplace, rather than superimposing their own interests. Pedagogical programs (conversations with artists, lectures), when they are unilaterally imposed on employees, may simply reinforce their perception that management considers them cultural philistines. Moreover, the "alibi function of corporate art" (B. Becker 1994, 183) masks one of the most significant features of corporate cultural politics: the corporation's unwillingness or inability to critically interrogate its own participation in the construction and representation of culture, for example, in terms of the social functions of the products and images it produces.

The work of artists Michael Clegg and Martin Guttmann represents a step in this direction. Their project for the DG Bank (Frankfurt), *Museum for the Workplace* (1995), involved a two-stage process designed to engage employees in a reconsideration of (1) their positions within the corporation, (2) the relations between employees and corporate art collections, and (3) the manner in which employees interact within the broader spaces and contexts of corporate communication (Sabau 1998, 7–9; Friede 1998, 11–17). In the first stage of their project, the artists asked DG Bank employees to contribute art objects (in the broadest sense of the term) from their possessions, objects that held some personal significance and that they would like to see in the workplace. These loaned objects—from childhood drawings, T-shirts, and posters to paintings and sculptures—were then "installed" in the employees' respective departments in the bank building and subsequently photographed in these new contexts by Clegg and Guttmann. In the second stage, the photographic prints were enlarged to life-size photos of the objects, framed, and hung in hallways and foyers of the building (Friede 1998, 14). Employees were then asked to record their reactions to the installations and to the process in general.

Clegg and Guttmann wanted employees to reconsider the boundaries between their private lives and their identities as bank employees in terms of the potential for a "utopian workplace" in which the "institutionalized division of personality" would no longer be necessary (Friede 1998, 16). The project privileges the role of the workers not as observers or audiences for corporate art collections but rather as participants in constructing environments that contribute to an understanding of their own interaction with the corporation. In his analysis of *Museum for the Workplace,* Michael Lingner describes the artists' work with diverse communities and publics, such as the DG Bank employees, as the creation of interactive situations, or "Soziotopes" (1998, 86). Although the selection process initially privileges the relations between the objects and the employee—as acts of personal selection and reflection—Clegg and Guttmann do not allow the objects to function solely as "egocentric images of self-determination" (Lingner 1998, 87) that art offers as symbols of autonomy. Rather, the photographic mediation of personal objects, their subsequent representation as parts of an installation, and their recontextualization within the workplace intentionally destabilizes

their aura and autonomy as personal possessions. Clegg and Guttmann are interested in placing objects and acts within a communicative context, that is, the nexus of expressing individual identity and corporate identity. The construction of culture in the workplace presents possibilities for exploring "forms of communication and forms of communal decision-making . . . which can also be applied to other areas" (Lingner 1998, 87).

Employee reactions to the project itself were ambivalent. The majority of those who participated in it approved of the collaborative or cooperative nature of the first phase, during which they selected objects, assisted the artists in assembling them, and made suggestions on the manner in which they should be installed and subsequently displayed. However, Clegg and Guttmann's realization of the project (the aesthetics of the portraits of the objects and the contexts of their exhibition in the bank) were a provocation for many workers (Sabau 1998, 70). Some commented that the personal objects seemed depersonalized and displaced as a result of the installation. Employees were particularly struck by their coworkers' willingness to share personal objects (e.g., a child's shoe) in the context of the workplace. Precisely this displacement of private objects into corporate space made many employees aware of the extent to which they wanted to protect their own private sphere as a separate space, while others became aware of the extent to which their private and corporate identities had become intertwined. The installations indicated the possibilities for employees to participate in the actual process of cultural production and the design of corporate spaces while simultaneously evoking considerable reflection on the relations among the bank, its corporate identity, and the employees' own identity (individually and collectively) within the corporate context.

Even seemingly minor ruptures in the facade of corporate culture from within remind us that ultimately the myth of consensus or the notion of employee identification with a corporate image is a highly unstable one, particularly in light of corporate downsizing. Daimler-Benz's merger with Chrysler Corporation (into DaimlerChrysler), for example, focused even greater attention on new transnational corporations (Hannerz 1996) as potent economic, political, and cultural entities without any long-term commitment to regions, nations, or social entities—a fact that was largely overlooked with respect to the economic interests of the pre-transnational corporation. Ralf Dahrendorf sees one of the problems of globalization as the preeminence of securing a competitive lead at the expense of solidarity and social integration.[33] Yet the more the corporation abandons the regional or national allegiances that implicitly define its image, the more it must insert itself in local communities, spaces, and politics in order to maintain its legitimacy.

Hans Haacke: Deconstructing Cultural Politics and National Identity

Berlin exemplifies just such a space within the context of postunification Germany— one that represents the intersection of corporate and national identities. This convergence formed the thematic focus of many of Hans Haacke's installations during the

1990s: *Freedom Is Now Simply Going To Be Sponsored—out of Petty Cash (Die Freiheit wird jetzt einfach gesponsort—aus der Portokasse)* (1990) near Potsdamer Platz in Berlin; *Raise the Flag (Die Fahne hoch!)* (1991) at Munich's Königsplatz; *Germania* (1993) in the German Pavilion at the Venice Biennale; *Cast Concrete* (1997) in the exhibition *Deutschlandbilder* in the Martin-Gropius-Bau in Berlin; *Corporate Culture (Standortkultur)* (1997) at the *documenta x* in Kassel.[34] Haacke's work not only exposes the paradoxes and political interests within German and U.S. cultural politics, it also addresses the globalization of corporate cultural politics within distinctly regional contexts by revealing the links between local, site-specific practices, modes of representation, and the transnational interests of the corporation. More than referencing or analyzing these conflicts, Haacke actually inserts his work into the context of corporate and national politics by occupying ideologically charged spaces, from monuments in Graz and Munich to outdoor advertising at the *documenta x* in Kassel. As such, the installations attempt to engage audiences in a dialogue regarding the historical and ideological role of these public and privatized spaces by problematizing individual and collective relations to the past and present. In this regard, Benjamin Buchloh has observed that Haacke's work performs both archaeological and mnemonic functions (1997, 414). In addition, Haacke's opposition to corporate sponsorship and its thematization in his work questions the potential for nonsponsored art within a global art market dominated by the institutional interests he challenges.

For those familiar with Haacke's controversial career, including his banning from the Guggenheim in 1971,[35] his work may seem to have been relegated to the margins of a radical aesthetic practice that Douglas Crimp compares to works by artists such as Daniel Buren, Michael Asher, Robert Smithson, or Richard Serra:

> Their contributions to a materialist critique of art, their resistance to the "disintegration of culture into commodities" [Walter Benjamin], were fragmentary and provisional, the consequences limited, systematically opposed or mystified, ultimately overturned. What remains of this critique today are a history to be recovered and fitful, marginalized practices that struggle to exist at all in an art world more dedicated than ever before to commodity value. (Crimp 1993, 155–56)

However, I would suggest that Haacke's installations have a heightened significance within the context of the public debates on cultural politics and on public policy with respect to corporate products such as tobacco, which I have outlined in chapter 1. Clearly, the debate over cultural politics has been precipitated both by a reproblematization of national representation in postunification Germany and by the privatization of public services and of some cultural programming. In addition, the ongoing reformulation of a cultural politics of national representation must be considered within the contexts of postunification debates over the new capital in Berlin, Christo and Jeanne-Claude's *Wrapped Reichstag* project, the Holocaust Memorial in Berlin (designed by Peter Eisenman), or Haacke's work *Der Bevölkerung* (2000) for the newly renovated Reichstag (designed by Norman Foster). Indeed, the heightened signifi-

cance of culture within postunification German politics is underscored by the fact that all three of these projects were only approved after lengthy debates in the German Bundestag.

Haacke critically engages the forms of national and corporate representation inscribed in the actual sites. Simply put, his work is part of the site, and the site is part of his work. For example, the installation *Freedom Is Now Simply Going To Be Sponsored— out of Petty Cash* explores the shifts in political and economic power in postunification Germany (Bourdieu and Haacke 1995, 92–95; Grasskamp 1995, 152). Haacke placed the Mercedes star logo (a familiar fixture atop Berlin's Europa Center) on top of a guard tower near the former "Death Strip" at the Berlin Wall at Potsdamer Platz. On opposite sides of the tower, he mounted quotations from Daimler-Benz and Mercedes advertisements that had appeared in *Der Spiegel* and the *New York Times.* The first was a variation on a line from Shakespeare's *Hamlet: "Bereit sein ist alles"* ("The readiness is all"). The second was from Goethe: *"Kunst bleibt Kunst"* ("Art will always remain art"). A portion of this property was purchased by Daimler-Benz in a sweetheart deal with the Berlin Senate, for about a tenth of its market value, before the plans for the area were fully developed. However, after a complaint was filed with the EU, Daimler was required to tender additional payments for the property (Bourdieu and Haacke 1995, 92–93). In anticipation of its office and entertainment complex (including a complex housing a casino, the Grand Hotel, a musical theater, and a 3D-big-screen movie theater), Daimler-Benz produced a "3D-Video-Visualization" and interactive portrayals of the architectural models at the Potsdamer Platz "Info Box" (an elevated information center) in Berlin and through its Web site (*Info Box: Der Katlog* 1996, 109–44).

Crimp referred to the aesthetic strategies utilized by Haacke as "radicalized site specificity" (1993, 155–56). Haacke appropriates the symbols of corporate image (the Mercedes star, or a larger-than-life-size package of "Helmsboro" cigarettes bearing U.S. Senator Jesse Helms's photo) to problematize the relations between corporate and national identities and to destabilize their representation. Initially, the spectator approaches the urban site of the installation (e.g., a public place or monument) during a daily routine (e.g., walking to work) or as a regularized part of urban activity (e.g., shopping, visits to museums, restaurants). Now, however, the spectator is confronted with a dramatic modification of the structure (or monument) or space.

For his installation *Raise the Flag* at the ceremonial gate (the Propyläen) at the Königsplatz in Munich (site of many Nazi rallies), Haacke hung two large banners, one with the names of German corporations and their subsidiaries that had supplied Saddam Hussein prior to the Gulf War, the other, with a death's head on it, reading, "Roll Call: German Industry in Iraq" (Bourdieu and Haacke 1995, 21–28). Haacke's visual and symbolic modification of the gate and its impact on the surrounding square presents a provocation and de-familiarization of the structure or object and its space, which induces the spectator to react to its inherent contradictions. In this case, Haacke unearths the political fragments of the Königsplatz's historical legacy under National Socialism and links them to the contemporary practices of Germany's manufacturing

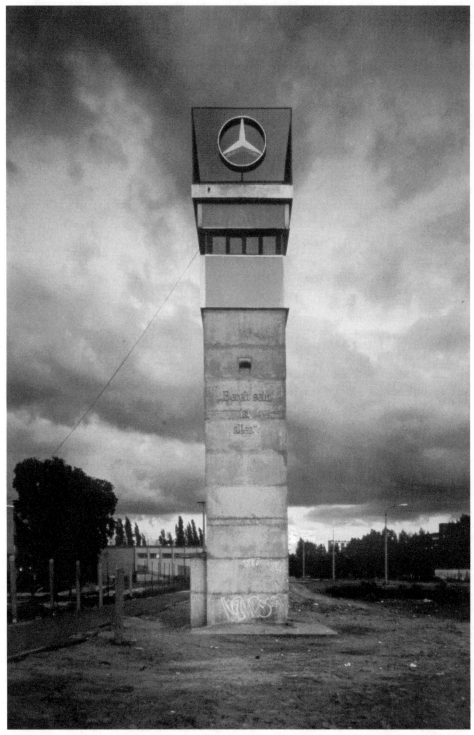

Figure 2.5. Hans Haacke, *Die Freiheit wird jetzt einfach gesponsert—aus der Portokasse (Freedom Is Now Simply Going To Be Sponsored—out of Petty Cash),* 1990. Installation, Berlin. Photograph by Peter Zellien. Copyright 2001 Artists Rights Society (ARS), New York/VG Bild-Kunst, Bonn.

Figure 2.6. The power of symbols: the Mercedes star.

industries—a history that is concealed by the square's present-day function as a site for tourist visits to two well-known museums of antiquity (the Glyptothek and the Antikensammlung) that contextualize the Königsplatz as site of consumption of high culture.

Walter Grasskamp has referred to Haacke's modifications of public sites or objects of mass consumption—such as the Berlin guard towers now topped with the Mercedes star and advertising texts or his "Helmsboro" cigarette box—as "subversive imitation" (1995, 144). Certainly, Haacke's appropriation of the familiar, his use of copies or counterfeits, should also be considered in terms of a postmodern project, to the extent that the installations appropriate widely recognized symbols as media to "de-doxify" (Hutcheon 1991, 7) or destabilize institutionalized representations of the symbol itself (e.g., the Mercedes star or the Marlboro package). This is the subversive character of the project, which intersects with what Linda Hutcheon has termed a critical "post-modernism of complicity and critique that at once inscribes and subverts the conventions and ideologies of the dominant cultural and social forces"(1991, 11).

Another installation, *Germania,* assumed a pivotal position in the representation of German culture as a part of the German Pavilion at the Venice Biennale in 1993. Grasskamp has analyzed Haacke's response to this site by tracing the historical function of the building as a metaphorical stage for national representation (1995, 136–37).[36] Originally constructed as the Bavarian Pavilion in 1909, the structure became the German National Pavilion in 1912. Under National Socialism, it regained its prominence as an instrument of cultural politics after Adolf Hitler's visit to the 1934

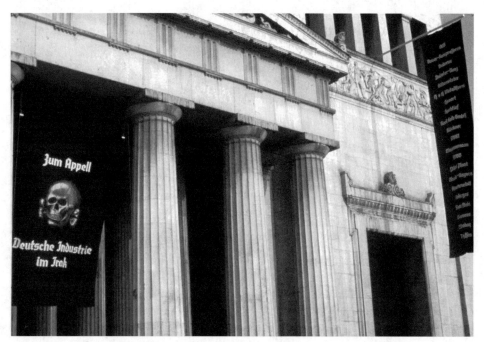

Figure 2.7. Hans Haacke, *Die Fahne Hoch! (Raise the Flag!),* 1991 (partial view). Installation, Munich. Photograph by Hans Haacke. Copyright 2001 Artists Rights Society (ARS), New York/VG Bild-Kunst, Bonn. Banner reads, "Roll Call: German Industry in Iraq."

Biennale and the pavilion's subsequent remodeling in 1938. After World War II and during the Cold War, the exhibitions displayed a sort of depoliticized "national art" (Grasskamp 1995, 140–41).

In 1993, however, *Germania* reproblematized the intersection of art, politics, and national identity in postunification Germany. Haacke's installation specifically referred to the historical context of the pavilion as a site of national representation under National Socialism through a photograph of Hitler's visit in 1934. A huge replica of a one-mark piece minted in the reunified Germany of 1990 mounted over the entryway, framing the photograph, underscored the metaphorical and visual banality of the *"DM über alles"* ("The German mark over everything"). The word "Germania," chiseled into the exterior of the pavilion, is repeated in the rotunda. The viewer could not enter, however, for the floor was a "rubble field," or *Trümmerfeld* (Grasskamp 1995), of broken and fragmented concrete and plaster, signifying both the historical terrain of fragmentation and discontinuity and the ongoing archaeology of remembering and forgetting. By placing the postunification one-mark piece precisely where the eagle and swastika once hung, Haacke seized upon the economic, political, and cultural functions of the historical pavilion and reformulated them in terms of the new cultural politics of "corporate identity" (Grasskamp 1995, 152).

By juxtapositioning the historical function of the building with the economic function of cultural politics, Haacke accentuates a linkage that, as Grasskamp observes, does not want to be recognized but nonetheless cannot be denied (1995, 152). Haacke challenges the spectator to examine the process of cultural production (beyond the contemplation of museal objects) and to participate in diverse forms of remembering. Many of his works address those spaces (physical and historical) that are not apparently occupied by corporate or public programming, asking the spectator not only to interrogate and explore the differences between public and privatized spaces but also to recognize where they intersect and converge. *Germania* reproblematizes *both* the representation of cultural and national identities *and* the social relations to which they refer. In doing so, it engages the spectator in the context of cultural production as a contested site.

Indeed, the linkages and dissonances of cultural politics and corporate identity were manifest in the cultural politics of a postunification Germany defined as "Corporate Germany" *(Unternehmen Deutschland)* by former Foreign Minister Klaus Kinkel. They are exemplified in Berlin's politics of space and illustrated by global corporate investment and representation in the Potsdamer Platz projects, and also by the merger of nonprofit, public, and commercial interests in cultural politics, for example, in the new Deutsche Guggenheim Berlin (a satellite and joint-venture of the Solomon R. Guggenheim Museum and the Deutsche Bank AG, initiated by the former U.S. ambassador to Germany) or in the film and media center housed in the Sony Center (*Info Box: Der Katalog* 1996, 166–67). The cultural politics of German unification also facilitated the reconfiguration and promotion of German identity in a more positive, post–Cold War perspective by attempting to relegate National Socialism, the

Holocaust, and forty years of national division to a more distant past. As a signifier of the new, global "Corporate Germany," the opening of the Berlin Wall and reunification provided a fertile field for global product and image promotion, such as the Pepsi-Cola advertisement cited at the outset of this chapter. In a sense, these politics of space and cultural politics, which marked the turbulence surrounding postunification German identity during the 1990s while creating an aperture for its reassessment, were realized and consolidated under the coalition government of Gerhard Schröder and his minister of culture, Michael Naumann. Not only did Berlin become a site of global corporate culture—simultaneously articulated as regional political and economic interests (with respect to the EU and eastern Europe)—but it also performed representational functions in the government's attempt to resituate the image of Germany's past (in the Holocaust Memorial and the "new" Reichstag) as that of a nation that had fully recognized its historical burden,[37] and in doing so could now turn to the future.

Part II

Culture, Artists, Events

3. Redefining Culture, *Absolutly*

The rapid growth of sponsoring during the 1980s and 1990s was facilitated by an increasing awareness of new definitions and uses of culture within the contexts of everyday life. This process of redefining culture was in part driven by corporations themselves and mediated through advertising and promotion. Reconfigurations of everyday culture and cultural identities (e.g., gender, ethnicity, or nationality) were shaped by and circulated within media that produced, packaged, organized, and disseminated culture for expanding global markets (e.g., cable and satellite television). This chapter examines the articulation of corporate cultural politics within networks of cultural production, representation, and dissemination. I will argue that these politics increasingly fuse cultural representation with social agendas, not only to ensure and validate legitimacy but also in order to insert corporate interests within local and global contexts.

The cultural politics of the corporation, as mediated through cultural, social, or ecological sponsorships, are more than just highly sophisticated corporate communications via advertising and public relations. The corporation's sociopolitical interests (e.g., in developing urban and regional spaces) cannot be adequately captured strictly in terms of the expansion and colonizing tendencies of advertising and public relations.[1] Rather than an end, advertising is a means to constructing social relations and spaces that are based on consumption. More importantly, I have argued, corporate cultural politics and the strategies of sponsoring (which are coordinated with but not synonymous with advertising and promotion) are a response to dynamic social forces challenging corporate politics both internally and externally. Sponsored culture, to be effective, must operate on the boundaries between those spaces it dominates and new spaces that are undefined or have yet to be defined in terms of resistance.

Yet corporate attempts to appropriate these spaces result in paradoxes and ruptures that potentially expose and destabilize these interests. Such dissonances range from the microlevel of internal labor relations (e.g., employee rejection of corporate art) to the macrolevel of political "damage control" in the public-policy sphere (e.g., the *Brent Spar* affair in Germany)[2] or with regard to legislation to limit cigarette and alcohol advertising in the United States. Other reactions are tentative, sporadic responses by

popular culture, reactions that alter corporate representation and image at the micro-political level (Fiske 1989, 214–17) rather than targeting the legitimacy of the corpo-ration as a social entity per se. Michel Roux, former head of Absolut Vodka's distri-bution in the United States, was outraged when he encountered an overweight, middle-class man wearing an Absolut T-shirt in an airport, because the combination ruined the chic, hip image Roux wanted to cultivate for the brand. As a result, Roux immediately ordered the merchandising discontinued (Lubow 1994, 68).

Thus, corporate cultural politics exist within a spectrum bounded by notions of a totalizing corporate hegemony on the one hand and organized resistance on the other. *Corporate cultural politics are actually self-reflexive in that they are predicated upon and emanate from the corporation's simultaneous anticipation and engagement of interactions between both forces: that is, the corporation's own attempts to assert its interests and, con-versely, resistance to those attempts.* Moreover, corporate cultural politics are not just an attempt to control the interplay of these forces, although they are frequently that too. They are a process of identifying, engaging, or orchestrating rather than simply elimi-nating forces of resistance, as well as those actions that simply undermine or block corporate interests. Finally, the articulation of corporate cultural politics only emerges when we examine the specific contexts where cultural and social policies intersect or occasionally clash.

Although sponsoring tends to be associated with high culture (Jordan and Weedon 1995, 55; Twitchell 1996, 19), a "top-down view" overlooks numerous forms of spon-soring that address diverse audiences and expressions of culture, in particular event culture (e.g., open-air concerts, street festivals, or sporting events), which I will exam-ine in subsequent chapters. Nor does this perspective accurately reflect the actual uses of culture among diverse social milieus, which no longer conceptualize such hierar-chies in their own construction of culture, regardless of whether they are associated with institutions of high culture (e.g., opera) or low culture (e.g., comic books). While *representations* of high culture are still employed by sponsors to package and me-diate notions of distinction, the actual production, mediation, and reception of high, low, mass, or popular culture are infinitely more complex and mutable than these cate-gories will allow.

Gerhard Schulze's analysis of contemporary German society suggests a notion of cultural orientations embedded within a "multi-dimensional space of everyday aes-thetics," which can no longer be conceptualized in terms of hierarchies between high and low (1992, 269).[3] Relegating sponsorships to the domain of high culture alone underestimates the considerable influence of the corporation in the production and representation of culture in everyday life, for example, with respect to our use of media, travel, food, design, or architecture. Limiting the influence of corporate in-volvement in culture to one domain also suggests a definition of culture that would reject the notion that everyday uses of culture involve an ongoing process of individu-al and collective redefinition and reconfiguration.

This chapter and chapters 4 and 5 examine specific examples of how artists and au-

diences participate in the reformulation of cultural representations and identities, either through *strategic alliances with institutionalized or sponsored culture* (e.g., Annie Leibovitz's collaboration with American Express) or *as forms of resistance to state and corporate sponsorships* (e.g., Christo and Jeanne-Claude's *Wrapped Reichstag*). These studies show that although corporations occupy a pivotal position in framing and organizing the contexts within which culture is produced, disseminated, and received, the actual contexts of reception are often contested sites. Collectively, the analyses attempt to trace the manner in which corporate cultural and social programs (1) perform self-legitimizing functions, (2) trade on the currency of identity and diversity, (3) provide platforms for collaborations with artists and institutions, or, conversely, (4) are rejected by other artists and signal forms of resistance. Cultural boundaries are also redrawn in terms of a politics of local and national identity. This chapter also investigates the relationship between corporate cultural politics and multicultural programming as a process of representing and redefining local, national, or transnational identities.

High and Low

The expansion of various forms of sponsoring not only reflects structural shifts within the cultural marketplace, but it also represents changes in the definition, function, and perception of culture by artists and audiences. In her article "What's High, What's Low—and Who Cares?" Barbara Kruger writes,

> [Art] can be defined as the ability, through visual, verbal, gestural and musical means, to objectify one's experience in the world: to show and tell, through a kind of eloquent shorthand, how it feels to be alive. And of course a work of art can also be a potential commodity, a vessel of financial speculation and exchange.
>
> But doesn't popular culture have the ability to do some of the same things; to encapsulate in a gesture, a laugh, a terrific melodic hook, a powerful narrative, the same tenuously evocative moments, the same fugitive visions? (1990)

Kruger's use of photography consciously problematizes the relations between representation and reality by employing artistic strategies that interrogate and destabilize the medium itself (photography), as well as its reproduction and exhibition, for example, as advertisements, photojournalism, or art.

Corporate sponsors have simultaneously identified and promoted the expanded uses of culture within the context of advertising and corporate communication. For sponsors, differences between high and low are only relevant to the extent that they correspond to target markets and the products or images directed toward those markets. Although sponsors certainly instrumentalize images of high art or popular culture when they wish to communicate with markets, they simultaneously espouse cultural pluralism.

The representation of a pluralistic, cultural democracy as a central feature of corporate politics was manifest in AT&T's sponsorship of the exhibition *High and Low:*

Modern Art and Popular Culture (1990–91). The exhibition was organized by Kirk Varnedoe (director of painting and sculpture at the Museum of Modern Art) and Adam Gopnik (art critic for *The New Yorker*). *High and Low* subsequently toured in Chicago and Los Angeles. An advertisement for the exhibition, titled "Expanding the Language of Art," legitimizes AT&T's own participation in cultural production and mediation by linking corporate communication, popular culture, and high culture:

> Modern art has had an extraordinary openness to popular culture—to styles and imagery derived from newspapers, advertisements, comics, caricature and graffiti. AT&T and The Museum of Modern Art present the first encompassing history of that century-long dialogue between "high" and "low." From Cubist collage and Surrealist fantasy to Pop art and beyond, "HIGH and LOW: Modern Art and Popular Culture" eavesdrops on the conversation between private imagination and public communication. As we at AT&T celebrate 50 years of innovative associations with the arts, we can think of no more fitting a collaboration than one that celebrates the associations *between* the arts.

Within the discursive logic of the advertising text, the conceptual linkage of communication among artists, audiences, and cultural expression (simplified to high and low) is reformulated in terms of a process of creative communication between the "arts" and the "corporation." The graphic design of the advertisement reinforces the image of the corporation as a cultural producer and partner in arts production.[4] An ampersand prominently links "High" and "Low" in the advertisement's poster art and forms an integral part of the corporation's logo (AT&T, originally American Telephone & Telegraph) in order to repeat this connection visually. Like most forms of cultural sponsorship, the advertisement for the sponsored project also becomes the medium for a promotional message, which in this instance appears prominently at the bottom right of the ad: "AT&T The right choice."

The use of the word "eavesdrop" by a multinational communications corporation suggests an overt and artificial pose of self-irony designed to attract an urbane, sophisticated audience to the exhibition. "Eavesdropping," in its literal meaning of illicitly listening to a private conversation, implicitly positions the exhibition's visitor as a voyeur rather than as a participant in the "dialogue." However, "eavesdropping" is also utilized to reposition culture in terms of a popular culture of equal-access consumerism harking back to old-fashioned telephone party lines (in contradistinction to the negative associations of wiretapping).[5] By defining a dichotomy between private and public spheres ("private imagination and public communication") parallel to a dichotomy of artistic expression (high versus low), the promotional text validates the apparent dissolution of these boundaries and thereby inserts its own participation as an expression of social and cultural democratization.

The advertisement for *High and Low* applies the notion of "eavesdropping"—that is, as an intervention in a communication not accessible to others—to the privileged function of high art. Yet we learn that this communication is no longer privileged. We are now permitted to participate in what was once an illicit act of overstepping

Expanding the language of art.

Since its beginnings, modern art has had an extraordinary openness to popular culture—to styles and imagery derived from newspapers, advertisements, comics, caricature and graffiti.

AT&T and The Museum of Modern Art present the first encompassing history of that century-long dialogue between "high" and "low." From Cubist collage and Surrealist fantasy to Pop art and beyond, "HIGH and LOW: Modern Art and Popular Culture" eavesdrops on the conversation between private imagination and public communication.

As we at AT&T celebrate 50 years of innovative associations with the arts, we can think of no more fitting a collaboration than one that celebrates the associations *between* the arts.

RIGHT: Juan Gris, *The Man at the Café.* 1914. Oil and pasted papers on canvas. Collection of Mr. & Mrs. William R. Acquavella.
LEFT: Roy Lichtenstein, *Okay, Hot-Shot.* 1963. Oil and Magna on canvas. Collection of Mr. & Mrs. S. I. Newhouse, Jr.

HIGH & LOW: MODERN ART AND POPULAR CULTURE.

AT&T
50
YEARS
WITH THE
ARTS
1940-1990

Oct. 7, 1990—Jan. 15, 1991.
The Museum of Modern Art,
11 West 53rd Street, New York.
High & Low information: 212 708-9850.
Feb. 23-May 12, 1991,
The Art Institute of Chicago.
June 23-Sept. 15, 1991,
The Museum of Contemporary Art,
Los Angeles.

AT&T
The right choice. © 1990 AT&T

Figure 3.1. Sponsorships legitimize corporate participation in cultural production.

sociocultural boundaries. The advertisement celebrates the dissolution of cultural and social difference by declaring the pluralism of everyday popular culture ("newspapers, advertisements, comics, caricature and graffiti"), to which high culture is also indebted. We learn that the commodity "high culture" is indeed as accessible as the everyday world of popular culture. For high culture is also reproducible, consumable, and therefore democratic.

High and Low provided an opportunity and forum for AT&T to legitimize its own

role as a cultural producer by defusing the critical relations between art (as high culture) and advertising (as commercial or low culture). The exhibition received extensive promotion (due to the AT&T sponsorship) and many reviews in the print media, and it also became a point of departure for debates among art critics regarding popular culture.[6] Arthur Danto suggested that much of the controversy concerning *High and Low* was related to the exhibition's emphasis on the relationship between art and advertising (1993, 152–56).[7] It is the deconstruction of this border that Danto believes was controversial, not only because it legitimized the equality of high and low culture, but also because it *reversed* that historical hierarchy (156).

Although Danto emphasized this inversion as the focus of the debate (rather than the curatorial practices of the exhibition itself), Douglas Crimp pointed out that neither the exhibition nor the catalog essays fully considered the problematic relationship between art and commerce within a critical framework:

> The premise of the exhibition was simple: artists sometimes transform aspects of popular and mass culture into high art, just as they transform "primitive" art into high Western expression. *High and Low* was quite uniformly condemned in the press for its simple-minded thesis and for its wholesale exclusion of contemporary practices that break down the distinctions the museum so unthinkingly reiterated. . . . Varnedoe and Gopnik summarily dismiss the entire range of serious thinking about their subject, from Frankfurt School mass culture and aesthetic theory and the cultural studies initiated during the 1960s at Birmingham to disparate contemporary feminist and postmodernist analyses. (1993, 30–31n24)

AT&T's sponsorship of *High and Low* illustrates both a promotional strategy and a politics of representation used to fuse the corporation with contemporary culture. The corporation's own mediation of *High and Low* communicates an undifferentiated, reductive, and binary perspective of cultural history as elitist in order to replace it with a new consumerist pluralism that ostensibly erases social boundaries.[8] This is accomplished by making "advertisements" synonymous with popular culture and then thematizing the merger between high and low culture. Once the advertisement is recognized as a legitimate form of cultural expression, the advertiser (as sponsor) is implicitly introduced as a legitimate producer of culture.[9]

When sponsors deploy forms of cultural difference, such forms are frequently decoys to be dispersed immediately by substituting a cultural pluralism of consumption. American Express, for example, employs both high and popular culture as forms of socioeconomic distinction that can be erased through acquisition. Although Frank Sinatra's songs may not be associated with high culture, a special performance in Germany for American Express cardholders was promoted as being exclusive and prestigious.[10] The Sinatra concert attains its exclusivity not through the inaccessibility of an aesthetics of high culture requiring prior knowledge of cultural codes but through the cost of participation. The fact that Sinatra's recordings are available to a mass market is irrelevant. The promotion and packaging of the concert was designed

to present it as a unique event with its own aura of exclusivity that could not be re-peated through the mass-produced recordings. In this sense, the sponsor attempts to recapture and recreate the aura of high art for its own patrons through socioeconomic inclusion of its members or exclusion of nonmembers from the spaces in which such events are sited.[11]

At the same time, forms of culture that have been associated with high art have been promoted and marketed for mass audiences. American Express's sponsorship of the Rembrandt exhibition in Berlin, London, and Amsterdam is only one example of the blockbuster art exhibitions organized by museums and corporations since the late 1970s partly to attract new audiences into museums but also to provide an economic and cultural legitimation for museums and sponsors in the context of a cultural poli-tics of pluralism (e.g., Hoffmann's slogan *"Kultur für alle"* ["Culture for everyone"]) in Germany, and diversity in the United States. Regardless of whether culture is branded as high or low, it is reconfigured for target markets based on its promotional value. Ac-cess is available to all who can pay the price. Indeed, the promotional strategies of sponsors and arts institutions suggest that the *representation of culture frequently su-percedes the audience's own participation in it;* participation is reduced to consumption rather than critical engagement. In other words, the promotional value of events or cultural programs, or their economic success (for the cultural institution), has in many cases become more important than their content, which becomes a form of packaging for the event itself—a dimension I will examine more closely in chapter 5.

Mapping Multidimensional Culture: Theoretical Perspectives

Certainly, sponsors have already internalized and applied the realities of a multi-dimensional culture and society, both in their cultural politics and market strategies. Sociologist Gerhard Schulze observes that the aesthetics of everyday existence are characterized by a de-verticalization *(Entvertikalisierung)* of social groups (1992, 167). He rejects the dichotomy of mass culture on the one hand and the fragmentation or particularization of social milieus—"where each individual acts as the inventor of his/her own style" (405)—on the other:

> Personal style always addresses a public. Because each public possesses a specialized knowledge of its own style, no random individual can be counted as part of the group. We can "dance at different weddings" for which there are in each case different aesthet-ic practices characteristic of that social milieu. The relations of prestige which would span social milieus become disparate and site-specific. Those who look beyond the boundary of their own backyard, looking down on others, cannot expect that their neighbors are looking back up at them. (405)

Schulze's explication of de-verticalization is echoed in Scott Lash's discussion of the process of sociological de-differentiation *(Entdifferenzierung)* related to postmodern-ism (Lash 1991, 5). The process of postmodernist de-differentiation occurs within all spheres of cultural production, mediation, distribution, and reception. The autonomy

of cultural categories is destabilized and spheres of cultural practice collapse, overlap, or merge. As Lash observes, this is particularly true of postmodernist *modes of representation,* which utilize images rather than words in the process of signification. In situating postmodernism with respect to modernism, Lash concludes that

> postmodernism can pose a greater threat to social and cultural order than modernism has done. This is, first, because postmodernism pervades both high and popular culture, while modernism has been confined to the realm of high culture. A further threat concerns stabilization in cultural paradigms. If realism promises stability and order in both representation and reality, then modernist autonomization and self-legislation effectively destabilizes the *representation.* Postmodernist de-differentiation on the other hand puts chaos, flimsiness, and instability in our experience of *reality* itself. (1991, 14–15)

In their analyses of de-verticalization and de-differentiation, Schulze and Lash underscore both a process of sociological reorientation (with respect to how milieus use culture in constructing identity and difference) and the representation of culture (in terms of Lash's "regime of signification"). Like Schulze and Lash, Andrew Wernick identifies a shift in the representation and construction of culture in terms of the relations between material and the symbolic economies:

> In trying to locate the place of promotion on the sociological map . . . the very distinction between the symbolic and material economies, between the regime of accumulation and the regime of signification, cannot be clearly drawn. And for good reason. Promotional practice is generated exactly on the boundary, a locus which implies the dissolution of the boundary itself. (1991, 185)

However, Schulze argues that this intersection of the material and symbolic consumption is determined by a complex interaction between the physical and psychological, an interaction that defines culture as a process of both material and symbolic production, mediation, and consumption. Although it is the representation and consumption of images that increasingly characterizes the organization of social relations, Schulze reminds us that the actual process of "experiencing the image" involves a combination, or fusion, of both cognitive and physical elements, whereby perceiving the object and actually experiencing it (sensually or emotionally) are two separate, albeit related, processes. The objective "facts" (e.g., the information on a wine label) must first be "translated into the individual's own subjective system of signs, before s/he can react aesthetically" (Schulze 1992, 97). This sensory perception can be conceptualized as meaning, which is simultaneously coded with a specific cognitive perception, or awareness, and is modified by new (or renewed) perceptions (97).

With respect to the aesthetics of everyday life, "there can be no clear division between physical and mental modalities" (Schulze 1992, 107). Experiencing the "everyday" (e.g., eating an ice-cream cone, lying in the sun, drinking the day's first cup of coffee, or making love) are only truly interpreted as pleasurable experiences when they

are cognitively linked with memories, fantasies, expectations, or interpretations. The sensory attributes of a specific situation (color, sound, movement, taste, smell) form the "raw material" that the individual combines with cognitive meanings in order to construct an aesthetic experience (Schulze 1992, 107). The construction of meaning based on the interaction between the physical and the psychological, or the sensory and the cognitive, reinserts the significance of reception, or more specifically, of audience and the contexts of reception, into the discussion of culture.

Audience positions (individually and collectively) are a critical component in the construction of image, identity, and experience as social space. Although the title of Barbara Kruger's essay "What's High, What's Low—and Who Cares?" addresses postmodern de-differentiation, it also focuses attention on "who" receives and defines culture. Kruger explores both the indeterminacy of representation (e.g., in photography) and the contingency of audience positions in terms of these social and gender relations. Rosalyn Deutsche situates these projects within a feminist aesthetics of representations, an aesthetics that challenges the spaces and relationships between viewers and cultural production:

> Built into the architecture of modernist looking is an injunction to recognize images and viewers as given, rather than produced, spaces and therefore as interiors closed in on themselves. But art informed by feminist ideas about representation disrupts this closure by staging vision as a process that mutually constitutes image and viewer. . . . By exposing the repressed relationships through which vision produces the sense of autonomy—by . . . exploring the viewer's noncontinuity with itself—this work also disturbs the sense that otherness is purely external. (1998, 302–3)

Feminist aesthetic practices underscore the fact that a multidimensional rather than hierarchical conceptualization of culture does not dissolve or erase differences with respect to gender, sexual, ethnic, or regional identities. Rather, they question and destabilize the social relations of power that constitute these spaces. Corporate cultural politics responds to this challenge by reconfiguring, organizing, and structuring identity and diversity as markets defined by consumption.

The use of photography and film in the work of feminist artists also points to the power of visual culture. The most evident expression of the interplay between the construction of cultural identities as commodities and the need to reinvent them constantly (as a result of shifts in social milieus) lies within the mass media, or what Douglas Kellner has termed *media culture* (1995, 16–17). It is not only the multidimensional character of culture but also its production, dissemination, and reception in multimedia formats that indicate the primacy of the image and the aesthetics of visualization as key components in defining social relations. Although Kellner argues that media culture "must be differentially interpreted and contextualized within the matrix of the competing social discourses and forces which constitute it," he also identifies it as "the dominant culture today" in terms of its role in socialization (e.g., in families, schools, churches) and projection of images (17).

The institutional, social (i.e., milieu-specific), and communicative functions of media culture identified by Kellner are related to Wernick's concept of *promotional culture*. Wernick investigates how forms of promotional discourse are linked with those that have been historically perceived as nonpromotional (e.g., the discourse of politics or at universities). He notes that "the range of cultural phenomena which . . . serve to communicate a promotional message has become today, virtually co-extensive with our produced symbolic world."[12] Through common siting and the appropriation (or assimilation) of similar modes of signification and rhetoric, Wernick argues, promotion has become the dominant mode of individual and institutional representation— from the manner in which individuals promote and package themselves as entities (e.g., in order to secure career advancement) to the marketing programs of nonprofit institutions (e.g., education, arts) designed to validate their social legitimacy and maintain economic stability.

The integration of promotional rhetoric and strategies of signification into diverse spheres of social activity has been accelerated and facilitated through the proliferation of visual images in the mass media and their increasing use as a predominant mode of communication. Corporate interests have unquestionably played a primary role in determining how cultural products and symbols are produced, circulated, and received. Nonetheless, this process has also been a result of resistance or subversion of the dominant images of symbolic expression (e.g., Warhol's use of advertising in art), which in turn evoke new forms of appropriation. As Wernick points out, promotional culture exists on the boundary between the symbolic and the material, a boundary that frequently cannot be discerned. I would argue that the cultural politics of the corporation increasingly require it to explore, occupy, *and redefine* social boundaries in order to maintain economic, political, and social legitimacy.

Wernick's analysis of advertising within promotional culture traces the erasure of boundaries between advertising, entertainment, and politics. Indeed, promotional culture is particularly useful for my discussion of sponsorship. Certainly, the notion of image transfer, which forms the conceptual centerpiece of most sponsorships, reinforces the idea of material and symbolic exchange among corporations, institutions, and audiences. However, it is a notion that extends beyond the immediate sites of consumption into the sphere of social interaction and production of culture.

Absolutly Warhol: Reconstituting the Myth of Patronage

The expansion of Sweden's Absolut Vodka brand in the United States (distilled by V&S Vin & Sprit, or simply V&S), under the direction of Michel Roux (CEO of Carillon Importers), became a paradigm for the re-signification of the sponsor as patron and illustrates the interests of corporate cultural politics in structuring social relations as consumption. By fusing arts patronage, advertising, and lifestyle promotion, Roux was able to make Absolut Vodka the leading imported vodka sold in the United States during the late 1980s and early 1990s (Brown 1991, 128; Tilsner 1994, 95). However, the idea of using contemporary artists and their artwork for the Absolut advertise-

ments was suggested by the artist-entrepreneur Andy Warhol in 1985. Warhol received $65,000 for his painting of an Absolut bottle (a price Roux refused to exceed for other artists' work in the future) and sold reproduction rights for five years (Brown 1991, 129; Lewis 1996, 65–67; Lubow 1994, 68). Despite initial skepticism from Carillon's TBWA advertising agency, Warhol's Absolut Vodka ads were enormously successful, even in venues beyond the upscale art magazines in which they were initially placed (Lewis 1996, 66). Warhol recommended other contemporary artists—Keith Haring, Ed Ruscha, and Armand Arman—who could continue the visual style he had established (Brown 1991, 129). The subsequent series of Absolut advertisements defined a visual aesthetic through the repetition of the Absolut Vodka bottle in various configurations and became a part of what TBWA executive Paul Donaher referred to as "owning a visual style"(quoted in Lubow 1994, 78).[13]

The success of this visual aesthetic relied on maximal repetition and variation. The serialization of the Absolut Vodka bottle, as an icon for contemporary art, was combined with the variation of its artistic representation in order to produce a visual trademark style.[14] Each artist inscribed the advertisement with a fusion of Absolut's image and his or her own artistic style in order to project it as a unique visual statement. This tension between the commodified repetition of the bottle and the artists' attempts to endow it with its own aura, but bearing their own visual trademark, was a critical factor in the success of the Absolut advertisements. Indeed, the interplay of repetition and variation is a key feature of seemingly disparate forms of mass-produced culture (e.g., special-edition automobiles, such as VW's Rolling Stones edition, or best-sellers).[15]

Clearly, one of the strategies of sponsors has been to engage artists in the process of cultural production in a systematic or regularized fashion. Whereas Warhol (and other leading artists) may have been able to approach this process with a degree of economic leverage, trading on his image as a cultural commodity, lesser-known artists utilized the commissions for Absolut in order to establish their own presence within the art market. In this sense, the Absolut advertisements were a collaboration that allowed all the participants (sponsors and artists) to increase their economic and promotional capital. Michel Roux required a steady source of artistic talent in order to generate a significant number of Absolut advertisements. For artists, the promotional value of the advertisements, which appeared in upscale media (e.g., *The New Yorker,* the *New York Times, Art & Antiques*), could be transformed into market value. For lesser-known "starving artists," like John Pacovsky, an Absolut advertisement provided media exposure in a notoriously competitive arts market. Before Pacovsky's work was featured in a special forty-page advertising insert ("Absolut Artists of the 90s") in *Art & Antiques* magazine, he had been painting commercial buildings in Wilkes-Barre, Pennsylvania. After Roux commissioned two paintings (for $5,000 each) for Absolut advertisements, Pacovsky's sales increased dramatically. As a result of Absolut ads, recognized artists, such as Romero Britto, were able to double both the asking price of paintings (from $5,000–$25,000 to $9,000–$40,000) and their volume of sales (Brown 1991, 128–29).[16]

Roux's personal involvement in commissioning an ever-expanding group of artists for the Absolut series was also designed to communicate the image of Absolut (and Roux) as patrons of the arts:

> Instead of being merely a liquor salesman, he was now a patron of the arts. The transformation was crucial, for the man and for the brand. For Roux, the whole world could be subsumed under the Absolut label, and he began commissioning Absolut fashions and Absolut concerts along with Absolut artwork. Absolut, already an advertising icon, became a cultural icon as well. (Lubow 1994, 68–69)

Richard Lewis (Absolut account manager with TBWA) remarked that Roux "took enormous pleasure in his role as the Medici of Teaneck" (Lewis 1996, 67). The vocabulary and imagery of patronage is replicated in the marketing trade journals. *Sales and Marketing Management*'s annual Marketing Achievement Award for 1992 described Absolut Vodka as "a product that . . . embraces the same commitment to quality, artistry, and charity that families like the De Medicis, the D'Estes, and the Guggenheims became known for during their respective reigns" ("Carillon Importers" 1992, 44). However, Roux departs from traditional notions of patronage when he acknowledges that he is not the actual collector. The artworks are owned exclusively by the corporation (Vin & Sprit), and the artworks "are not an investment. . . . They're advertising" (quoted in Brown 1991, 129).

In this context, the reintroduction of the notion of patronage also corresponds to my discussion of the historical development of corporate identity and corporate cultural politics during the 1980s, that is, what Hans Haacke and Stefan Römer identified as attempts to reinstate the "aura of the artist" and link it to the creative entrepreneur (Römer 1992, 64). Walter Grasskamp argues that the contemporary use of patronage is based on the nineteenth-century bourgeoisie's own idealized notion of the patron, which it projected upon earlier epochs in order to legitimize its own interests. The clerical, feudal uses of commissioned art were later rewritten as selfless patronage. Historical distinctions among those who functioned primarily in promoting the arts, those who collected, and those who endowed the arts (with capital or property) were conflated and fused into the image of the patron (Grasskamp 1992, 82–83).

The fiction of the selfless patron became a medium for the legitimation of corporate cultural politics (Grasskamp 1992, 82), which could be recycled in diverse contexts. Roux's own appropriation of the vocabulary and posture of patronage, promotionally disseminated in business and professional magazines (e.g., *Forbes* and *Sales and Marketing Management*), provided a "package" for the promotion and exchange of the product. However, the representation of the Absolut campaign as patronage exposes the dissonances of corporate cultural politics, in this case, the contradictions between a "sponsoring philosophy" of patronage and the sponsoring practice of symbolic and material exchange. Thus, culture is signified and dually encoded as auratic, transcendent, or distinctive while it is also instrumentalized as a serialized, reproducible commodity. The fusion of "art" with "marketing" in the language and representational

politics of corporate sponsors such as Carillon (consider their slogan "Marketing after all, is an art of its own") or Philip Morris ("It takes Art to make a Company great") facilitates an apparent dissolution of the cultural hierarchies that historical patronage supported and replaces them with the projection of a consumer-oriented, pluralistic, culture of distinction. Finally, the vocabulary of corporate patronage performs a self-legitimizing function by inverting and merging the uses and meanings of art and market (e.g., "the art of marketing"). This process positions the corporate sponsor within the cultural marketplace as (1) an artist (entrepreneurship becomes synonymous with creativity), (2) a patron (a venture capitalist in cultural investments), (3) an art dealer (a broker or mediator of cultural programs), (4) a collector (consumer or investor), and (5) an audience/consumer (the corporation claims to be part of local communities and promotes its interests as being consonant with the community's own).

Roux's commissions (paintings, sculpture, glasswork, jewelry, furniture, cartoons, fashions, symphonic music, ballets) and promotions (e.g., for the Museum of American Folk Art or the Museum of Native American Art) project the image of the sponsor who embraces the notion of pluralistic, diverse cultures—not an image based on sociocultural hierarchies of high versus low ("Carillon Importers" 1992, 44). Yet sponsoring's appropriation and multiplication of cultural production divorces culture from the construction of marginalized cultural and social identities by defining the relations between cultural production and audiences in terms of subcultures of consumption. Despite a representational politics of cultural diversity, Roux returns to the vocabulary of patronage and cultural distinction in order to reinscribe the artwork *and* the product (Absolut Vodka) with the transcendence of a "classic": "Years from now, there will be people listening to a piece of music commissioned by our product. And that will be the legacy of the product—something that lasts. Something that can be enjoyed again and again. Like Absolut, of course" (quoted in "Carillon Importers" 1992, 44).

Sponsoring's image transfer is complete. Art, defined as the "Good, True, and Beautiful" (Bourdieu and Haacke 1995, 143–44), is bestowed upon the commissioned works of art *and* Absolut Vodka as they become one. Grasskamp concludes that the patron's privileged social status as a cultural arbiter is created through an illusion, or magic ritual of sorts: The patron selects works of art from the marketplace and then transforms them back into the aesthetic ideal that the artist supposedly produced (and the market eradicated) (1992, 83). Historically, the patron has maintained social legitimacy by ameliorating and compensating for the market's influence on art. Yet the market forces that lead to the commodification of the artwork are also those that provide the patron with the capital to acquire art (Grasskamp 1992, 83). Corporate cultural politics, articulated in sponsoring philosophy, draws on the notions of alterity (cultural difference), aura (in Walter Benjamin's sense), and the shock of the avant-garde, as well as of the transcendence and distinction of high culture, in order to effect a symbolic or material exchange *and* social legitimation. The paradoxes between the sponsoring philosophy (auratic, transcendent culture) and the sponsoring practice of

PHILIP GLASS
ABSOLUT VIENNA

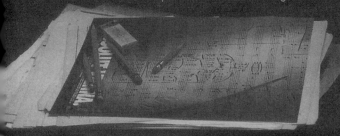

One in a series of 20 portraits celebrating ABSOLUT VODKA's 20th anniversary.

market organization cannot be reconciled without problematizing the social legitimacy of sponsorship itself. This would require a corporate cultural politics that recognizes and critically interrogates the corporation's own participation in the institutions and processes of cultural production, distribution, and reception (Brock 1992, 33).

Absolut Style

In many respects, the Absolut promotional campaign was less about the use of art in advertising per se (for this had been done before) than about re-signifying the social function of contemporary art itself in order to access subcultures of consumption, who would accept the product as part of a lifestyle orientation. The fusion of art and advertising also facilitated a transfer of the image of patronage from the sponsor to consumers, that is, by linking a lifestyle of arts appreciation (visiting museums, attending concerts and cultural events) with one of arts consumption or patronage (acquiring art and music).[17] Thus, consumers could become "patrons" in their own right.

This link between arts appreciation and arts consumption was accomplished by creating an image and sociocultural profile for the product. Because mass-market products are frequently interchangeable, the product image is often divorced from the material or visual characteristics of the product itself. This was certainly the case with vodka, defined as a "neutral spirit without distinctive character, aroma, taste, or color" ("Carillon Importers" 1992, 44). Absolut's image was related to how and where it was used and the associations of those who use it. It was strongly linked to relaxation and leisure and presented as the drink of hip, culturally sophisticated professionals, particularly in urban settings, as well as of those who purchase art and antiques. Advertising executive Manni Arlow characterized Absolut as clever, current ("It's become part of our society" [quoted in Lubow 1994, 79]) and contemporary ("Absolut changed the name of sophistication in the liquor business" ["Carillon Importers" 1992, 44]). As part of his effort to promote Absolut Vodka and, more importantly, to link it to consumers' lifestyles, "Roux was out most nights until the early morning 'promoting the brand' (that is, drinking it) at fashionable bars and restaurants, meeting new artists, signing up new work" (Lubow 1994, 68–69).

An integral part of engaging the lifestyle of Absolut customers involved the production, promotion, and merchandising of other cultural products that complemented the Absolut image (e.g., T-shirts). Sponsoring consultant Alfred Schreiber refers to this promotional technique as "creating programs that interact with the consumers themselves" (1994, 15). These promotions also addressed audiences directly through "event-centered marketing":

> Most paintings have been unveiled in events held at the Whitney Museum, which have attracted considerable media attention and targeted an upscale demographic segment. . . . In 1989, it [Absolut] sponsored a concert called "Absolut Concerto" at New

Figure 3.2. Absolutly Leibovitz: Absolut vodka celebrates its history of patronage as a "classic." Photograph by Annie Leibovitz.

York's Avery Fisher Hall. The concert featured four new symphonic works that Absolut had commissioned. Needless to say, a celebrity dinner followed. Absolut also commissioned a song called "Absolut Lee" from Antonio Carlos Jobim, and sponsored Jobim's first American concert. Copies of "Absolut Lee" were later distributed to the entire readership of *Rolling Stone* as bound-in recordings. (Schreiber 1994, 135–36)

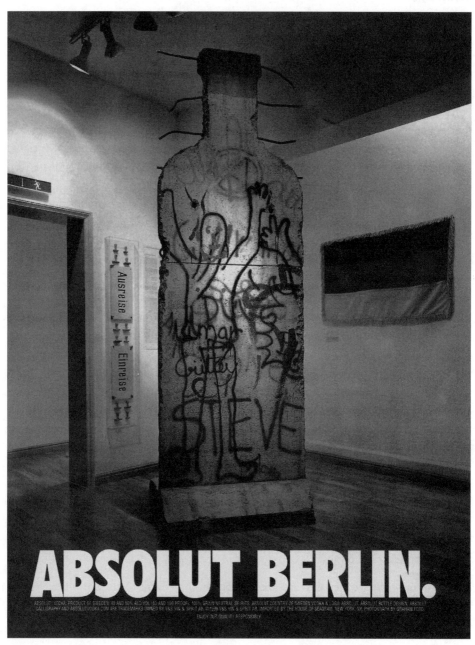

Figure 3.3. A depoliticized Berlin Wall as museum piece and product promotion; it's all part of Absolut lifestyle.

Schreiber describes the jazz sponsorships as "a logical extension of brand promotion to a younger audience—a likely group of vodka buyers, comprised of various ethnic groups and savvy urban whites" (136). Absolut had become a "badge product," that is, one that people would consume, wear, or display as an outward sign of distinction (Lubow 1994, 65). As we have seen, however, distinction also implies social exclusion, particularly for those who did not embody urban sophistication and style. Defining who wore this "badge" and how they wore it became crucial for Roux. His colleagues explain that "Roux saw a fat, slovenly man at Newark airport wearing an Absolut T-shirt. Saying that he wanted it for his collection, Roux bought the garment for fifty dollars, and stopped manufacturing Absolut T-shirts" (Lubow 1994, 68). Because Absolut T-shirts had been absorbed by the mass market of middle-class America, they no longer communicated the badge of social distinction. An egalitarian, equal-access, consumer pluralism, in which everyone could buy the culture they could afford, had in fact not replaced the hierarchies of taste and style.[18] Roux wanted to craft an image for Absolut that eschewed the overt symbols of wealth and power but covertly represented socioeconomic exclusion.

Yet social exclusion can also be appropriated to signify stylistic exclusivity. This was certainly the case with respect to Absolut's marketing and promotion to urban gay communities—in terms of both the sponsor's politics of representation and its attempts to communicate with new markets. Although most major corporations refused to advertise in gay and lesbian publications, Absolut employed images of gay males as a promotional vehicle in order to target urban, intellectual gays, as well as the larger intellectual and artistic community in urban markets.[19] Advertisers, like Absolut, "view gay publishing as just another form of target marketing to reach a group with money to burn" (Johnson 1991, 31). Because urban, intellectual communities identify with gay concerns (e.g., AIDS, censorship, local politics), advertisers employ images of gays to attract attention to their products. "Embrace the Unknown," a promotion for a new vodka brand, Priviet, pictured an interracial gay couple. But Roux was particularly interested in using images of gay males to reach wider audiences: "I don't think the two men should be run in a gay magazine. . . . I don't want that kind of targeting. It could be in *Paper* or *Ocean Drive*" (quoted in Lubow 1994, 64).

Raymond Foley, publisher of *Bartender* magazine, referred to Absolut as "a brand that always leads the way in the liquor industry when it comes to exciting, socially responsible advertising and marketing" (quoted in "Carillon Importers" 1992, 44). Beyond the specific practices of the Absolut promotion, the appeal of creating images of a socially responsible and culturally engaged corporation—in order to counteract the pervasive negative images associated with the liquor or tobacco industries—is obvious. However, the appropriation of some images (gay males) and the exclusion of others (middle-class overweight males) also reminds us that a significant motivation for the projection of images and identities is even more pragmatic than winning or maintaining a positive public image (although that is important too): These images

are ultimately based on expanding market share. The integration of cultural and social sponsorships provides new channels of communication and contexts (e.g., events) in which sympathetic consumers can be addressed. More importantly, such sponsorships also facilitate the corporation's own participation within those communities by situating it within networks of cultural production (artists) and mediation (museums).

"One World/One Store": Benetton, Social Sponsoring, and Globalization

If the corporation has, as we have seen, assumed a pivotal position in redefining culture by ostensibly embracing and facilitating an inversion of the high/low hierarchy in order to legitimize its own participation in culture, then it has simultaneously re-formulated its participation in the construction of social identity and community by redefining lifestyle (as organized consumption) in terms of social sponsorships.[20] As a function of corporate cultural politics, a major objective of cultural and social pro-motions is participation in communities:

> It's not a question of simply taking your messages to the media . . . but of taking the en-
> tire process one level higher by creating programs that interact with the consumers
> themselves. . . . It may mean supporting social organizations that have particular mean-
> ing for the people you are trying to reach . . . [in] the arts, sports, schools, local govern-
> ment, nonprofits, festivals, or community development programs. The first steps . . .
> are to identify . . . the target markets you want to reach . . . then to work backward . . .
> to become involved with specific programs . . . and convey a strong profile for your
> products or services. (Schreiber 1994, 15)

Schreiber (in the subtitle of his book) calls this new form of lifestyle marketing "Build-ing the New Customer Partnership." The "partnership" involves more-direct partici-pation in the construction and organization of communities than occurs in tradition-al philanthropy. Although promotional campaigns, like Absolut Vodka's, attempt to signify products through identities (e.g., urban gay males), social sponsoring inserts the interests of the corporation into the local contexts of sociocultural interaction. This process increasingly involves the sponsor in the construction of ethnic, gender, and regional or national identities.

One of the most visible and controversial forays into the construction of social identities has been the series of Benetton advertising campaigns that began in 1984 with the "All the Colors of the World" campaign. Although Benetton did not initially sponsor events (such as concerts for nonprofit causes), it created media events that provided a basis for consumer identification based on strong affinities with social causes. Photographs of impoverished children working at a construction site in a de-veloping country, a duck swimming in an oil spill, or human body parts stamped "H.I.V. Positive" created outrage but also considerable attention in the international media by removing these photographs and texts from "the ghetto of advertising" (Schnibben 1992, 120). However, Benetton was less concerned with the negative re-sponses among older consumers and media critics (conservative or liberal) than with

the reactions of their target audience of young consumers, who had considerable disposable income and were inured to the routine promotion of entertainment and consumer products. Initially, Benetton's audience seemed to belong to "Generation X," that is, young adults 16 to 27, whom sponsors perceived as "highly astute judges of the media," conscious of style, and "concerned with AIDS, the environment, racial equality" (Schreiber 1994, 48, 238).

Benetton addressed this younger audience with images of social conflict and injustice. Perhaps its advertisements were successful in part because they effected the transformation from the marketing of lifestyle, imaged as entertainment and consumption, to the marketing of lifestyle orientations based on products linked to social causes (Schreiber 1994, 238–39). Large segments of affluent youth markets in industrial countries are receptive to overt communication on social issues. Purchasing Benetton products may have intensified Generation Xers' sense of participation in social causes and provided a feeling of empowerment by offering them the opportunity to spend their money for clothing with a corporation that claimed to share their concern for social issues. Unlike the stereotype of anticonsumerism associated with their parents' generation of the 1960s, Generation Xers were more concerned with how and what they consumed (Schreiber 1994, 48). Even if the consumers of Generation X were sometimes skeptical of Benetton's motives, they perceived that their money did not go to an "anonymous" corporate entity whose social politics were unknown (Schreiber 1994, 238). Benetton's advertisements made a case for its progressive corporate social politics, although the case may have not been credible for many consumers.

Henry Giroux argues that social conflict is defused or contained in Benetton's promotional strategy by depoliticizing aspects of everyday culture (1994, 196). The political contours of social inequality are flattened and relativized. Lifestyle is defined through a diversity of stylistic distinction within the pages of *Colors* (Benetton's magazine for its customers):

> Interspersed amid commentaries on music, pizza, national styles, condoms, rock stars, and the biographies of various Benetton executives, *Colors* parades young people from various racial and ethnic groups wearing Benetton apparel. In this context, difference is stripped of all social and political antagonisms and becomes a commercial symbol for what is youthfully chic, hip, and fashionable. At the same time, *Colors* appears to take its cue from the many concerns that inform the daily lives of teenagers all over the industrialized world. (Giroux 1994, 196)

The images in the Benetton advertisements provide an organizing filter for the interpretation of social reality and conflict. Many of the promotions appropriate postmodern strategies of contingency and the use of a documentary-style photography; their "structuring principles are shock, sensationalism, and voyeurism," which function in terms of "offering its [Benetton's] publicity mechanisms to diverse cultures as a unifying discourse for solving the great number of social problems that threaten to

uproot difference from the discourses of harmony, consensus, and fashion" (Giroux 1994, 196, 203).

From an audience perspective, the impact of the Benetton advertising campaigns may be difficult to assess. The promotions were obviously very successful in creating a positive, socially concerned image for the stores among youth markets despite court decisions banning some of the advertisements that were deemed exploitive in several European countries (Germany, France, and Italy).[21] The success of Benetton's advertisements among teenagers and young adults seems to indicate that they accept its commercial interests as a fact of the marketplace but are simultaneously attracted by its socially provocative advertising, which distinguishes it from other image-oriented promotions such as those for fashions and perfume. Teenagers like the aggressive, provocative, "in-your-face" stands on social issues, but they also recognize that Benetton's motives are not completely altruistic.[22] Indeed, Benetton's image within subsequent generations of younger consumers, such as "Generation Y" (the successor to Generation X), may be fading as a result of constantly changing fashion trends, as well as Benetton's "down-market" retailing with chains such as Sears.[23]

I would argue that Benetton's involvement in social issues primarily fosters a community of consumers rather than communities of participants engaged in addressing common concerns. Even if we assume that Benetton was encouraging alliances between its audience and socially active nonprofits such as Greenpeace, Amnesty International (Ayub 1993, 66–68), or the SOS Racisme (for which it sponsored a conference), the corporation's advertisements do little to educate or inform audiences of more-complex underlying issues (e.g., the ramifications of and its own involvement in corporate globalization). As Hans Haacke has pointed out, the corporation does not donate funds to charitable or advocacy groups, and its labor relations practices are hardly progressive (i.e., its ongoing support of textile subcontractors who often provide workers substandard working conditions and wages) (Haacke 1995, 228–35).[24]

Benetton has defined communities of participation primarily with respect to two sites of consumption and promotion: its megastores and Benetton Web sites. The megastores are designed as surrogate meeting places for a global community:

> The megastore is more than just a retail outlet, it is also a place for people to meet and get together. Benetton has always aimed to be more than a global group manufacturing and selling clothes; it has also promoted an open and international lifestyle, and the new megastores are an essential part of this concept. (Benetton Web site)

Both the megastores (locally) and the Web site (globally) represent attempts to intervene in and organize communities in terms of a lifestyle of consumption. Benetton's "One World/One Store" advertisements portraying multiethnic, multicultural models reflect what Malcolm Waters has termed a "complex interweave of homogenizing

Figure 3.4. Alliances for social causes and self-promotion.

UNITED NATIONS HIGH COMMISSI ONER FOR REFUGEES. CONTRIBUTION FOR KOSOVO. CALL 800-770-1100 OR 202-296 -1115. WWW.USAFORUNHCR.ORG

Send checks to:
United States Association for UNHCR
1775 K St., NW
Suite 300
Washington, DC 20006

Direct transfers to:
United States Association for UNHCR
Account #6650377 9
ABA (routing) #254070116
Citibank Washington DC 20036

with differentiating trends" characteristic of globalization (1996, 139). The "One World/One Store" advertisements globalize the symbolic exchange of Benetton products through social identities and issues while localizing the material exchange of consumption through the siting of its urban megastores. Although the promotional text of the Web site attempts to present images of a progressive, socially responsible corporate politics, it actually reverts to older models of international understanding through commerce:

> Ten new stores have opened in Syria, where Benetton is the only foreign clothing brand present in the market. Since 1995, moreover, Benetton has been present in Pakistan, where the first store was inaugurated by ex–Prime Minister Benazir Bhutto. (Benetton Web site: "The Commercial Network")

While social sponsorships and promotions, through their very existence, reveal the extent to which commerce, culture, and politics are interwoven into everyday life, they simultaneously deflect attention from the corporation's own social, economic, and cultural politics of local or global workplaces.[25] They redefine the sites of symbolic and material consumption (e.g., shopping centers, megastores) as places where milieu-specific values (e.g., ecological concerns, diversity, multicultural understanding, family values) can be reinscribed and mediated. Benetton's upscale mall location, the urban megastore, and the corporate Web site provide the contexts within which shared allegiances to social causes *and* the lifestyles of teens (with significant disposable incomes) can be channeled into consumption. Just as Absolut Vodka was designated a badge product, Benetton clothing also became a badge for shared lifestyles that aspired to social equity but failed to link them to organized efforts for social action (such as Amnesty International or Greenpeace).

Community partnerships or local alliances with educational institutions, health care, and nonprofit organizations solidify and legitimize the role of the sponsor as a participant in the formation of social policies (education, government, social welfare). Indeed, the participation of corporate sponsorship in education and local nonprofits in the United States is increasingly taken for granted and is becoming an essential component of such organizations' financial stability. Social sponsoring, like cultural sponsoring, is often more than just image promotion; it also integrates product promotion into nonpromotional contexts. Social sponsorships in education, for example, involve direct and indirect forms of product placement and merchandising in the classroom in order to promote new educational products as well as consumer products targeted to children.[26] These programs underscore the increasing role of educational and cultural institutions (e.g., schools, museums) as sites of consumption and, conversely, the use of malls, megastores, and theme parks (e.g., Disney World, Epcot) as sites of socialization and education.[27]

A "Genuine" Saxon

Benetton's social advertisements and the controversy regarding their legitimacy or legality illustrate the extent to which corporate interests are embedded in the con-

texts of social relations and their power to construct or frame identities. However, the corporation's projection of itself as a participant in public discourses on social issues—accompanied by the signifiers of corporate image (e.g., logos or brand-name products)—ultimately points to its own interests in constructing social relations. These politics of representation have become very visible in postunification Germany as it moves from a rather homogeneous to a more multicultural society. Indeed, notions of German identity and nation were increasingly problematized as tensions between East and West Germans and relations between Germans and ethnic minorities, migrants, and asylum seekers became the focus of social, political, and cultural debate. The resurgence of right-wing and neo-Nazi groups and of hate crimes against ethnic minorities after unification also coincided with new waves of political refugees and other asylum seekers.[28]

During the early 1990s, religious and nonprofit groups realized that their campaigns to combat hate crimes could not reach mass audiences without the type of media coverage and public actions used successfully by groups such as Greenpeace and Amnesty International (Stolz 1993, 56–57). Rock concerts and other events designed for regional and global causes (e.g., AIDS, Hunger in Africa) were recognized as effective vehicles for fund-raising and consciousness-raising efforts (Stolz 1993, 57). The impact of social advertising (positive or negative) reinforced the potential for commercial sponsorships in the social sector in Germany. Regional initiatives supported by coalitions of religious, social, professional, and political groups induced the national and local media (television, radio, press)—including Germany's major public and private television stations, ARD, ZDF, RTL, and MTV—to contribute free airtime and advertising space for spots (Stolz 1993, 57–58). Coalitions of human rights, political, and religious groups sponsored candle-light vigils *(Lichterketten)*—human chains of silent protest strung throughout urban centers (e.g., in Berlin, Munich, and Frankfurt am Main).[29]

Although many media, such as Munich's *Süddeutsche Zeitung,* supported the *Lichterketten* without using them as a promotional vehicle, other media combined public information with public relations. One issue-oriented social advertisement sponsored by the *Sächsische Zeitung*—and voted the best of the year by one hundred advertising executives—illustrates the attempt to construct German identities in terms of multiculturalism. The newspaper's advertisement is a black-and-white frontal photograph of Sam Njankono Meffire, an African German born in Zwenkau (in Saxony). Meffire appears underneath large, black, bold letters declaring, *"Ein Sachse"* ("A Saxon"). The advertisement (part of a series of promotions called "Ein Sachse") asks the reader to accept Meffire—who worked with skinheads after unification and protected "foreigners" during his training as a policeman—not because he is different but precisely because he is not; that is, he is "a Saxon," a German, a policeman (and thus *legally* not designated a "foreigner") (Leif and Galle 1993, 9).

The advertisement undermines the notion of a German cultural identity based on ethnicity by intentionally addressing audiences (i.e., the radical right) who would reject the visual provocation of a black Saxon. In designing the advertisement for the

Figure 3.5. Diversity sponsoring for social causes. *The heading reads,* "A Saxon." *Text at lower left reads,* "Sam Njankono Meffire, born 1970, in Zwenkau, Saxony." *Text at lower right reads,* "There are more Saxons than one thinks. Every day about one million of them read the *Sächsische Zeitung*—one of German's largest newspapers. . . ."

Sächsische Zeitung, Scholz & Friends (considered one of Germany's most innovative advertising agencies) (Hardenberg 1998, 47) attempts to confront the radical right with the contradiction, which it refuses to accept as reality. However, this confrontation is only accomplished by simultaneously inscribing a binary and assimilationist view of identity that projects Meffire as a true *"Sachse,"* erasing any vestiges of Meffire's own ethnicity and social status as a man of color living in Germany. Moreover, the visual and textual discourse of the advertisement clearly privileges the notion of German identity (intensified through the notion of the "Saxon") over any sociocultural significance of ethnicity. The advertisement's headline declares Meffire is a German (and his legal and social status as a policeman affirms this), rather than suggesting the much more threatening notion that he should be accepted on the basis of *not* being German, for example, as a migrant or asylum seeker, whose legal status may be indeterminate. Thus, the scales of binary opposition between German and non-German—an implicit component of the advertisement's attempt to argue that such differences are not important—tip in favor of validating that which is German. That is to say, despite all, Mefirre is ultimately a Saxon. Indeed, the ad's text states, "There are more Saxons than one thinks." More significantly, the notion of a hybridization of identities in Germany, which would explore or provoke the tensions between Meffire's social status and professional identity (as a policeman) within Saxony as well as the manner in which his status as an African German alters his social identity, is over-

looked as a potentially productive perspective in approaching a dialogue on multiculturalism and Germany.

Of course, the advertisers would argue that the objective of the promotion is to reach their audience on an emotional level rather than through differentiated argumentation. They are simply applying the strategies of contemporary fund-raising for social causes. Dieter Stemmle, a professional fund-raiser, refers to the power of the visual idiom to appeal to audience values by linking them to an emotional experience, or what Stemmle describes as the experience of viewing the advertisement:

> In the social sphere, dealing with values is a part of all forms of corporate identity. These values are not simply a given. Rather, they are exchanged, in communication, in personal encounters, and in the manner and way of human existence. Values are experienced. They emerge from the depths of the human being and become an experience *[Erlebnis]*. Sometimes they are authentic, sometimes bold yet simple, sometimes quite human, and sometimes they are foolish. Values can move people and their moods. New value orientations can conquer borders and even tabus. (1993, 27–28)

Yet the distinction between appealing to sympathetic audiences and "conquering borders" is crucial—particularly the assumption (by the *Sächsische Zeitung* and the advertising agency) that the radical right can be reached through campaigns in mainstream print media. The advertisers for this campaign believed it could. Sebastian Turner, managing director of Scholz & Friends during the promotion, explained the strategy of using a visual provocation for the advertisement featuring Meffire: "Those who hate foreigners tune out when they are confronted with logical arguments. Therefore the advertisement must be understood faster than an individual full of hate can turn the page" (quoted in Leif and Galle 1993, 9). Although those who commit hate crimes do not respond to "logical arguments," the strategy of visual provocation based on emotional responses can also illicit the opposite response: The perception that minorities (a black man) have become part of the power structure (a policeman) may provide simply another provocation to resist institutional power and assert that those social institutions have been taken over by non-Germans. Although both the Benetton and *Sächsische Zeitung* advertisements employ similar discursive strategies of visual provocation related to social issues, they address fundamentally different audiences. Benetton's youth market is basically sympathetic to the corporation's products and message, but the *Sächsische Zeitung*'s audience lies outside of the paper's readership and perceives the message as a challenge to its own values. Although the two forms of promotion pursue different strategies of representation, both actually depoliticize ethnic diversity and political difference.

This is illustrated in another advertisement for the *Sächsische Zeitung* (designed by Scholz & Friends) in the series "Ein Sachse," which pictures the German Reichstag with the familiar headline: "Ein Sachse." As part of the advertisement for the newspaper, the reader is told that the Reichstag was constructed of Saxon sandstone. In

this case, identity and community are constructed as the assimilation and convergence of regional with national identity. Saxony, as a "new" state in the unified Germany from the former German Democratic Republic (GDR), is aligned with the quintessential signifier of German national identity, the Reichstag. In this respect, the advertisement is an affirmation that its readers are also "authentic" Germans, part of the history and tradition of Germany, rather than citizens of the former GDR who have been assimilated, or colonized, by the Federal Republic of Germany (FRG). The manifest political and economic conflicts within postunification Germany are erased in favor of the integration of regional and national identity. Indeed, the promotion appropriates the Reichstag as "A Saxon" not only in order to establish Saxony's own legitimacy as "authentically German," but also in order to state unequivocally that the core of being German (i.e., the national identity associated with the Reichstag) is Saxon. Thus, the advertisement trumps the West Germans by declaring that the Reichstag belongs to Saxony, and in doing so it also tentatively asserts Saxony against its neighbors to the west according to the motto, "Not only are we Germans too, but we are the real Germans."

In many respects, German corporations are only beginning to explore sponsorships that construct ethnic and national identities.[30] However, they are likely to increase as minorities gain access to greater economic, political, and social power in Germany. Although levels of social sponsorships in Germany are relatively low (in comparison to sponsorship of sports and cultural programming), they are increasing dramatically in response to budget constraints, particularly in the new states where the demands for social infrastructure continue to grow.[31] Organizations such as Aktion Kontrapunkt, which actively solicits sponsors for programs to combat xenophobia through support of intercultural groups, or Sozialsponsor in Aachen, which supports a variety of social organizations in the city of Aachen and makes its logo available for contributors, can now be approached through professional sponsoring agencies such as the Europäische Sponsoring-Börse, an online clearinghouse for sponsoring projects.[32]

As sponsorships within the area of multicultural projects increase, they will in all likelihood follow similar trends in U.S. image and product promotion, which integrate social sponsorships with marketing and promotion. During the late 1990s, ethnicity was rapidly introduced into German advertisements in order to signify shifts in values among younger, more affluent consumers. Changes in the traditional family in Germany to "mixed marriages" and "blended families" were appropriated, not to promote diversity or understanding but to link a product with these values and identities. The first page of one such advertisement for Audi features a white father and mother with a black son and Asian daughter. The caption reads, "Does a family have to look like a family?" In response, the second page of the ad shows a new automobile with

Figure 3.6. Identity politics in postunification Germany: Who is more German? The image here is the German Reichstag prior to renovation. *The heading reads,* "A Saxon." *Text at lower left reads,* "The Reichstag building. Constructed from 1884 to 1894, from Saxon sandstone." *Text at lower right reads,* "There are more Saxons than one thinks. Every day about one million of them read the *Sächsische Zeitung*—one of Germany's largest newspapers. . . ."

Ein Sachse.

Es gibt mehr Sachsen, als man denkt. Rund eine Million von ihnen liest Tag für Tag die Sächsische Zeitung, eine der größten Zeitungen Deutschlands. Mit einer Auflage von 426.073 Exemplaren* erreicht die Sächsische Zeitung in ihrem Verbreitungsgebiet eine komfortable Zweidrittelmehrheit**, in den neuen Ländern kommt sie problemlos über die Fünfprozent-Hürde.*** Weitere Informationen schicken wir Ihnen gerne zu. Rufen Sie einfach Verena Freitag an. Sächsische Zeitung, Ostra-Allee 20, D-01067 Dresden, Telefon (0351) 4864-404, Fax (0351) 4864-439.

Sächsische Zeitung

Das ist Sachsen.

Das Reichstagsgebäude.
Erbaut von 1884 bis 1894 aus sächsischem Sandstein.

the caption, "Does a limousine have to look like a limousine? The new Audi A6. Visions begin with questions" (Hardenberg 1998, 48).

Multiculturalism has also become an image factor of regional marketing within Germany and the EU. In the state of Mecklenburg–West Pomerania, for example, an image advertisement of two Japanese students studying piano at the University for Music and Theater in Rostock is designed to address negative images of Rostock and of the state (as a result of hate crimes during the early 1990s) by positioning them as a site of culture, open to and sought out by foreigners.[33] The advertisement plays on images of the "east"—Japan and East Germany—in order to link the cultures of "the distant old east" with "the new German northeast." Mecklenburg–West Pomerania is projected as tourist-friendly, cultivated, and open to foreigners. Indeed, the final line of text addresses the negative image of the region, concluding, "Just in general, a lot of things are different than you think."[34] Both the Audi advertisement and the promotion for Mecklenburg–West Pomerania want viewers to associate their products with open-mindedness, innovation, creativity, and cultural diversity. These advertisers seem to be telling their readers that their products provide a validation for these new values and identities to which Germans, individually and collectively, aspire.

Among some nonprofit organizations, corporate involvement in social marketing has been viewed with considerable skepticism. Amnesty International in Germany has rejected sponsorships by the Body Shop cosmetics chain, despite agreements between the corporation and other Amnesty International chapters in the EU (e.g., the United Kingdom) and internationally (Ayub, 1993, 66–69). Some consumer groups in Germany have also been proactive in attempting to limit the extent to which firms can link support for ecological groups with their product image.[35] Although there may be resistance to such overt forms of social sponsoring as image promotion, the social policies of privatization in Germany have already legitimized greater involvement by the corporate sector. Moreover, as the national entities of international organizations begin to solicit funds multinationally within the EU's single market, administrators of groups such Amnesty International and Greenpeace foresee increasing competition for contributions within and between their organizations (Ayub 1993, 66).

Whereas regional cultural diversity may be employed in order to open market niches in the competition for a presence in European urban centers, the political and social conflicts of ethnicity, gender, sexuality, or nationality are promotionally defused or dissolved in order to facilitate the globalization of market interests. In a sense, the reconfiguration of German identity (including the identity of the "New Berlin") expressed through the filter of corporate promotion and social sponsorships may mirror the dynamics and tensions occurring within the EU at large. As David Morley and Kevin Robins observe, concepts of diversity and community become even more problematic as the EU attempts to integrate dissonant identities within Europe into an idealized projection of the "New Europe":

> The language of official Euro-culture is significant: it is the language of cohesion, integration, unity, community, security. The new European order is being constructed in

terms of an idealised wholeness and plentitude, and European identity is conceived in terms of boundedness and containment. (1995, 189)

Multicultural and Diversity Sponsoring
Buying Events—Defining Communities

Based on their extensive experience in ethnic marketing in the United States, many multinational corporations have considerable experience in multicultural sponsorships that can be used to access emerging markets in Germany. Sponsorships in the United States attempt to fuse notions of ethnicity, national identity, and community by integrating social and cultural sponsorships. In societies characterized by mass-produced consumer products, the notion of "difference" provides a vehicle for distinguishing brand-name products as well as addressing expanding minority markets. For example, AT&T's "New Art/New Visions" program shows work by women and "artists of color" while providing financial aid for galleries to show and acquire the works. However, AT&T concedes that it is also addressing women and African Americans, who purchase an increasing portion of services from the corporation. And by spending $100,000 to sponsor a retrospective show of Jean-Michel Basquiat's work at New York's Whitney Museum, AT&T (like other firms) also hoped to balance its image of only supporting traditional high culture ("Politically Correct Patrons" 1992, 89). (Yet the audience for the shows at the Whitney could hardly be considered demographically diverse.)

Although African Americans compose the largest minority population within the United States, the majority of diversity-oriented sponsorships are directed to the Hispanic community (Thomas Harris 1993, 268). Although market analysts disagree as to the causes for this disparity, many believe that it is related to linguistic difference, which facilitates targeted communication with Hispanic communities and higher levels of brand loyalty in comparison with other ethnic groups (Fry 1991, 12; Thomas Harris 1993, 268–69). Corporations have been extremely successful in merging social and cultural sponsorships with product promotion through cultural festivals for Hispanic communities. Indeed, most major Hispanic events now include extensive sponsorships.

More than 1.5 million people attend the annual Calle Oche (Carnival Miami), which is supported by one hundred corporate sponsors, including Anheuser-Busch, AT&T, Campbell's Soup, Coca-Cola, and Colgate-Palmolive (Freeman 1998, S-12; Thomas Harris 1993, 265). Puerto Rican Day and Hispanic Day parades in New York or Fiesta del Sol in Chicago provide popular-culture venues for product promotion and sampling (Thomas Harris 1993, 266). Because the impact of the promotional message is diffused through the participation of numerous sponsors, many corporations are now organizing and "buying" their own events, such as the International Salsa Festival in Miami coordinated by WLTV-TV and sponsored by Anheuser-Busch, which acquired exclusive rights to sell Budweiser beer at the festival (Freeman 1998, S-13). Laurie Freeman concludes, "As advertisers begin demanding more impact from

sponsorship, events will have to be tailored more to companies' wishes" (1998, S-13). We see once again that corporate sponsors, by buying and producing their own events, have assumed the functions of cultural producers and promoters in order to define contexts of cultural production.

Most programs accentuating ethnic minorities integrate a variety of sponsored projects with links to local educational institutions, museums, and the media. The objective of many of these sponsorships is to embed products within an entertainment event. Kodak sponsors Hispanic festivals where participants can be photographed with television celebrities from Telemundo (a Spanish-language TV network). Families pose for photos together in an Outdoor Funshot Studio (and they can also purchase film from a Kodak kiosk) (Fry 1991, 13). Family-oriented activities are a vehicle for promoting picture taking as consumption and provide opportunities to structure contexts of social interaction with the family and communities in terms of lifestyles that consume themed environments. Events are also used to establish links to community events and institutions; for example, Kodak sponsors the California Museum of Latino History (Fry 1991, 13).

Support for local events, nonprofit groups, museums, and education functions to legitimize and validate the corporation's political and economic interests. Philip Morris, in the 1960s, became one of the first corporations to utilize extensive cultural sponsorships of theater productions, exhibitions, dance, museums, arts organizations, and educational arts programs. In the *Philip Morris Companies Incorporated Corporate Contribution Guidelines* for organizations seeking funding, Philip Morris employs notions of community, diversity, and empowerment in order to maintain its socioeconomic legitimacy, specifically within the following programmatic foci: education (teacher education, training, and recruitment; adult literacy; K–12 education reform), the arts (dance companies, theaters, music groups, museums), hunger and nutrition, conservation and environment, civic and community causes, and the AIDS epidemic.[36]

In its documentation of sponsored programs, *Philip Morris and the Arts: 35 Year Report,* communities are defined in terms of diversity. However, diversity is multiply-coded not only as cultural, national, ethnic, or gender diversity, but primarily as market diversity:

> In the 1970s and 1980s, Philip Morris began to broaden its business interests, strengthening its operations in other industries and other countries. The expansion of its work force and markets enhanced the company's interest in cultural diversity and gave rise to a continuing series of exhibitions that examined and celebrated that diversity. (*Philip Morris and the Arts* 1993, 3)

Contesting Public Policy

Philip Morris's interest in maintaining its global and local economic interests is revealed in its guidelines and criteria for sponsorship. Of the two criteria applied to all grant proposals, the second asks, "Is the organization active in a community that has a major Philip Morris operating company presence?"[37] Thus, *the link between economic*

and cultural interests is clearly established from the outset. The corporation only agrees to provide cultural support where it also maintains its economic interests. Although these interests are clearly global (in terms of distribution and consumption), they are physically present in the politics of space (manufacturing and administrative facilities) and labor relations, which are key to retaining favorable conditions of production— including issues of taxation, land use, and unionization. Maintaining a local power base for labor and governmental relations through positive image projections (and especially through sponsorships of educational and arts programming) is a significant component of corporate politics. Investments in social and cultural institutions are bargaining chips that can be leveraged at the local or regional levels in order to validate corporate legitimacy and responsibility. Yet at the same time, corporate interests in protecting market share and profitability for brands are global. During the 1990s, the regulation of tobacco (cigarettes) became the focus of public-policy debates both in the United States and in the EU. In the United States, extensive class-action suits, legal actions by attorneys general in many states, increased taxes on cigarettes, new legislation regulating the sale of cigarettes to minors, and damaging revelations regarding tobacco industry practices all threatened the image and sales of tobacco manufacturers. Within the EU, bans were introduced on tobacco advertising and on sports and cultural sponsorships by tobacco companies (using brand-name marketing and merchandising).[38]

Philip Morris, like other corporations, is keenly aware of the impact of public policy upon its interests, and it addresses public policy in mass-media public-relations campaigns and annual shareholder reports:

> We understand that our stock price can be affected by investor concerns about the public policy and litigation environment facing our tobacco business in the United States. . . . First, we at Philip Morris believe in our businesses, our positions and our people. We are proud of our work, our company and our employees. Second, we believe we are right and we are devoting all the necessary resources to our efforts. Third, legal battles demand both patience and tenacity.[39]

The extent to which the tobacco industry perceived itself as embattled during the 1990s and beyond was revealed in its annual reports, which discussed at length the potential impact of pending and proposed litigations and taxation on the "business environment."[40] As a result of litigation and legislation, as well as extensive media coverage of industry cover-ups regarding the harmful effects of tobacco, Philip Morris launched a series of new public promotions highlighting its past work as a good corporate citizen, for example, providing bottled water from a Miller Brewing Company plant in a flooded community or contributing to shelters for abused women.[41]

The relations between corporate interests and public policy are contested by the corporation within local, national, and global contexts. In these contexts, sponsorships provide a medium to construct corporate images and to define "alliances" or "partnerships" with consumers and institutions (based on markets). With regard to tobacco-related lawsuits in the late 1990s, Philip Morris attempted to placate its shareholders

by stating, "We're fighting for our rights and the rights of our consumers."[42] Yet the tobacco corporations recognized they would lose the public-policy battle in the long run, and they accordingly shifted their public relations to a more conciliatory tone of corporate citizenship in the face of the negative publicity. In this sense, Philip Morris's *Corporate Contribution Guidelines* for sponsored programs from the early 1990s could be read somewhat ironically. For they explicitly define the participation of the corporation as a central component of the community: "The relationship between a company and its surrounding community is profoundly symbiotic. The welfare of one is tied closely to the welfare of the other."[43]

"Latin American Women Artists": Brokering Identities or Organizing Markets?

Philip-Morris's sponsorship of the exhibition *Latin American Women Artists: 1915–1995,* organized by the Milwaukee Art Museum (MAM) in 1995, illustrates the degree to which corporations have become participants in the construction and promotion of "identity politics" and multiculturalism. In Milwaukee, Philip Morris and its subsidiary Miller Brewing Company have established such symbiotic relationships referred to above, in part through sponsorships of the MAM since 1976.[44] The institutional relations between the sponsors (Philip Morris and the NEA) and the museum are evident in the MAM's press release on the *Latin American Women Artists* exhibition. The press release also signals the integration of Philip Morris into the cultural context of the exhibition. The participation and contributions of Philip Morris function to frame the MAM's own promotional text for the exhibition. The text of the press release alternates between the museum's descriptions of the significance of the project as "the first large-scale exhibition in the U.S. to emphasize the important contribution of Latin American women to 20th-century visual arts" and statements from the sponsor (George L. Knox, vice president of corporate public affairs) that link arts sponsorship with corporate business interests locally and globally (in Latin America):

> Philip Morris' long history of arts patronage and strong commitment to supporting the achievements of less-recognized artists makes this exhibition particularly important to our corporate arts support program and to our business relations within our communities both here and throughout the hemisphere.[45]

Philip Morris carefully maneuvers between its image as a multinational corporation and as an arts patron. Whereas the press release refers to "arts patronage" and "corporate arts support program," the *Corporate Contributions Guidelines,* the annual shareholder reports, and the comprehensive *Philip Morris and the Arts: 35 Year Report* use the terms "sponsorships" or "sponsored by," which more clearly refer to the exchange of capital and goods for image promotion. "Arts patronage" is obviously directed to the high arts and media audience, including local opinion leaders in education, culture, business, and politics.

Figure 3.7. Sponsoring diversity, art promotes "corporate citizenship" and community relations.

They speak the same language.
Yet each has something very different to say.

Mari Mater O'Neill (Puerto Rico), *Paisaje en Fuego #2 Autorretrato*, 1992. Collection Mr. and Mrs. Pedro Muñoz Marín, San Juan, Puerto Rico

Latin American Women Artists, 1915–1995

The range of expression you see here emerged from a world of influences. Some modern, some ancient. Some Spanish or Portuguese, others African or Asian. You're invited to the first large scale exhibition of 20th-century Latin American women's art ever presented in the U.S. These 35 artists from 11 countries find expression through a variety of media—from painting and sculpture, to fiber, works on paper, even multimedia installations. This celebration of shared heritage, this homage to ancestral richness, will give you an enlightening insight into the forces that have shaped artistic development in this century. Each artist has much to say. Come listen. For more information, call (414) 224-3240.

Milwaukee Art Museum March 3–May 28, 1995
Phoenix Art Museum July 7–October 1, 1995
The Denver Art Museum/Museo de las Americas October 28, 1995–January 14, 1996
The National Museum of Women in the Arts, Washington, DC February 8–April 29, 1996

PHILIP MORRIS COMPANIES INC.

Kraft Foods, Inc.
Kraft Foods International, Inc.
Miller Brewing Company
Philip Morris International Inc.
Philip Morris U.S.A.

Supporting the spirit of innovation.

© Philip Morris Management Corp. 1995

Frida Kahlo (Mexico), *Naturaleza muerta: pitahayas*, 1938, Madison Art Center, Wisconsin. Bequest of Rudolph and Louise Langer

Alicia Penalba (Argentina), *Faun des Mers*, 1959, Contemporary Collection of The Cleveland Museum of Art

Both the bilingual catalog and the press releases situate the significance of the exhibition with respect to other important exhibitions of Latin American art. Rather than breaking new ground, this project was designed to assemble works by more than 150 Latin American women artists in one retrospective exhibition; the artists included Frida Kahlo, Tarsila do Amaral, María Luisa Pacheco, Olga de Amaral, Ana Mercedes Hoyos, Ana Mendieta, María Magdalena Campos-Pons, Jac Leirner, and Leda Catunda. Many works (e.g., those of Frida Kahlo) had been exhibited individually throughout the United States and Europe but had never been organized thematically or chronologically in order to present their collective contributions. Curator Geraldine P. Biller emphasized that the exhibition was "even more impressive than the sum of its parts," underscoring the variety and diversity of interpretations, cultures, and artistic media.[46] Diversity is clearly one of the central themes of the exhibit and its promotion:

> In *Latin American Women Artists,* audiences will discover a rich variety and diversity of images that dispels any perception of stereotypical Latin American or women's art. Visitors will also recognize their shared heritage in this hemisphere, and may gain a clearer understanding of the historical, political, social and economic forces that have shaped artistic developments during this century.[47]

For Philip Morris (and Miller Brewing), the notion of diversity is pivotal in cementing its legitimacy and validation as an equal-opportunity, affirmative-action employer and participant in community affairs. The references to the corporation's "expansion of its work force and markets" (*Philip Morris and the Arts* 1993, 3) come fully to bear in this regard. The fact that Miller Brewing is a major employer in the Milwaukee area, with a significant Hispanic population, was clearly a factor in the sponsorship, which was to be a vehicle for reinforcing positive community relations.[48] Moreover, diversity training and multicultural programming have become institutionalized within most major corporations, not only as a form of documenting and implementing adherence to federal regulations but also as a means of improving internal labor relations within industries with minority populations (Gordon 1995, 18–19) and in order to access minority markets.[49]

The final page of the Philip Morris and MAM press release is almost entirely promotional in nature, devoted to enumerating Philip Morris's cultural-diversity sponsorships with MAM and its other national sponsorships, such as of *Black Art Ancestral Legacy: The African Impulse in African-American Art* (exhibition at MAM, 1990), *The Latin American Spirit: Art and Artists in the United States, 1920–1970* (exhibition at the Bronx Museum of Arts, 1988), Ballet Hispanico of New York, and Intar Hispanic American Theater and Repertorio Espanol.[50] The promotional package for the sponsorship of the *Latin American Women Artists* also included the usual advertising in major upscale magazines (e.g., *Gourmet*) repeating the diversity motif: "They speak the same language. Yet each has something very different to say." A series of cultural programs accompanying the exhibition included music and theater with a Latin

American emphasis. Philip Morris also produced a video *(Diverse Roots, Diverse Forms)* featuring "six artists whose work derives from their Latin American heritage."

With respect to Latin American art and issues of multiculturalism, Mari Carmen Ramírez has examined the changing role of museum curators in mediating culture and identity. While operating as arbiters and brokers (who have become "sanctioned intermediaries" within networks of museums, galleries, technical or professional experts, and sponsors), they simultaneously mediate the interests of artists (1996, 22). Ramírez argues that as curators have become increasingly bound to these institutional networks, they have reduced the scope of their curatorial roles. Although the historical notion of curators, as arbiters of taste, invested them with greater authority, it also tied them to more elitist notions of curatorial practice and representation. Contemporary curators no longer function as authorities of cultural "excellence" but, rather, as brokers of identities (Ramírez 1996, 22–23). Yet this transition is particularly problematic and inherently conflicted:

> This situation places the cultural broker at the very core of a contradiction: on one hand, she/he can be credited for helping to tear down art-world hierarchies, seemingly democratizing the space for cultural action; on the other hand, in a market scenario where "identity" can only be a reductive *construct,* the framing and packaging of images of the collective self can only result in a highly delusionary enterprise. The tensions of this contradiction confront art curators with a dilemma: where should they position themselves vis-à-vis the identities of the groups they claim to represent? (Ramírez 1996, 23–24)

Ramírez traces two important sets of interrelationships: (1) the evolution of Latin American art within the contexts of its original production, and its promotion and marketing in the United States through major exhibitions, and (2) conversely, the oppositional and peripheral role in the United States of Latino art, which was gradually integrated into the mainstream (30–33). These processes led to an eventual conflation of Latin American and Latino art in the U.S. art market, but only after Latin American art was first "mainstreamed" as a form of marginal art, "a term that could only be used formerly to describe Latino art's position with respect to the institutions that exercise power in US society" (33). Many U.S. museums attempted to avoid the more politically and socially volatile Latino art by purchasing Latin American works that would absolve them of their responsibility to address Latin culture:

> It was precisely the mainstream's omnivorous demands for symbols of Latin culture to placate the more radical demands of Latino groups that paved the way for the acceptance of Latin American art and identity in the United States. This fact suggests that the conflation of identities between Latin American and Latino artists registered by the . recent exhibition boom, instead of presenting an alternative to the transnational flow of identities, is an expression of the same demand for easily marketable and consumable cultural symbols. (26)

Corporate cultural politics appropriate Latin American art in order to legitimize multinational financial interests in terms of (1) market expansion within Latin America, (2) Latin American investment in the United States, and (3) the acceptance of local ethnic communities as markets. Ramírez argues that

> one of the unacknowledged forms in which this exchange has taken place has been through art exhibitions, which under the semblance of collective representation have functioned to mask the complex process of validation of Latin American countries in global financial centers represented by New York. Further complementing this flow of identities from Latin America into the United States has been the presence of a post-civil-rights Latino political and artistic movement acting within the broader parameters of multiculturalism. (25)

Ramírez points to efforts by Latin American financial interests to promote their own legitimacy within U.S. and European markets through the currency of cultural capital, arguing that there is a direct link between which artists are most desired by patrons of Christie's or Sotheby's and which the Latin American nations have been most successful in promoting their financial interests through the medium of cultural identity, "particularly Mexican, Colombian, Venezuelan and Cuban-American economic elites" (30).

Although the sociopolitical forces redefining ethnic identities have presented openings for museums to participate in the mediation of multiculturalism, these identities have also been appropriated locally, nationally, and transnationally as vehicles to legitimize financial interests. Ramírez concludes that the contradictory tensions between the forces seeking integration (i.e., transnational capital, corporate sponsors, and the art market) and the "democratic aperture exemplified by multiculturalism" (e.g., oppositional forms of art in the Latino communities) are being brokered through notions of identity—as articulated in major exhibitions of Latin American art during the past few decades (34).[51] Although Ramírez argues for a critical curatorial practice that would foster this democratic aperture of a multiculturalism incorporating multiplicity and diversity of artistic practice, rather than reducing identity to a trope, she concludes that current circumstances severely limit this potential as a result of commercialized art markets that are "increasingly driven by the marketing and consumption of false difference" (1996, 35). Timothy Luke also points to the signification of Hispanic identity as a brand name within art markets:

> The aesthetic reduction of Hispanic ethnicity to a narrow range of ritualized symbolic identity, grounded upon long-gone or even mythical signs of authenticity, in itself does tremendous violence to the real diversity, richness and mystery of the many different Hispanic traditions. Yet, since the expectations of agencies, art galleries, and rich patrons are primed with these dubious notions of "Hispanicness," the artists still are trapped into grouping their visions around this symbolic golden mean of taste or face further poverty, greater obscurity, and worse neglect. (1992, 188)

Sponsors have vested interests in framing and defining cultural contexts (such as museum exhibits and cultural festivals) and in shaping representations of identity (community, ethnicity, gender, nation) as vehicles for legitimizing their own participation. These interventions can function in terms of promoting a politics of pluralism and difference defined as organized lifestyle and consumption. They simultaneously function to defuse oppositional forces that present alternative or diverse models of identity and community that threaten the spaces occupied by corporations. Corporate participation in the production, mediation, and dissemination of culture has become so much a part of institutionalized networks in the United States, that it is no longer perceived as an "intervention." References to community or arts "partnerships" and "alliances" in education, cultural production, health, and labor reinforce and validate the legitimacy of such participation (Schreiber 1994, 239–47). Although many corporations actually fund programs that might be considered oppositional or critical of social agendas or interests, their impact is frequently defused or appropriated as avant-garde fashion (e.g., Philip Morris's sponsorship of Bill T. Jones). More importantly, corporate cultural programming frequently diverts attention from a more rigorous and critical examination of its own institutional interests in local and global public policies, a strategy that also attempts to neutralize the dissonances among culture, politics, and economics.

By demanding that sponsorships only be granted in locales where the corporation maintains operational interests (as Philip Morris does), corporations reveal the inextricable link between their economic and cultural interests, for example, between the factory or workplace and the museum. In this instance, cultural sponsorship can only occur where economic interests (corporate sites) exist from the outset. By diverting attention from the actual sites of corporate power and redirecting it to cultural production (the sites of "arts support") and social programs (for education, health care), corporate cultural politics attempt to erase the nexus of economic and cultural interests (manifest in contemporary culture) and to eliminate an interrogation of the "culture of the workplace"—for example, of how social and cultural environments inside and outside corporations are organized. In other words, the corporation has defined the legitimacy of its interests in community affairs through the power of capital. Yet it does little to interrogate its own participation in the production and mediation of culture. Nor does it recognize any attempt by communities or public interests (including the sporadic attempts of stockholders) to question corporate policies as legitimate.

Redefining culture in terms of a genuine multiculturalism necessitates a dialogue within and between cultures rather than a monologue that is primarily structured by the institutional interests of cultural production (Jordan and Weedon 1995, 484–87). Rather than attempting to fuse communities, social or cultural institutions, and workplaces into seamless communities of consumption, the exploration and interrogation of their conflict, difference, and diversity (which defines their boundaries) may potentially reveal the contours of and create the conditions for shared social spaces.

The need to experience difference as well as shared values is a significant force in

contemporary culture. Corporations have recognized the primacy of experience and have organized much of their communication with respect to events. Corporate consultant Alfred Schreiber writes, "We're looking for something that's rooted more in experience than image" (1994, 246). Chapters 4 and 5 will investigate the interplay of images (popular culture and photography) and experience (events) in corporate cultural politics and the construction of identities. They will also examine various modalities within the continuum of manipulation and resistance by exploring the positions of artists—in collaborations with sponsors (Annie Leibovitz and American Express) or in attempts to create noncommodified spaces for art (Christo and Jeanne-Claude's *Wrapped Reichstag*).

4. Sponsoring Lifestyle:
Travels with Annie Leibovitz

In the mid-1990s, *Life* magazine featured Annie Leibovitz as "probably the most successful photographer of her generation" and, as one writer suggested, "the Matthew Brady of the baby boomers" (Van Biema 1994, 49).[1] First at *Rolling Stone* and then later at *Vanity Fair,* Leibovitz became known as the visual chronicler of the rock-and-roll sixties to the Reagan-Kohl-Thatcher eighties. Her photographs of celebrity icons, such as John Lennon and Yoko Ono, the Rolling Stones, or Ella Fitzgerald, became staple commodities of popular culture. Writing for *Time,* Richard Lacayo plots the trajectory of Leibovitz's own career within the context of the transition from sixties counterculture to mass media commercial culture of the eighties. More significantly, Lacayo concludes that Leibovitz "has been a crucial figure in this transition"(1991, 74). The road from Woodstock to Woodstock '94 reflects Leibovitz's own professional biography, from a photojournalist for *Rolling Stone* to celebrity photographer for *Vanity Fair.* In addition to her work for mass-market print media, Leibovitz has also accepted extensive commissions for corporate clients, including The Gap and American Express. She also produces for the art-photography market through periodic shows in galleries and museums, as well as through book publications of her work. Indeed, Leibovitz's work in multiple venues and media, as well as her collaboration with corporate sponsors, is characteristic of many contemporary artist-entrepreneurs.

This chapter will examine how the images of "celebrity" (mediated by the aesthetic strategies employed in Leibovitz's photography) construct contemporary images of identity and place. Leibovitz's projects (unlike those of other postmodern photographers such as Barbara Kruger or Cindy Sherman) do not inherently problematize the uses of photography and representation; rather, they illustrate the problematic aspects of postmodern photography within media culture (Kellner 1995). In terms of our discussion of the cultural politics of corporate sponsorship, the use of photography both as a medium of visual communication and consumption and as contemporary art situates it precisely on the boundary of art and mass consumption—an attractive site for corporate image transfer. For Douglas Crimp, photography assumes a pivotal position in tracing the end of modernism and the turn to postmodern aesthetics:

The centrality of photography within the current range of practices makes it crucial to a theoretical distinction between modernism and postmodernism. Not only has photography so thoroughly saturated our visual environment as to make the invention of visual images seem archaic, but it is also clear that photography is too multiple, too useful to other discourses, ever to be wholly contained within traditional definitions of art. Photography will always exceed the institutions of art, will always participate in nonart practices, will always threaten the insularity of art's discourse. (1993, 134)

It is important to identify postmodern strategies and artistic practices that incorporate elements of what Linda Hutcheon refers to as a "postmodernism of complicity and critique" that simultaneously "inscribes and subverts the conventions and ideologies of the dominant cultural and social forces of the twentieth-century western world" (1991, 11) or to differentiate between a postmodernism of accommodation and a postmodernism of resistance (Crimp 1993, 14). Leibovitz's photography seems to be primarily situated within a postmodernism of accommodation, yet many works (including those for American Express) also present a potential for critique or resistance. An analysis of Leibovitz's photography—in terms of its representation of the conditions of postmodern culture and with respect to postmodern photography in general—illustrates the function of her work as a component of corporate cultural programming and advertising and then situates its impact within the broader contours of contemporary culture and society.

In order to understand how the construction of identity relates to the globalization of corporate cultural politics, the following discussion positions Leibovitz's work within the processes and institutional matrices of its production, mediation, and media reception through an investigation of (1) sponsoring, advertising, and lifestyle-travel marketing at American Express; (2) the conceptual development of the "Portraits" advertising campaign and the collaboration between Leibovitz and American Express; (3) the transformation and recontextualization of the "Portraits" from advertisement to art exhibition; and (4) the representation of lifestyle, social milieu, and identity found in examples of Leibovitz's photography.

Consuming Lifestyles: Acquiring Cultural Capital

In 1992, American Express sponsored an exhibition entitled *Annie Leibovitz: Photographs, 1970–1990,* organized by the International Center of Photography (Rochester, New York) and in cooperation with the National Portrait Gallery, Smithsonian Institution (Washington, D.C.).[2] The exhibition spanned Leibovitz's work from the black-and-white documentary style for *Rolling Stone* in the 1970s to color portraits for *Vanity Fair* in the 1980s and 1990s. *Photographs,* which subsequently launched an international tour in Munich, marked the culmination of an extensive collaboration between Leibovitz and American Express, a collaboration that had begun with one of American Express's most successful advertising campaigns, "Portraits." In many respects, the success of the "Portraits" advertising campaign, which reinforced Leibovitz's

oben: Willem Dafoe, 1987
erste Seite (außen): David Byrne, 1986 (oben)
Whoopi Goldberg, 1984 (unten)

PXP 6057

Ella Fitzgerald, 1988

Mikhail Baryshnikov, 1990

Beth Henley, 1987

Prominenz oder als überraschend poetische Huldigung einer Person des öffentlichen Lebens inszeniert wurde: die unmittelbare Wirkung auf das Publikum beruht auf dessen Image und Ansehen.

Im Laufe ihrer künstlerischen Entwicklung wandelte sich Annie Leibovitz von einer Prominenten-Fotografin zur prominenten Persönlichkeit selbst. Annie Leibovitz ist heute eine der erfolgreichsten und am meisten publizierten Künstlerinnen. Sie hat es verstanden, die Welt der Werbung zu nutzen, um einige der eindrücklichsten Portraits der amerikanischen Pop-Kultur zu schaffen. Es sind dies Arbeiten, die weit über den vergänglichen Nutzen für Magazine und Werbezwecke hinaus Bestand haben werden.

Deichtorhallen Hamburg
14. August · 20. September 1992
Freier Eintritt für American Express Mitglieder

Figure 4.1. Promotional brochure for the *Photographs* exhibition.

style of celebrity portraiture as an identifiable commodity within mass-market maga-
zines, paved the way and "preprogrammed" the success of the subsequent *Photographs*
exhibition in international museums. For American Express, the sponsorship of
Leibovitz's "art photography" in the form of an exhibition was a logical extension of
that same "promotional photography," which could now be recontextualized and me-
diated via the museum.

In order to understand the significance of the *Photographs* exhibition in relation to
the "Portraits" advertising campaign, it is necessary to recognize the role of cultural
sponsorships at American Express. Rather than functioning as isolated instances of
corporate patronage or philanthropy, sponsorships are an integral part of the corpo-
ration's marketing and communications strategy. The selection of forms of cultural
production that are suitable for potential sponsorships, as well as their conceptual
development, is orchestrated with marketing and image goals. Susanne Wegerhoff
(vice-president public affairs and communications at American Express International)
explained that

> the psychographic communication goals, such as increased recognition of the corpora-
> tion, of the trademark, as well as an improved image, are the primary point of depar-
> ture for the formulation of objectives. In terms of objectives related to image, we are
> primarily concerned with the improvement of the distinctive dimensions of image
> (e.g., [those which are] dynamic, endowed with value, [or related to] exclusivity,
> achievement). The atmosphere of the very real context in which cultural sponsorship
> occurs (concerts, art exhibitions, theater, etc.) effects a direct transfer of the image from
> the sponsored project to the sponsor. (1992b, 52)

The psychophysical semantics of an event-oriented society, theorized by sociologist
Gerhard Schulze, are reflected in the sponsoring practice described by Wegerhoff, that
is, merging the psychological recognition and anticipation of an imaged commodity
(e.g., an event) with the actual physical experience of that event (as a "consumable"
product) (Schulze 1992, 252; Weinberg 1992, 38). Events are the common denomina-
tor of sponsorships, utilized to access audiences and facilitate the image transfer from
event to sponsor (Bruhn 1991, 33). Wegerhoff emphasizes sponsoring's potential to
leap-frog the communications barriers of an information society and thereby reach
audiences ("target markets") directly within their own private sphere of experience,
such as at concerts, art exhibitions, or in the theater (1992b, 52).

American Express employs culture as an advertising medium for regional and
international products and services, in particular for lifestyle marketing to target mar-
kets utilizing travel and culture as consumer services. Who are these target markets,
and what forms of culture does American Express select in order to address them?
Wegerhoff explains that

> corresponding to our global marketing orientation, the emphases [of our projects] are
> those which cross boundaries. Their form and content are in harmony with the lifestyle

of our main target markets—cosmopolitan, culturally engaged, frequent travelers; consumers who also have good earnings and buying power. . . . Thus the product image of American Express and the character of the sponsored event also converge under the sign of mobility which facilitates our core products in the most important area of business—Travel Related Services (TRS). (1992b, 55)

The extensive collaboration with Annie Leibovitz provided the opportunity for American Express to coordinate three strategic areas of corporate communication: the product image, the interests of their customers and target markets, and subsequently the image of the sponsored project (i.e., Leibovitz's *Photographs* exhibition). At this point, we can anticipate and identify the projection of commodity images that are both embedded in the "Portraits" advertisements and inscribed in the context of the *Photographs* exhibition: lifestyle as distinction, exclusivity, individualism, or anticonventionalism; notions of travel and mobility; and both local and global culture as a consumer product.

Designing "Portraits"

In 1986, the international advertising firm of Ogilvy & Mather developed the "Portraits" concept for American Express in order to replace an existing celebrity series entitled "Do You Know Me?" (Meyer 1988, 11). Although numerous high-profile fashion photographers (including Richard Avedon, Irving Penn, Herb Ritts, Lord Snowden, and Bruce Weber) were considered for the project, art director Parry Merkley chose Annie Leibovitz because of her work with *Vanity Fair*, in particular "her use of color and her ability to show familiar faces in a new light" (quoted in Meyer 1988, 11). Within the advertising and communications industry, "Portraits" became one of the most successful advertising campaigns of the 1980s. Leibovitz received the American Society of Magazine Photographers' Innovation in Photography Award for 1987. For the German version of "Portraits," featuring both German and international celebrities, Leibovitz received the Art-Directors-Club Gold Medal and a silver medal for illustration and print advertising in 1991.

The "Portraits" were effective advertisements precisely because they operated on the boundary of advertising and art photography. In magazines, this was also the boundary between advertising and editorial content. Rather than explicitly representing the commodity or services, the photographs initially replaced the product image with a celebrity image (embedded within a very specific lifestyle context) and then transferred that image back to the product (Wernick 1991, 99). From lifestyle magazines to news magazines (*Vanity Fair* in the United States or *Der Spiegel* in Germany), "Portraits" functioned in editorial *and* advertising modes. The photographs imaged celebrity lifestyles while providing an advertising vehicle. As mass-circulation magazines increasingly assumed the aesthetic strategies of advertisers, Leibovitz found a forum for the development of her work within the portrait style that had now been abandoned by *Rolling Stone* magazine. In an article on her work for American Express, Stephen Meyer explains that

during her [Leibovitz's] last years at *Rolling Stone* . . . editor Jann Wenner began insist-
ing on close-cropped cover photos with direct eye contact. Studies had repeatedly
shown this style sells more magazines. "The person on the cover had to be recognized,"
Leibovitz adds, "That was a problem for me. I wanted more conceptual shots, 'inside
shots.' Part of my signature was that you could take a more complex shot and make it a
cover—that's what they used to do at *Rolling Stone*. But you can't do it anymore. For
any magazine." (Meyer 1988, 19)

The work with American Express allowed Leibovitz "to do precisely what magazines
won't let her do on their front pages" (Meyer 1988, 19). In an inversion, or conver-
gence of style and function, magazines became the promotional context for the edito-
rial style of the advertisement (Wernick 1991, 119). Many mass-market consumer mag-
azines had become promotional media designed to frame advertising. When asked
about differences between editorial photography and advertising projects, Leibovitz
responded, "I don't see any difference. There's nothing I've done for American Express
that I wouldn't do for *Vanity Fair*" (quoted in Meyer 1988, 19). Nonetheless, Leibovitz
now rejects advertising projects that include direct product placement in the photo-
graph (Kanner 1988, 28), preferring to develop the "conceptual shots" that have be-
come her signature style for celebrity photography. This approach was well suited to
corporate marketing objectives, which increasingly reject explicit product advertising
in favor of a range of images related to the consumption of the product within culture
(Wernick 1991, 93, 117).

"Portraits" was conceived to offer the "inside story" on famous personalities. Each
photo was designed to reveal an aspect of a celebrity's lifestyle that was not generally
known but that played a significant role in his or her personality (*Econ* 1992, 17).
Ogilvy & Mather rejected photographs of celebrities in their "normal" professional
surroundings. For example, Luciano Pavarotti standing with a pitchfork in front of a
barn on a farm outside Milan was chosen over a shot of Pavarotti in an opera house
(Meyer 1988, 18). Like Leibovitz's photographs in *Vanity Fair,* each "Portrait" for
American Express became a "photo story," a narrative, revealing the unknown, uncon-
ventional, or unexpected details of the celebrity's life, with the background providing
context and completing the narrative. By simultaneously revealing and constructing
the private sphere of the celebrity, the photos functioned like coded tabloid stories,
with the celebrities as willing participants.[3] The Ogilvy & Mather agency was able to
blur the conceptual boundaries between "editorial" and "advertising" functions and
styles by developing "editorial" shots profiling the celebrity rather than the product.
Moreover, the "Portraits" emulated the serial character of mass-market magazines by
introducing new celebrity photos on a regular basis (Wernick 1991, 107–11, 119).

In place of a lengthy promotional text praising the American Express Card or
celebrity endorsements, Ogilvy & Mather foregrounded the image of the celebrity.
This actually focused greater attention on the text: "Membership has its privileges."
This brief statement created a conceptual link and image transfer (Bruhn 1991) be-

tween the celebrity image projected in the photograph and the corporate image medi-
ated through the iconography of the green or gold American Express Card. The sim-
plicity of the advertisement's design focused the viewer's attention on the photograph
while reinforcing the commodity sign of the corporate image (i.e., the credit cards).

The visual layout of the advertisements reveals that culture and capital are in-
scribed within the narrative of the celebrity photograph, which is positioned in the
center of the page, and within the celebrity's American Express credit card (as a text),
which is located in the lower right (e.g., "Wim Wenders. American Express Member
since 1988"). First, the photo activates preexisting images of the celebrity and then
constructs another new dimension of that image. Second, the text-as-caption "names"
the celebrity and explicitly links him or her to the corporation by reproducing a fac-
simile credit card embossed with the celebrity's name. The text over the credit card is
a direct appeal to the *consumer:* "Pay with your good name" *("Bezahlen Sie mit Ihrem
guten Namen"),* while the *celebrity's* name and the credit card itself are fused as com-
modities. Potential cardholders are not only acquiring the power of the card, but they
are also joining the ranks of the celebrity members and by association buying a part of
the image and the commodities-defining lifestyle.

The text on the German card, "Pay with your good name,"[4] raises the credit card
icon to a second-order sign by substituting the card with the name on it. The adver-
tisement almost leads the viewer to believe that the card itself (in its material form) is
superfluous. (This is actually the case in telephone transactions, which only require a
name and an account number, and it may be the future of transactions based on a finger-
print or retinal scan.) The cardholder's name replaces the card and embodies the power
to demand possession, a "privilege" (based on American Express's slogan "Membership
has its privileges") granted only to the few. Of course, the name signifies a promotion-
al appeal to the potential cardholder. By directly addressing the consumer, the person-
ality of the cardholder (signified by "your . . . name") assumes a pivotal position with-
in the structure of the advertisement whereby the symbolic and economic potential
of the credit card "product" is temporarily subordinated to the personality of the
cardholder.

The projection of the *consumer's* personality directly into the text of the adver-
tisement (i.e., by placing the statement "Pay with your good name" over the card)
counterbalances the dominance of the celebrity's persona, which assumes center-stage
prominence. "Pay with your good name" is an appeal, suggestion, command, or rec-
ommendation from the celebrity to existing and potential members. Moreover, it in-
vests the cardholder with the status of name recognition. Indeed, the possession of
the card itself validates the cardholder's credit status within the constantly expanding
spaces of consumption (in stores, restaurants, entertainment venues, etc.). Shifting
the focus from the celebrity photograph to the consumer's perspective also operates
as a sort of preemptive strike within the overall logic of the advertisement by allaying
fears that the celebrity's personality occupies a superior socioeconomic position.[5]

As a sign of capital accumulation, the card becomes the great leveler of cultural

hierarchies (Schulze 1992, 167). By transforming prestige (which the celebrity possesses) into economic status (possessed in varying degrees by both celebrity and cardholder) and then transforming it back again, the card allows the cardholder to join the ranks of the privileged (by virtue of the economic status that it represents). The possession of the card effects its own image transfer as it links the sociocultural status of "respect" and "privilege" with economic power. Cultural status and economic status merge and become synonymous. Within the logic of the advertisement, the card represents the potential for the accumulation and expenditure of economic and cultural capital that can be traded back and forth in a sort of symbolic bank account (Bourdieu and Haacke 1995, 18). In this respect, the linkage of the "Portraits" advertising campaign with the sponsorship of Leibovitz's *Photographs* exhibition defines cultural sponsorships as the accumulation, transfer, and circulation of economic and cultural capital.

Yet the accumulated cultural capital of celebrity status can only be "traded" for the economic capital of consumption (and vice versa) through the symbolic currency of media culture (Kellner 1995). Those who have limited or modest celebrity status within media culture (e.g., little-known artists) are perceived as possessing only nominal amounts of cultural capital (defined in terms of the market value of their work). Obviously, artists' failure to successfully market or promote their own image within media culture frequently leads to the failure of the work itself in the marketplace.

For the American Express cardholder, the economic capital expended to purchase the privilege of participation in a cultural event is exchanged for the relative status of the event itself and the prestige of attending it. The greater the expenditure, the higher the level of possible participation. Thus, American Express regularly offers cardholders access to premieres of operas or to concert series through reserved blocks of tickets. For example, the premiere of José Carreras in *Carmen* in Dortmund was reserved solely for American Express members, who could also purchase a "VIP Package" entitling them to an exclusive entrance to both the performance and a champagne buffet. Such VIP events offer the potential to trade the cultural capital of the event back into economic capital by networking with business and social contacts. Thus, these events frequently function as stages for promotional representation rather than as venues for the actual performance.

Photographs: Membership Has Its Privileges

In 1992, American Express sponsored the European premiere of the exhibition *Annie Leibovitz: Photographs, 1970–1990* at the Munich City Museum (Münchner Stadtmuseum) (MSM). The exhibition reinforced Leibovitz's image as "a star who photographs stars"[6] and illustrates the coordination of cultural programming with advertising, lifestyle or event marketing, and the promotional interests of museums.

As is customary for most authors and artists with a high media profile, Leibovitz was extensively engaged in promotional activities prior to and during the opening in Munich. The opening itself was a media spectacle, extensively documented for American Express by the communications firm ABC/EUROCOM, in order to track

the media's reception of the sponsorship.[7] Extensive reports and lead stories appeared in more than one hundred publications, including Germany's major print media (*Frankfurter Allgemeine Zeitung, Süddeutsche Zeitung, Abendzeitung, Die Welt, Das Bild, Bunte, Vogue, Cosmopolitan*), and on both public and private television and radio (ARD, ZDF, Bayern 3, RTL plus, SAT 1, 3 SAT, WDR). ABC/EUROCOM referred to the media coverage as a "nationwide media blitz" which supposedly reached 30 million viewers (ABC/EUROCOM 1992, 1).

A primary focus of the initial reports in the German press was the spectacle of the opening, rather than the exhibition itself; the actual photographs in their museal function as representations of culture or art were subordinated to the projection of their collective promotional image in the media. This promotion was facilitated through two institutions of cultural production and mediation: the museum and the corporate sponsor. In the case of the *Photographs* opening, both American Express and the MSM were engaged in their own forms of self-promotion through the vehicle of the exhibition. They were joined in this project by Annie Leibovitz (an artist-celebrity in her own right) and the other German celebrities (e.g., Bernd Eichinger, Marianne Sägebrecht, and Wim Wenders) who attended the opening. The synergy of local cultural politics (i.e., Munich as a site for local and global culture represented by "personalities" and "dignitaries" from the arts, politics, and business) and corporate cultural programming was facilitated by an "exclusive reception for Platinum Card Members" hosted by Wolfgang Till (director of the MSM) and Jürgen Aumüller (president of American Express TRS).[8]

Writing in the *Süddeutsche Zeitung*, Claus Heinrich Meyer speculated that the reception was not really for Annie Leibovitz but was, rather, for an "intergalactic conference of the rich and beautiful" in Germany's jet set. He concluded that they could be divided into two groups: the celebrity-artists who had already been photographed by Leibovitz (e.g., Marianne Sägebrecht and Wim Wenders) and those "personalities" who wanted to join the exclusive circle of "members" but who had not been included in the promotion (e.g., Duchess Gloria von Thurn und Taxis).[9] Although the satirical, and occasionally critical, tone in the media coverage indicated that the event was not to be taken too seriously, many reports replicated the entertainment function of celebrity lifestyles represented by the stylized self-irony of both the "Portraits" and *Photographs*.[10] Ultimately, most of the press reports performed promotional functions by defining the exhibition primarily in terms of celebrity lifestyle. Because many reports framed the discussion of Leibovitz's *Photographs* in the museum exhibition within the context of the preceding "Portraits" advertising campaign, distinctions between promotional photography and art photography were effectively eliminated. By focusing on Leibovitz's dual role as artist and businesswoman, the media also reinforced the merger of the artist and entrepreneur as well as the fusion of advertising and art.

The event ("opening of an art exhibition") became a promotional sign for Leibovitz, other artist-celebrities, the museum, and the sponsor. Indeed, all of the participants (including the media itself) could profit from its direct and indirect promotional

value, which included (1) higher media ratings resulting from the celebrity coverage, (2) more visitors to the MSM and positive image promotion, (3) increased sales of the *Photographs* catalog and note cards in the MSM and local bookstores, (4) publicity for Leibovitz and for the other celebrities at the opening, (5) cross-promotion and reinforcement of the American Express "Portraits" advertising campaign, and (6) positive publicity for American Express's cultural programming within editorial and arts sections of the media. Cumulatively, these sites and discourses of promotion and consumption perform a self-legitimizing function.

Apart from the institutional perspective of the culture industry, the VIP reception illustrates how the representation of self (i.e., of individual or collective "celebrity") and Other are also fused within processes of cultural production and reception. Acts of photographing (production), being photographed, and viewing photographs (reception) are closely linked, even conflated.[11] The celebrity audience at the opening is the object of the exhibition itself. Celebrities are assembled to view the representations of themselves—their "promotional Other." To the extent that they collectively compose a social milieu ("international celebrities"), the celebrities are present not simply to view their own pictures or those of their peers but also to promote themselves. By "performing" acts of viewing (in front of the international television and the press photographers), they function simultaneously as performers and audience. In many forms of cultural sponsorship, celebrity-artists occupy a preeminent position in the communication and transfer of images:

> Thus, within the wider economy of advertising the construction of show business celebrity, indeed celebrity of every kind, serves as a kind of capital goods subsector, supplying inputs both for the (self-) promotional activities of the culture industry itself, and for those of commodity production as a whole. (Wernick 1991, 109)

Sponsoring and *Kulturtourismus*: On the Road

Although the sponsorship of the *Photographs* exhibition appears to have functioned primarily on the level of image transfer and in the accumulation of cultural capital, there were also tangible economic benefits built into an integrated marketing and promotional program. By linking the exhibition and advertising to notions of lifestyle, travel, privilege, and distinction, audiences were engaged in the consumption of American Express services.

For American Express cardholders, one of the "privileges of membership" included free admission to the *Photographs* exhibitions throughout Europe and in the United States. Prior to the Munich premiere, German cardholders received a brochure with information on the exhibition and on Annie Leibovitz (as "star photographer"). In addition to a description of the exhibition, cardholders were provided with lists of Munich hotels, restaurants, and shops, all of which, of course, accepted the American Express Card.[12] Although the experience of "attending an exhibition" represents the conceptual focus of the promotional information, this occurs within the context of a lifestyle that includes a shopping trip, a meal in a fine restaurant, and perhaps a night

or two in a luxury hotel. These are all experiences that complement the experience (in the sense of Schulze's *Erlebnis*) of the "art exhibition." The packaging and marketing of consumption as an experience provides a form of orientation for the weekend visitor to the art exhibition. In this respect, Schulze has emphasized the function of advertising in providing orientation and suggestions for consumers confronted with the multitude of competing experiences in the marketplace (1992, 436, 442–43). Indeed, the museum increasingly structures the experience of the museum visit in terms of consumption, most visibly through restaurants, gift shops, or invitations to events. Meanwhile, corporations accelerate the privatization of museum administration and financing by renting museum spaces for exclusive corporate functions.

The sponsoring concept that linked the celebrity lifestyles projected in the "Portraits" advertisements to the *Photographs* exhibitions at international museums was designed to achieve a higher profile for the American Express travel and leisure-activity products and services. American Express defines international culture as a product consumed by cardholders who are internationally oriented and mobile, with well-defined, individualistic lifestyles (Wegerhoff 1992a, 6–7). Travel as consumption forms an essential part of the act of participating in culture, particularly in global culture.

This is confirmed by John Urry's analysis of postmodern tourism in his book *Consuming Places* (1995). Here, Urry expands on the thesis that "places are increasingly being restructured as centres for consumption" (particularly visual consumption) (1). The privatization of public spaces and their reconfiguration as sites of consumption also reflects a corporate politics of space (see my chapter 2). Moreover, the historical evolution of corporations such as the Thomas Cook travel company (or American Express) has played a major role in the *social organization* of tourism and in structuring how places are consumed aesthetically (Urry 1995, 142–43). First, corporations had to cultivate the confidence of monied social classes, which would allow them to move increasingly larger groups through time and space via transportation technologies. Once this was accomplished, the sites for consumption could be expanded exponentially. Thus, mobility is a concept central to the process of both modern and post-modern societies (Urry 1995, 143). Furthermore, the packaging and structuring of tourism in order to overcome resistance to geographic and national boundaries—the promotion of "aesthetic cosmopolitanism" versus normative or cognitive emancipation (Urry 1995, 145)—has facilitated the transition to postmodern tourism as consumption. The packaging of shopping, dining, staying at hotels, and participating in cultural activities reflects the de-differentiation of spheres of social interaction so that "tourism" is defined and legitimized in terms of leisure, culture, sports, education, or hobbies (Urry 1995, 150–51).

The politics of space are directly related to corporate globalization and the articulation of a global corporate cultural politics. Globalization, as an interplay of homogenizing and differentiating tendencies (Waters 1996), is manifest in corporate product promotion and advertising, which devises specialized local campaigns for global products. In the case of "Portraits," German celebrities provided local identification for a

global promotion. Global integration, on the one hand, and individual differentia-
tion, on the other, are mediated by representations of exclusivity and mobility in
many of the "Portraits" advertisements. In "Portraits," American Express combines
global marketing with a regional focus:

> The goal of this campaign is to support and expand the world-wide market position of
> American Express. . . . The selection of prominent figures is representative of this posi-
> tion. "Portraits" is running primarily national, but also international, themes in Asia,
> North and South America and in a few European countries. In each market the
> Portraits-Series consists of a balanced mix of prominent figures from the areas of athlet-
> ics, culture, politics, and business.[13]

The constellation of images involving travel or mobility and exclusivity are particular-
ly striking in a number of the "Portraits" advertisements developed for the German
market, including those of tennis star Michael Stich, director Wim Wenders, and ac-
tress Hanna Schygulla. Each of the advertisements was designed to address existing
and potential markets for American Express products by projecting milieu-specific
images and identities linked to global travel and consumption.

Michael Stich

Consonant with the campaign's objective of presenting celebrities outside of their pro-
fessional context, Leibovitz's photograph of Michael Stich takes him off the tennis
court and puts him in an oily repair shop. Stich, standing next to his vintage motor-
cycle in black leather pants and a black T-shirt with cut-off sleeves, is reminiscent of
James Dean or the young Marlon Brando. Stich's motorcycle clearly refers to its icon-
ic function in popular culture in Europe and the United States, and in doing so it em-
ploys notions of freedom (defined as mobility), power (facilitated by speed), and indi-
vidualism. In discussing the effectiveness of these images in the advertisement, an
industry annual writes, "The newly-crowned Wimbledon champion "escapes" from
the white world of tennis to the oil-covered motorcycle workshop, where he lets the
camera capture his dream of the big freedom on two wheels" (*Econ* 1992, 19). Just as
jeans evolved from a symbol of sixties counterculture to a sign of middle-class lifestyle
(Schulze 1992, 313), the motorcycle has become less a symbol of the "Hell's Angels"
subculture and more a sign of youthful vitality, individualism, and personal freedom
now appropriated by wealthy enthusiasts and collectors.

The photograph of Michael Stich projects these cultural referents on several levels.
Obviously it addresses audiences who identify Stich as a young, successful tennis star,
but it also links the images of youthfulness, vitality, and strength (associated with
sports) with the power, speed, and freedom provided by the motorcycle. Success is the
glue that bonds these two dimensions (sports and mobility) in the advertisement. The
physical prowess of the "athlete as sport star" is a commodity that can be transformed

Figure 4.2. Michael Stich and American Express: sports, motorcycles, and upward mobility.

Michael Stich. American Express Mitglied seit 1991.

into economic capital and celebrity status. The motorcycle embodies the corporate image of the entrepreneur as a rugged individualist (loner) who dares to stray from the paved road in order to explore new vistas and who in doing so achieves financial rewards and privilege. (Terms such as "venture capital" are clearly related to this concept of risk taking.)

Mobility also represents economic mobility. The athlete's physical strength, mental focus, and financial success converge. The hidden dream of young, male entrepreneurs—to become successful sports figures who can jump on the motorcycle and just "get away from it all"—is a potent image that is by no means limited to the cultural context of Germany. In the United States, the freewheeling entrepreneur-publisher Malcolm Forbes was known for his passion for Harley-Davidson motorcycles, which he frequently rode with his friend Elizabeth Taylor.[14] In Germany, Harleys have also become the toys of successful entrepreneurs and managers, who embrace them as a symbol of individuality and privilege. As a signifier of popular culture, the motorcycle has also become a postmodern symbol for mediating contemporary experience and identity. This was illustrated by the Guggenheim Museum's description of the motorcycle's cultural role in its exhibition *The Art of the Motorcycle,* sponsored by BMW: "More than speed, it embodies the abstract themes of rebellion, progress, freedom, sex, and danger."[15]

The Michael Stich "Portrait" provides an ideal medium for American Express to address both a younger audience of potential customers (in their twenties and thirties) and new or existing cardholders who may be somewhat older (in their forties) but who strongly identify with the projections of youthfulness, mobility, and exclusivity offered by American Express. I would suggest that the audience for the Stich "Portrait" corresponds to a social milieu that Schulze characterizes by its desire for self-fulfillment *(Selbstverwirklichungsmilieu).* This milieu constructs its identity on the borders of diverse forms of cultural expression: "between Mozart and rock music, art exhibitions and movies, contemplation and action, anti-barbaric and anti-conventional distinction" (Schulze 1992, 312, 318). For Schulze, this well-educated milieu's mobility emanates from the centrality of the student lifestyle (travel, cafés, bars, bistros, concerts, sports) as a dominant factor constructing identity in later professional life. Even among professions characterized by conformity (e.g., managers and engineers), the creation of a distinctive professional identity based on self-fulfillment has become more apparent: "The desire for originality leads to a receptivity to new signs, be they in fashion, sports, styles of music, manners of speech, or points of view" (Schulze 1992, 312–13). The internal segmentation of this milieu accounts for what may seem to be surface contradictions of seemingly disparate groups, that is, yuppies; those who want to get ahead in the world and those who have dropped out of professions; consumer addicts and those who shun consumerism (Schulze 1992, 312). What characterizes all of these submilieus is their common orientation toward self-fulfillment, toward pursuing an objective "Because I want it this way" (312). For this milieu, "The highest authority is the subject itself" (319). Authority figures and rigid hierarchies are

viewed with skepticism. Thus, American Express developed its new Blue Credit Card in order to reach

> a new wave of young consumers who are not prepared to sacrifice personal life for work—"work to live," not "live to work" is their motto. American Express indicates that this shift in consumer attitudes is changing the behavior and spending habits of 23 to 35 year-olds. Fifteen years ago these attitudes were held by only one-quarter of the population, but the research indicates that this will grow to 50 percent within the next 20 years.[16]

The Stich advertisement seems to address a significant segment of the members of this milieu, who are younger (under forty), perceive themselves as belonging to the upper-middle class or upper class, and are "upwardly mobile" (Schulze 1992, 320). Perhaps they fit the stereotype of the "yuppie"; however, they do not wish to be perceived as such and attempt to assert their individuality professionally as well as personally.

Mobility and individuality formed the basis of student existence, which young professionals now utilize as a form of orientation in order to structure identities. Certainly the "Portraits" advertisements project the image of celebrities who are active, successful nonconformists, both professionally and personally. Moreover, they respond to a sociopsychological orientation that Schulze identifies as paradigmatic for many younger Germans—that of the artist:

> Within the myth of the artist . . . the traditional components of mastery and privileged participation in the sublime have largely disappeared. . . . Both ordering principles had to become obsolete to the degree that the artist became the ultimate projection of the idea of self-fulfillment. The artist is the primary performer of his/her own subjectivity. . . . This milieu imagines the artist as someone who "works damned hard on himself or herself," frequently in solitude, but always unwaveringly dedicated to oneself. Certainly, the breakthrough to this self-fulfillment represents *the* paradigmatic experience of this milieu. (1992, 317)

The lifestyle of the artist is indeed a powerful myth used in cultural promotion. In the 1990s, 20 percent of young Germans between the ages of sixteen and twenty-four selected the artist as an ideal form of existence and ranked it as the most desirable profession; professional athlete was ranked second.[17] Images of the artist have also been adapted to contemporary corporate culture, where artists are reconfigured as artist-entrepreneurs and linked to the creativity of new product innovation (see chapter 2).

Wim Wenders

Mobility (as a product) becomes a lifestyle and mode of experience that allows the individual to actualize self-fulfillment. Whereas the photograph of Michael Stich constructs self-fulfillment in terms of the physical power (of sports) and technological power (of mobility), Leibovitz's "Portrait" of director Wim Wenders also employs mobility (as a life-defining experience), in this instance to represent the contemporary

Wim Wenders. American Express Mitglied seit 1988.

Bezahlen Sie mit
Ihrem guten Namen.

Tel. 01 30-3750

artist. For it is the film director who epitomizes the allure of the artist in postmodern culture, promising to combine the popular with the avant-garde.

In the first of two advertisements, Wenders is relaxing in the driver's seat of his vintage Citroen. American Express explains that Wenders, "who has a weakness for classic cars, drove a so-called 'gangster car' even as a student at the Munich Film School."[18] Again the student experience forms the basis for lifestyle orientation defined by mobility, and the automobile facilitates self-fulfilment as the site and source of creativity: "This famous Citroen also provided the framework for the first concept photo that Annie Leibovitz photographed of Wim Wenders. The automobile as the site of relaxation and inspiration: many of his ideas for films and screen plays originated on the road in the automobile."[19]

Travel as a signifier of artistic creativity is projected in a second photograph of Wenders shot in Berlin, where he stands in the no-man's-land of the former "Death Strip" with a remnant of the Berlin Wall to his right and the Reichstag in the background. American Express points out that this is a site similar to those chosen by Wenders for the 1987 movie *Wings of Desire (Der Himmel über Berlin)*.[20] Initially, the sociohistorical context of Berlin, as the actual site of the photograph, is subordinated to the promotional image of the director and his film. American Express utilizes the international recognition of the film and the director as a filter for experiencing the city. We may not have experienced Berlin firsthand, but we have seen *Wings of Desire*. We can travel to Berlin to stand, like Wenders, and envision the film that we have seen. The advertisement links associations of the city of Berlin as a travel destination with the experience of cinema as a commodity. Wenders's persona as a successful director provides a thematic point of departure for associations revolving around Berlin as a destination, which can of course be experienced by using the American Express Card.

Beyond representations of "cultural tourism," however, the Wenders advertisement also functions in the realm of corporate and public cultural politics. Berlin, the Reichstag, and the graffiti-covered Wall are not incidental props. They provide the context for the presentation of a German national identity (in the new capital), an identity that is linked with the introspective creativity of one of the nation's most prominent filmmakers who, framed by the symbols of German history past and present, gazes up into a rather stormy sky. Whether the clouds on the horizon link "the heaven over Berlin" with the turbulence of postunification Germany or simply with the "stormy temperament and introspection of the artist" is not significant within the discursive structure of the advertisement, which tells us that introspection and self-confidence are not mutually exclusive—in defining either the artist's persona or national identity. The successful artist, posed between the Reichstag and the Wall, provides a marketable image for the promotion of a new national orientation. Standing at the intersection of culture, national identity, and commerce, Wenders becomes a promotional icon for postunification Germany—introspective, creative, contemporary, and self-confident.

Figure 4.3. Wim Wenders and American Express: artists, lifestyles, and consumption.

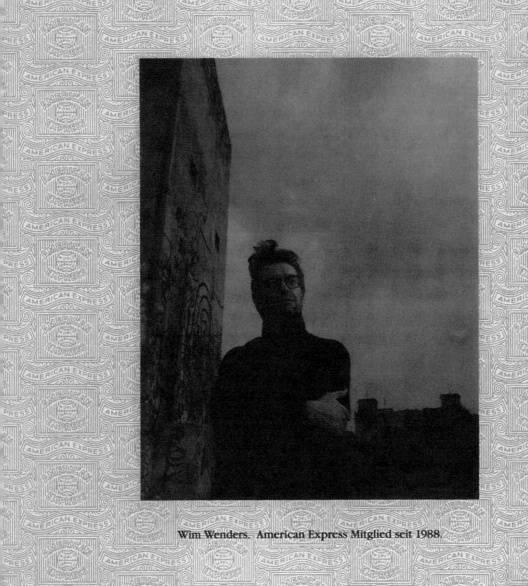

Wim Wenders. American Express Mitglied seit 1988.

Bezahlen Sie mit
Ihrem guten Namen.

Tel.: 01 30-3750

By centering the artist between the Wall and the Reichstag, rather than examining the triangulation of the forces embedded in these three images (i.e., the relations between contemporary cultural production and representations of German history and identity), cultural politics takes a depoliticized turn. Whereas artists such as Christo and Jeanne-Claude or Hans Haacke interrogated notions of German history and identity during the 1990s by problematizing the *sites* and *contexts* of their representation, the American Express advertisement foregrounds the mythical persona of the artist as the new Germany. In this scenario, both the Reichstag and the Wall are aestheticized through the work of the artist and can be comfortably relegated to the visual background (provided by the Reichstag) as "past" (history). Even more than the artist's work, it was the image of the artistic persona itself as a convenient packaging for self-fulfilment that provided the foundation for a depoliticized cultural politics of consumerism. Understood both as corporate cultural politics and the cultural politics of postunification Germany, this image was also consonant with the "Bonn Republic's" politics of "no experiments" that attempted to defuse rather than engage cultural conflict. In the context of the Wenders "Portrait," shot in 1992, Germany is reconfigured within the artistic modalities of dynamism, creativity, individuality—all of which conformed with images of creative entrepreneurship and the Kohl government's articulation of a cultural politics defined as "Corporate Germany."

Yet viewers who are familiar with Wenders's work and look past the surface-level projections of persona (as well as the Wall and the Reichstag as props) are confronted with a paradox replicated in the director's own work. Although the notions of travel and mobility explored in many of Wenders's road movies, such as *The American Friend, Kings of the Road,* and *Paris Texas,* or within the broader contexts of *Wings of Desire* or *Until the End of the World* reject the certainty and security of final destinations (such as those offered by cultural tourism), they invoke contemporary myths about the search for destinations, even if such destinations are sometimes empty or illusory. Robert Kolker and Peter Beicken conclude that the search for the metaphorical road is confronted with the longing for love and stability:

> Wenders attempts to account for Germany's appalling past by exploring the cultural and personal lacunae in its present, by using restlessness and motion as a metaphor for the inability to stay still and remember. . . .
>
> Wenders gives up the angelic freedom of the wanderer for the flesh and blood of the lover and expresses a sudden fear of the complex, articulate image of the road. In doing so, he comes home to the banality of the unsurprising and undesiring. Love as *Heimat* [Home] is created by a desire that is superior to the forces that forever oppress the ordinary. (1993, 165, 166)

To the extent that viewers bring their own experiences with Wenders's films to their viewing of the advertisement, such conflicts also become apparent within the visual

Figure 4.4. Wim Wenders at the Berlin Wall with the Reichstag in the background: cultural capital and the new "capital of culture."

discourse of the photograph. Ultimately, this narrative does not point to mobility as the actualization of self-fulfilment (through travel as an accumulation of cultural capital); rather, it evokes a realization that travel in a postmodern, global culture has itself become meaningless. In this sense, Leibovitz's photograph integrates this aspect of Wenders's work in the 1990s by juxtapositioning the uncertainty of the road with the security of *Heimat* (the depoliticized political culture of Kohl's postunification Germany). And it is precisely that uncertainty that the corporation promises to overcome.

Hanna Schygulla/Maria Braun: The American Express Card—Don't Leave Heimat without It

The images of travel and mobility, freedom, individualism, and creativity projected in the photographs of Stich and Wenders are also embedded in one of Leibovitz's most successful photographs for American Express in Germany: Hanna Schygulla as Maria Braun.[21] Schygulla's "reprise" of her role in Rainer Werner Fassbinder's *The Marriage of Maria Braun (Die Ehe der Maria Braun)* (1979) for an American Express advertisement raises issues of ambiguity and identity in postmodern photography, issues that are also present to greater or lesser degrees in much of Leibovitz's portrait photography during the 1980s and 1990s.

As forms of postmodern self-parody, many of Liebovitz's photographs are doubly coded as statements of unconventional, individual, narcissistic, or artistic identities (e.g., actress Marianne Sägebrecht as Venus) and as promotional signs. The hip, postmodern film enthusiast (Kellner 1995, 254) might be amused by the thought of Wim Wenders wandering through Berlin like a character in his film *The Wings of Desire,* or by the notion of Hanna Schygulla posing as Maria Braun in an American Express advertisement. Nonetheless, the fact that director (Wenders) and actor (Schygulla) can simultaneously assume and reproduce the identities of artist and promoter (for American Express) is very much a part of the postmodern fragmentation of identity, of a sense of role-playing (Kellner 1995, 258–60).

Schygulla, posed as Maria Braun in the middle of railroad tracks dissolving into the horizon, seems to address existing or potential cardholders through the overt reference to Fassbinder's movie and, by implication, to its social critique. Yet the advertisement allows the viewer to "have it both ways" by participating in the role-playing represented in the photograph, that is, assuming positions projected by Schygulla (for American Express) and/or Maria Braun. Images of identity and lifestyle inscribed in the "Portraits" advertisements reinforce multiple modes of existence that can be actualized through consumption.

Indeed, identity and consumption are central themes in Fassbinder's *Maria Braun,* themes that are recirculated in the symbolic structure of the advertisement.[22] Maria Braun with an American Express Card is, of course, true to type, and we can certainly imagine her as a cardholder. However, in a key scene of the film, Maria explains to the company accountant, Senkenberg, how she can represent management positions during

Figure 4.5. Hanna Schygulla as Maria Braun: two American Express cardholders.

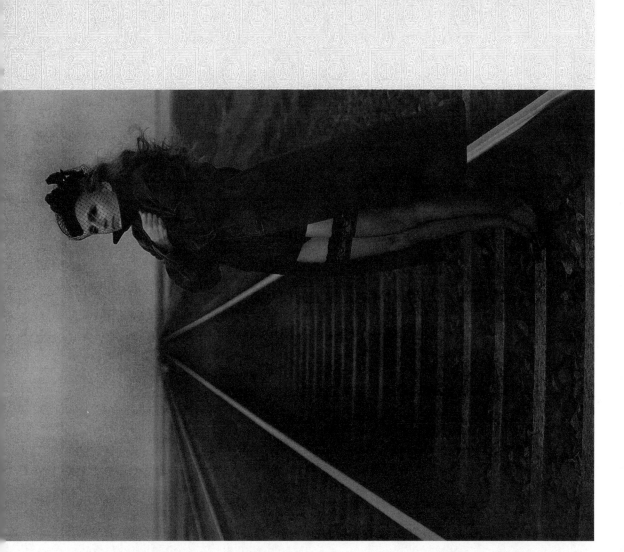

Hanna Schygulla. American Express Mitglied seit 1991.

labor negotiations but afterward laugh and joke with the chief labor negotiator, who happens to also be her brother-in-law: "Because I am a master of deceit. A capitalist tool by day, and by night an agent of the proletarian masses. The Mata Hari of the Economic Miracle!" (Rheuban 1986, 110). Maria Braun as the Mata Hari of Germany's Economic Miracle presents a much more complex and ambiguous image of the successful businesswoman than one might expect to encounter in an American Express advertisement.[23]

The Mata Hari metaphor links sexual, political, and economic subversion. The character Maria both attempts to structure identity by separating the various roles she chooses to play but also painfully recognizes that sex, politics, and economics cannot be divorced from one another. The factory owner, Oswald, is both Maria's employer and lover. Although he holds the economic power of capital that Maria desires, he ultimately develops a psychological dependence upon Maria. Early in their relationship, Oswald cannot comprehend why Maria wants to be treated as an employee during the day but can assume the identity of his lover after hours. She instructs him in the nature of this relationship: "Last night I was the Maria Braun who wanted to sleep with you. Today I'm the Maria Braun who would like to work for you" (Rheuban 1986, 106).

Maria Braun is clearly a metaphor and allegorical figure for the representation of Germany's Economic Miracle (Elsaesser 1989, 270). In Fassbinder's narrative, however, the pursuit of economic happiness, of realizing the myth of the "miracle," is also linked to the historical experience of fascism and ultimately to self-destruction (Elsaesser 1989, 267). The explosion of Maria's new home (the embodiment of the post–World War II middle-class dream) and her own demise in it represent the cumulative psychological damage in her own life and her failure to somehow manage the fragmentation of her identity. Maria's attempts to negotiate her multiple identities as "wife"—and her fantasy of an ideal marriage with her husband, Hermann, who accepts a jail sentence for Maria and then leaves for Canada upon his release (having been "bought" by Oswald)—businesswoman, mistress, and daughter seem to be doomed from the start, for they reflect and internalize the larger social and psychological fragmentation and repression of the past in post–World War II Germany.

If we return to Hanna Schygulla's portrayal of Maria Braun in the American Express advertisement, it seems unlikely that the disastrous consequences of the culture and politics of consumption that are so graphically represented in Fassbinder's film were intended in the conceptual development of the advertisement. Nonetheless, the film provides the thematic focus for the advertisement. Schygulla assumes the persona of Maria Braun, including the visual references to the film represented by Maria's clothing and the railroad tracks. Schygulla as Maria, in her black lingerie and leather coat, standing in the middle of the tracks, evokes a sense of artificial, staged eroticism and vulnerability—a quality of intentional artificiality and irony that Leibovitz consciously employs in many photographs to parody the celebrity image.[24]

The focus on the body as the primary site for the projection of the celebrity image is an intrinsic component of Leibovitz's portraiture. Images of romance and adventure

in the representation of Maria are fused with the notion of train travel as a signifier of mobility in the "Portrait" advertisements. However, the train is an obvious reference to the site of Maria's first encounter with the industrialist Oswald, which leads to her subsequent financial success. Distinctions between the image of Hanna Schygulla and that of Maria Braun are blurred and become one within the advertisement. Hanna Schygulla not only portrays Maria Braun, she *is* Maria Braun. In this sense, it is Maria Braun who stands in front of the camera for American Express. Schygulla's endorsement of the American Express card is simply another role. Both the professional actress (clearly recognizable to the German audience as Hanna Schygulla) and the fictional Maria Braun master the art of assuming identities.

The ambiguity of the multiply coded photograph, inscribed with contradictory messages, is characteristic of contemporary advertising practice. In his discussion of cigarette advertising, Kellner concludes,

> One of the features of contemporary culture is precisely the fragmentation, transitoriness, and multiplicity of images, which refuse to crystalize into a stable image culture. Thus, the advertising and cultural industries draw on modern and postmodern strategies, and on traditional, modern, and postmodern themes and iconography. (1995, 255)

In some respects, the associative structure of the Hanna Schygulla/Maria Braun "Portrait" may be similar to cigarette ads, which promise fulfillment and yet, taken to their logical conclusion, also imply self-destruction.[25] The rupture between family, home, and place in *Maria Braun* is graphically portrayed in the final scene of self-destruction resulting from the gas explosion that results from her attempt to light a cigarette.

Fassbinder linked the destruction of Maria's new house (which she attempted to make into her own "home"/*Heimat*) to Germany's postwar history by running portraits of the FRG's chancellors (with the exception of Willy Brandt) as a background to the credits. Simultaneously, the hysterical voice track of a sports reporter (on a radio broadcast) declares "Germany is World Champion! *[Weltmeister]*" against Hungary—affirming a new national self-confidence. Thus, the advertisement's fusion of Schygulla with Maria Braun actually undermines travel understood as the security of home and a stable identity.[26] Paradoxically, the advertisement can only be successful to the extent that the viewer recognizes Schygulla as Maria Braun, but this association also potentially evokes the finality of Maria's demise at the end of the film, which leaves a lasting impression in the mind of the viewer.

Postmodern Photography and Identity

As we have seen, the intersection of photography, advertising, and the museum constitute pivotal components of the institutional and discursive structure of the sponsorship of the "Portraits" promotion and the *Photographs* exhibition. At this point, I would like to return to the discussion of the mediation of photography, both as art and advertising, in order to situate Leibovitz's work more precisely within the context of postmodern photographic practices. In his book *On the Museum's Ruins* (1993),

Douglas Crimp delineated the central role of photography in "theorizing a shift from modernism to postmodernism" (15). Crimp argues that the evolution of the photographic medium represents a "watershed between modernism and postmodernism" that can be traced as a series of phenomena, including

> (1) the reclassification of photography as ipso facto an art form and its consequent "museumization," (2) the threat posed by photography's reclassification to the traditional modernist mediums and to the aesthetic theories that underwrite their primacy, and (3) the advent of new photographic practices that refuse the tenets of authorship and authenticity upon which photography is newly comprehended. (15)

In *Photographs, 1970–1990,* we see the evolution of Leibovitz's work from the photojournalism of the 1960s and early 1970s—which projected culture and politics through the documentation of the subculture of rock groups in *Rolling Stone* or through photographic essays (e.g., on Richard Nixon's resignation)—to the more self-parodic, staged style of superficial glamour projected in *Vanity Fair.*[27] Although Leibovitz's choice of subjects (media celebrities) did not change dramatically during the 1970s and 1980s, there was a perceptible shift in aesthetics. Her photography increasingly integrated approaches that are both modern and postmodern. As one of the most prominent photographers of the 1980s and 1990s, Leibovitz has contributed to postmodern photography's proliferation within upscale print media *(Vantity Fair, The New Yorker).* Although Leibovitz's work profited from the "museumization" of photography as art, it is unclear to what extent individual works engage a postmodernism of resistance rather than one of accommodation (Crimp 1993, 14), and I would now like to investigate these positions more fully.

Annie Leibovitz's photography, like the work of many other postmodern photographers, is informed by the development of multimedia artists, in particular Andy Warhol, who adapted Marcel Duchamp's concept of the ready-mades by utilizing the technological potential of reproduction inherent in the all-pervasive photographic medium. In this regard, Abigail Solomon-Godeau writes,

> Accordingly, when photography began to be incorporated in the art of the 1960s, its identity as a multiply reproducible mass medium was insistently emphasized, nowhere more so than in the work of Andy Warhol. Warhol's exclusive use of already extant mass imagery, his production of series and multiples, his replication of assembly-line procedures for the production of images . . . constituted a significant break with modernist values. (1991, 104)

In a sense, Warhol, along with Rauschenberg, Ruscha, and Johns, was adapting the ready-made to reexpress the commodification of the object through the postmodern "already-made" (Solomon-Godeau 1991, 104). Unlike Alfred Stieglitz, Edward Weston, or Walker Evans, who wanted to maintain the auratic quality of the photograph as a work of art, postmodern photographers such as Vince Leo, Connie Hatch, and Martha Rosler were interested in problematizing this tradition, particulary with re-

spect to institutional or representational critique (Solomon-Godeau 1991, 106). Linda Hutcheon underscores Barthes's analysis of photography and fiction (in *Roland Barthes by Roland Barthes,* 1977) in delineating a "split between the self-image and the imaged self" (Hutcheon 1991, 41).[28]

Three photographs of Warhol in the *Photographs* catalog (Leibovitz 1991/92, 50–51) reflect this process. The first photograph of Warhol (1976) holding his constant companion (the tape recorder),[29] under his arm and pointing a camera back at Leibovitz—the photographer being photographed by the subject—references this split between the "self-image and the imaged self." It also attempts to break the facade of photography as mirror while recognizing its power of "inscription and construction" (Hutcheon 1991, 41).[30] On the opposite page of the catalog, we see two black-and-white photographs, one above the other. In both, Warhol (holding his dachshund) is pictured only on an artist's canvas. The photographs show the American realist artist Jamie Wyeth (in Warhol's studio in New York) working on a painting of Warhol (Leibovitz 1991/92, 50, 230n; see also Leibovitz 1991). In the top photograph, Wyeth is painting the canvas, his back is toward the photographer, and Warhol's image is facing the viewer/photographer. In the lower photograph, Wyeth has a brush raised to the canvas and has turned to the viewer/photographer; however, his face is masked with a black handkerchief. The photographs of Wyeth painting Warhol conceptually telescope the three artists: Leibovitz (as the photographer, unseen but nonetheless present to the viewer of the photograph), Wyeth (as the masked but present portraitist), and Warhol (the object of the photographs and Wyeth's painting).

The triangulation of the three photographs deconstruct the artist and the auratic quality of the artwork. This is accomplished first by reproducing and "copying" the process of representation (in two photographs of Wyeth painting Warhol, placed one above the other). Second, Warhol critiques traditional portraiture (the representation of the subject), through the parody of posing with his pet, while undermining the portrait through his surreal "stare" that simultaneously breaks the realist mirror of portraiture. Wyeth negates the cult of the celebrity painter by turning his back to the camera (rather than assuming a promotional pose next to the canvas) in the top photograph and by masking his identity in the bottom photograph. The photographs interrogate the identity of the artists (Warhol, Wyeth, and Leibovitz) through self-irony (Wyeth wearing a mask), parody (Warhol "holding court" with his lapdog), and anonymity. Posing as the "masked artist" draws attention to the artist rather than to the subject on the canvas and simultaneously references the cult of the artist in a mass-media society where the celebrity image cannot, in any case, be concealed. The viewer's attention is directed to the presence of the "invisible" photographer (Leibovitz) and the act of photographing (as a process of cultural production and representation) through the photograph of Warhol pointing his camera at the unseen subject (the photographer Leibovitz).

Leibovitz's work in the *Photographs* catalog, particularly beginning in the mid-seventies, at once aestheticizes the personal, intimate, and private and yet parodies the

cult of the celebrity. The photographs engage the process of myth making and celebrity, with its attendant notions of power, wealth, fame, and stardom, while simultaneously demythologizing the celebrity persona, not only through the explicit self-irony on the part of the subjects as photographed objects but also as a result of the extensive and intentional staging or dramatizing of photo sessions.

Leibovitz has commented that these staged situations "frequently have more to do with what photography really is. Sometimes there is a lot of manipulation in photos that are supposed to look 'genuine'" (Sischy 1991/92, 10). The staged quality of much of this later work directs the viewer's attention to the medium of photography itself and to the celebrity persona, as a construct or artifice, and questions the legitimacy of the "subject as authority," as, for example, in the representation of conspicuous consumption in the photo of Ivana and Donald Trump in the Plaza Hotel, New York City (1988) (Leibovitz 1991/92, 175). The use of "deliberate banality" (Hutcheon 1991, 129), as in a photo of Roseanne Barr and Tom Arnold mud wrestling in Malibu, California (1990) (Leibovitz 1991/92, 204–5), appropriates the body as a prop and commodity of media culture while calling attention to mud wrestling as a signifier of the popular. Other photos, for example, of John Lennon with Yoko Ono (photographed several hours before his death in New York City) (Leibovitz 1991/92, 116), focus on the vulnerability of the body rather than its costuming or "packaging"—represented in its quintessential form in Leibovitz's photos of an opulent, bejeweled Liberace (Leibovitz 1991/92, 126–27). A photo in which Christo has "wrapped" himself parodies his own work while representing the body's commodification (Leibovitz 1991/92, 119). The body as a literal canvas, for the artist's work and its use as a site of self-promotion, is imaged in a photo of artist Keith Haring (Leibovitz 1991/92, 162–63).[31]

Theorists of postmodern photography (e.g., Benjamin Buchloh, Douglas Crimp, Rosalind Krauss) have emphasized "its dismantling of reified, idealist conceptions enshrined in modernist aesthetics—issues devolving on presence, subjectivity, and aura" (Solomon-Godeau 1991, 127). Although Leibovitz's work in *Photographs* seems to address many of the issues of postmodern photography (e.g., questioning representation in photographic practice, de-centering the subject, recognizing the "constructed" quality of photography, exploring the relationship between self image and imaged self, or between photographer and subject), we must inquire to what extent her photographs operate primarily within the confines of technique and style, without defining or engaging strategies of opposition.

By the early 1980s, some techniques of postmodern photographic practice (e.g., montage and reshooting pages from magazines or directly from television screens) had become part of a more standardized repertoire. Much of the postmodern photography displayed in galleries during this period represented a "newly constructed stylistic unity" that obscured its critical referents without specific, prior knowledge—particularly the second generation of postmodernist photographers (e.g., Frank Majore, Alan Belcher, Stephen Frailey), who appropriated media culture (especially advertising) in a more celebratory fashion, that is, without questioning its "institutional frame" (Solomon-

Godeau 1991, 135). The potential to critically engage institutional contexts of cultural production became crucial in defining strategies of a more critical or oppositional postmodernism:

> In the absence of a clearly defined oppositional sphere and the extreme rarity of collaborative practice, attempts to clarify the nature of critical practice must focus on the artwork's ability to question, to contest, or to denaturalize the very terms in which it's produced, received, and circulated. What is at stake is thus not an ethics or a moral position but the very possibility of a critical practice within the terms of art discourse. And, as a fundamental condition of possibility, critical practices must constantly address those economic and discursive forces that perpetually threaten to eradicate their critical difference. (Solomon-Godeau 1991, 134)

The potential to define positions and aesthetics of opposition with respect to the institutions of cultural production is obviously of central importance, not only with regard to the specific relationship between Annie Leibovitz and American Express but also in terms of a more generalized analysis of corporate sponsors and artists as entrepreneurs. We must indeed question the extent to which artistic projects or individual works, like Leibovitz's, that function in collaborative modes (e.g., advertising, sponsorships) hold the potential for even tentative forms of opposition.

Leibovitz's photograph of Hanna Schygulla illustrates that the potential reception of postmodern advertising is by no means unambiguous and cannot be easily reduced to a typology of manipulative strategies. Moreover, the context of reception and the audience are key factors that ultimately codetermine the potential for the formation and mediation of oppositional practice. Precisely because postmodern strategies are engaged simultaneously in "complicity and critique" (Hutcheon 1991), there is also the possibility for widely divergent forms of reception in terms of the complicitous or critical functions of cultural production. It is this feature that makes many works of postmodern culture attractive to sponsors, yet these works may also contain the potential to oppose the instrumentality the sponsor may attempt to impose upon them. It is the *context* of the work's reproduction (e.g., as advertisement, in a museum, as a public work of art, in an art catalog, as a greeting card) that suggests the relative potential for oppositional practice within a specific site and a particular point in time. Site-specific works (e.g., by Hans Haacke or Louise Lawler) maintain a degree of formal and aesthetic flexibility in order to address the objects and institutions of cultural production and simultaneously to involve audiences in a critical reflection of those processes.

Leibovitz's photographs for American Express, The Gap, or the National Fluid Milk Processor Promotion Board (i.e., celebrities photographed with milk mustaches) rely on a "signature style" characteristic of some postmodernist photographers (Solomon-Godeau 1991, 146).[32] This is also evident among photographers who have done extensive work in advertising (e.g., Richard Avedon or Herb Ritts). Apart from the early photojournalism for *Rolling Stone,* most of Leibovitz's work, for example, for *Vanity*

Fair, communicates little about its promotional function. Even if one assumes that the imaged celebrities may be viewed in both critical and celebratory modes, any link to an institutional context (e.g., the sponsor or the media industry) is represented through collaboration (e.g., its linkage to the corporate logo) rather than through critical inquiry.

In an interview in the photography magazine *Aperture,* Leibovitz explains,

> In the advertising work I've done, again, no one has told me how to take the picture. I couldn't work any other way. Still, I don't want to underestimate how working for American Express or the Gap somehow does influence the picture—even though no one is telling me how to take it. Sometimes my work in *Vanity Fair* can feel to me more like advertising than the advertising work does. The cover of the magazine is no longer to me, a photograph. It's turned into a *cover.* . . . You know, there's a difference. (Melissa Harris 1993, 12)

Although Leibovitz is aware of the problematic relationship between the photograph and the advertisement and of the artificiality of attempting to maintain editorial work and advertising work as separate spheres, with few exceptions, these tensions do not seem to be addressed in her work during the 1980s. In the 1990s, however, Leibovitz seemed to turn to more-overt representations of social and political themes.

The Cultural Politics of Place and Identity: Sarajevo, the Gulf War, Las Vegas

During the 1990s, Leibovitz attempted to balance high-gloss, high-profile celebrity photographs by returning to the black-and-white photography she used in the 1970s, not in the documentary style of photojournalism associated with her earlier work (e.g., politics and rock music published in *Rolling Stone*) but in art photography based on modernist aesthetics (emphasizing presence, subjectivity, and aura). The *Photographs* catalog conceptually brackets the postmodern celebrity photographs by closing with the more modernist representations of dancer-artists Mark Morris, Mikhail Baryshnikov, and the White Oak Dance Project. This series includes studio studies of dancers, dancing, and the body (as in the nude study of "swimming dancers" shot underwater).[33] The works fall more clearly in the tradition of studio art photography—by representing individual artistic expression, authenticity, and originality—in contrast to the glossy, even garish, color of the celebrity shots accentuating the subject's self-parody and irony and occasionally the subject's own sense of superficiality. Clearly, both modern and postmodern aesthetics are employed as strategies of representation in Leibovitz's works during the early 1990s. More significant, however, is a shifting emphasis of techniques and approaches that seem to be employed in an attempt to balance institutional demands (e.g., of sponsors, editors, publishers) with Leibovitz's own interests and projects.

A 1994 profile of Leibovitz in *Life* magazine, "The Eye of Annie Leibovitz," seemed to signal a conscious effort to subtly reposition her own image within the mass media. The article's blurb established a major theme of the story: "Her work defined celebrity

for the '60s generation. Now she is training her gaze on more serious—and riskier—subjects" (Van Biema 1994, 46). What is meant by the "more serious and riskier subjects" is explained by Leibovitz as "a dance of sort of getting back to moments when I feel more . . . involved" (quoted in Van Biema 1994, 54). Her series of photos for an AIDS campaign appeared in bus shelters in San Francisco, and she spent more time working with dancers Mikhail Baryshnikov and Mark Morris. *Life* explains that while working with Morris and the White Oak Dance Project, "she allotted herself weeks. The subjects were often unknown, the medium black-and-white, the tone both more intimate and more experimental. She was happy; she was taking risks again" (Van Biema 1994, 54).

Yet Leibovitz's real risk was a trip she took to Sarajevo with Susan Sontag.[34] The *Life* article links Bosnia to Leibovitz's earlier work as a photojournalist and her efforts to balance commercial and artistic projects:

> In Bosnia, she discovered, there was no image to manipulate. . . . One day as she turned left while driving through the bombed-out city, "a mortar went off to the right." One of its victims was a boy who had been riding a bicycle. He died in her car, on the way to the hospital. She made a picture at the scene of the atrocity: the abandoned bike, set off by the ogre's brush stroke of the boy's blood. It was a still life, like the photograph of Jagger's wrist 18 years before But on an infinitely greater scale. (Van Biema 1994, 54)

The following week, Leibovitz returned to Los Angeles to photograph action hero Sylvester Stallone as *The Thinker*.[35] The obvious irony of the coincidence of these two projects, which juxtapose the omnipotence of Sarajevo with the image of a contemplative warrior-as-intellectual Stallone, are not explicitly expressed in the *Life* article; however, they are, again, related to Leibovitz's capacity to accept such contradictions:[36]

> She seems comfortable now with her various levels of seriousness. She says she will return to Bosnia: "I think I'm hooked. I know the people there now." Yet there is little sense that she fears being consumed by her involvement the way she allowed herself to be when she was 25. (Van Biema 1994, 54)

In the photograph of the boy's bicycle, reproduced in the *Life* article along with some of the well-known celebrity photos, we see very different images of travel and celebrity. Here, mobility, signified by the abandoned bicycle (and blood-stained concrete), is a function of war rather than of lifestyle and culture as consumption. We see a bicycle turned over on the concrete, not the aesthetic appeal of a jet plane or a cruise ship linked to the exoticism of travel. The "celebrity" in this photograph is absent and anonymous, a victim of the random violence of war. Yet the *photograph* of the bicycle is also a commodity that can be bought, sold, and reproduced in the glossy pages of *Life*-style magazines and within media culture at large.

Two years earlier (1991–92), Leibovitz had completed a very different series of photographs on the Gulf War for *Vanity Fair,* which also granted publication rights to the German men's magazine *Männer Vogue* (February 1992). These photos were much

more in the tradition of the postmodern photography of the 1980s. Even though *Life* ascribed the role of photojournalist to her two years later, in an interview with Anja Schäfer of *Männer Vogue*, Leibovitz renounced any aspirations to return to documentary journalism.[37] Leibovitz rejected media images of the war as a façade, like the veneer of the celebrity persona, and preferred to work on the visible contradictions of this facade:

> During my stay in Lebanon, there was a cease fire one day and I observed how photographers constructed a battle scene. I think it was at that point in time that I decided that I preferred, consciously—and for the viewer visibly—to stage photos. I'm no photojournalist and I don't make any bones about that. I don't trust photojournalism any more.[38]

The photographs of the "Desert Storm" series presented the narrative of the war through its celebrity politicians, soldiers, media figures, and artists.[39] Like the celebrity "Portraits" of the 1980s, the "Desert Storm" photos are multiply coded. They can be viewed as jubilant, celebratory images of the "winners"—Gen. Norman Schwarzkopf grinning, Peter Arnett (media star for CNN) relaxing at pool side with his fiancée—or as a construction, a facade of artificiality. It is likely that the celebrities preferred the former interpretation to the latter. One of the imaged celebrities is a Stealth bomber (F-117-A) accompanied by the following text:

> Silent, invisible, and so expensive that it could be made out of pure gold. Its successful missions have silenced the loudest critics. You just need smart airplanes to drop smart bombs. And in peace time? Off to Gotham City. Batman is waiting.[40]

The associations of war and entertainment seem to foreshadow the Sarajevo-Stallone connection several years later. On the following page, a photograph of a Stealth bomber pilot, and its accompanying text, also suggest the Hollywood connection to the film *Top Gun*:

> War is not death. War is not flowing blood. War is not suffering children. War is the silent Super-Slow Motion Picture of a bomb which is inserted into a ventilation duct. Joe Bouley is one of the pilots who photographs the Super-TV-Event at the stick of the flying super weapon. War is clean.[41]

Although the photos and their texts may be interpreted as polysemic images, operating simultaneously in the modes of complicitous celebration and critical cynicism, it is questionable to what extent the photos themselves evoke or engage responses rather than simply providing a validation for, rather than challenging, existing viewer positions.[42] I suggest that when viewer positions are extremely polarized by ideology, as in this case, postmodernist strategies of appropriating structures of dominance and representation in order to reveal their contradictions are largely ineffective. In essence, each viewer takes from the photograph what he or she wants rather than recognizing such internal tensions and contradictions. The photographs offer a range of images from which viewers may choose. With regard to reception, Victor Burgin observes,

A fact of primary social importance is that the photograph is a *place of work,* a structured and structuring space within which the reader deploys, and is deployed by, what codes he or she is familiar with in order to *make sense.* Photography is one signifying system among others in society which produces the ideological subject in the same movement in which they "communicate" their ostensible "contents." (1986, 153)

Viewers may wish to identify with the victorious allied troops, their generals, or nations; with the Kuwaitis; with Peter Arnett, the CNN reporter who provided an interview with Saddam Hussein; with violinist Isaac Stern, who continued playing at a concert during a bombing raid in Israel; or with the authors of the sarcastic and blackly humorous accompanying texts and editorials that intend to subvert the facade of the pictures. In this context, the viewers' identification is not so much linked to a specific personality as it is to the image of what they believe the celebrity and photograph are supposed to represent:

Rather than constructing something like a subject or interpellating individuals to identify themselves as subjects, media culture tends to construct identities and subject positions, inviting individuals to identify with very specific figures, images, or positions, such as the Marlboro man, the Virginia Slims woman, a soap opera mother, or a Madonna.

Yet postmodern claims concerning the complete dissolution of the subject in contemporary culture seem exaggerated. Rather, it seems that media culture continues to provide images, discourses, narratives, and spectacles that produce pleasures, identities, and subject positions that people appropriate. (Kellner 1995, 259)

Like the "Portraits" advertisement of Wim Wenders in Berlin, the "Gulf War" celebrities offer a series of images linking personal and national identities. It is the very real sense of *place* at that given moment that also functions as both symbol and index.[43] Thus, the viewer defines the relationship between Wim Wenders and the Berlin Wall with respect to Germany, between CNN reporter Peter Arnett and his controversial interviews from Baghdad conducted with "the enemy" Saddam Hussein with respect to "patriotism" and "loyalty,"[44] or between the combatants, the site of combat in the Kuwaiti desert, and "Desert Storm" as a signifier of national identity. In this case, "Desert Storm" becomes a radical signifier of both mobility and war, asserting the dominance of (occupying) space over time.

The intersection of identity and place is also reflected in "Showgirls," a "Portfolio by Annie Leibovitz" (text by Stephen Schiff) for *The New Yorker.*[45] Alternating color and black-and-white photos of four Las Vegas showgirls—in full costume on one page and in their "everyday" dress on consecutive opposing pages—the series juxtaposes notions of illusion and reality within the context of a city that has become a paradigmatic representation of postmodern culture. Which photo represents the illusion, which the reality? Are they really everyday women, or does their dual identity make them extraordinary? The article emphasizes their ability to move between these identities, between those of exotic showgirl and mother; those of wife and working

woman. For the audiences, the image of the showgirl is not considered sleazy or taboo. It has merged with corporate entertainment and Las Vegas to achieve a new legitimacy. Las Vegas has been reimaged and has "transformed itself from Sin City to a kind of Slot Machine Disneyland" (Schiff 1996, 69). Entertainment conglomerates, such as Disney and MGM, have established Las Vegas as a legitimate site for family vacations. The new identity of the showgirl as a sort of "renaissance woman" converges with corporate projections of a new Las Vegas:

> Alma, who is Dutch, is familiar to Las Vegas habitués, because her likeness adorns the tail of one of Western Pacific's airplanes, and billboards all over town proclaim her "A Showgirl for the 21st Century." Alma speaks five languages, takes correspondence courses in Dutch law, and is married to a film professor at the University of Nevada; she starred in his most recent short film. (Schiff 1996, 69)

As Schiff implies, part of the attraction of Las Vegas lies in the entertainment industry's preoccupation with promoting the romance and nostalgia of Las Vegas's forbidden past while conceptually reinventing the city as a nonthreatening, legitimate venue for culture. Indeed, it is a place where the viewer and audience may, as at a theme park, select what they find appealing. Showgirl Linda Green frequently sees this nostalgic romanticism in her audiences: "I wear these big white feathers at the end. . . . And I look at people and they're looking up at me, and I see tears in their eyes sometimes. The way it's lit and sparkly—they're looking at me like I'm this brilliant white angel" (Schiff 1996, 69).

A letter to the editor of *The New Yorker* reveals a different perspective on "Showgirls." The writer explains that the photos provided an opportunity to discuss notions of "illusion/truth" with her daughter after her son had received a copy of the annual swimsuit models in *Sports Illustrated:*

> Later, when my twelve-year-old daughter was looking through *Sports Illustrated,* I told her, "you know, many of those photographs are just an illusion. I'd like to show you what real women look like." Leibovitz's photographs gave me an opportunity to talk over some important issues about beauty, illusion, and self worth with my daughter.[46]

The "Showgirls" portfolio was integrated into a book collaboration, *Women* (1999), with Susan Sontag, who had suggested a larger project focusing on women (both celebrities and "average" women) in everyday contexts (Goldstein 1999, 1).[47] For Leibovitz, the "Showgirls" are among her most successful photographs—an approach she developed at the very end of the project and one she believes she would use more extensively if she were doing the book again. Leibovitz emphasizes their resonance with the public after their publication in *The New Yorker* and in particular the fact that they seem to convey a sense of empowerment (Goldstein 1999, 2). I believe Leibovitz means empowerment in the sense that the women can control or create their own stage presence or aura. However, I would ask what the context of the Las Vegas casino conveys about the nature of their work and the workplace itself, and whether it under-

mines this notion of empowerment? Leibovitz's reading of the casino context is, I think, a very postmodern one, which many of the show's teary-eyed spectators would not share. It is important to distinguish between the reception of the showgirls as performers in the actual context of the casino and the photographs, which (through the juxtaposition of the photos in their dual roles) present a dynamic tension between the identities the women assume. Moreover, the readership of *The New Yorker* is in many instances a very different audience than the spectators at the Las Vegas shows.

As Kellner observes, "Personal identity is thus fraught with contradictions and tensions" (1995, 258). The images in Annie Leibovitz's more recent photographs may well represent attempts to make the viewer conscious of these tensions, but they can also function as a way of resolving them or of creating new forms of mystification. In any case, I would like to reemphasize that the actualization of these images, or their reconstruction by the viewer, cannot be limited to binary oppositions (e.g., illusion versus reality)—although the construction of some images (such as the "Desert Storm" photographs) seem to create more-polarized viewer positions than others—rather, they elicit a spectrum of potential interpretations.

A sense of *place and context* assumes a key position in the anticipated reception of the photographs and in structuring their actual reception in museums, in galleries, in the editorial content of magazines, or as advertisements. How the site (a motorcycle repair shop, the Berlin Wall, a street in Sarajevo, a Las Vegas casino) is incorporated into the discursive structure of the photograph and linked with personal or national identity is crucial to Leibovitz's own vision of her photographs as intentionally staged constructs that question the notion of a seamless, documentary, photojournalistic reality. By foregrounding the site as an integral component of constructing or destabilizing identity, she expands the potential for symbolic associations that engage the imagination of the viewer, regardless of whether this occurs within the context of the advertisement or of art photography. In some instances, for example, the photograph of Hanna Schygulla, these associations may at least tentatively subvert or undermine the actual promotional message of the advertisement. Although this is probably not an intentional strategy employed as institutional critique, it nonetheless reveals the paradoxes of corporate promotion, which increasingly attempts to instrumentalize intertextual cultural references. Though these decontextualized references (e.g., Maria Braun promoting American Express) attract the attention of the viewer through their unexpectedness, they may also signal the paradoxes and dissonances embedded in the promotional message, as well as the reconfigured photograph or text. In their mediation of cultural production, sponsors attempt to mobilize the polysemic dimensions of culture and recontextualize them with the corporation's own site-specific referents. In chapter 5, we will see that by organizing and structuring the actual sites of cultural production and reception, corporations attempt to frame or channel the modalities of this communication. And it is at these selected sites, at events, that the sponsor can directly, physically, engage artists and audiences through culture.

5. Sponsoring Events: Culture as Corporate Stage, from Woodstock to Ravestock and Reichstock

I would like to begin and end this discussion with two examples of events that were *not* sponsored and that were represented in the media as expressions of resistance to or subversion of commodified culture: Woodstock and Christo and Jeanne-Claude's *Wrapped Reichstag*.[1] We might consider the temporal and spatial distance between Woodstock and the *Wrapped Reichstag* not simply as beginning or ending points but, rather, as markers that can assist us in an analysis of the event within postindustrial societies and postmodern culture. Both Woodstock and the *Wrapped Reichstag* became reference points and signifiers of culture and politics, albeit in different cultural and historical contexts.

In his definition of architecture "as the combination of spaces, events, and movements without any hierarchy or precedence among these concepts," Bernard Tschumi traces the "insertion" of the event, as a notion central to the social practice of architecture, to the sociopolitical demonstrations and actions of the late 1960s, particularly "les événements" (e.g., street barricades) in Paris, which represented both social *events* and social *movements* (Tschumi 1994, 255). Tschumi refines this notion by adapting Michel Foucault's concept of event as "the moment of erosion, collapse, questioning, or problematization of the very assumptions of the setting within which a drama may take place—occasioning the chance or possibility of another, different setting."[2] For Tschumi, Foucault's event is ultimately a "*turning point*—not an origin or an end." Moreover, Tschumi proposes integrating shock as a critical aspect of the event, which "in order to be effective in our mediated culture, in our culture of images, must go beyond Walter Benjamin's definition and *combine the idea of function or action with that of image*" (257).

Certainly, Woodstock and the *Wrapped Reichstag* involved various forms of "erosion," "questioning," or "problematization" of their respective sites. In the case of Woodstock, the sense of community that emerged spontaneously as a result of both the unexpected magnitude of the event and the physical conditions (rain, mud, and insufficient sanitation and food) was related to its "failure" to function as a planned, commercial event. Indeed, by most accounts the event itself was a disaster (Espen 1994, 73). Yet the sense of "being there," of "surviving the event," of sensory "shock,"

along with the feeling of shared participation in the music and audience interaction, was a cathartic experience for the participants. Not only did Woodstock become a very different experience than what the media and the participants expected, but it also had a totally unexpected resonance in terms of its subsequent reception, signification as an icon of 1960s sociopolitical movements, and commodification as a consumer product (Epsen 1994, 71).

Christo and Jeanne-Claude's plans to wrap the Berlin Reichstag explored the signification of its architecture (both as a building and as a monument) and its site (as an ideologically charged space) from the outset. Manfred Enssle and Bradley Macdonald discuss Christo and Jeanne-Claude's project in terms of its challenge to auratic art and its recontextualization as a museal artefact (1997, 2). They argue that the value of the *Wrapped Reichstag* emanated from its power to engage public discourse on German identity and to subsequently engender what Guy Debord referred to as a "community of dialogue" (1995, 2). Although the completion of the project was the result of many years of lobbying on the part of Christo and Jeanne-Claude, the final debate within the German Parliament and the wrapping as an event must be considered within the historical context of German unification and the decision to move the capital to Berlin. Thus, the debate over the wrapping of the Reichstag, the actual process of wrapping, the viewing of the event (which became a series of mini-events), and the reception in the international media all became a part of larger discussions regarding national identity and the reformulation of cultural policy.

Although Woodstock may have achieved its initial (historical) significance as a result of chance or serendipity (Espen 1994, 71)—while the *Wrapped Reichstag* questioned the assumptions that the historical symbol represented—both events marked *turning points* and became lightning rods for subsequent debates over politics and culture. Moreover, they were rapidly integrated into the institutions and distribution channels of media culture as points of reference within media discourse on cultural politics. Yet neither event was conceived as an overt protest of commodified culture. Woodstock was planned as a commercial event. It failed and only generated income in the following years as a result of its subsequent marketing and merchandising.[3] Christo and Jeanne-Claude pointedly rejected corporate sponsorship or merchandising for their project, preferring to retain a greater degree of control over the site and its signification, by coordinating the licensing and marketing (pictures, prints, postcards, etc.) themselves.[4] Recognizing the economic exigencies of cultural production and the difficulties, indeed the impossibility, of financing a project of this magnitude "outside" the marketplace, they chose to negotiate an economic and artistic path that would grant them a greater degree of artistic freedom to structure the site of its reception.

Precisely because Woodstock and the *Wrapped Reichstag* accumulated considerable cultural capital as signifiers of cultural politics (of their respective eras), they can also be retrospectively projected as events defined as turning points. Whereas Tschumi foregrounds events as problematizing the site and questioning their inherent logics, I would, in addition, suggest that they are multiply coded with respect to their potential

to attract, entertain, or stimulate *and* simultaneously subvert (i.e., challenge the assumptions of the event). In this sense, it is not surprising that Woodstock and the *Wrapped Reichstag* may be considered as characteristic of postmodern culture as both "complicity and critique" (Hutcheon 1991, 11–13). I believe it is this potential to attract and to simultaneously subvert the basis of that attraction that has made Woodstock and the *Wrapped Reichstag* powerful cultural symbols. Tschumi's elaboration of the event as shock extending into social action can also be understood within a range of expressions and responses, that is, its potential for social critique, the use of shock as a strategy of the entertainment industry, and attempts to undermine or subvert the shock value of entertainment in postmodern culture by turning it back on itself.[5] The subversive power of the event is expressed both in its potential to offer pscyhophysical stimulation as entertainment and to question the assumptions of that entertainment (i.e., the event itself), and in its potential to employ the event as a medium to create "communities of dialogue." Thus, events function within a multidimensional space characterized by attraction, shock, and subversion.[6]

I would like to explore the implications of event culture, upon which much of corporate sponsorship is based. The functions of events, within multiple modalities and discourses, include their aesthetics of visualization and technology; their politics of structuring, organizing, and defining spaces; their mediation of subculture scenes; and their potential to stimulate critical discourse and social action. Tschumi and Enssle and Macdonald trace the aesthetics of those events that define themselves as social provocation (such as the *Wrapped Reichstag*) to the Situationists and political actions of the late 1960s, which attempted to "bring art into the 'streets,' thus aesthetically reappropriating the contradictions of everyday life for emancipatory purposes" (Enssle and Macdonald 1997, 16, 21n47; Tschumi 1994, 255). Although some events, such as Woodstock, became pivotal cultural symbols as a result of their representation and circulation within media culture, most events are much shorter-lived and less successful in engaging their audiences either in the experience of the event itself or in forms of critical discourse. Nonetheless, they collectively possess enormous cultural power through their integral role in societies based on generating new experiences.

The Event as *Er-leben*

Events form the core of almost every form of cultural sponsorship. Behind the planning and implementation of corporate sponsorship, there is usually an event, organized to maximize the interaction among its participants: artists or producers, sponsors and their clients, media markets, and audiences. Sponsors and promotion specialists have developed the management of events into a science based on various areas of cultural production, including the performing arts (opera, musical, theater, ballet), music (classical, jazz, rock, pop), visual arts (painting, sculpture, photography, installations), fiction and nonfiction literature (literary prizes, readings, exhibitions), historic preservation, and architecture (Roth 1989, 108–9; Schreiber 1994, 66). These areas represent just a few of the more common sites of cultural production utilized by corporate

sponsors for marketing and communication. Sponsors frequently employ matrices in order to coordinate their communications objectives (i.e., marketing, sales, promotion, etc.) with their perceived image of a particular cultural event, for example, an art exhibition in a museum (Bruhn 1991, 243). Some of the "image characteristics" assigned to various areas of cultural production include atmosphere, modernity, aesthetic appeal, originality, competence, exclusivity, prestige, tradition, responsibility, youthfulness, and harmony (Bruhn 1991, 243). For example, whereas photography is linked to modernity, originality, and exclusivity, ballet is associated with atmosphere, aesthetic appeal, originality, prestige, and harmony. In the initial planning stages, such matrices are used to match the cultural image characteristics with a corresponding product image or promotional message. This is all part of what has become known as psychographics (Wegerhoff 1992b, 52; Schreiber 1994, 66), or more specifically, "lifestyle and event marketing," which comprises a central objective of sponsorship—that is, image transfer.

For sponsors, events are much more effective vehicles for reinforcing images than are print or media advertising because they capitalize on the specific significance of the site (e.g., an arts festival) for a particular audience or market. More importantly, events are interactive. They engage the audience in the performance and reception of cultural products (e.g., singing and dancing at rock festivals). Anthony Tortorici, a former vice president for public affairs at Coca-Cola, writes: "Events are inherently active, rather than passive, on several levels at the same time. And, for a marketing message to be memorable to consumers today, it has to make that transition. Events are the things that make that happen" (quoted in Schreiber 1994, 150). For serialized or annual events (e.g., festivals), sponsors may either try to "buy" the event, in which case their name is prefixed to the event, or develop their own events under their name or in cooperation with a nonprofit sponsor. Actually "owning" an event is most common in sports sponsoring; however, it is also practiced within cultural sponsorships, particularly for music and cultural festivals or specialized programming (e.g., the *Texaco–Metropolitan Opera International Radio Network*) (Schreiber 1994, 97, 146–47).[7]

For Gerhard Schulze, events play a central role in societies oriented to experiences *(Erlebnisse)*: "The goal of experiencing *[erleben]* something forms the centerpiece of a contemporary [social] rationality based upon the demand for experiences" (1992, 425). Schulze traces the shift in Germany from a society in which individuals and groups were primarily concerned with issues of survival and economic or material existence (Germany's Economic Miracle of the 1950s) to one in which structuring an enjoyable life has become predominant (during the 1980s). This does not mean that economics do not continue to play a significant role in defining social relations. However, Schulze argues that in advanced, postindustrial societies like Germany, there has been a qualitative and quantitative shift in orientations: from an economic semantics (based on the differentiation between "more" and "less") to a psychophysical semantics of structuring "experiences" *(Erlebnisse)*. The prefix *"Er"* (from *"ur,"* "original") refers to seminal experiences, that is, those defining "the original" or authentic experience within life

(Leben) and referring both to the act or process of experiencing (i.e., the verb *erleben*) and to the state of experiencing *(das Erlebnis)*. Once the basic structures of survival are in place, the existential task of the individual is to determine how to "experience life," or literally live life *(Er-leben),* by selecting, managing, and interpreting the significa-tion of experiences (Schulze 1992, 140):

> The aesthetics of everyday life are constructed as a relationship between the sign and the object. Whatever constitutes the object of everyday aesthetic episodes—from *The Moonlight Sonata* to auto accessories—appears (from the perspective of the semantic paradigm) as a sign whose contents are experiences. (Schulze 1992, 96)

The construction of an *Erlebnis* as both a psychological (cognitive) and physical (bodily/sensory) process is central to an understanding of the experience and the event. The individual must translate the objective information of the sign (e.g., the label on a wine bottle) into his or her own sign system before he or she can react aes-thetically (e.g., judging the wine to be good or bad) (Schulze 1992, 97). Likewise, the sign (e.g., "Coca-Cola") is linked to the expectation of a specific sensory experience (i.e., how Coca-Cola tastes or the expectation of how it tastes). In this sense, the indi-vidual can only purchase the offer of the experience or the product, but not the ex-perience itself. This must be reconstructed each time the "product" is experienced (Schulze 1992, 548). Schulze foregrounds the significance of the body as the primary site of experiencing. Even if we are not always aware of it, "aesthetics go through the body" (106). As the site and medium of "experiencing," the body has particular im-plications for events (e.g., rock concerts or events associated with high culture) and "interactivity."[8]

Although the orientation to and search for experiences characterize Western socie-ties such as Germany, Schulze points out that the symbolic function of events as signi-fiers of a "philosophy of life," of the "meaning of existence," or of social movements has diminished:

> Woodstock is over. Even though the rock concert audiences have become more expres-sive, the real or imagined ecstasies of the fans are not based on a "meaning of life." . . . Enjoyment is the predominant level of meaning: counter-culture has paled, as has the stimulus of personal involvement mediated through an experience . . . a "philosophy of life." . . . Wearing jeans, driving a motorcycle, pop music, open styles of travel and dance as expression of a world view . . . have been reduced to psychophysical states of stimulation. . . . normative connotations have faded . . . and been superceded by the desire to just have a little fun. (1992, 548)

Although clichéd notions of "living life to the fullest" or, as one beer ad in the United States exhorts, "Grab[bing] all the gusto you can get!" are not new, in the sense that they project a sybaritic or hedonistic lifestyle, their proliferation and projection into most spheres of everyday life based on structuring largely commodified, enjoyable ex-

periences characterize some key aspects of both promotional culture (Wernick 1991) and media culture (Kellner 1995).

Although everyday aesthetic experiences are marked by the disintegration of an existential component of meaning linked to cultural products, the deterioration of the normative connotations of aesthetics is particularly apparent within high culture (Schulze 1992, 546). Participants in high culture rely, with increasing frequency, on the suggestion of a "deeper significance" (constructed by cultural mediators and audiences alike), while a genuine sense of a worldview *(Weltanschauung)* related to a cultural production fades (Schulze 1992, 546). In many respects, the defense of local folk traditions by government-sponsored cultural institutions (e.g., in Bavaria) represents an attempt to preserve the mythologies of those spaces that the state and commercial interests were actually destroying through land development policies (e.g., the Franz-Josef Strauss Airport in Erding near Munich) and the expansion of suburban spaces around the city. Thus, the meaning of events is also related to their function as a space for the representation of cultural politics.

Opera as Corporate Stage: The Bregenz Festival

Contemporary events, even those that seemed to be immutable "classics," such as the annual production of Wagner's *Ring* at Bayreuth, are increasingly subject to the renegotiation of their signification through production, staging, sponsorship, promotion, and marketing.[9] Germany (and the EU in general) has experienced a proliferation of arts and music festivals since the early 1980s. Relatively new festivals, such as the Schleswig-Holstein-Musikfestival, launched in 1986, became high-profile vehicles for local cultural policy (promoting regional tourism) and image promotion of major German corporations (Lufthansa, Audi, Windsor). Schleswig-Holstein became one of the most successful, and controversial, of the new event festivals of the 1980s by offering a mammoth program (more than 227 concerts in 1987) to a mass audience (of more than 220,000) at competitive prices (DM 35–100), and at a variety of sites, including some rather unorthodox venues (e.g., in barns).[10]

As sponsorship specialist Peter Roth concedes, "The whole festival is planned and constructed like a consumer product" (1989, 250–55). The festival logo unites the natural setting of rural Schleswig-Holstein (lakes, meadows, roofs, and seascape) with music (musical notes) signifying both the tourists' "romantic gaze" (Urry 1995, 191) and their collective consumption of the event product (music performance). Inexpensive tickets (averaging DM 35) were intended to attract younger audiences to the performances. Promoting high culture for the masses reflected Germany's regional and cultural politics of the 1970s, expressed by Hilmar Hoffmann's slogan "Culture for everyone" *("Kultur für alle")*. This "democratization" of cultural spaces was most notably linked to the cultural politics of expansionist building programs in Germany, for example, in Frankfurt am Main, under Hoffmann's aegis (1970–1990), which shifted the city's image from that of a sterile banking metropolis *(Bankfurt)* to that of a regional center for contemporary urban culture (particularly through new museums

along the Main River).[11] Although the Schleswig-Holstein-Musikfestival had become the media's paradigm for marketing regional culture through public and private support, its overexpansion threatened it with imminent collapse (Roth 1989, 252–53). By the mid-1990s, Schleswig-Holstein was accumulating debt at the rate of DM 2.5 million per annum, less than 60 percent of the seats were being sold, the number of concerts had been reduced to 110 for the eight-week season, and in a rather ironic twist, Franz Willnauer came from the Salzburg Festival (Schleswig-Holstein's rival in the south) to become the artistic director.[12] Schleswig-Holstein was a highly visible example of the cyclical nature of many new festival concepts. Simultaneously, sponsored promotions touted in the media (e.g., *Der Spiegel*) by Schleswig-Holstein's president, Björn Engholm, brought the commodification of cultural events into the public consciousness and revealed public culture's growing dependency upon corporate funding.

The Bregenz Festival in Austria illustrates how the resignification of cultural events occurs—in terms of both a postmodern *tourism of visual consumption* (Urry 1995, 139–40) and *the insertion of commercial interests into event organization and its aesthetic mediation.* Both of these processes relate to broader issues concerning the corporate politics of space. Bregenz, as a city and festival site, is strategically located in the so-called triangle *(Dreiländereck)* between Switzerland, Austria, and Germany. By attracting audiences from all three markets (up to 6,500 spectators), Bregenz typifies the emergence of regional cultural marketing within the EU. The recent history of the festival (which was founded in 1946) is characteristic of international trends for funding cultural programs in the EU during the 1980s and 1990s. Cuts in government support for culture increased the festival's dependency upon sponsorships, fund-raising, and marketing. A scathing government audit of Bregenz Festival finances in 1981 led not, however, to programmatic cutbacks but to an unprecedented expansion—including aggressive marketing and promotion—that has continued into the twenty-first century. Indeed, Bregenz's management reestablished it as a "premier festival" event through an "expansive corporate policy" (Feldmann 1992, 81). The festival's communications director Bernd Feldmann explains:

> Opulent productions on the world's largest lake-side stage were supposed to make Bregenz into a focal site of festival offerings during the summer. The new [market] position took hold. Spectacular productions such as Jerome Savary's *Magic Flute* (1985/86) and his *Carmen* (1991/92) attracted the public. Bregenz freed itself from its Me-Too-Image and advanced to one of the leading festivals in Europe. (81)

The new "marketing mix" of opera, theater, and orchestral performances, combined with the promotion of large-scale events on the floating stage, was so successful that by 1995 the production of *Fidelio* had reached a new season-attendance record of 206,490 visitors.[13] Bregenz illustrates the institutional convergence of corporate and nonprofit interests based on the rationales of market demand (Schulze 1992, 510–11), as well as the integration of corporate marketing and promotion strategies as a basis for reformulating its mission, objectives, and image from within (defined as corporate

identity). In this respect, Bregenz is characteristic of contemporary arts management (within museums, symphonies, and festivals) that synthesizes corporate and cultural interests.

The image of "the stage" represents a metaphor and locus of attraction for the marketing and communication of the Bregenz Festival's own corporate identity as well as those of its corporate sponsors and audiences. Unlike Schleswig-Holstein, which predicated performance on a dispersion and "democratization" of the performance sites (from barns to castles), Bregenz made the *image of the stage* and the *visual scale* of its productions the preeminent features of its promotion. Indeed, the relationship between the festival's image, stage, and production parallels similar strategies of signification used by museums to mediate their image, architecture, and contents (Ritchie 1994, 12). New museums employ architecture as a focal point of their communication efforts (e.g., Frank Gehry's Guggenheim Museum Bilbao) and then link them to exhibitions. Similarly, Bregenz utilized its architecture, Europe's "largest lake-side stage," in order to communicate the image of the festival and the physical scale of its performances. The stage and the opera productions are signified two ways: through visualization techniques (similar to stunts and special effects utilized in films) and the stage engineering that supports the production. Feldmann explains:

> Expensive stage superstructures require additional and corresponding investments. The international reputation which Bregenz enjoys was achieved through the courage to produce spectacular productions on the lake-side stage. The dramaturgical concept which attempts to enthuse a large segment of the public by presenting a visualization of the content has been successful. However, this also requires extraordinary efforts. (1992, 82)

These "extraordinary efforts" include using a stuntman who, in the final scene of *The Flying Dutchman,* dives from a thirty-three-meter lighthouse, specially constructed for the Bregenz production and later moved to Vienna's Technical Museum. Both the construction and moving projects were sponsored by the Association of Austria's Casinos (Feldmann 1992, 85). The stage set for a similar megaproduction of *Carmen* included eighteen-meter mountain walls made from original castings taken in the Swiss Alps. For *Fidelio,* a thirty-six-meter high metal wall and forty-five prison cells were constructed.

The use of dramatic stage effects have become part of the experience *(Erlebnis)* of events (from the Rolling Stones rock concerts to Andrew Lloyd Webber musicals to classical opera) and have shaped audience expectations for live performances. They are facilitated through sophisticated hardware and software, often provided by the corporate sponsors in a sort of cultural "technology transfer" of know-how. Technology links the corporation, the event, and the cultural production not only by creating an image but also by actually changing the aesthetic mediation of the production itself and the manner in which it is experienced. The fusion of technological innovation with the opera as a signifier of artistic creativity facilitates the social legitimation of the

corporate sponsors (e.g., Mitsubishi Motors Corp. and Digital Kienzle). In this respect, we can observe an attempt to harmonize the signification of the festival with corporate image in order to effect an image transfer from festival to sponsor:

> Here, sponsors use the possibility of creating a connection to the sympathetic "Festival" product. In order to achieve this relationship it is, however, necessary to reach an agreement with respect to the fundamental ideas so that the involvement of the sponsor is credible and can produce the image improvement which is desired. (Feldmann 1992, 83)

The second phase of this process involves both technological and image transfer between the cultural production and corporate sponsor:

> The particular challenge of the lake-side stage, which must resist each storm, and therefore continually places new and unknown demands on theater technology, is one such component of the image. Corporate ideas are similar in nature: the urge to produce new things, the search for better solutions, the courage to lead the way in new technologies that can be useful to humanity. All of these form the basis of this connection. (Feldmann 1992, 83)

The image goals of the cultural organization "Festival" and those of the corporate image become inextricably linked. We can observe how the festival, operating in marketing and promotional modes, accepts the image objectives of the corporation in order to re-image (or conceptually repackage) its own festival product that is consonant with the corporate image. Once completed, this process facilitates the corporation's own re-imaging in order to effect an image transfer between the festival and the corporation and allows the corporation to operate in its "cultural mode." The product festival and the corporate image as product are blurred and merge.

The signification of the festival as a cultural production at a specific place and time and its functions as a commodity are mediated through a series of relationships among (1) the stage and the space within the natural environment it occupies on Lake Constance, creating a background for the stage; (2) the opera production and its adaptation, which is designed to maximize the stage's technological potential for dramatic effect; and (3) the characteristics of the outdoor stage as a dynamic physical environment (both natural and meteorological) for the performance. Thus, the stage, the cultural production, and the environment (the lake and weather conditions) function as promotional signs within three distinct modes. First, the stage is signified as the site of technological innovation. This notion is transferred to the image of the sponsors through their technical support and services. Second, the creativity of artistic production is associated with corporate innovation. Third, weather conditions (as dramatic effects) become metaphors for the social and economic "environments" in which the corporation operates and interacts. Let us now examine examples of these three dimensions, first for the Bregenz Festival and then for corporate sponsors.

The Festival Image: Stage, Opera, Environment

First, the festival promotes the *image of the stage* in terms of its extraordinary physical and technical characteristics (as a "technical wonder"); its dramaturgical aspects and set designs for specific productions (e.g., the lighthouse in *The Flying Dutchman*); and its social function as a privileged site of performance and reception (e.g., the uniqueness of the event). Second, the *image of the cultural production* (opera) is related to the creativity and mastery of the director, actors, cast, and musicians, to the thematic attributes of the original piece, and to the director's unique interpretation of the work. Yet the productions are subordinated to the promotion of opera as an "event" per se, that is, opera as spectacle. English director David Pountney, who directed *The Flying Dutchman, Nabucco,* and *Fidelio,* remarked that in Bregenz, "there are still real festivals and not simply any old, interchangeable events, that call themselves that. . . . Here, people want to have, and should have, their feast for the eyes" (quoted in Umbach 1995, 158). Pountney attempts to engage the audiences on sensory and emotional levels. In his production of *Fidelio,* he wants the audience to sense the "sterile idyll" that exists within the domesticity of their own homes, making couples prisoners to their own isolation, that is, "the loneliness of the individual in today's affluent society" (quoted in Umbach 1995, 158).[14] Third, the festival instrumentalizes the *image of the environment* as a technical effect. The actual backdrop of "real nature" surrounding the stage is subordinated to the technical effects of "simulated nature" (storms, wind, Swiss Alps) reproduced on the festival stage. This should be considered within the context of the visualization strategies (effects), which create new virtual experiences—in part, a result of expectations audiences bring with them from their interaction with film and television.

The Sponsor's Image: Stage, Opera, Environment

For corporate sponsors (e.g., Mitsubishi Motors Corp., Digital Kienzle), we can trace a parallel process of signification. First, the *image of the stage* represents the innovative aspects of technology and know-how or technology transfer from the corporate sector to the cultural sector. In some cases, technical products and services are provided as part of sponsorship. Digital Kienzle, for example, provided technical assistance in establishing computerized ticketing and reservation systems (Feldmann 1992, 88). Set design and technical production are perceived as technical achievements. Part of the sponsorship package includes an exclusive "behind the scenes" look into the technological apparatus of the production for "VIPs" (i.e., in order to show how technology facilitates the staging of culture). Feldmann writes: "The 'commonality in our intellectual striving' that is documented through the application and command of new technologies encouraged the Japanese automobile manufacturer [Mitsubishi] to 'support the ambitions of the Bregenz Festival'" (88). The quotation marks intentionally underscore two key phrases ('commonality in our intellectual striving' and 'support the ambitions of the Bregenz Festival'), which are employed as discursive strategies to effect the image transfer between corporation and festival. Through its financial and

technological support, the stage is signified as a privileged site of cultural production in which the corporation also participates.

Second, the sponsor engages the *image of the cultural production* primarily on the symbolic level. Special seating, receptions before or after the event, meetings with the director or performers, lectures, and other "events at the event" are very tangible measures with symbolic value, designed to create a sense of exclusivity through interaction with the performers. More importantly, they create a sense of participation in the production of culture. VIPs are encouraged to believe that they are "in some small way making it possible." Of course, the sponsor also intends that the audience will associate the range of positive images (e.g., creativity, innovation, exclusivity) with the corporation and its products. This is reinforced by placing the sponsors' names on tickets, in concert programs, in advertisements, and on signs or posters. Feldmann emphasizes the importance of the festival as a promotional vehicle that can reach an extensive media market in Austria, Switzerland, and southern Germany. Indeed, the value of the sponsorship lies not only in the event itself but in its broader signification in the media as an advertisement, particularly for international corporations that want to achieve greater image recognition in new markets (Feldmann 1992, 83).

Third, sponsors perceive the *image of the environment* in both physical and symbolic dimensions. Obviously, the meteorological conditions (rain, sun, heat) on an openair stage influence audience predispositions toward the performance and its reception. More important, however, is the attractiveness of the geography (lake-side stage) and the privileged cultural site combined with an entertainment package (e.g., reception, dinner, overnight stay). Environment is defined as an ambience conducive to relaxation, stimulation, and entertainment. The event provides an opportunity to enhance the cultural experience through good weather, scenery, food, culture, and shopping within a corporate "rewards" or promotions program for employees, clients, or valued customers. As a form of lifestyle sponsoring and cultural tourism, these activities surrounding events are directly related to corporate promotion of travel products (as we have seen with American Express) as well as to the touristic practices that gradually merge the consumption of products (shopping) with culture (events) and places (Urry 1995, 148–51). In fact, Feldmann emphasizes that it is difficult for sponsors to attract clients to Austria's Voralberg region without offering a special event (1992, 88n5):

> In an age of telecommunications and over-crowded schedules . . . contacts are more difficult to achieve. There must be an occasion, an opportunity must be found. An evening of opera under the open sky, for example, with a sunset on Lake Constance, a business discussion in a holiday-like setting . . . Combined with a personal tour of the lake-side stage, with a look backstage, to be on stage. "By the way, the performance was made possible through our support." Your business partner will be amazed, your prestige will grow. (Feldmann 1992, 83)

Regional sponsors, such as the Wine Growers Association of Lower Austria (Winzerverband Niederösterreich) utilize the site to emphasize their "rootedness" in the re-

gion and to promote regional identity as product identity. Toward this end, the growers developed a special festival wine, including opera motifs on the labels, to be sold during the festival season (Feldmann 1992, 88n6). The cultural production, the region, and its products are linked symbolically and physically to the festival through their visual and material consumption by the participants.

In this manner, both the Bregenz Festival and the regional sponsors are promoting regional business development through culture. The "environment" of the Bregenz Festival, as a second-order sign, also relates to the notion of a "friendly or hostile business environment." Communicating the image of an environment friendly to employees, clients, and customers both at events and in promotional materials referring to event sponsorship has become a part of corporate cultural politics. Culture becomes a vehicle for regional economic development and promotion *(Kultur als Standortfaktor)*. As Urry observes, tourism is predicated not only upon visual consumption but also on the physical consumption of places (1995, 192), for example, through increased development of roads, hotels, shopping and restaurant complexes, or sports facilities. This is certainly the case in Austria, which relies heavily on the promotion and consumption of its own spaces as touristic commodities.

Moreover, festivals in Bregenz, Schleswig-Holstein, or Bayreuth become a stage for political representation in the sense that they function as validation for the government's economic development projects. Politicians use their appearances at high-profile events to show their support (real or ostensible) for culture and, more importantly, as a stage for their own promotion, resulting from the attendant media coverage.[15] In this respect, the staging of events plays an integral role in "promotional politics" (Wernick 1991, 124–51). The political and economic interests of corporate cultural politics and state cultural politics converge. The cultural production itself recedes strategically (through the instrumentalization of its communicative value) into a subordinate position. In the case of the Wine Growers Association, regional identity, product identity, political identity, and economic identity are fused within the site of the cultural event. The festival event becomes a symbolic stage for the marriage of regional economics and politics at the altar of high culture.

The emphasis on "visualization" techniques utilized at Bregenz indicate a shift from aural to visual modes of reception within event and media culture. With regard to rock music, Lawrence Grossberg writes, "The visual (whether MTV, or youth films or even network television, which has, for the first time since the early 1960s, successfully constructed a youth audience) is increasingly displacing sound as the locus of generational identification, differentiation, investment and occasionally even authenticity" (1994, 54). In his review of the thirty-six-meter wall designed for *Fidelio* at Bregenz, Klaus Umbach remarks that

> not even Pink Floyds "Wall" was constructed and equipped as bombastically as this icon of the 1950s. . . . From the back, this monster looks like a launch runway from "Star Wars." . . . From the front . . . it is a smooth, black facade, behind which the horror

[of the piece] resides, with a lot of hidden high tech. When . . . the orchestra . . . intro-
duces the most famous choir of prisoners in opera . . . then the shutters on . . . seven
tracks within the Bregenz wall ascend to the sky; 45 small, chalk-white, spotlighted cells
open up and out of 45 mens' throats resounds Beethoven's alluring call: "O welche
Lust!" (1995, 158)

Elaborate technical productions have become an essential component of event cul-
ture, particularly rock tours, for example, the Rolling Stones Voodoo Lounge Tour
stage with its monumental viper. Following prior performances in London, Tokyo,
Sydney, and Madrid, American Express sponsored what it called "the most beautiful
and spectacular *Carmen* that there ever was" in Dortmund with José Carreras and
Julia Migenes on a revolving stage surrounded by "hundreds of singers and dancers,
horses and bull fighters."[16] Special effects were a standard part of the production
repertoire of the Andrew Lloyd Webber musicals of the 1980s and 1990s (e.g.,
Phantom of the Opera, Cats, Starlight Express, Sunset Boulevard).

Events as diverse as Bregenz's *Fidelio,* Rolling Stones tours, or Webber's musicals
share similar production strategies, regardless of differences in content and audience.
Such strategies not only reflect the dissemination of a visual aesthetics of effects—e.g.,
of lighting, computer animation, physical size, scale, movement, collision, or destruc-
tion—that have been defined largely through the globalization of electronic media,
but they also underscore the proliferation of a standardized administration and pro-
motion of event culture on a global scale. Just as traveling museum exhibitions facili-
tate cultural globalization, event culture is also produced and packaged for global mar-
kets and staged locally. Corporations employ similar promotional strategies (e.g., VIP
receptions, collateral events, tourist packages, image advertising) whether they are
sponsoring Carreras in *Carmen* (American Express) or the Rolling Stones (Volkswagen).

Open-Air, Rock, and Youth Culture

Mass media dissemination and local reproduction are integrated in order to maximize
the economic and promotional potential of cultural production. Concerts on tele-
vision heighten the audience's demand to experience artists live and in person. Alterna-
tively, live concerts reinforce the demand for concert videos and recordings. Although
spectators attend an event to experience a particular artist, group, or repertoire, these
expectations have already been mediated and conditioned by recordings, prior con-
certs, and media promotion (Wernick 1991, 114–15). Despite their distinct contexts of
reception, the interaction of live events and their reproduction or dissemination in
media defines individual and collective expectations and constructs the cognitive and
physical process of experiencing.

Audiences want to realize their expectations *and* to be surprised by the unexpected
(Rau 1994, 251). This sensory stimulation could range from a sunset during an aria be-
hind the opera amphitheater in Verona to body surfing in the "mosh pit" at a rock
concert. Although the object of the event itself (the performance of the cultural prod-

uct) provides a pretext or occasion for attending, for audiences the event is constitut-
ed through the process of interaction and mediation between the performance itself
and the context of the performance. The spectator can listen to the song at home on a
CD or watch a video; however, it is the psychophysical engagement of the individual
within a specific site that offers the experience of a broader range of stimuli (intellec-
tual, emotional, sensory) than the familiar contexts of home, work, or commuting
(Schulze 1992, 135).

Christof Graf traces the power of open-air events to their roots in outdoor rock
concerts of the 1960s and to their function as a platform for mediating ideologies
(1996, 47–48). Although sponsors and event producers attempt to organize and struc-
ture the contexts of events through production technologies and promotional images,
it is during the process of reconstructing the experience of the event that audiences
can potentially construct their own spaces and definitions of events. The following ex-
amination of the intersection of event culture and youth subcultures will explore the
extent to which events offer such spaces, not only for corporate cultural programming
but also for the construction of social identity and community.

Open-Air Movies: The Drive-In Revisited?

Open-air movies, which have become popular among young, urban audiences in
Europe, illustrate increasingly complex relationships among production, perfor-
mance, and reception. Open-air films are frequently projected on an inadequate
screen with comparable sound quality, and viewing one as a "live" performance is less
important to the audience than spending a summer evening under the stars. In this
respect, the popularity of the open-air movies may share some of the features of the
old drive-in theaters in the United States or the Auto-Kino in Germany, which are
rapidly disappearing. (Open-air movies have also enjoyed sporadic popularity on col-
lege campuses in the United States.) Open-air movies in Europe distinguish them-
selves from traditional movie going through both their interactive and their performa-
tive qualities.[17] Audiences at open-air events arrive up to two hours ahead of time to
socialize, eat, and drink. Many open-air movies are well-known classics or cult films
(e.g., *The Rocky Horror Picture Show*) rather than first-run features. The audience
knows the plot and may only watch the film intermittently while conversing and cir-
culating, much in the way they view video clips on MTV. One of Germany's leading
movie critics, Peter Buchka, concluded that "one does not simply go to a perfor-
mance; rather, one uses it for one's own performance. To a great degree it is a matter of
the mixture of various experiences *[Erlebnis-Mix]*, which such a *special event* promises,
that is important."[18] In the case of *The Rocky Horror Picture Show*, specific scenes and
dialogue have become part of the cult repertoire, functioning as cues for audience
performance.

On the one hand, the popularity of open-air movies may mean that youth audi-
ences are redefining the function of events in their own way for various types of inter-
action that privilege the audience over the cultural production or performance, or

that they are structuring their own interpretations as a basis for performance (in the case of *Rocky Horror*). Although the significance of the film does not dissolve, the film does become relativized as only one part of the experience rather than *the* experience. On the other hand, does this process imply a devaluation of the film medium as a cultural production, if it is reduced to a subordinate or superficial role of background, as if it were mere Muzak? Unlike the ritual reenactment of *The Rocky Horror Picture Show,* which engages the audience in a performative mode (i.e., interacting with the content of the film), open-air movies seem to relegate film to atmosphere. Thus, they may serve similar functions as the drive-in movies, albeit in different historical and social contexts.

Youth Scenes

The shift to audience performance can also be seen in the popularity of rave and techno, as well as subsequent *Love Parade* and *Mayday Party* (rave) events in major urban areas during the 1990s (including Berlin, Zurich, Cologne, Munich, and Vienna) (Henkel and Wolff 1996, 106). The first *Love Parade* in Germany began in 1989 in Berlin with approximately 150 people following a VW van under the banner "Peace, Happiness, and Pancakes." By the late 1990s, the Berlin *Love Parade* was an event (estimated at more than 500,000 participants) promoted by the international media as a "World Party"; promotions included pictures of the Brandenburg Gate in the background, symbolizing postunification, global culture.[19] The parades combine outdoor processions through cities with alternative styles of dress, performance, and music in a carnival atmosphere. However, the participants attempt to resist the commercialization of a "carnival tradition" (like that of, e.g., Mardi Gras in New Orleans; Carnival in Rio de Janeiro, or Fasching or Karneval in Germany) by creating their own fashion or design styles.[20] Although the music and the site are components of the events, they do not constitute them. The meaning of the event is constructed through the participants' own utilization and modification of dress, body decorating, dance, music, and interaction.[21] Techno fans are frequently more interested in producing their own performances and utilizing music they can dance to than in listening to a group on stage.[22] With regard to the role of rave culture in constructing identity for younger women in Britain, Angela McRobbie concludes,

> This interplay of dance, music and image produces a powerful popular aesthetic. Immersion in rave also influences patterns of love and friendship. Despite being ostensibly open to all, the codes of "rave authenticity" which include "white label" tracks, fanzines, flyers as collectors' items, well-known DJs, famous clubs, legendary raves, double meanings in music lyrics, argot, ritual and special items of clothes, are continuously drawn upon as resources for constructing who the raver is. (1995, 173–74)

Events are both linked to and an expression of a subculture's ongoing process of self-definition. For McRobbie, the attraction of subcultures within youth culture is found, in part, within "the modes of empowerment they offer" (174). By shifting the focus

from the artists' (re)production and performance to audience performance and construction of events, the institutional and promotional systems of event development and marketing are at least temporarily destabilized. The "subversive" element of subculture events resides both in their potential to challenge the commercial rationality of a structured marketplace of producers who control financing and distribution and in their potential to reconfigure cultural representation and meaning. Sarah Thornton's research on British rave culture and the media illustrates how youth subcultures also utilize media in the construction of their own subculture:

> Youth subcultures are not organic, unmediated social formations, nor autonomous, grass-roots cultures which only meet the media upon "selling out" or at moments of "moral panic." Micro-, niche and mass media are crucial to the assembly, demarcation and development of subcultures. They do not just represent but actively participate in the processes of music culture. (1997, 188)

Information on the rave and techno scenes (McRobbie 1995) indicates that a significant portion of participants both come from middle-class backgrounds and tend to be employed in middle-class positions (e.g., as a bank teller).[23] Events such as the *Love Parade* offer the opportunity to escape the conformity of these structured workplaces. They are attractive, at least in part, as a subversion of the middle-class stereotype and of media attempts to label and organize their status (e.g., as members of Generation X or Generation Y).[24] For sponsors, it is precisely this tension between resistance or escape on the one hand and accommodation on the other that makes such events useful as sites of intense audience participation. Thornton points out that "moral denunciations" of youth culture in the media are often part of publicity campaigns designed to "render a subculture attractively subversive as no other promotional ploy can" (1997, 184).[25] The higher the level of attraction (or the tension that leads to that attraction) associated with an event, the greater potential the sponsors see for engaging an audience. Within the youth subculture of techno parades, the event represents precisely that domain in which nonconformity (versus the structured rationality of everyday life) is expressed. In this respect, the struggle over the representation of the event within the subculture is truly contested.

The shifting contours of youth subcultures present a challenge for corporations and their sponsorship programs that attempt to assess and organize cultural production. Nonetheless, corporations have become adept at exploring, delineating, and appropriating new cultural territory. One way in which this occurs is, as Grossberg observes, the "attempt to organize taste via the marketing of scenes."[26] Subculture scenes are of special interest to producers of consumer products if they can be defined by "a particular logic which may, in a sense, transcend any particular musical content, thus allowing the scene to continue over time, even as the music changes" (Grossberg 1994, 46). Scenes are characterized by the intersection of cultural practices (fashion, music, language) and sites where they are articulated or acted out.

For Schulze, the desire for collective forms of orientation defines almost all scenes

and involves a notion of community or collective, even if it is not explicitly expressed by its participants (1992, 463–64). In his study of subculture scenes in Germany, he identifies youth scenes as constituting the largest proportion of all types of scenes and, more significantly, exerting the greatest influence on other scenes (e.g., those characterized by high culture, new culture, pub culture, or community-center culture) (470, 494). By observing and attempting to participate in youth scenes, corporate sponsors want not only to gain access to markets but also to enter communication networks within youth scenes that provide "input" for other scenes (Schulze 1992, 494). The commodification of scenes through their representation in promotional culture (e.g., advertising) further reinforces the status of youth culture within media culture at large. A large portion of event culture is composed of events oriented toward youth markets, despite the fact that many events (musicals, festivals, operas, symphonies, or exhibitions) are associated with middle-aged fans or audiences. Many events outside of youth culture reconfigure and appropriate media images from youth scenes, linking them to associations of "youthfulness" or "dynamism," which are especially appealing to middle-aged and older audiences.[27]

The marketing and commodification of the techno scene in Germany resulted in a national or European "Techno Tourism," but it also led to a return to local clubs as the raves or larger events lost their attraction (Henkel and Wolff 1996, 109, 154). Rather than attempting to decipher the "codes" of youth subculture, sponsors chose to develop programs that would allow their market and trend researchers to become part of the scene (Henkel and Wolff 1996, 150) and in some cases to organize it. In fact, sponsors were involved in promoting the *Love Parade* from the very beginning, starting with a modest contribution of DM 700 and progressing to contributions of more than six figures by the mid-1990s. More importantly, sponsors utilized the event as a stage for product promotion and merchandising (Henkel and Wolff 1996, 150). In addition to achieving image transfer, market research on subculture scenes may be a major objective of sponsorships. The data gathered from sponsorships, which provide access to subculture scenes, are then translated into new products and services.

One example of corporate exploration into youth scenes was a promotional campaign linking various youth scenes with events sponsored by Philip Morris and integrating them into an advertising campaign for "Light American" cigarettes in Germany. Each market, which by no means constituted a scene in the sociological sense, was assigned a "minister," who appeared regularly in advertisements and was in charge of coordinating events related to a particular "scene." The "minister for design and fashion" (Isabelle von Waldburg) sponsored competitions for young designers, scholarships at Hamburg's Design Academy, or moderated discussions on fashion trends on television. The "minister for music and nightlife" (Michael Reinboth) sponsored a German tour by French hip-hopper MC Solaar and a competition for best new bands, and he directed the first "DJ Orchestra" at one of Munich's "in" clubs (the Parkcafe). The "minister for love" (Chris Blue) supported an AIDS benefit, sponsored the Museum of Erotic Art in Hamburg, and appeared with the band Love-Modul on

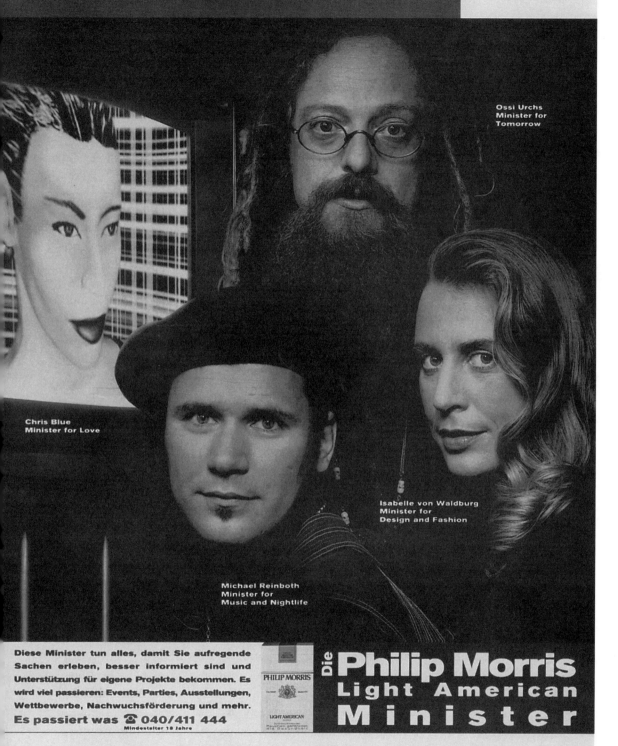

Figure 5.1. Corporate ministers of culture: defining youth subcultures. *Text at top reads,* "The ministers have arrived. 'We work so that you can have your fun.'"

tour. The "minister for tomorrow" (Ossi Urchs) sponsored the Hamburg Media Festival (Hamburger Mediale), discussions on virtual reality, and cyberspace exhibitions.[28] German cigarette manufacturer Reemtsma pursued a similar strategy to expand its presence within the contemporary art scene by sponsoring the international art exhibition *documenta ix* to promote "West" cigarettes through special limited-edition packages and posters designed by Russian artist Konstantin Zvesdochotov. In return, Reemtsma sponsored an exhibition of Zvesdochotov's work in Moscow (Wolf 1993, 365–73).

Various youth scenes are traversed and interconnected for the audience through the organization and marketing of lifestyle events by the "ministers." Identities, crossing youth scenes, are mediated by fashion, dress, design; music, nightlife, and entertainment; love and sexuality; media and computer technology.[29] Eric Hopf directs Hop Hopf Schmitz und Schmitz in Berlin, an agency that specializes in scouting scene trends (e.g., which brands of beer are in or out). However, Hopf concludes that subculture trends change too rapidly to be directly employed for corporate communication. Therefore, his firm attempts to decipher the underlying attitudes of various youth scenes and decode them for corporate managers, who then address scenes using the appropriate language and message. Rather than relying on traditional forms of promotion such as posters and advertisements, agencies organize parties and print their own T-shirts and caps for the event. Like other areas of cultural programming, sponsors increasingly design, initiate, and produce culture rather than simply financing events. Philip-Morris's competitor, R. J. R. Reynolds Tobacco, has also attempted to link their product (Camel cigarettes) with the techno scene by sponsoring large raves and DJ competitions and by producing recordings. However, such promotions do not go unnoticed by the audience they address, and they frequently backfire if they are not carefully designed and implemented. Such was the case when one sponsor produced a special unisex perfume, Eau Techno, which became the object of considerable derision.[30]

As Thornton points out, "Youth culture's hierarchies operate in symbiotic relation to a diversity of media. Media not only act as symbolic goods or marks of distinction, but as institutions. They are crucial to the creation, classification and distribution of cultural knowledge" (Thornton 1997, 188–89; see also Gottdiener 1995, 185). Youth culture draws on the media to reformulate subculture identities, in terms of both resistance and accommodation, while the media respond to new formations within subcultures with their own strategies of resignification and distribution.[31] Although Schulze's analysis implicitly confirms this symbiotic relationship between subcultures and the media, in the sense that they "learn" from each other, he also argues that the institutions of cultural production are primarily reflexive; that is, they orient their activities toward having an effect on their audiences (1992, 425). Subcultures are interested less in their impact on media culture at large than in their impact on their own articulation and formation of identity and in their interaction with other participants within a scene or subculture, although they are not completely indifferent to their ef-

fect on the media. Their primary orientation is to the media culture within the sub-culture and its uses in constructing and communicating identity, such as fashion, posters, T-shirts, flyers.[32] In any case, the relationship between youth subculture and media may be characterized as functionally symbiotic but asymmetrical in terms of institutional production of social and economic relations. Moreover, the representa-tion of the youth scene is a contested space within which the participants (individuals, subcultures, artists, media, nonprofit groups, and corporations) can redefine expecta-tions and meanings within specific contexts of events.

Although techno parades and other events of youth subcultures (or scenes that cut across subcultures) should be considered not as organized social resistance but, rather, as ways that youth subcultures define themselves as what they are not (McRobbie 1995, 173–74), they do indicate a tentative rejection of institutionalized event culture. However, Schulze argues that "our habituation to the institutionalized production of culture has gone so far that we can hardly imagine our own production of culture as a common practice within the realm of everyday aesthetics" (1992, 519). The notion of an unstructured, spontaneous event, or an event not based on the market rationales of "success," seems to be an anomaly within event and media culture, which attempts to appropriate the "spontaneity" of the "happening" and serialize it by buying into suc-cessful events (e.g., concert series or tours) or by creating new events (e.g., techno par-ties and festivals). Indeed, the administrative and organizing logics of institutionalized cultural production (music festivals, theaters, museums, symphonies) are, as Schulze points out, a function of their desired effect on the public (recognition, validation, audience approval) (425). This manufactured spontaneity characterizes the parameters within which many sponsored events occur, such as the revivals of Woodstock in 1994 and 1999.

Woodstock Revisited: Back to the Future?

Events such as Woodstock '94 and Woodstock '99 remind us that although audiences may play an increasingly important role in participation and performance within event culture, the institutionalized production and signification of the event by the media and sponsors assumes a pivotal position in organizing and structuring events. The manner in which this structuring occurs relates to image as well as consumption. In this regard, I will focus primarily on Woodstock '94 in order to illustrate how the original event was recycled and reconfigured, before making some brief comments on Woodstock '99.

Marketing the image of Woodstock '94 involved the simultaneous deconstruction of the original Woodstock (now framed as a passé and somewhat naive event linked to the sociopolitical aspirations and culture of 1960s youth) and the construction of a modified image that, ironically, utilized Woodstock as a cultural signifier of noncon-formity, social harmony, and noncommercialism. This reconfiguration of Woodstock was based on an apolitical, environmentally friendly, and technologically conscious consumerism.

The promoters (PolyGram Diversified Ventures) employed the residual positive images of the original Woodstock while satirizing its anticonsumerist worldview as obsolete. The positive image dimensions included notions of love and sexuality (one promotional item was an official Woodstock '94 condom wrapped in psychedelic foil labeled "I COME IN PEACE"); music as an expression of youth culture, global peace, and the environment. Liquor and cigarette advertisers were rejected because PolyGram believed they would "tarnish" the Woodstock trademark (Milward 1994, 36).[33] The "fabled dove and guitar logo" that subsequently became a promotional signifier for the 1969 Woodstock Festival was modified to two peace doves sitting on the neck of a guitar (Milward 1994, 36). Peace, music, and a sense of community, symbolized by the two doves, linked images of the original Woodstock with the new Woodstock '94 and the later Woodstock '99. Pepsi paid two million dollars for the rights to use the dove and guitar logo in conjunction with its corporate logo, thus facilitating the subsequent image transfer from Woodstock '94 to the Pepsi image and product. Woodstock '94 as a unique event (an *Erlebnis*) epitomizing the experience of "living life" and uniting a "new generation" through its own event was expressed in the slogan "Live it. Love, Pepsi." Meanwhile, the distinct social and political contexts of the two events were essentially depoliticized as part of Pepsi's promotion, as reflected in the financial media's commentary: "In fact, Pepsi may be a perfect sponsor. Earlier this year, it cleverly spoofed Woodstock in a commercial showing yuppies with BMWs and cellular telephones converging on a Woodstock reunion."[34]

Unlike the promotion of the the original event, the promotion of Woodstock '94 left nothing to chance. The primary source of revenue for the sponsors (Pepsi and Häagen-Dazs) was not the event itself but, rather, the income derived from promotion and advertising prior to the event. Pepsi published 10 million copies of a guide to Woodstock '94, available in convenience stores, supermarkets, and movie chains. *Woodstock '94: The Guide* included information on the performers as well as "whimsical" statistics, such as the fact that Pepsi expected the participants to consume 76.2 million fluid ounces of Pepsi and 12 million fluid ounces of Lipton Brisk Iced Tea (also a Pepsi product) (Milward 1994, 36). The promoters, PolyGram, only projected breaking even on the event itself ($30 million in costs versus $33.75 million revenue from tickets), so most of the pre- and postpromotion was targeted toward potential revenues from pay-per-view, soundtrack, movies, home video, and merchandising. PolyGram president John Scher conducted market studies in order to assess which artists and bands would appeal to the sixteen- to twenty-five-year-old target audience for Woodstock '94 and was surprised to learn that older groups, such as Crosby, Stills, and Nash, tested positively (Milward 1994, 36). This is, however, not surprising given the ongoing reception of musical styles and artists associated with 1960s rock and roll and their subsequent promotion as rock classics (e.g., Jimi Hendrix, the Grateful Dead, or Led Zeppelin) (Ross and Rose 1994, 8–9).[35]

ECAUSE IT TAKES YOU PLACES
STREET MAPS CAN'T REACH

BECAUSE IT'LL HELP YOU SCORE
COOL T-SHIRTS

BECAUSE 800 ACRES CAN BE
A SERIOUS HASSLE TO NAVIGATE

BECAUSE IT PUTS YOU
FRONT ROW VIA PAY-PER-VIEW

BECAUSE IT GETS
YOU INTO WOODSTOCK
THROUGH CYBERSPACE WHEN YOU
CAN'T GET THROUGH
THE GATE

BECAUSE IT'S
FREE AND SO
ARE YOU

WOODSTOCK '94

LIVE IT
LOVE, PEPSI

get the guide

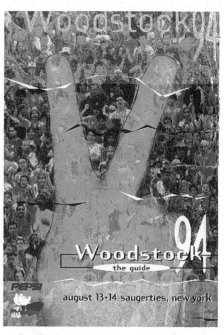

Woodstock 94
the guide
PEPSI
august 13·14 saugerties, new york

AT CONVENIENCE-TYPE STORES CONVENIENT TO YOU
WHILE SUPPLIES LAST

Figure 5.2. Consuming Woodstock.

Woodstock '94: Theme Park for "The Woodstock Nation"

"Festivals within the festival," such as Ravestock at Woodstock, situated Woodstock '94 within the party culture of rave and resignified the original Woodstock:

> Woodstock 69 was one of the biggest parties ever—so big its repercussions are still being felt. We are providing no less an opportunity for Woodstock 94 to become re-nowned as another historic party with the addition of Ravestock at Woodstock.[36]

The Ravestock promotion erases the sociopolitical associations of the original Woodstock and reconfigures it simply as "one of the biggest parties ever." For the pro-moters, Woodstock was only useful as a vehicle for publicizing raves as new event products in the United States:

> Our goal has been to awaken America to the electronic dance revolution by incorporat-ing raves into the festival movement in this country. The Woodstock festival has served to define an entire generation. Woodstock 94 will define our generation and is the ideal vehicle to introduce electronic dance to the masses.[37]

Another festival within the festival, the Mind Expansion Village, employed images of the psychedelic counterculture of the 1960s but resignified them as technological (i.e., occurring in cyberspace) rather than psychological or physiological exploration. The "village" (playing on associations of the "global village") included the Surreal Field and the Communications Village. Both events addressed youth culture through computers and electronic technologies, but they did so primarily in depoliticized, promotional, and product-related terms.[38] MEGA Interactive Festivals, Ltd., de-scribed the Surreal Field as a six-acre "interactive village" designed to "provide a futur-istic experience for the Woodstock nation." The political content of Abbie Hoffmann's "Woodstock nation" was thus transformed into a catchall designation for anyone in the younger generation. The Surreal Field was a promotional festival for technology producers to showcase their products. A compact-disc interactive (CD-I) exhibit "demonstrating music, film and game software titles for this revolutionary home entertainment system in a 200,000 square foot theatrical arena" included a sculpture, a multimedia theater, and an interactive live performance by Todd Rundgren, all sponsored or "showcased" by Philips Media. Apple Computers pro-duced the daily "Woodstock '94 Nation News," which was projected onto image-magnification screens on the main stage and presented game, music, and sports CD-ROMs in the Apple tent. General Cinema Corporation sponsored Peter Gabriel's MINDBENDER, "a ten-passenger capsule style motion simulator" that was billed as "the first music video you can ride."

Danny Scolof, president of MEGA, characterized the fusion of event, entertain-ment, and electronics within "game culture" as "a confirmation of the interactive gen-eration. We are witnessing the cultural impact of the first post-graduates of 'Nintendo University'. These forward-thinking individuals are not content to sit and observe—they participate!"[39] The Surreal Field underscores the function of "interactivity" in

sponsored culture: to engage audiences at specific sites and contexts, not only with other participants but also with the sponsors and their products. "Interactivity," the buzzword among event sponsors in the 1990s, referred to technological modes of expression and mediation (interactive performances) as well as to the use of technology to structure that interaction, for example, in simulated rides, interactive compact discs, and multimedia theaters (such as IMAX) (Schreiber 1994, 241–43). In this regard, game culture is an increasingly important component of youth culture (Grossberg 1994, 54; see also 58n15), since it is an important dimension of how youth use technology to construct culture and identity (Thornton 1997).

The Communications Center Project within the Mind Expansion Village provided interactive links among festival participants and to the "outside world" through a variety of communications technologies: radio network, computer network (e.g., online conferences, video-art, festival news), video art show, and documentaries. These conversations on the Internet were projected onto a 250-foot-wide video screen. With respect to these and other "events at the event" (such as the Eco-Village), Woodstock '94 mirrored similar developments in contemporary environments for consumption, for example, events at malls, at theme parks, or at "hyperstores" (i.e., stores within a store).

Indeed, the future of many festivals may be related conceptually to theme parks or malls,[40] which provide a variety of interactive experiences within the context of larger events. Disney World and other theme parks offer such interactive events on a daily basis, combined with opportunities for product promotion and consumption. The hybridization of themed and event environments is also reflected in urban architecture, such as in the work of David Rockwell, who designs "multisensory" environments, or "Imax-itecture." The *New York Times* commented that "Mr. Rockwell's work embodies the current convergence of technology, entertainment and design" and is indicative of "a citizenry hungry for rapid-fire visual and spatial imagery. . . . It's a type of design that could only exist now."[41] With respect to a cultural politics of space, such strategies facilitate the insertion of corporate interests within the sites of events. They organize, structure, and mediate the aesthetic processes of experiencing events through product images, technologies, and consumption. In this sense, the consumption of the event, as a function of lifestyle, facilitates the integration of the event into patterns of everyday life (and lifestyles) that reinforce patterns of consumption.

Ultimately, the promoters and sponsors of Woodstock '94 were primarily concerned with its commercial potential as a product (with all the related licensing, merchandising, and product revenue) rather than with the event itself. If we consider "Woodstock" as an ongoing process of promotional resignification rather than as a distinctive break in that process, then the original Woodstock and its successors perform similar functions as promotional signs, despite the fact that audiences would construct their meanings differently. Woodstock as a cultural commodity that involves an ongoing process of recirculating and reimaging cultural signs ("love," "global

peace," and "freedom") within changing historical contexts reveals that the *images* of Woodstock in media culture (not the historical events) began to elide.

Apart from Woodstock's capacity to function as a promotional vehicle for the signification of consumer products, it marks a cultural territory that is challenged within and between generations as well as between audiences and sponsors. While the 1969 Woodstock Festival, understood as a paradigm for events that were linked to a philosophical or existential *Weltanschauung,* is certainly over in the sense that most contemporary events can no longer fulfill this function (Schulze 1992), it retains its vitality as a site for the reinscription, defense, or appropriation of cultural meaning. The debate over what Woodstock actually meant (or means) was most apparent in numerous articles and editorials prior to Woodstock '94 and to a certain extent *after* Woodstock '99. For example, in "The Woodstock Wars," Hal Espen describes both the mythologizing and debunking of Woodstock and its function as a symbolic rallying point for generational and ideological conflict (1994, 70–74).[42]

In 1999, remnants of the Woodstock image, defined as anticommercialism, were employed both by the audience and the review media in response to the violence that erupted at the conclusion of the event, resulting in fires, rioting, and sexual assault. *Rolling Stone* attributed the violence (which caused an estimated $600,000 in damage) to the audience's anger over extraordinarily high prices for tickets, food, and bottled water and over the "squalid conditions and greedy promoters" (Hendrickson 1999, 35). (Although the producers, John Scher and Michael Lang, suggested that the succession of three heavy-metal bands may have contributed to the violence, they also conceded that the sanitary conditions were also a factor.) Matt Hendrickson of *Rolling Stone* concluded that, compared with other successful events such as England's Glastonbury Festival, Woodstock '99 failed because its producers were focused primarily on profit: "Other producers of large events agree that if the first rule is to make money, the event is doomed to failure" (Hendrickson 1999, 41). It was indeed ironic that the notion of Woodstock as an event celebrating nonviolence and anticommercialism had been transformed into the opposite. What is relevant for the purpose of our discussion is, moreover, the media discourse underscoring the links between corporate greed and the violent response.[43]

Whether Woodstock is defended by old hippies of the 1960s, rejected by conservative yuppies, considered marketing hype by Generation X or Generation Y, or adopted by segments of youth culture as an expression of love, sexuality, and global peace, audiences can use it to define political, generational, or cultural boundaries. Woodstock became as important for what it was as for what it was not. The intersection of culture *and* politics as an integral component of Woodstock '69's image had to be neutralized in order to employ it promotionally in subsequent versions of the event. Nonetheless, the recycling of the event during the 1990s (much like the introduction of VW's New Beetle), evidencing its ability to be multiply used in culture and politics, marks its longevity as an icon of contemporary youth culture and its latent power of subversion.

It's All for a Good Cause: Mega-Events

Events perform important functions for individuals, groups, and institutions by organizing and structuring the representation of community. Contemporary events usually reference social and political issues covertly rather than overtly. Thus, an opera festival such as the Bregenz Festival may provide the platform for a presentation by an Austrian politician while serving as a promotional vehicle for regional identity. However, any clear relationship between the image of the festival and a sociopolitical agenda is either highly mediated or only articulated through the administrative structure of cultural politics. The cultural politics of events are, for the most part, implicitly rather than explicitly represented.[44] Nonetheless, there are some cultural events that are primarily concerned with their own representation of social or political issues. These events are also illustrative of the way notions of community are constructed and represented within event culture.

One way in which concerts have been linked to social and political action is through "mega-events" for charitable causes (e.g., Live Aid, Farm Aid, Amnesty International's Human Rights Now!),[45] which also receive support from corporate sponsors. Reebee Garofalo characterizes them as "mega" because they expand the involvement of artists, promoters, and audiences beyond the site to include simultaneous events at other international sites as well as broadcasts linking the sites with mini-events staged by participants in their own community or for viewing at home (1992, 257). Most mega-events are related to concert tours or have an international component, although they may be regionally or nationally based. In Germany, Rock against Racism (Rock gegen Rassismus) or the Band for Ethiopia addressed local as well as regional or global issues.

Garofalo explores four functions (discussed by Tony Hollingsworth) of mega-event concerts for charity: fund-raising, consciousness-raising, artist involvement, and agitation (Garofalo 1992, 257, 269n10). High-profile recording artists facilitate the international distribution of mega-events (on television, video, CD, the Internet, and other formats) to mass audiences and become attractive vehicles for sponsors such as Pepsi (Garofalo 1992, 258, 269n14). Artists and audiences seem to be willing to accept the commercialization of the events for fund-raising if they believe in the cause, although sponsors frequently identify themselves with mega-events rather superficially in order to fulfill promotional objectives. Although some rock promoters are reluctant to accept corporate sponsorship, Garofalo argues that

> given the scale of mega-events, however, most would be impossible without some kind of corporate involvement. Amnesty International's Human Rights Now tour would have gone bankrupt had not Reebok bailed them out at the last minute. Further, there is a more optimistic reading of the situation: that the power of popular music—and, in particular, the phenomenon of mega-events—has obliged corporations and world leaders to accommodate initiatives that are essentially left wing or progressive. (263)

However, Garofalo also concedes that charitable mega-events are frequently open to appropriation or manipulation. For example, Margaret Thatcher delivered "a pre-taped message on Britain's concern for the environment" for an environmental fund-raiser, Our Common Cause at Lincoln Center. The event included artists, entertainers (e.g., Herbie Hancock, Sting, Richard Gere), and scientists. It was sponsored by Sony, Panasonic, and Honda—all of whom prominently displayed their logos in the telecast (Garofalo 1992, 263). The corporate leaders of Reebok, which spent approximately ten million dollars to finance Amnesty International's Human Rights Now! tour to four-teen countries, seem to have been sympathetic to the cause, although they were wary of aligning themselves too closely to it (T. Harris 1993, 228; Ayub 1993, 66–69). On the other hand, some sponsors may be willing to accept a level of calculated risk with respect to social issues precisely because they offer the potential of high-profile events.

Viewing sponsorship of mega-events strictly as a necessary evil or a means to an end may underestimate the significance of a network of interdependencies among product culture, its circulation, and the broader context of cultural production and the mass media. Most sponsorships are integrated into a comprehensive promotional program that addresses audiences in diverse media and event formats. The impact of a promotion is cumulative and aggregate. (Although a single event may have a dramatic impact on altering audience attitudes, positively or negatively.) Although some audi-ences may regard corporate involvement in charitable mega-events skeptically, corpo-rations also understand the limits of the events' impact on audiences and are pragmat-ic about any financial returns (T. Harris 1993, 228). There seems to be little evidence that charitable mega-events per se will, as Garofalo suggests, oblige sponsors to as-sume more-progressive positions. It is more likely that corporate entities, particularly multinational corporations with diverse audiences and multiple agendas, will negoti-ate many sources of influence, be they governmental, market, or internal. Moreover, corporate policies that appear to be socially progressive in one area (e.g., employee relations) may be regressive in others (e.g., environment, consumer issues, or health care). Moreover, their policies within foreign subsidiaries and subcontractors may lead to further contradictions and conflicts with the articulated policy of the corporate headquarters. Mega-events may contribute to a shift in sponsors' attitudes and social policies when sponsors recognize that consumers articulate a sustained, critical aware-ness of the links between corporate politics and products. Because mega-events tell us little about the relative progressiveness of their corporate sponsors, they are at best a weak indicator of corporate responsibility rather than a catalyst for change, as Garofalo suggests.

With respect to the audiences at mega-events, Garofalo sees their potential in terms of activating, organizing, and mobilizing support for existing organizations that will "enlist people directly into the ongoing political activity of the organization." For example, Amnesty/USA gained 200,000 new volunteers as a result of the Conspiracy of Hope tour (Garofalo 1992, 248–49, 268; Storey 1996, 111–12). (In Germany, Am-nesty International rarely works with sponsors; Ayub 1993, 67). Mega-events linked to

high-profile, socially engaged organizations (e.g., Greenpeace, Amnesty International) may facilitate volunteer recruitment and provide a sense of community or shared purpose for the participants. The communal character of these events is channeled through the collective experience of mega-events as a central component of subculture scenes and shared lifestyles (Graf 1996, 97–98). And it is perhaps in this dimension that some vestiges of a relation between "a philosophy of life" and the event, to which Schulze refers, may still exist, albeit through much more diffuse forms of expression and rebellion.

Yet Garofalo concludes that mega-events cannot simply serve as recruitment or promotional devices for nonprofit causes if their objectives are not translated into political action at the macro level. Live Aid organizer Bob Geldof believes that audiences may also become accustomed to the proliferation of "special" mega-events within event culture:

> We've used the spurious glamour of pop music to draw attention to a situation, and we've overloaded the thing with symbolism to make it reach people. But people get bored easily. People may have been profoundly affected by the Live Aid day—some were shattered by it—but that does not translate into a massive change in consciousness. (Quoted in Garofalo 1992, 268)

Ultimately, Garofalo links the political power of the mega-event to its potential as a catalyst for change rather than as a source of consciousness, and "for those interested in lasting structural change, it has to be recognized that they are no substitute for a political movement" (268–69). Although Garofalo's use of the term "mega-event" is linked with progressive issues and organizations, we should also remember that mega-events could be used for agendas of social conservatism or for those more susceptible to resignification by the sponsors.

The latter may be the case with respect to broad-based fund-raising events for food, children, or world peace that consciously avoid ties with liberal political groups (such as Greenpeace or Amnesty International). For example, a mega-event to combat hunger in the United States, Hands across America (1986), was created by Coca-Cola and Citibank in order to capitalize on the success of the international We Are the World campaign against hunger by projecting the notion that the corporations were involved in community charitable causes—or what Schreiber calls "the new customer partnership"—and product promotion (Schreiber 1994, 3–6). The sociocultural politics of this "partnership" are clearly embedded in the promotional strategy expressed by Coca-Cola's head of public affairs:

> Hands Across America was right for the time in America, and right for Coca-Cola. American concern for homelessness and hunger were at an all-time high. We had just come off the controversial New Coke introduction and Classic Coke reintroduction. We needed something to re-bond the company with America. It was perfect. (Quoted in Schreiber 1994, 5)

More than 4 million people participated in the event by joining hands on 25 May 1986. The Coca-Cola/Citibank promotion involved public schools (80 percent of U.S. junior high schools received social studies kits on hunger and homelessness), the media (satellite broadcasts and extensive coverage in the press as well as a "Coca-Cola Radio Network" associated with DJ Dick Clark's United Stations), celebrity volunteers, theme parks, baseball parks, and a "Coca-Cola Cord" strung across sparsely populated areas of the Southwest.

Hands across America illustrates the intersection of social and cultural sponsorships in corporate cultural politics and the way sponsors appropriate events for charitable causes and notions of community to create a shared identification with their products and image. Such events also indicate that corporations are assuming the functions of creating and producing social programs (previously considered the domain of nonprofits and government) and are structuring them as events designed to augment promotional objectives. Yet the process of cultural programming and corporate promotion is constantly subject to its own resignification and social legitimization. Consumer loyalties to brands, services, or perceived images can disappear overnight, and profiles of consumers per se become more illusive. The emergence of social sponsorships as a component of corporate cultural politics is a recognition of the fact that corporate legitimacy must be continuously validated.

Perhaps the real potential for engaging subculture scenes for social and political causes is, at least initially, at the microlevel of organization rather than at the top-down macrolevel of production and promotion associated with media mega-events. Local initiatives can still address international or global concerns through grassroots events linked with local interests, despite their limited media exposure. This is illustrated through local organizations such as the Munich nonprofits Sarajevo Is Next (SiN) and Sarajevo Music Forum (SMF). Protestant groups at Munich universities developed SiN in 1994 as a result of contacts established in Bosnia during relief efforts, leading to active cultural exchanges between Munich and Sarajevo.[46] With the political assistance of the head of Munich's Social Democratic Party working with officials in Sarajevo, SiN organized the successful Futura Sarajewo techno festival, which was attended by 4,000 in Sarajevo in 1998. (Earlier, high-profile groups, such as U2, had promised to encourage other bands to perform in Sarajevo, but these plans never materialized.)

At least one objective of the event was to create opportunities for Sarajevo youth to share cultural experiences that would rebuild a sense of belonging and community. A parallel techno festival in Munich, Post Futura, provided the participants with information on the social context of Sarajevo by showing Adi Sarajlic's prize-winning documentary film *Streets on Fire* (1997) prior to the festival. In addition, leaders of the SiN and SMF involved Sarajevo students in rebuilding the city's cultural infrastructure through plans for a new cultural center, with partial funding provided by the EU and sponsors. The program also offered internships in cultural management and media in Munich for interested students.

Although local initiatives like SiN are certainly not immune to the exigencies of fund-raising and the interests of sponsors, their local emphases and more tightly focused objectives make them less appealing for the type of national mass promotion and commercialization of social spaces (e.g., in schools) manifest in Hands across America. The interaction between Munich and Sarajevo provides a basis for ongoing social change through local initiatives rather than the ephemeral impact of most mega-events, which lack sustained community involvement at local levels. Despite their greater fund-raising potential, extensive media coverage reaching mass audiences, and cooperation with international aid organizations, most mega-events do not create the foundation and continuity for institutional involvements and collaborations—among local political, cultural, and humanitarian organizations—that would simultaneously activate, unite, and strengthen subculture communities for social causes.

The Wrapped Reichstag

Finally, I would like to examine an event that illustrates a very different function with respect to community, the public sphere, and cultural politics in Germany during the 1980s and 1990s: Christo and Jeanne-Claude's *Wrapped Reichstag*. From the outset, the concept of wrapping the Reichstag represented a more subversive response—to the site, to the historical image of the building itself, and to German cultural politics of national identity—than any other event in recent decades. The project (formally titled *Wrapped Reichstag, Berlin, 1971–95*) reproblematized the cultural politics of national identity and of corporate sponsorship. Manfred Enssle and Bradley Macdonald observe that the project posed a series of challenges to contemporary paradigms of public art and its financing (1997, 1–2, 11).

The first and perhaps most important provocation relates to the site and its signification. When Christo and Jeanne-Claude first conceived the project in 1972, the Reichstag was located in the center of a divided Berlin, next to the Wall, and symbolized the historical experience of a divided nation as well as the East-West conflicts of the Cold War. In 1986, Christo remarked that "the building is of the greatest importance with respect to the German nation and European history and it is related quite dramatically to that which Germany is today." Christo was more concerned with the symbolic character of the Reichstag and its environment than with the architectural features of the structure: "I'm primarily interested in the site. The building in and of itself is not especially interesting" (quoted in Yanagi 1993, 23, 26). After German unification, the symbolic power of the Reichstag site still carried its historical associations; however, these also assumed a new dimension: the debate on Germany's new capital (Bonn versus Berlin).[47]

The notions that the meaning of art could develop out of its relationship to the political and social symbolism (embedded in the site of its production and exhibition) and that this symbolism could be employed as a form of "material" for the creation of the artwork reinserted the controversial relations between art and politics into the debate over a cultural politics of national identity.[48] The temporary character of the

wrapping and viewing by the public also stood in contrast to the perceptions of "permanence" and "continuity" that many associated with the Reichstag. The project challenged both the permanence of the work of art and its mode of exhibition (i.e., enclosing a public building at a public place rather than in a museum), and in doing so it contested representations of the Reichstag based on a cohesive national identity. Enssle and Macdonald argue that, through its interrogation and deconstruction of notions of immortal, auratic art and its provocative resignification of public space, the *Wrapped Reichstag* "engender[ed] both a 'game with time' and a 'community of dialogue'" that functioned "both as an aesthetic event and as a cultural—indeed historical and political—intervention" (1997, 1–2).

Both before and after unification, the political and cultural debate over Christo and Jeanne-Claude's project reiterated the symbolic importance of the Reichstag and its representation with respect to national identity. In the late 1970s, Bundestag president Carl Carstens (Christian Democratic Union [CDU]) had rejected the project, fearing that the symbolic integrity of the building could be damaged, while the mayor of Berlin, Claus Schütz (Social Democratic Party [SPD]), and the head of the Social Democrats, Willy Brandt, embraced the project.[49] Political debates during the 1970s and 1980s culminated in a narrowly approved Bundestag vote (292–223) for the project in February 1994. The Bundestag's formal approval could not, however, resolve the inherent contradictions of the so-called Bonn Republic's cultural politics of national identity, which failed to come to terms with a conflicted past or present *(Vergangenheits- oder Gegenwartsbewältigung)*, which the Reichstag represented. (Chancellor Helmut Kohl, for example, had opposed the project.) Wolfgang Schäuble (CDU/Christian Social Union [CSU]) assumed a paternalistic view of the project's reception and interpretation ("So many people would not be able to understand and accept it"), which also became the basis for his political argumentation. Schäuble perceived the Reichstag as a symbol of German parliamentary democracy and unity. Employing the political vocabulary of unification, Schäuble asserted that the project would polarize rather than unite the nation.[50] Peter Conradi (SPD) and Freimut Duve (SPD) referred to the positive value of the project as a counterbalance to negative media images of Germany resulting from hate crimes against foreigners during the early 1990s (e.g., in Rostock, Mölln, Solingen, and Hoyerswerda). Conradi and Duve argued that German self-confidence in its national identity could not be fragmented by simply wrapping the Reichstag. Rather than resolving the differences in a cultural politics of national identity, the debate over the Reichstag project performed an important function by reproblematizing the relationship among politics, art, and commerce. In this respect, the political and cultural debates over the Reichstag became a prologue to discussions over the reformulation of postunification cultural politics in the late 1990s, particularly with respect to public spaces, representation, monuments, and remembering.[51]

Christo's own financing of the 15-million-mark project (through the sale of signed limited-edition prints, drawings, and models) presented an alternative paradigm to government or corporate funding of public-art projects.[52] The financing was also an

important part of the project's design. The artists wanted to create an open area surrounding the Reichstag in which public discourses, performances, and forms of social interactions could occur without the structural or organizational constraints of government intervention or corporate sponsorship (e.g., advertising, VIP tents, public or private receptions, or sponsored "events at the event"—all of which attempt to organize and structure audience participation).[53] Indeed, Christo and Jeanne-Claude have consistently rejected public and corporate funding for their projects:

> By financing this project myself, I preserve my integrity. On the other hand, sponsors and public offices do not have the possibility of becoming involved in such a project. In 1972, when we initiated this project, there were so many people against it, that no foundation, government agency, or institution would have become involved in something that was so controversial, contested, and difficult. However, all of this belongs to the reality of my project. It is the subversive dimension of my work, which normally stops people from participating in it. (Quoted in Yanagi 1993, 29)

The Reichstag project was not a naive attempt to deny political, commercial, or media influences or uses; rather, it recognized these frequently contradictory interests and engaged them as part of the project itself, for example, during the extensive political debate over the project. In order to realize the project, Christo and Jeanne-Claude had to become involved as lobbyists for the *Wrapped Reichstag*, making fifty-four visits to Germany between 1976 and 1995. The preliminary process of engaging the public spheres of politics and cultural criticism—through meetings with public officials, Bundestag presidents, and the media—became an integral part of the work and preparation for its ultimate realization after unification (Enssle and Macdonald 1997, 5).

Once the Reichstag was wrapped, it was an overwhelming success in the media as well as with politicians (including Helmut Kohl), who immediately called for the installation to be extended beyond the 23 July 1995 deadline and suggested that some of the additional costs for security could be financed through corporate sponsors. Politicians pointed to the approaching summer vacation season during late July and August and the importance of making such a "world attraction" available to the public.[54] The attempt to capitalize on the *Wrapped Reichstag* project as a logo for the "new Germany" (which received positive reviews in the international press) and as an economic stimulus for the Berlin economy was indicative of the reformulation of foreign cultural policy based on the "synergy" of "culture, commerce, and the institutions of foreign policy."[55] Of course, the plan to transform the *Wrapped Reichstag* into a longer "attraction" was rejected by Christo and Jeanne-Claude, who resisted its institutionalization as a fixture of governmental cultural programming.

The success of the *Wrapped Reichstag* as a political and cultural event was a result of its intrinsic challenge to contemporary events in terms of their logics of location, organization, repetition, permanence, technological (especially audiovisual) mediation, and structured signification. The *Wrapped Reichstag* was a postmodern project to the

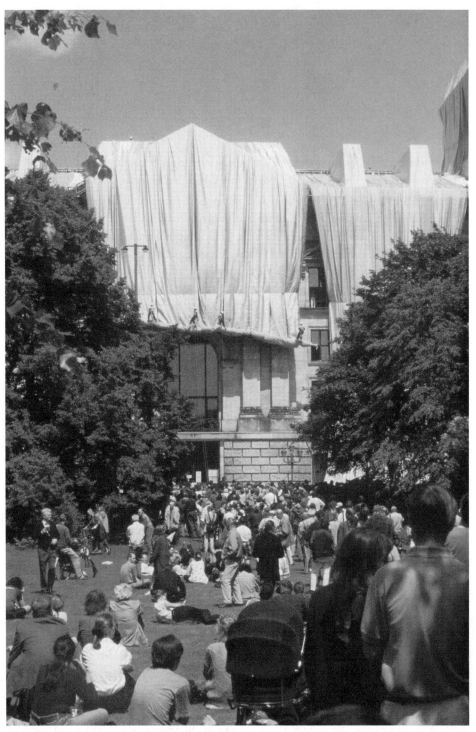

Figure 5.3. Christo and Jeanne-Claude, *Wrapped Reichstag,* south facade (wrapping in progress). Photograph by Dave Yust/Colorado State University.

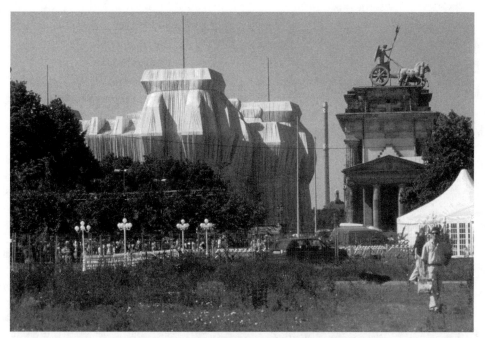

Figure 5.4. Christo and Jeanne-Claude, *Wrapped Reichstag* and Brandenburger Tor: symbols of the "new Germany"? Photograph by Dave Yust/Colorado State University.

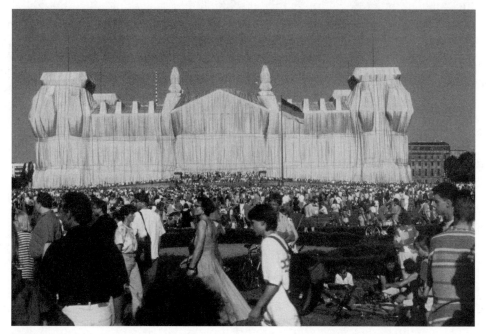

Figure 5.5. Christo and Jeanne-Claude, *Wrapped Reichstag,* west facade. Photograph by Dave Yust/Colorado State University.

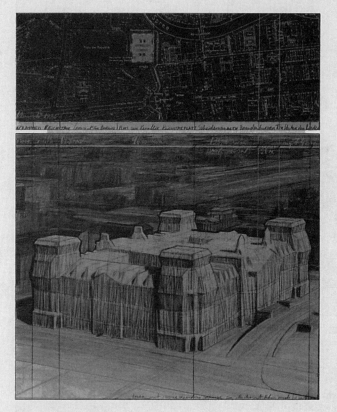

Christo, "Wrapped Reichstag -
Project for Berlin", Collage 1986
Im Besitz der Berlin Hyp.

Zeichen
des Neubeginns

Das Reichstagsgebäude ist eng mit der deutschen Geschichte dieses Jahrhunderts, mit ihren Höhen und Tiefen verbunden. Nur wenige Meter vor seiner Ostfassade stand seit 1961 die Berliner Mauer. Aus dieser Zeit stammt die Idee des Künstlers Christo, den Reichstag zu verhüllen.

Die veränderten politischen Umstände haben seinem Projekt neue Aktualität verliehen. In der Verhüllung des Reichstages, vor seiner Wiederherstellung als Sitz des Deutschen Bundestages, liegt die Chance, eine Zäsur in der Geschichte sichtbar zu machen. Die künstlerische Aktion erlaubt einen neuen Blick auf den Ort und seine Bedeutung. Und sie kann ein Zeichen setzen für den friedlichen Neubeginn in der Mitte Berlins.

Als eine der führenden Hypothekenbanken in Berlin und Brandenburg trägt die Berlin Hyp zum Aufbau der Stadt und des Umlandes bei. Unsere Unterstützung zeitgenössischer Kunst ist selbstverständlicher Bestandteil unseres Engagements für die Entwicklung der Hauptstadt.

Berlin Hyp
Berliner Hypotheken-
und Pfandbriefbank AG

extent that it utilized a widely received symbol as a medium to "de-doxify" (Hutcheon 1991, 7) or destabilize institutionalized representations of the symbol (the Reichstag) itself. This is the subversive character of the project, referred to by Christo, which intersects with a critical "postmodernism of complicity and critique that at once inscribes and subverts the conventions and ideologies of the dominant cultural and social forces" (Hutcheon 1991, 11). Through its visual aesthetics of negative space (defining the object in terms of the space around it rather than the space it occupies), the project presented a catalyst for the signification of what the Reichstag was not rather than investing in a resignification of what it was. The Reichstag's symbolic power as a political and historical signifier provided the attraction of the event for the spectator while the (subversive) deconstruction of the relations that have defined its representation (e.g., permanence and continuity versus temporality or rupture) became a catalyst for public discourse and interaction. By intentionally problematizing the representation of the Reichstag, the project facilitated public involvement both through spectators' participation in the event at the site and through public discourses regarding the representation of the Reichstag/*Wrapped Reichstag* (as an art form, national monument, or political institution) that occurred in the media.

Although the response to the *Wrapped Reichstag* seemed to be largely positive, the significance of the project cannot be seen solely in terms of its popular success (and festival atmosphere); rather, its significance must be considered with respect to its potential to engage discourse on culture and politics within a domain temporarily freed from institutional interests. Enssle and Macdonald consider the project in relation to Jürgen Habermas's suggestion (based on Albrecht Wellmer) that aesthetic experience "permeates . . . our cognitive significations and our normative expectations":[56]

> To be sure, discernible emancipatory reverberations did not result from the Christos' ephemeral aesthetic project. For some people . . . the momentary release or epiphany created by the aesthetic spectacle sufficed; thereafter life went on. In this sense, the experience, like other "leisure" activities in the capitalist life-world, provided little more than a needed respite. . . . On the other hand, new games with time and novel communities of dialogue became possible because the *Wrapped Reichstag* opened a physical and mental space of autonomy. In this space, human beings, if only opaquely and briefly, could choose to practice and imagine—indeed celebrate—transcendent human possibilities. (Enssle and Macdonald 1997, 20–21)

In her discussion of Christo's El Tejon Pass project *(The Umbrellas, Japan-USA, 1984–91)*, Judith Baca argues that *The Umbrellas* did not sufficiently engage multiple perspectives and communities (i.e., Native Americans) in order to integrate art in public spaces more fully into the everyday life of diverse communities inhabiting those spaces (1996, 134–35). However, the *Wrapped Reichstag* seems to more directly reference the historical and cultural memory *and* the participation of communities in

Figure 5.6. A Berlin bank promotes its interests in cultural politics through art acquisitions.

interrogating the representation of the site. To a much greater degree than other projects (such as *The Umbrellas*), the *Wrapped Reichstag* references the cultural, historical, and political ideologies inscribed in the Reichstag and the space it occupies within Germany. By stimulating diverse discourses within the actual urban space of the Reichstag (e.g., as it references the ideological and physical spaces of a divided Germany) and the multiple communities who experienced it, Enssle and Macdonald argue, the project had "initiated a unique politics of everyday life . . . providing the possibility of contesting the constraints of the organized life-world" (1997, 15). Yet Christo and Jeanne-Claude's project stops short of engaging communities collaboratively in the production of culture in public spaces in order to foster their own participation in the process of representing communal identities and spaces. Such an approach was used in Baca's *The Great Wall of Los Angeles* project (Lacy 1996, 202), in community-based projects (e.g., Bonnie Sherk and *A Living Library*) (Lacy 1996, 275–76), or in projects sited within corporate spaces (e.g., Clegg and Guttmann's *Museum for the Workplace*).

Despite these reservations, the *Wrapped Reichstag* marked a distinct departure from contemporary event culture, and from many of Christo's past projects, in its potential to stimulate public dialogue on German culture, politics, and national identity. The *Wrapped Reichstag* utilized attraction as a form of subversion to destabilize the object of the event itself (the Reichstag). Even the visual attraction of the *Wrapped Reichstag* activated the public's own sense of visualization and fantasy rather than employing audiovisual effects as a strategy of suggestion.[57] In this respect, the *Wrapped Reichstag* did not utilize multimedia technology to organize or structure experience; rather, it shifted the construction of the event experience to the audience, and in doing so it invited spectators to participate in and assume responsibility for redefining the process of experiencing the Reichstag and the historical, cultural, and political spaces it occupies.

Part III

Museums, Cyberspace, Audiences

6. The Sponsored Museum; or, The Museum as Sponsor

The museum must redefine the notion of art as property and its valuation in a centralized market-place of capitalized goods and ideas. The museum must be an open text of possibility, become a hybrid space and culture engaged in communication and technologies, through projects that constantly question its ends. In this way the museum can redefine itself for the next millennium and contribute to the rethinking of art and culture.

— **John G. Hanhardt, *Acts of Enclosure***

Breaking Down the Walls

The museum assumes a central position in the institutional mediation of culture. Andreas Huyssen has identified it as "a key paradigm of contemporary cultural activities" (1995, 14). As a result of its privileged status in cultural representation and mediation, it has become an attractive venue for sponsorships that reinforce the institutional convergence of museum, sponsor, and public cultural policy. We have also observed that the museum provides a staging area for events, for its own public-relations activities, and for corporate or public interests. Indeed, museum culture and event culture may be partially merging. Both are characterized by similar orientations to materiality, immediacy (e.g., "blockbuster" exhibitions), the primacy of visualization (e.g., the "visual character of tourism," Urry 1995, 140), and, more recently, interactivity between audiences, exhibitions, and technologies as dominant modes of communication.

Thus, contemporary analyses of the museum frequently intersect with notions of event culture. I have suggested that events not only be investigated in terms of problematizing the assumptions of the event itself (which Tschumi relates to architecture), but also with respect to their *potential* to attract or entertain *and* simultaneously subvert (i.e., challenge the assumptions of the event). Woodstock and the *Wrapped Reichstag* provided examples of contemporary events that operated within the modalities of both entertainment and subversion. In his discussion of audience response to the blockbuster exhibits of the 1980s, Huyssen proposes that audience desire be recognized as an inherent component of contemporary culture and be productively integrated into exhibitions and curatorial practices: "It is not exactly a new idea to suggest

that entertainment and spectacle can function in tandem with complex forms of enlightenment in aesthetic experience" (1995, 24). John Hanhardt refers to the tension or dialectic between entertainment and subversion, or between the museum, its exhibition practices, and the audience, when he calls for the museum to initiate "projects that constantly question its ends" (1995, 47). Huyssen expresses this ongoing redefinition of the museum in terms of fulfilling an anthropological need directed toward the past and present, envisioning its potential as "a space for creative forgetting":

> Fundamentally dialectical, the museum serves both as burial chamber of the past—with all that entails in terms of decay, erosion, forgetting—and as site of possible resurrections, however mediated and contaminated, in the eyes of the beholder. No matter how much the museum, consciously or unconsciously, produces and affirms the symbolic order, there is always a surplus of meaning that exceeds set ideological boundaries, opening spaces for reflection and counter-hegemonic memory. (1995, 15)

Although the following studies of contemporary museums point to a convergence of interests among museums, corporations, foundations, and governments, the reconfiguration of the museum's mission and its curatorial practices also draw our attention to the dissonances and paradoxes within and outside the museum that create spaces outside of institutionally defined boundaries for counter-hegemonic culture. Before turning to a closer examination of the emerging contours of the global museum, I would like to highlight some of the theoretical perspectives relevant to our investigation of the relations between museums and corporations.

A significant feature of the museum is its transformation into a multiple-use cultural center that incorporates production and audience interaction. Architect Ian Ritchie identifies the Centre Pompidou as a paradigm for this new synthesis of museum and cultural center. More specifically, he perceives a change in the interrelationship among three factors: image (the museum's location and function within urban space as a privileged site), container (the "internal spatial experience" visitors share with one another), and contents (the interaction between visitors and the objects of the museum's collection):

> The traditional notion of the museum is being challenged by contents becoming events and container becoming catalyst, which, in turn, is leading the contemporary museum to become the place not of study, but of provocation and debate (e.g., the Pomidou Centre, Paris; the Ecology Gallery at the Natural History Museum, London). This can be restated as a decision on the part of museum directors for the museums to be part of today's real world and to be an active educational ingredient in our thoughts about the future. (1994, 12)

In Germany, Christoph Vitali, director of Munich's Haus der Kunst, has promoted the museum as a cultural center for younger urban audiences. Evening and weekend events integrate entertainment with information, discussions, and guided tours of exhibitions. Yet Vitali claims to attract audiences to the exhibitions themselves, rather

than instrumentalizing them as promotional packaging. He reports that 8,000 guests at a film and disco "Party in the Museum," sponsored by Philip Morris, viewed a Richard Lindner exhibition well into the early morning: "Our hope of introducing new segments of visitors to art in this manner was fulfilled" (Bosetti 1997, 122). Student memberships entitled younger subscribers to special events at the Haus der Kunst throughout the year, while wealthy patrons participated in Vitali's personally conducted art tours.

At the same time, he has attempted to increase consciousness of the historical function of the museum by integrating a permanent exhibition on the Haus der Kunst under National Socialism into the entry wing. By focusing attention on the museum's historical function as an instrument of National Socialist propaganda, he also directs the public's attention to its contemporary function: It is not merely an entertainment venue but also a site where both the historical and contemporary relations between art and politics are crystallized (Vitali 1997, 5). However, it is not clear whether the permanent exhibition documenting the role of the museum during and after National Socialism (located in the wings of the foyer) will eventually be overlooked by most visitors or become an integral component of contemporary exhibition practices that interrogate the museum's own interests, both past and present. Thus, the Haus der Kunst represents the dynamic tension between entertainment and missions of museum pedagogy. Vitali's reformulation of the Haus der Kunst marks the redefinition of the museum with respect to its relations with the public. This is not just a part of the wider democratization of museums that occurred during the last three decades of the twentieth century; it is also a distinctive feature of museum marketing and promotion, which integrates the museum into urban lifestyles and event culture (Schulze 1992, 422–23).

Another example of this process is provided by Jean-Christophe Ammann, director of the Frankfurt Museum for Modern Art, who invited Karl Lagerfeld to introduce the new Chanel fashion collection in the museum. In a scene reminiscent of Andy Warhol's happenings, model Claudia Schiffer wore new Chanel fashions while dancing on artist Katharina Fritsch's installation *Tischgesellschaft (Dinner Partners)* (Bosetti 1997, 122). In a similar vein, the Kunstmuseum Wolfsburg exhibited sketches by fashion designer Wolfgang Joop and offered visitors free samples of Joop! perfume and cosmetics. Although both instances indicate the extent to which the museum has become the site of postmodern performance and event culture, they also reflect a significant role reversal. Museums now stage and mediate the promotional activities of commercial enterprises (in this instance, Lagerfeld and Joop) while deriving their own promotional value from events in order to increase attendance. Meanwhile, corporations are increasingly exhibiting and mediating culture (not limited to corporate products) through their own museums. The blurring of functional boundaries underscores the extent to which the interests of corporate and nonprofit institutions are converging—a process that has been facilitated, in part, by the redefinition or erasure of institutionalized notions of high, low, and commercial culture which I discussed in chapter 3.

Figure 6.1. The fashionable museum: the Giorgio Armani retrospective at the Guggenheim.

By joining other cultural centers offering entertainment, information, and education (e.g., theme parks, shopping complexes, urban tourist venues, and universities), museums attempted to reaffirm their social legitimacy and reinforce their fiscal stability at a time when budgets for new projects, particularly in postunification Germany, were becoming increasingly dependent upon private patronage and corporate sponsorship. In order to survive within a marketplace that has organized the commodification of experiences (Schulze 1992), the museum has assumed some of the functions of other cultural institutions (education, public outreach, entertainment). Meanwhile, the museum's "competitors" (corporations) have appropriated some of the museum's own functions, such as representing, exhibiting, and mediating cultural and technological artifacts in corporate museums (a dimension which I will also investigate later in this chapter).

As the museum redefines itself and is defined by internal and external forces, the distinctions between cultural institutions become less clear. By adapting the survival strategies utilized by other cultural producers, museums have, since the 1970s, been able to maintain and expand their programs and meet public-policy demands for increased access. However, they have also had to reformulate their own distinctive institutional image. In any case, the redefinition of public cultural politics in terms of markets and public-private "partnerships" (discussed in chapters 2 and 3), suggests the integration of cultural politics into a marketplace for events and experiences. This process also reflects a convergence of interests between market-oriented cultural production (i.e., the entertainment, media, and consumer product sectors) and nonprofit or public institutions (Schulze 1992, 528–29).

Whereas the government role of cultural politics in the United States has been relegated largely to a marketplace driven by local public support and private sponsorships, in Germany this process of convergence and assimilation is still characterized by a tension between political and market interests (Schulze 1992, 529). For Gerhard Schulze, German cultural politics is situated between two poles that characterized institutional culture prior to unification, that is, within a spectrum between (1) the total dominance (or politicization) of culture as it existed in the former German Democratic Republic (GDR) and (2) the liberal market models of apparent nonintervention as practiced in the United States and the United Kingdom (522). Although Germany tries to avoid either of these extremes by "attempting a balancing act between neutrality and politicization" (523), Schulze concludes that it has become difficult to uncouple the rationality of the general market for experiences and events *(Erlebnismarkt)* from cultural politics, particularly as nonprofit institutions compete with commercial entities for audiences and revenues (528).

Thus, we can observe two separate but related forces operating in the redefinition of the museum. First, museums gradually incorporate many of the functions of other cultural centers. Second, they simultaneously distinguish themselves from other competing museums and cultural centers through thematic specialization. Both aspects— *functional de-differentiation* and *thematic specialization*—are indicative of the process

of cultural hybridization. For example, the proliferation of new science and technology museums in Europe and North America, as well as the various permutations of theme parks with their historical or cultural emphases, signify the process of hybridization and de-differentiation (Lash 1991, 5, 11–15). The Rock and Roll Hall of Fame and Museum (Cleveland, Ohio) mediates and represents contemporary history from the 1950s to the present by fusing elements of popular culture and music in its exhibitions and curatorial practices. As a Hall of Fame that regularly inducts new members *and* a museum that offers the spectator the narrative of the "legends" of rock-and-roll history through multimedia and memorabilia, the center combines elements of a museum, theme park, information center, and festival (e.g., when performances are linked with downtown events).

In *Consuming Places* (1995), John Urry traces the relationship between postmodern tourism and the significance of place. Hybridization reflects the fact that postmodern tourism is "segmented, flexible and customised" (151). As touristic practices become a part of everyday life, the museum becomes less a part of "cultural tourism" than an integral part of lifestyle: "The contemporary subject inevitably engages in what we might call tourist practices much of the time. In postmodernity many spheres of social and cultural life are de-differentiated. Tourism is nowhere and yet everywhere" (150). Museums assume a pivotal position in cultural tourism and regional politics due to their importance as a signifier of urban marketing or the "packaging of local identity" (169). The museum as factor for regional marketing *(Standortfaktor)* is utilized to define both local, national, and European identities. However, Urry also points to the obvious paradoxes of conflicting interests when regional urban centers compete for tourist expenditures, a phenomenon that will accelerate with greater mobility between European cities (e.g., the Eurostar from London to Paris offers weekend shopping packages).

Walter Grasskamp considers the processes of de-differentiation in terms of the internationalization of museum architecture and museum management. These processes have extended to smaller regional museums and have gradually eliminated historical distinctions between museums, based on national or regional identities or distinctive collection profiles (1992, 90–91). He argues that the internationalization of museum management and the proliferation of new museums may lead to a legitimacy crisis if museums can no longer perform their traditional functions: selection, filtering, and endowing artifacts with privileged status through curatorial and exhibition practices. Grasskamp questions whether demands to expand holdings will eventually relativize collections as a whole and in doing so undermine the museum's status as a cultural arbiter and filter. If selection criteria lose their plausibility, he argues, a crisis in selection policies (and legitimacy) is sure to follow (1992, 93–94). While it is precisely this problematization of selection and curatorial practice that many critics and artists (e.g., Crimp 1993; Hanhardt 1995; Huyssen 1995) welcome as an opening for the new museum—indeed, a necessary process in redefining the museum—Grasskamp suggests that the museum's social function may inevitably

erode as it is subject to conflicting cultural and political interests: "In any case, the art museum's task of distilling the arrogance of the marketplace, the influence of collectors, the unreasonable demands of the bureaucracy, and the entry applications from the depots into a socially unifying essence is not becoming any easier" (1992, 97).

If the museum can only survive by constantly redefining its own mission, contexts, and interactions with audiences and markets, can it maintain sociopolitical legitimacy and compete with other cultural centers when its institutional status is relativized or indeterminate? This may be one of the many paradoxes of cultural politics, particularly in postunification Germany. Such paradoxes led Schulze to question many of the assumptions of German cultural politics since the early 1970s. These include the institutional consensus that (1) the programs of cultural institutions should, ostensibly, counteract consumerist behaviors, (2) institutional autonomy can or should be maintained, (3) cultural programing designed to address the interests of specific social milieus must simultaneously appeal to wider audiences, and (4) politics should remain unpolitical. How indeed "should cultural politics accommodate itself with the paradoxical imperatives which it has established for itself?" (1992, 527). Schulze concludes that German cultural politics (like cultural politics in the United States) increasingly resolves these issues by accepting the economic rationale of the cultural marketplace that renders the distinctions between cultural politics and market superfluous.

The Global Museum: New York—Bilbao—Berlin and Back

New York—Bilbao

Cultural Politics

One response to these conflicts has been for museum administrators to cultivate a stable, high-profile image for the museum (through name recognition and architecture) while changing its contents (Ritchie 1994), and reconfiguring the relations of the contents to audiences through events. In this respect, the Solomon R. Guggenheim Museum in New York, as an entity of the Solomon R. Guggenheim Foundation (SRGF), has been "cloning" its image through international branch museums, so-called satellites, which then grow their own local hybrids while trading on the cachet of the Guggenheim name. The hybrid Guggenheims incorporate a globalization of the museum's image and a market for its collections and merchandising while the local satellites bearing the Guggenheim name are, in theory, allowed to develop their own regional identity. The expansion of the Guggenheim domestically and internationally has included the restoration of the Solomon R. Guggenheim Museum in New York; the Guggenheim Museum SoHo New York; the Peggy Guggenheim Collection in Venice; the Guggenheim Museum Bilbao; the Deutsche Guggenheim Berlin; the Venice Guggenheim Museum of Modern and Contemporary Art; and the Guggenheim Las Vegas.[1] The globalization of the Guggenheim has been largely the work of its director Thomas Krens, who aggressively pursued new sites and cooperative agreements in New York and throughout Europe.

The Guggenheim Museum Bilbao (GMB), designed by Frank Gehry, is a key cultural component of a major urban renewal project that positions the museum and its image in the center of the battle among European cities for cultural tourism (Ritchie 1994, 12). Extensive construction of a rapid-transit system and a recreational and commercial harbor, including waterfront entertainment, a shopping complex, and a concert hall, are designed to provide new infrastructure and attract corporate investment (Bradley 1997, 50). Here, Paul Goldberger refers to the Basques as "a kind of cross between canny developers and political rebels" (1997, 49). The GMB is perceived as a key factor in improving the image of the city and the Basque region, which is largely associated with issues of Basque separatism (Bradley 1997, 50). The impetus for the Guggenheim in Bilbao came, however, not from ETA (Euskadi ta Askatasuna/ Freedom to the Basques), as the radical separatist wing is called, but from the conservative forces of the city of Bilbao. Goldberger remarks, "What could be better than to channel the nationalist impulses into an art museum that would dazzle the world and blunt the harsh edges of ETA?" (1997, 48). Toward this end, regional and multinational corporations (including El Banco Bilbao Vizcaya, The Chase Manhattan Bank, and Ericsson) have provided funding for the project.[2]

Initially, Krens was looking for a venue to display or rent out 211 minimalist paintings from Count Giuseppe Panza di Biumo's art collection, which the SRGF had acquired in 1990. When no major museums were willing to rent the collection for longer than a temporary exhibition, Krens pursued the idea of finding a Guggenheim "satellite" in Spain (Bradley 1997, 50). Inspired by Frankurt's success in cultivating urban culture through high-profile museum projects, Bilbao proposed an extensive agreement with the SRGF in 1991, an agreement that would position the museum (and the city) prominently "along the artistic Atlantic axis with Bourdeaux and Great Britain" (Bradley 1997, 50). The Basque and regional Biscay governments essentially paid the Guggenheim to conceptualize, design, and oversee the construction of the museum and to administer it for a twenty-year contractual period (which could be extended to seventy-five years).

The new museum in Bilbao was a good deal for the Guggenheim. The Basque and Biscay governments paid for all construction costs ($100 million) and ongoing operational expenses and also agreed to pay for all administrative and curatorial services provided by Guggenheim (*Museo Guggenheim Bilbao* 1997, 2.1–2.2). The Basque government allocated $50 million to acquire a new Spanish and Basque art collection. However, the best part of the deal (for the SRGF) was a $20-million tax-free "donation" made to the foundation by the Basque government, which referred to it as a "rental fee" in exchange for loan privileges (access to six thousand works in the Guggenheim collection) and use of the Guggenheim name for merchandising (Bradley 1997, 51). The GMB was granted exclusive rights in Spain to merchandise products related to the Guggenheim collection as well as the Bilbao museum's own holdings (*Museo Guggenheim Bilbao* 1997, 6.44–6.47). In addition, the Basque and Biscay governments carried the sole financial liability for the GMB, an agreement almost identical

to standard franchising contracts (Bradley 1997, 52). Although subsequent negotiations provided the local governments more authority in the operation of the GMB and a higher degree of exclusivity in marketing the Guggenheim merchandise in Spain and Europe, critics pointed out that the economic impact on the region and projections for ongoing administrative and project costs (targeting 45 percent of total operating costs from the Basque government and roughly 42 percent from corporate sponsors for exhibitions) were unrealistic (*Museo Guggenheim Bilbao* 1997, 6.2–6.4; Bradley 1997, 52).

In terms of cultural politics, one of the major motivations for the project was the Basque government's desire to promote a positive image for the region in order to attract foreign investors and tourists. The GMB was packaged and marketed to wealthy tourists (and museum patrons) who might travel from Bilbao up the coast to San Sebastian and the resorts in Biarritz, France. Here, the GMB envisioned that 40 percent of the projected 500,000 museum visitors (after 2000) would be from outside of Spain, primarily from the United Kingdom, France, and Germany, shifting most of its media budget (75 percent) from domestic to foreign advertising (*Museo Guggenheim Bilbao* 1997, 6.12, 7.25). At least in terms of museum marketing and development, the critics may have underestimated the success of Frank Gehry's architecture in attracting mass audiences to the GMB. Indeed, it far exceeded projections during the first year, with more than 1,300,000 visitors.

Although the GMB seems to have become an economic and promotional coup for Thomas Krens—one that he would like to emulate in New York City[3]—the actual development of its contents has been a controversial issue from the museum's inception. The extent to which the GMB will be able or willing to cultivate exhibitions related to regional Basque identity was the object of considerable controversy, particularly during the early stages of the project (Bradley 1997, 105–7). Despite the sizable budget for acquisitions of Basque and modern Spanish art, both the exhibitions and the purchases for the GMB have been predominantly modern "masterpieces" that would either draw from or augment the Guggenheim's own collection. Although works by some established Basque artists (Eduardo Chillida) and some in the younger generation (Juan Luis Moraza, Txomin Badiola, and Prudencio Irazazábal) were purchased or commissioned, many of the major acquisitions to the Basque collection have been works that Krens believes will complement the SRGF's own collection and establish Bilbao's international reputation through "signature works by foremost masters of modern art" (GMB press release), including Mark Rothko, Clyfford Still, and Willem de Kooning (Bradley 1997, 105). Krens also focused the collection on major acquisitions of works by contemporary European and U.S. artists such as Francesco Clemente, Anselm Kiefer, Jeff Koons, Sigmar Polke, and Richard Serra. In fact, separate galleries were designated for Kiefer and Serra. Despite Krens's goal that the GMB should "facilitate a north-south cultural exchange by connecting us to Mexico, Central and South America," his exhibition plans for the GMB drew from the standard repertoire of Guggenheim touring programs (e.g., *20th-Century Art: Masterpieces from the Guggenheim Collection*) rather than emphasizing the Basque and Spanish modern

collections (Bradley 1997, 105). While the seventeen exhibitions planned from 1997 to 2000 included some Basque and Spanish projects, Bradley observes that the three-year plan left little room for curators to develop a dynamic program, particularly when they had to "answer to a director as formidable as Krens" (1997, 105).

Clearly, the Basque government is attempting to carefully balance international and regional images for the GMB. Will the GMB, under the administrative and curatorial control of the SRGF, function primarily in terms of warehousing and filling the gaps in the Guggenheim's main collection (through acquisitions of contemporary Basque and Spanish art) while providing the Basque government an international cultural icon (Frank Gehry's architecture)? Krens has stated that he conceptualizes the Guggenheim's various satellites as operating independently but that the collections form components of "the Guggenheim as an organism" that is "essentially unified under one curatorial organization" (Bradley 1997, 53). What consequences does this unified organization have for developing a range of curatorial practices within a diverse regional context? Will Basque art be reduced to a trope within the significantly larger Guggenheim collection? Bradley questions the extent to which regional Basque art has been given the potential creative space to evolve independently of the Guggenheim's own global curatorial and acquisition strategy (1997, 105).

To the extent that Bilbao's exhibitions are largely a function of the Guggenheim's own interests, the new museum may confirm Walter Grasskamp's thesis that the internationalization of museum administration may lead to a greater uniformity of exhibition and acquisition practices. By functioning as a depot—albeit an architecturally significant one—for the Guggenheim's rapidly expanding collections and by exporting its own brand name for museum administration, marketing, and merchandising, GMB (and other satellite museums) indicates that differences between museums based on either regional, national, or even arbitrary patterns of development seem to be dissolving in favor of a more uniform globalization (Grasskamp 1992, 91).

Krens regards the satellites as a necessary and logical consequence of the SRGF's growth strategy and its "operation efficiency," which is required because the foundation receives no government subsidies (Diamonstein 1994, 150). Although he does not envision satellites as an option for government-subsized museums, he believes that more-extensive international agreements and cooperation among museums (which began with the Metropolitan Museum of Art's *Tutankhamen* exhibition in 1976) have become an inevitable part of institutional survival (Diamonstein 1994, 152). Obviously, major museum collections represent a considerable cultural commodity that can be circulated to expand the image of the museum and to facilitate its own growth. In the case of the Guggenheim, its limited exhibition space (despite a highly controversial expansion project in Manhattan) led to domestic and international expansion both in order to maximize the economic return on its extensive collections and in order to realize the full potential value of the global communication of its image. With regard to Bilbao, Bradley concludes that "no matter how eloquent Krens waxes about 'thinking

globally,' the potential for mishaps at the GMB due to cultural misunderstandings is sobering" (1997, 106).

From a different perspective, the GMB may also be a missed opportunity to engage the uniqueness of the Basque context precisely because the Basque collection is different from the international collections that are circulated through the Guggenheim satellites and rented out for touring exhibitions. In terms of fostering interaction among the local communities, the contents of the museum, and the museum's environment or structure itself, the GMB may represent a potential that can only be activated to the extent that the SRGF and the Basque government are willing to relinquish a degree of their own control. The potential value of Bilbao could emanate from creating a cultural context that, as Schulze suggests, is not based on its economic rationality. Partially uncoupling museums (or other public institutions) from cultural and institutional politics that demand a return on investment may actually increase their attractiveness to audiences and, paradoxically, let them become economically viable (1992, 527–28). Of course, difference and resistance can easily be appropriated by the networks and markets of cultural production, and institutionalized alterity is difficult to maintain (Schulze 1992, 519). Nonetheless, even modest efforts in this direction may prove to be more successful in actually creating a distinctive profile for new museums that could ensure their legitimacy as dynamic forums for social interaction rather than solely as markets for cultural consumption. Museums, sponsors, and governments are increasingly undermining their own goals to differentiate themselves from other cultural centers by allowing administrative objectives (and the convergence of economic interests through cooperative agreements, partnerships, or satellites) to direct programing.

Architecture

Even if the global museum's contents and exhibition practices seem to grow increasingly similar, one of the most potent symbols that nonprofit and corporate institutions utilize to mediate identity and assert their institutional interests is architecture. The Solomon R. Guggenheim Museum, designed by Frank Lloyd Wright, has become a cultural icon and theoretical point of reference for contemporary architects (Haenlein 1994, 24–25). In designing the GMB, Frank Gehry and Thomas Krens reasserted the Guggenheim as a symbol of avant-garde modernity in a massive structure of limestone and polished titanium (twice the size of the Centre Pompidou), which Gehry compared to a "metallic flower" (Bradley 1997, 55).

However, the development of the project references images of modernity and postmodernity. Gehry drew his inspiration from the "surprising hardness" of Bilbao's industrial seascape and the futuristic images of urbanity in Fritz Lang's 1926 film *Metropolis*. Referring to both of these sources, Bradley remarks,

> Indeed, the GMB calls forth both industrial might and an other-worldly newness. Its largest shapes, reminiscent of power plants and ship hulls and prows, allude to Bilbao's

industrial and shipbuilding mastery. Its more freely sculpted forms, such as the "metallic flower," lend the building an ethereal, space-age character. The building's intergalactic aura is enhanced by its silvery surface . . . which glows and shimmers in the sunlight and is reflected in the river. (1997, 55)

Gehry's design has been acclaimed by critics for its imaginative incorporation of distinctively modern styles (e.g., Gehry transforms Frank Lloyd Wright's central spiral into a tilting atrium) and postmodern styles, providing functional yet flexible exhibition spaces with natural lighting. These range from the immense "boat" gallery (450 feet long by 80 feet wide) for works such as Richard Serra's *Snake* (1997; 102 by 24¾ feet) to more intimate and idiosyncratic spaces. For Krens, experiencing the museum's structure is a central part of the GMB's concept:

Another "theme" of mine was to privilege the architectural experience. As a program requirement, I told Frank and the other GMB candidates [Arata Isozaki, Coop Himmelblau] that the building had to be one of the great buildings of the world, as well as one of the great art museums. (Quoted in Bradley 1997, 53)

New York Times architecture critic Herbert Muschamp considers the GMB a defining moment both in Gehry's work and in contemporary architecture. It is a life-transforming experience—a pilgrimage and epiphany—he calls "the miracle in Bilbao" (1997, 54). The GMB is a "Lourdes for a crippled [American] culture: This building's design and construction have coincided with the waning of a period when American architecture spectacularly lost its way" (72). Muschamp argues that the postmodern architecture of the 1980s sacrificed its creativity and "deteriorated into

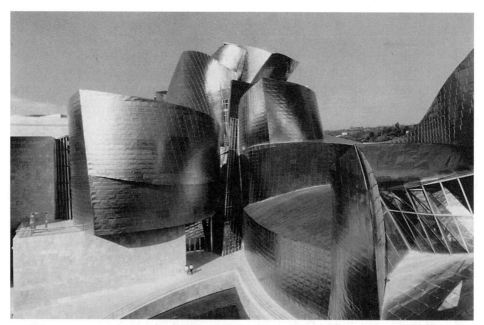

Figure 6.2. The Guggenheim Museum Bilbao: art, architecture, and cultural politics. Copyright FMGB Guggenheim Bilbao Museoa, Bilbao, Spain, 1998. Photograph by Erika Barahona Ede. All rights reserved. Partial or total reproduction prohibited.

a career strategy for reactionaries, opportunists and their deeply uncultivated promoters. . . . Even without the help of the Disney company, architecture plummeted into the realm of the packaged tour" (72). Muschamp believes that in Bilbao Gehry has rediscovered an aesthetic freedom and a sense of the creative force of history that had been lost in postmodern architecture. Goldberger also heralds Gehry's design as one of the century's great architectural achievements:

> It does not cower in denial of modernism . . . but, rather, enhances it by joining modernism's power to the civilizing forces of urbanism. And it does not reject the glory of monumental form, which in an age besotted by the notion that real space may someday give way to virtual space makes Gehry almost conservative. (1997, 53)

For Muschamp, Bilbao is a distinctively American work, indeed, a product of American culture. Marilyn Monroe is the metaphorical embodiment of an "American style of freedom" in Bilbao:

> That style is voluptuous, emotional, intuitive and exhibitionist. It is mobile, fluid, material, mercurial, fearless, radiant and as fragile as a newborn child. It can't resist doing a dance with all the voices that say "No." It wants to take up a lot of space. And when the impulse strikes, it likes to let its dress fly up in the air. (1997, 72)

The sensual appeal of Bilbao reminds us of event culture's attraction and simultaneous potential for subversion. The metaphorical implications of the GMB as Monroe—which Muschamp admits is "totally my projection" (although Goldberger also describes the museum as "voluptuous") (Goldberger 1997, 49)—may be less important for Muschamp than its potential to engage spectators in their own free association (Muschamp 1997, 82).

Thus, Muschamp attempts to establish the Bilbao experience as paradigmatic in two respects. First, it reflects the potential of museum architecture to engage spectators (individually and collectively) on an emotional level through the chemistry between its design and the urban site. Second, the museum is a watershed in American architecture, particularly in its transformation of both modern and postmodern idioms. Muschamp credits Gehry with rescuing and rejuvenating American architecture from "the painted desert in which . . . [it] has been stranded in recent years" (1997, 82). Yet it is precisely a "postmodern architecture as style" that Muschamp invokes when he defines Bilbao as an architectural milestone:

> An art form that has long depended upon appeals to external authority—history, science, context, tradition, religion, philosophy or style—has at last come to the realization that nobody cares about that sort of thing anymore. Architecture has stepped off her pedestal. She's waiting for her date outside a bar on a rainy early evening in Bilbao, Spain. (82)

I would argue that Bilbao cannot ignore its own dependencies and links to mechanisms of power, legitimation, and social representation, both past and present. In

part, these interests (including those of the SRGF and local and regional governments) are articulated in a politics of space, that is, the physical, social, and symbolic spaces the GMB occupies.

By privileging the moment of spectator self-reflection (expressed in the language of religious mysticism and pilgrimage) and the representational function of the GMB as a signifier of a revitalized American architecture, Muschamp overlooks the potential to engage the multiple narratives of Basque culture as productive and pivotal elements in negotiating the GMB's own identity within the social relations of its temporal and spatial context. Rather than positioning Gehry's work as an embodiment of what is quintessentially American, Goldberger considers it "a metaphor for Basque culture and the relationship it aspires to have with the world: a thing apart, yet entirely willing to make a connection on its own terms" (1997, 53).

Thus, the mediation of the GMB's architecture functions on two intersecting planes of signification. First, Gehry's project is contextualized within the tradition of American modernist architecture (specifically, Frank Lloyd Wright's work and the Solomon R. Guggenheim Museum in New York) while creating its own iconic status as a cultural landmark. The globalization of the Guggenheim image, mediated through architecture, facilitates the transfer of cultural capital from the institutional and cultural context of New York to Bilbao, and in return, of economic capital from Bilbao back to New York (i.e., through the licensing agreements for the satellite). Second, the GMB gains its site-specific identity as a result of its location within Bilbao's urban space, which is promotionally inscribed with the Guggenheim image. Seen strictly as two distinct modes of representation, the museum can operate either as a signifier of U.S. culture (both architecturally and institutionally) *or* of Bilbao's urban culture (as an expression of regional cultural politics). Although the Guggenheim's promotional strategies may switch modes of representation depending upon the audiences (or markets) addressed, my discussion of the cultural politics of the SRGF and the regional status of the GMB reveals that the project involves the negotiation of the foundation's interests as well as those of the Biscay government. The intersection of image, content, and context exposes the paradoxes in attempting to define the project as quintessentially either American or Basque. In this sense, the attempt to signify the GMB as "American" (i.e., U.S.) or Basque signals the project's inherent contradictions and cultural displacement (i.e., it can neither be exclusively signified as "American" or "Basque").

Yet it is precisely the (re-)negotiation and critical interrogation of these paradoxical relations between the GMB and the SRGF that could form the basis for creating the GMB's own unique contribution as a hybrid museum. The sense of cultural displacement emanating from the institutional interests of the SRGF's administrative and curatorial control, on the one hand, and the attempt of the Biscay government to establish the GMB as a platform for indigenous culture and economic development, on the other, could be employed to engage local communities as well as visitors in examining their own relations to the museum project. Exhibitions and cultural programs devel-

oped by the GMB might thematize and investigate these tensions, integrating them into the museum project itself.

Berlin—New York

Another Guggenheim satellite, the Deutsche Guggenheim Berlin (DGB), reinscribes the Guggenheim family history, national identity, and corporate cultural politics within the context of the museum.[4] Here, the strategy of naming, that is, designating the "Deutsche Guggenheim Berlin," performs multiple functions within the promotional signification of the museum (1) by linking German national identity with the new capital, (2) by reinscribing the Guggenheim name within the German context of the family's "roots," and (3) by simultaneously, and ambiguously, identifying the site of the museum within the Deutsche Bank headquarters in Berlin. In a special page of its Web site titled Museum History, the Guggenheim and the Deutsche Bank provide a joint statement (i.e., press release) designed to document, interweave, and legitimize their respective interests in German culture through family and institutional narratives:

> "Deutsche Bank has a long history of supporting the arts," notes Mr. Rolf Breuer, Spokesman of the Board of Managing Directors of Deutsche Bank AG. "Deutsche Guggenheim Berlin represents the opportunity to reach a wider audience than ever before. The outstanding exhibitions to be held there will stand as a mark of our commitment to quality."

The text then links European and U.S. cultural traditions more explicitly:

> The ties between the Guggenheim Museum and Germany are far-reaching. The Guggenheim family traces its origins to the city of Frankfurt, and Hilla Rebay, the first director of the museum, emigrated to New York from Prussia. The Guggenheim has a strong representation of German works in its collection and has organized a number of important exhibitions devoted to German artists, including Josef Albers, Georg Baselitz, and Joseph Beuys.[5]

In some respects, however, the emergence of the DGB had less to do with family roots or German artists in the New York collection than with the coalescence of U.S.-German cultural politics, corporate promotion, and Thomas Krens's globalization strategy. In 1993, the U.S. ambassador to Germany, Richard Holbrooke, asked Krens to develop a cultural exchange program in Berlin. According to Krens, Holbrooke "pointed out that it might be a nice gesture to leave something behind," Krens added, "like a new Guggenheim" (quoted in Cowell 1997). Understood in this context, "a new Guggenheim" symbolized the parting "gift" of U.S. culture to mark the end of the Cold War (Cowell 1997). But the Guggenheim as a cultural marker "left behind" in the urban topography of the new German capital also facilitated the cultural politics of U.S.-German relations by employing it as an image of that which is both American and German while concealing the paradoxes and conflicts, both past and present, in the nations' relations. The Guggenheim is signified not only as a *U.S.* cultural icon

(associated with Frank Lloyd Wright's building and the New York cultural scene) but also as representative of the Guggenheim family's ties to German culture and art, the museum's extensive collection of European works, and the historical significance of Berlin. Configured in this light, the Guggenheim is a cultural signpost designed to commemorate the legacy of U.S.-German cultural relations at the end of the Cold War while pointing to the new German capital. Like the promotion of the GMB, the promotional signification of the DGB reveals a sort of code switching between the German and U.S. modes of representation. However, switching the code, paradoxically, facilitates the actual conflation or merger of what it expressly attempts to achieve (i.e., an institution that claims distinctive German and U.S. cultural traditions). In doing so, a more uniform globalization is invoked, one that blurs these cultural differences and histories and effectively short-circuits any possibility of allowing the tensions between cultural identity and history to become a part of constructing the DGB as a museum or of employing them in order to engage visitors.

Moreover, the DGB's ultimate address, in the Deutsche Bank headquarters located at Unter den Linden, in the heart of the capital of the former GDR, alludes to the economic and cultural conquest over the East, referred to by Alan Cowell as the "new U.S. sector in Berlin" (1997). Krens had conceived of a permanent exhibition space in Berlin, which materialized after he met Hilmar Kopper of the Deutsche Bank in 1996 and they subsequently agreed to establish a museum gallery in the bank's new Berlin headquarters in 1997. Promotional material for the DGB highlights the importance of the Deutsche Bank site within the historical center of the "old" Berlin and as a site of commercial, cultural, and political representation in the "new" Berlin: "located at the intersection of Unter den Linden and Charlottenstrasse, two of the most historically significant streets in Berlin" (Guggenheim Web site).[6] Banks (e.g., Dresdner Bank at Pariser Platz and Deutsche Bank at Unter den Linden), hotels (the new Adlon at Pariser Platz), embassies, and government agencies dominate the urban spaces and intersections of cultural politics in the new center. That space marking the termination of Unter den Linden at Pariser Platz, designed to represent Germany's symbolic entryway into the capital at the Brandenburg Gate, demarcates commercial and political interests not only through its representative structures but also through its establishment as an exclusionary space from which "undesirable" pedestrians and street vendors are ejected.[7]

Thus, the signification of the DGB by the Guggenheim Foundation and by the Deutsche Bank functions within temporal and spatial axes. Historically, it establishes the meaning of U.S.-German cultural relations through the narrative of patronage provided by the Guggenheim family and the institutionalized promotion of German culture, mediated by the Guggenheim museums. In terms of a politics of space, the DGB physically and symbolically expresses the interests of corporate capital (and property development) in the center of the "new Berlin" and legitimizes them by fusing the Deutsche Bank's headquarters with the cultural status of the museum. By joining the words "Deutsch(e)," "Guggenheim," and "Berlin," the naming of the muse-

um becomes the ultimate signifier of cultural, national, and corporate identities. More-over, the interests of the museum and its corporate sponsors (Deutsche Telekom, Hugo Boss, and Lufthansa) are concretized in the curatorial practice of exhibitions. In 1997, the Deutsche Bank and the SRGF commissioned James Rosenquist's *The Swimmer in the Econo-mist* (1997–98), a site-specific artwork integrating subjects of economy, industry, and consumerism in postunification Germany. For the exhibition, Hugo Boss recreated Rosenquist's paper suit, which he wore to 1960s pop art open-ings, in a "superdurable" DuPont Tyvek, in a limited-edition design sold exclusively through the DGB.[8]

Image Politics

The Guggenheim's globalization (of its collections and administrative apparatus) and the reproduction of its image (with regional foci) indicate a simultaneous internation-alization of museum exhibitions combined with forms of regional specialization. Both of these processes reflect a complex network of homogenizing and differentiating ten-dencies associated with globalization (Waters 1996, 139). The global expansion, mar-keting, and touristic consumption of the collections are facilitated by the instrumen-talization, mediation, and dissemination of the Guggenheim image. And all of this occurs through collaborations with its major sponsors as a form of image transfer be-tween museums and sponsors.[9]

A prominent example of image transfer and dissemination is the Guggenheim's agreement with fashion designer Hugo Boss. The Guggenheim provides artworks from its collections and a Guggenheim library (books, videos, CD-ROMs about art) for the Hugo Boss corporate offices in Stuttgart, and, most importantly, it allows the use of its name in connection with Boss's sponsoring activities. In return, the Gug-genheim receives substantial financial assistance for several exhibitions to tour each year, beginning at the Guggenheim museums in New York and then moving on to Venice and Bilbao (Zipf 1997, 36). In addition to a Hugo Boss Prize ($50,000), the corporation works with the Guggenheim to plan educational outreach activities for children. Likewise, the Guggenheim develops workshops for Hugo Boss employees designed to stimulate creativity through appreciation of the visual arts (Zipf 1997, 37). By associating itself with Hugo Boss, the Guggenheim links its image to a post-modernism of visual consumption, that is, of contemporary fashion, irony, and a cos-mopolitan lifestyle. In this sense, the Guggenheim employs strategies of visual imme-diacy and stylistic provocation used in lifestyle and fashion advertising. These strategies are particularly apparent in the work of artist Matthew Barney, who created highly stylized, provocative tableaus and was awarded the Hugo Boss Prize (by a jury of mu-seum curators, which normally includes Guggenheim director Thomas Krens).[10] In a series from *The March of the Anal Sadistic Warrior* (1995), Barney used the facade of "fashion-as-packaging" for his critique of institutionalized power (e.g., in sports) (Zipf 1997, 37). Recognizing the visual power of social provocation in promotion (e.g., in Benetton advertising), Hugo Boss, through the Hugo Boss Prize, appropriates

Barney's social and visual provocation as a medium for projecting its own image (Zipf 1997, 37).

However, artists also participate in the promotion of the museum for their own self-promotion. At the opening of his new show at the Guggenheim in 1995, artist Ross Bleckner wore a new Hugo Boss suit. In 1998, counterculture icon Dennis Hopper *(Easy Rider)* signed a contract with Hugo Boss to promote the clothing line and appeared promptly thereafter at the Hugo Boss Prize ceremony in the Guggenheim Museum. Grasskamp points out that the context was suitably ironic, for it coincided with the Guggenheim's exhibition *The Art of the Motorcycle* sponsored by BMW. Grasskamp identifies an increasing trend since the early 1980s among artists to rent or sell their works or bodies as promotional spaces (1998, 84–85). Whereas Andy Warhol called attention to the erasure of the boundaries between advertising and art and simultaneously retained control over the production of his work by establishing himself as a marketing and promotional entrepreneur, artists and performers such as Bleckner or Hopper simply rent their status as celebrities for their own promotion and that of the advertiser. In this sense, they have become subcontractors for a global museum that also leases or franchises its name for local image promotion.

The "promotional transfer" (Wernick 1991, 111) effected between the Guggenheim and Hugo Boss involves a role reversal. The museum is profiled as a fashion and trendsetter with a sense of sophisticated style (targeted to younger, culturally sophisticated, affluent audiences) while the corporation is projected as an arbiter, filter, and reservoir of cultural goods. The nexus is complete when the role of the artist is invoked through prizes and exhibitions in order to instrumentalize associations of creativity both for the museum and the corporation. Indeed, artists are actually integrated into this process as participants in their own right, becoming a part of a triangulation of promotional interests that mutually reinforce one another.

Postunification Cultural Politics

Thus, the globalization of the Guggenheim, both institutionally and symbolically, operates simultaneously within the realm of local cultural politics, national identities, and global corporate interests. Whereas the Guggenheim New York confers Bilbao with the prestige of its own museum as a major force in urban and regional culture, the DGB trades on the cultural currency of Berlin and the image of the Guggenheim name within the European cultural marketplace. Berlin (and the Deutsche Bank) invests the Guggenheim with the prestige of its new site as a European political and cultural center. Krens conceded that "we will play a very modest role in the cultural life of this community [Berlin]. . . . But it will be an active role, and it will be fun" (quoted in Cowell 1997).

However, it could also be argued that the promotion of the Guggenheim image attempts to contribute to Berlin's status as an international cultural capital. Indeed, such efforts to consolidate its legitimation and rank as a *global* corporate, political, and cultural center between western and eastern Europe may be seen as an attempt to

Limited–Edition Celebrity Helmet

These collectible helmets were worn and signed by international celebrities on the occasion of the opening of our exhibition **The Art of the Motorcycle** at the Guggenheim Museum Bilbao.

Celebrity signatures include:
Lawrence Fishburne
Frank O. Gehry
Bob Geldof
Lauren Hutton
Jeremy Irons

Figure 6.3. Purchasing a piece of celebrity: *The Art of the Motorcycle* in the Guggenheim's Internet store.

resolve the historical and spatial ambiguities of Berlin (as a space claimed by contesting social and ideological interests). Berlin became a focal point for German cultural politics (in particular, under Gerhard Schröder's State Minister for Cultural Affairs Michael Naumann), for example, in the debate over the Holocaust Memorial. By shifting the programmatic emphasis to Berlin as the "new center," Gemany's cultural politics cannot avoid these conflicts and ambiguities—both past and present—nor can it circumvent its tentative status as "work in progress." Again, such tensions could be employed to reinvigorate a dialogue on contesting forces and images of social and cultural relations embedded in Germany rather than instrumentalizing them as promotional packaging for what former Foreign Minister Klaus Kinkel called *Unternehmen Deutschland* ("Corporate Germany") (1996, 10).

Privatizing the Museum: "Postutopian Cultural Politics"

Volkswagen and the Kunstmuseum Wolfsburg

The fusion of regional, national, corporate, and institutional identities is indicative of cultural politics in postunification Germany. Economic privatization; reduced budgets

for public theaters, symphonies, or museums; the debates on the new capital in Berlin; and attempts to redefine German foreign cultural policy and images of national identity (e.g., Christo and Jeanne-Claude's *Wrapped Reichstag*) are all symptomatic of shifts in the relations among cultural institutions, audiences, artists, and corporations. The Kunstmuseum Wolfsburg (KMW), opened in 1994, is a paradigmatic example of the museum's function in representing history, regional identity, and corporate cultural politics—in particular, the pivotal role of the KMW in mediating the sociopolitical interests of Volkswagen and the city of Wolfsburg.

The political and economic interests of Wolfsburg and Volkswagen are inextricably linked. Unlike the Deutsche Guggenheim Berlin, which integrates the dual signification of national and corporate identities into its name through the designation "Deutsch(e)," the associations between Volkswagen and Wolfsburg are already embedded in German history, technology, and product culture (e.g., the "Wolfsburg edition" of the VW Jetta automobile). During the latter half of the twentieth century, Wolfsburg and Volkswagen were synonymous in the consciousness of most Germans. The equation "Wolfsburg = Volkswagen" was a result of the politics of National Socialism, which established the city by decree in 1938, calling it *"die Stadt des KdF [Kraft-durch-Freude]-Wagens bei Fallersleben"* ("the city of the strength-through-joy automobile near Fallersleben"). Promotional literature on VW and the city make no mention of its original name or function, only referring parenthetically to the founding date and its later renaming for the castle Wolfsburg.[11]

The subsequent success of Ferdinand Porsche's Volkswagen as a German and American cultural icon (through the early 1970s) established a generally positive product image and gradually erased the connotations of its origins within National Socialism. Yet Wolfsburg has remained a company town in the sense that cultural, municipal, and regional politics are linked to Volkswagen interests. Wolfsburg also marks the process of postwar reindustrialization and urbanization that contributed to the changing composition of the German workforce, especially the influx of foreign "guest workers" *(Gastarbeiter)* who provided a pool of manual laborers in construction and manufacturing. As we have seen, labor relations remain a key component of corporate cultural politics in general. For corporations like Volkswagen, which maintain a large industrial force composed of significant numbers of non-German employees, labor relations have become a vital component of municipal and corporate politics.[12]

Although the reimaging of the Volkswagen product occurred rapidly (from the NS "Kraft-durch-Freude" car, to the fun-loving "Beetle" of 1960s popular culture in Disney's movie *Herbie* or the symbol of 1960s antimaterialistic, student counterculture, to the New Beetle of the late 1990s), the reimaging of the city of Wolfsburg was quite a bit more difficult. Wolfsburg's history—signified first as a site for workers' barracks and factories and later as one of geographic isolation and proximity to the German-German border—contributed to the perception, internally and externally, of cultural isolation and an island mentality, despite public-relations efforts to profile it as a crossroads between east and west.[13] However, German unification changed the

sociopolitical and economic geography of Germany as well as Wolfsburg's position within that geography. The KMW project coincided with a shift in the city's proximity to the new center of German political power—that is, to Berlin, the new capital—and a concurrent reconfiguration of cultural identities within postunification Germany. Thus, Wolfsburg's relocation on the map of a unified Germany also facilitated its cultural and economic reconfiguration regionally and internationally within the EU.

The museum concept was designed to trade on the international reputation of Volkswagen and establish its collections and exhibitions accordingly:

> When an industrial enterprise of VW's calibre becomes involved with contemporary art and culture, this new connection will presumably attract world-wide attention. It is precisely this fact that commits the new museum from the very beginning to a quality level that can stand up to high international standards. A regional outlook would be doomed to failure in a place like this. (Haenlein 1994, 25)

This concept statement by Carl Haenlein (chief consultant for the project) illustrates the extent to which Volkswagen's interests were the primary force behind the museum and indicates that the legitimacy of these interests were accepted a priori.

Unlike other cities, Wolfsburg had a source of funding (Volkswagen) at a time when public arts funding was being slashed in Germany. The KMW project was one of the last major museums to be opened in Germany before the end of the century.[14] What made it remarkable, in terms of postwar German cultural politics, is that it was largely privately financed.

Two foundations generated the capital for the construction of the museum and its ongoing administrative costs. In 1986–87, the Kunststiftung Volkswagen was created by Volkswagen AG and the City of Wolfsburg in order to provide a nonprofit vehicle for the subsequent distribution of earnings from the Holler Stiftung (as per the wishes of Asta Holler). The Holler Stiftung (established in 1990 with a capital of DM 360 million) was based on the investments and estates of Christian and Asta Holler, principle owners of the Holler Group and the Volkswagen-Versicherungsdienst GmbH (VVD) in Wolfsburg, which sold and marketed VW auto insurance on a contractual basis through dealerships (primarily in western Europe and Brazil).[15] Asta Holler required that 40 percent of the earnings of the Holler Stiftung (after adminstrative expenses) be transferred to the Volkswagen Art Foundation (Kunststiftung Volkswagen), whose primary objective would be to promote art and culture in Wolfsburg by funding a museum and a collection of contemporary art. Other revenue sources included a single grant from Volkswagen AG for DM 5 million, financial support from the City of Wolfsburg (including the donation of city-owned property for the museum), contributions from the heir of a major VW importer in Italy and a Swiss importer, and other individual or corporate donors (Schow 1994, 105). The Holler Stiftung provided major funding for the construction of the museum (DM 70 million), for operational costs, and for collection development. In addition, the Holler Group negotiated bank credit for the building project (Schow 1994, 105).

Although the KMW remains the exception to the rule in the German museum scene, it is nevertheless indicative of funding schemes for future museum projects that now rely more heavily on corporate and private donors (e.g., the Pinakothek der Moderne in Munich). The KMW project also reflects the new realities of German cultural politics based on privatization and public-private agreements. Yet even without the formalization of such agreements, there is increasing consensus regarding the legitimacy of private and corporate funding for culture. In his comments about the development of the KMW project, Haenlein writes,

> the need to be informed about Beuys and Baselitz, Merz and Warhol, Matisse and Picasso is rapidly becoming a requirement that is assuming a political dimension. VW's foundation of the Wolfsburg Kunstmuseum must be seen in this light. One of the largest industrial enterprises in the Western world—its products have a decisive influence on modern life and habits—is associating itself with contemporary fine art. This museum . . . is in a position to show that modern technology (the VW enterprise) and contemporary culture (the museum) have a common source, creative human beings. (1994, 25)

This approach is reminiscent of the image transfer from sponsored culture to the corporation and back again that has become the centerpiece of sponsoring strategies. Again, we see that corporate identity is defined through technological innovation linked to the artists' creativity: "Their imagination provides the impetus for developments in the technological and cultural spheres. This is a basis for structures that will enable VW to be identified with contemporary art and Wolfsburg to be identified with the new museum" (25). Artistic innovation becomes the medium of product design in a postmodern marketplace that stylizes the commodified product. Yet the effects of mass commodification, standardization, or the history of the automobile manufacturer and its labor relations—which have had a considerable impact on Western society since 1945—are omitted from this description of the relationships among culture, the corporation, and society.

The KMW is envisioned spatially and temporally as "a gateway to the late 20th century" (Hackelsberger 1994, 42) and designed to provide a focal point for the urban expansion of Wolfsburg. The structure assumes a prominent visual position in defining the otherwise unremarkable skyline of the city (Hackelsberger 1994, 40). Establishing the museum as an integral component of the city center (augmenting the expansion of the town hall) recognizes and validates culture as an essential element of urbanization. In terms of a politics of space, the museum also provides a site for the mediation of corporate and city marketing within an area that had been perceived as a public space in the city center.

As a medium for corporate communication and city marketing, the KMW facilitates the fusion of the signifiers "Volkswagen" and "Kunstmuseum." The KMW's "pink-whale" logo, like the Beetle, becomes a ubiquitous symbol of Wolfsburg's contemporary cultural scene. Unlike the potentially negative connotations of automobile

manufacturing, the associations evoked by the pink whale are positive and environmentally friendly. Moreover, the new KMW was envisioned as "a focal point for Wolfsburg's intellectual and spiritual life" (Haenlein 1994, 30). The museum functioned as an institutional anchor and center for the coordination and staging of culture. As such, it provided a center for new development and also became one of the driving forces of urbanization in Wolfsburg.

The museum as a filter, stage, or locus of cultural production in Wolfsburg—and the way it promotes the interests of Volkswagen and the city—was illustrated in a special exhibition *Italienische Metamorphose: 1949–1968 (Italian Metamorphosis: 1949–1968)* at the KMW. A multidisciplinary presentation of Italian art, design, fashion, jewelry, photography, and architecture provided a documentation of the growing importance of Italian culture within Europe and globally. Italian product design, fashion, film, and cuisine and the notion of Italy as the embodiment of la dolce vita for German tourism—all left an imprint on contemporary culture. Although the exhibition undoubtedly documented the international influence of Italian culture, it simultaneously functioned as a promotional vehicle for municipal and corporate (labor) relations vis-à-vis the spatial and symbolic axis of Italy-Wolfsburg-Volkswagen.

A summer of cultural programs, the Italian Summer in Wolfsburg, coordinated by the cultural affairs department of the city (as well as by local museums, galleries, and the Italian Cultural Institute located in Wolfsburg) reinforced the thematic emphases of the exhibition through films, performances, and lectures. However, the actual meaning of the cultural events for the city and VW becomes clear in the cultural affairs director's reference to the significance of Italy and Italian workers in Wolfsburg:

> For many years a soft breeze of southern culture has billowed through the rather cool industrial city of Wolfsburg. Due to its traditionally high proportion of Italian workers, Wolfsburg is often called one of the largest Italian enclaves north of the Alps. For decades Wolfsburg has been happy to live with these fellow citizens.[16]

The trope of exotic southern culture *(südländische Kultur)* is reinscribed within the context of Wolfsburg and Volkswagen. Although the cultural and economic relations among Italy, Wolfsburg, and Volkswagen presumably provide the impetus for the exhibition and the Italian Summer, it is precisely the nature of these relations that the cultural programs fail to explore. The history of German-Italian relations within the specific context of Wolfsburg and with respect to the lives and social realities of Italian workers in the city could have made a productive contribution to understanding "Italy" as it relates to the social fabric of its reception in Wolfsburg.[17]

The convergence and coordination of cultural politics in Wolfsburg is revealed by the way the three entities either share or assume functions previously within the domain of their partners. The KMW provided the stage for fashion designer Wolfgang Joop to present his fall/winter collection. Television personality Alfred Biolek was moderator for the show in the museum's foyer. In addition to "Joop!" posters and T-shirts, the KMW presented an exhibition of Joop's own drawings. The museum also

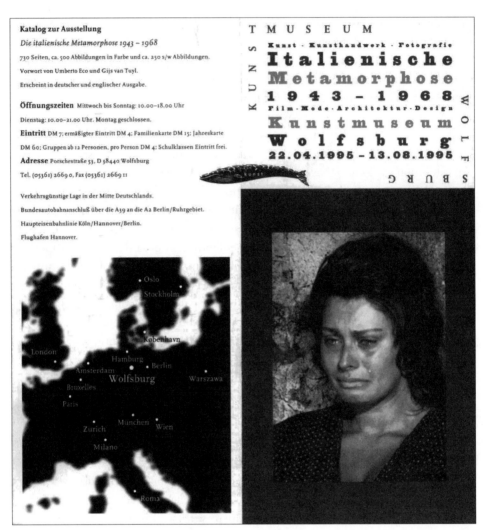

Figure 6.4. Exhibiting Italy at the KMW: La dolce vita for Italians in Wolfsburg?

distributed free samples of Joop! perfume to visitors during the course of the exhibition. The issue here is not whether museums should include fashion as culture, for it certainly is a significant force in contemporary culture, but rather the extent to which museums cooperate with designers (e.g., Guggenheim and Hugo Boss or the Haus der Kunst and Karl Lagerfeld) in providing sites for events that promote consumer products and in return promote the museum "product" through celebrity personalities.

I suggest that these events also provide the opportunity to address visitors in terms of their own positions as "consumers" of various forms of culture, be it in the context of the museum or the shopping mall. For example, such an exhibition might also ask visitors to consider various modes of consumption and aesthetic experience with respect to how and why they "consume" the Joop exhibition, his fashions, or other products. To a certain extent, these events, primarily oriented to visual or sensual re-

ception, within urban centers have become a prevalent form of postmodern tourism (Urry 1995, 148–49).

The experiential link *(Erlebnis)* between product, image, and cultural event was a motivation for Volkswagen's sponsorship of the Rolling Stones Voodoo Lounge tour, as well as for prior tours by Genesis and Pink Floyd.[18] With respect to cultural politics in Wolfsburg, Volkswagen was able to score a public relations coup by bringing the Rolling Stones to Wolfsburg to perform at the factory's immense parking lot under the VW logo. The parking lot became the venue for the production of event culture and the reinforcement of a positive corporate image within the ranks of its employees locally, while the Stones sponsorship is deployed globally by VW public relations as a medium for improving sales and thereby ensuring jobs:

> It's important for us to achieve international synergy. Therefore our strategy is based on cooperation with groups that have an international standing and simultaneously reach several generations. When it's a matter of increasing sales and ensuring market share and, as a result, jobs, then we say "Think big!"[19]

Postutopian Cultural Politics

The convergence and de-differentiation of institutional interests within public and corporate cultural politics points to what Schulze has referred to as postutopian cultural politics in Germany (1992, 524–26). From the 1950s to the early 1990s, Germany pursued a "utopian" orientation with the objective of pluralistic participation. Schulze traces the evolution to postutopian positions in terms of the variation, evolution, and repetition of the following interrelated motifs: (1) the representation and *mediation of high culture* during the 1950s; (2) the *democratization and popularization of high culture for "the masses"* (e.g., Hilmar Hoffmann's notion of "Culture for everyone" *["Kultur für alle"]* in the 1960s and 1970s); (3) a sociocultural orientation that addressed *individual identity* and *diverse social milieus* through *pedagogical programs* and also accepted the *legitimacy of historical everyday culture* during the 1980s; (4) economic orientations that legitimized *culture as part of an urban infrastructure* designed to attract industry, jobs, and tourism during the 1980s and 1990s. Schulze argues that the consensus that defined and organized public cultural politics in terms of democratization, diversification, education, or public good have been gradually replaced by the economics of market acceptance, which validate democratization and public approval. Economic rationales, although secondary in many cases, are therefore accepted as a legitimate objective of cultural politics (1992, 500–501).

Werner Heinrichs suggests that fierce regional competition among cities in Germany and the EU has led to higher investments in city-marketing programs, in which museums assume a high-profile position, while other cultural programs are reduced or eliminated. (Heinrichs 1994, 346–47, 350). Local funding for arts and culture in the United States during the 1990s has also led to a growing gap between urban and rural funding for cultural programs, not only because the tax base of rural areas is small but

also because corporations select projects in areas where their interests are most vital and visible—a factor that has also excluded low-income urban areas from sponsored culture (Larson 1997, 159).

For Schulze, postutopian thinking in cultural politics represents a transition from offensive to defensive strategies. The defensive position is less concerned with forces outside the institutional spectrum of cultural-political activity than with the internal forces of (self-)destruction that operate under the guise of making constructive progress (1992, 528–29). Certainly Schulze is correct in suggesting that the forces of change are emanating from within systems of cultural politics, for the spectrum of participants has expanded to include many who were previously considered on the outside—most notably corporations as well as cultural consultants and managers. Corporations, working with management consultants and public-relations agencies specializing in cultural programming, have collectively institutionalized cultural politics in their own right while establishing cooperative agreements with public and private institutions. Sociopolitical rationales are increasingly subordinated to economic rationales (e.g., public approval is based on tickets sold), which can be used to validate legitimacy and maintain or expand institutional interests (Schulze 1992, 529). If a convergence of corporate and public cultural politics, based on a consensus of the economic rationale, leads to their functional integration, then, Schulze asks, "What is the point of [public] cultural politics?" (529). Indeed, the lines between questions of public and corporate interests in culture, which would not be primarily dependent upon the economic rationales of market success, have become increasingly blurred.

Corporate Museums: BMW and Vitra

The conceptualization of foreign cultural policy as "Corporate Germany" (Klaus Kinkel) and the proliferation of sponsorships indicate that Germany is indeed in the process of transition to a postutopian cultural politics. This is a system that increasingly resembles strategies in the United Kingdom and the United States, which have established networks of corporate cultural politics. However, corporate programs of cultural politics must also continually redefine themselves, even in opposition to their own past programs, in order to differentiate themselves within a marketplace of events and experiences. As corporations operate in their cultural mode and institutions assume corporate strategies, it is more crucial than ever for audiences and communities to recognize the interests of those involved in these systems. Part of this process involves mapping the positions of the participants within systems of cultural production, which, seemingly, do not distinguish between "inside" and "outside."

One of the institutions that inverts notions of public and corporate culture is the corporate museum. Initially, many corporate museums were literally depots where artifacts dealing with product or corporate history could simultaneously be stored and displayed for interested visitors. Using the corporate museum as an important promotional and public-relations vehicle was frequently an afterthought rather than a result of corporate strategic planning. Such museums were also a product of the international

boom in museums and growing public interest in everyday culture, beginning in the 1980s.

In her extensive analysis of German corporate museums, Anne Mikus characterizes the corporate museum as a "transitional form within the [corporate] communications mix, between the segments 'sponsoring' and 'advertising'" (1997, 225). Clearly, the expanded notion of the museum provided an opening for corporate museums to utilize the positive image of public museums in order to promote the cultural role of the corporation and its products. As hybrids within the museum landscape, corporate museums, like many other museums, defy simple categorization. Mikus suggests a broad definition of the corporate museum as "a permanent collection presented as an exhibition, founded and maintained by a corporation" (1997, 15).[20] Despite many similar or overlapping functions, Mikus distinguishes corporate museums from corporate archives, collections held by corporate chief executives, corporate collections (which may or may not be publically loaned or exhibited), art collections used primarily for interior decoration, and some corporate galleries (to the extent that they rely on external, temporary exhibitions) (1997, 17–18).

Although corporate museums vary in size, contents, and curatorial practices, most focus on representations of the firm through its products (e.g., auto museums) or scientific and technological innovation. Yet even these representations of product culture are often mediated through sophisticated exhibitions that address the sociocultural contexts and interrelationships of culture and product technologies—albeit frequently from an affirmative stance. The BMW Museum and the Vitra Design Museum present two examples of the corporate museum's function within the museum landscape, as a part of the redefinition of cultural politics, and in mediating social history and culture. Unlike museums in general, many corporate museums contextualize consumer products (e.g., BMW automobiles and Vitra chairs) within the actual site of production (adjacent to factories and administrative facilities). Yet they simultaneously decontextualize their products by transforming them into museum artifacts and selectively creating new contexts. The way these processes of contextualizing and decontextualizing occur relates to their politics of representation and the curatorial practices employed—in these two instances—in very different ways.

The BMW Museum: Back to the Future II

Like Volkswagen's organization of the Kunstmuseum Wolfsburg project, the BMW Museum and the Vitra Design Museum relate to the mediation of history through industrial products and to notions of mobility and place. History, mobility, and place provide the thematic foci for the design of the BMW Museum and its exhibition strategies. This is underscored in its brochure *The BMW Museum Experience,* which promises 300,000 visitors annually a "one of a kind" experience and ranks itself as "a fixture of Munich culture" equal to the city's other leading museums—that is, the Deutsches Museum and the Neue Pinakothek (2–3, 15).[21] The reader is told that the museum is one of the city's most popular venues and an integral part of metropolitan

and regional culture: "This is hardly surprising for its holistic approach and aesthetic design are a reflection of its surroundings: in this south German metropolis, nature, technology, science, culture and art are all closely intertwined, and always have been."[22]

The museum itself is located at the base of BMW's corporate headquarters and factory (near the "futuristic" Olympic Village and Park) in a titanium structure, which has been compared to a large, windowless silver bowl, next to the "four-cylinder" administrative high-rise. Founded in 1968 as part of the design for a new headquarters building, which would capitalize on the 1972 Olympics and the architecture of the Olympic Park, the museum was conceived primarily as an exhibition area for documenting BMW's history. However, the heavy tourist traffic to the Olympic Park after the 1972 Games also led to unanticipated numbers of visitors to the BMW museum (opened in 1973) and its subsequent reconceptualization in 1979 as a museum that presented the automobile from a sociotechnological perspective.[23]

BMW – ein gutes Stück München

1

Das BMW Haus und das Museum befinden sich am Rande der ausgedehnten Anlagen des BMW Stammwerks im Norden Münchens. Gleichzeitig bilden Sie ein Ensemble mit den Bauten der Olympischen Sommerspiele von 1972 – über eine Fußgängerbrücke gelangen Sie in wenigen Minuten vom Olympia-stadion zum BMW Museum.

Dieses darf man getrost als eine der großen Attraktionen Münchens bezeichnen – von den Museen der Stadt verzeichnen nur das Deutsche Museum und die Neue Pinakothek mehr Besucher. Mit seiner interdiszi-plinären, ganzheitlichen Perspektive und seinem hohen ästhetischen Niveau ist das BMW Museum durch-aus typisch für seinen Standort – in München rücken Natur und Technik, Kultur und Wissenschaft auf eng-stem Raum zusammen.

The BMW Building and the Museum are just next to the large premises of BMW's original factory in the north of Munich. They also form a perfect match for the buildings of the 1972 Summer Olympics, a pedes-trian bridge taking you from the Olympic Stadium to the BMW Museum within a matter of minutes.

It is no exaggeration to call the BMW Museum one of the biggest attractions in Munich. Indeed, of all the museums in the State Capital of Bavaria, only the Deut-sches Museum and the New Art Gallery attract even larger crowds. Providing an interdisci-plinary, all-round perspective and maintaining a high standard of aethetic style and class, the BMW Museum is typical of its location, Munich being a place where na-ture and technology, culture and science are all combined in per-fect harmony.

2

3

1 BMW Haus und	1 BMW Building and
BMW Museum	the BMW Museum
2 Olympiagelände	2 Munich Olympic
München	Grounds
3 Ausstellung in der	3 Exhibition at the
BMW Galerie	BMW Gallery
4 Theater für Kinder	4 Children's theatre
im BMW Hochhaus	at the BMW Buil-
5 Art Car Ausstellung	ding
in BMW Pavilon	5 Art Car exhibition
6 München ist Kultur-	at the BMW Pavi-
vielfalt	lion
	6 Munich – a place
	of cultural versatil-
	ity

4

5

6

Figure 6.5. The BMW Museum: history, mobility, and a sense of place.

BMW engaged the Emmy- and Oscar Award–winning film designer Rolf Zehet-bauer (*Cabaret, Inside the Third Reich* (TV), *The Boat,* and *The Never-Ending Story*), writer-filmmaker George Morse, designer Charlotte Krings, engineer Gunter Spur, and sociologist Hans Martin Bolte to coordinate several films and a state-of-the-art multimedia exhibition. Successive exhibitions and films integrated BMW's role as a major historical force in technological and social development. Unlike the older AutoMuseum Volkswagen (in Wolfsburg), which is primarily a display of automobiles in a large hall preceded by vitrines documenting VW history,[24] the BMW museum was designed by a team of filmmakers, engineers, designers, and sociologists who anticipated the need to represent the corporation as a legitimate and integral component of social and cultural life. By packaging the BMW narrative in an interactive, multimedia format, the designers also created a successful tourist attraction.[25]

Each exhibition (accompanied by a growing number of multimedia and interactive displays) addressed time, space, and mobility in terms of automobiles (especially BMW's), technology, and society. Each of the titles for the successive exhibitions linked these elements: *Zeitsignale (Signals of Time)* (1979–84); *Zeitmotor (Motors of Time)* (1984–90); and *Zeithorizont (Time Horizons)* (1991–present). "Mobility in the flow of time," an overriding theme of *Zeithorizont,* provides a conceptual leitmotiv for the recurring significance of the BMW automobile past, present, and future.[26] Yet this exhibition focuses on the future of the automobile, and in a broader sense of technology, looking into the twenty-first century. In describing the conceptual development of *Zeithorizonte,* the BMW public-relations information establishes three main themes and a question:

- Quality of life is doable.

- Progress is doable.

- The future is doable.

- What kind of progress is globally legitimate, simply because it is responsible?

The rhetorical question regarding "what kind of progress" seems to be cast aside when the text concludes,

> It's not the pressing problems—of finite resources, environmental overload, and overcrowded transportation systems—which are preeminent, but rather dealing with them through targeted solutions. The exhibition *Zeithorizont* deals with the "new normalcy" in the thought and feelings of our time. Today people react more calmly, pragmatically, without illusions. People believe in the future and that life will not be any less livable tomorrow than today.[27]

The self-confident, affirmative tone of the public-relations text is replicated and mediated within the exhibition. Videos and texts construct the relations among technology, mobility, society, and leisure through the prism of thematic emphases, including CAD-construction, robots, changes in the workplace, motor sports (i.e., motorcycle

„Zeithorizont"
erweitert
Horizonte

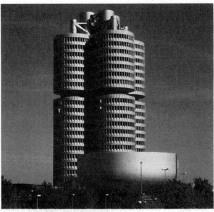

Zeithorizont im BMW Museum München
Horizons in Time at the BMW Museum, Munich

Figure 6.6. Expanding our horizons: interpreting time and space through product technologies.

and automobile racing), families (roles for men and women, leisure), the automobile of the future, precision (instrumentation), and the history of technology. Although the videos occasionally raise a random question, such as "What is the future of the family?" without further elaboration, they inform the viewer once again that environmental and social problems can be solved through technology.[28]

Although BMW public relations emphasizes a nonlinear conceptual development in the exhibition, the chronological presentation of automobiles and motorcycles becomes the focal point for visitors as they walk through the first three-quarters of the exhibition. The museum building itself is structured as an upward spiral with four platforms. Technological information and displays (e.g., manufacturing an automobile from start to finish) are interspersed with vehicles, motors, and other devices, which are suspended from ceilings or mounted on walls in order to heighten their vi-

sual impact. The visitor's steady progression upwards physically reinforces the representation of technological progress. The BMW Museum, clearly reminiscent of Frank Lloyd Wright's spiral in the Guggenheim, provides the dramatic stage for the presentation of the BMW narrative.

However, the representation of the upward spiral of continuity (as a signifier of progress) has become increasingly problematic as contemporary architects recognize the importance of designing museum spaces that allow for the discontinuities and ruptures of twentieth-century art and culture. Haenlein's remarks (in reference to the KMW project) characterizes this perspective:

> The spiral of the Guggenheim Museum, for example, reflects historical continuity, something like an eternal recurrence of those forces that lie behind history. . . . History is systematized only in books—in exhibitions the wild and disorderly structure of history should remain perceptible—a chaotic element that could revitalize even the over-administered life of modern man. (1994, 24)

The idealized space of BMW's modified spiral mediates the coherence and continuity of a technological progress apparently unbroken by the discontinuities of history. Although social or technological ruptures (e.g., the role of BMW under National Socialism or the automobile and environmental issues) are integrated into the historical stage of the exhibition, they are presented not as pivotal events and issues but, rather, as metaphorical bumps in the road of the automobile's progress. These discontinuities are relativized by the visual and representational continuity of the exhibition as a whole, which directs visitors along a single path upward, mirroring the linear path of technological advancement and optimism described by *Zeithorizont*.

However, as Roger Silverstone observes, museums function in terms of multiple, frequently overlapping logics—with respect to categorization but also with regard to how they represent and physically structure time and space in the exhibition (1994, 168–69). Although the dominant orientation to time in the *Zeithorizont* exhibition may be toward the future, the BMW Museum also looks to the past. A special exhibition on the BMW Isetta, for example, rewrites history—defined as a culture of mobility—through the postwar automobile, understood as an icon of tourism, of lifestyle, and of the economic upward-mobility of Germany's Economic Miracle.

The Isetta: Reconfiguring History and Identity

The fortieth birthday of the BMW Isetta in 1995 provided the opportunity for a special retrospective exhibition *(BMW Isetta: Zeitzeuge der 50er Jahre)* focusing on its role in the social context of Germany in the 1950s. The Isetta *motocoupé*—even smaller than the VW Beetle—only sold 160,000 units between 1955 and 1962 and never reached the popularity of the Beetle (which was selling 1,500 units daily during its peak). But it was an affordable BMW for middle-class consumers and later became a cult object for collectors.[29] Although the exhibition opened with a series of promotional events (e.g., parade of Isettas through Munich, competitions for collectors, a

drawing for an Isetta, a Children's Grand Prix Race), the exhibition's focus was not on the automobile itself but on BMW's documentation of the corporation's historical role as seen through the perspective of the Isetta.[30] BMW describes the documentation as "showing the networking of corporate activity with the social contexts [that] place the Motocoupé Isetta within the sociopolitical, technological, and everyday context of the 1950s."[31]

Each island within the exhibition takes a familiar theme as a point of departure. The first exhibit area (island 1), entitled "The New Mobility: Fun with the Car," epitomizes mobility and tourism as a lifestyle defined by the new consumer products (e.g., televisions, portable radios, mixers, and coffee makers) of Germany's Economic Miracle. At island 2 ("Technology Conquers Our Lives"), the visitor reads that the "belief in the benefits of science and technological progress remained euphoric and largely without criticism"; the social and cultural criticism of the 1950s are not mentioned here. Everyday life during the Economic Miracle (island 3) is portrayed through the filter of nostalgia. Socioeconomic upward mobility and physical mobility are facilitated by the German automobile industry; the VW Beetle was a promotional icon of the boom. Lifestyle becomes nostalgia through references to furniture and design (the kidney-shaped cocktail tables *[Nierentisch]* or the pastel-colored Isetta), alcohol and fashion (VAT 69 and Cinzano), home styles (basements renovated as *Partykeller*), and rock and roll (island 4). German victories in soccer and other sports (island 5) reflect national identity and a renewed self-confidence ("We Are Somebody Again— Not Only in Soccer"). The historical narrative associates the male consumer's interest

Figure 6.7. "Technology takes over [conquers] our lives." Photograph by Mark W. Rectanus.

in sports and automobiles with images of a Germany that is once again a winner. Thus, soccer, automobiles, and the German nation are all defined by their relations to identity and, more significantly, to power. Food, fashion, music (island 6), and vacation trips in the Isetta to "Bella Italia" (island 7) complete the picture of an increasingly European lifestyle of cosmopolitanism based upon mobility and consumption. German-Italian relations are also referenced in terms of Germany's growing economic prosperity and power, which drew on the Italian labor market in the latter half of the 1950s (island 3).

Finally, the construction of the Berlin Wall (1961) provides thematic closure for the exhibition. An Isetta that was used to smuggle nine people across the border in 1964 is included in the exhibition, on loan from the Check-Point Charlie Museum in Berlin. As Germany becomes a divided nation and the "euphoric" 1950s yield to the political realities of the 1960s, the Isetta is represented as a vehicle of political freedom—the quintessential symbol of mobility defined as freedom. Of course, 1962 marked the end of the Isetta's production, preserving it permanently as an icon and a collectable of the 1950s.

Thus, the curatorial practices of the Isetta exhibition relate to strategies and politics of representation that attempt to reestablish the significance and centrality of both product and corporation for the social context. What is at issue here is not whether corporations, products, and technologies have played a role in social history but, rather, how they mediate historical narratives in order to retell these stories. The analysis of the Isetta exhibition within the BMW Museum illustrates the continuing function of the

Figure 6.8. Isetta, hula hoops, and sports. Photograph by Mark W. Rectanus.

automobile as one of the most potent symbols of power, leisure, consumption, mobility, freedom, and, in this case, national identity. The sense of coherence and continuity represented symbolically in the *Zeithorizont* exhibition and physically in the upward spiral of the museum itself is projected back to the historical narrative of corporate identity during the 1950s. This is an identity that affiliates itself emotionally and politically with media symbols (hoola-hoops, rock and roll, Italy, and sports events) used as a short hand to signify an era. The Isetta exhibition and *Zeithorizont* reconstruct these codes as forms of remembering and translate them into the temporal, spatial, and political modalities of mobility. Whereas *Zeithorizont* focuses the visitor's attention forward to a "pragmatic" vision of the future, the exhibition-within-the-exhibition (Isetta) reassures visitors of a continuous link to the past.

Silverstone points out that this process is part of the myth making inherent in the narrative of exhibitions: "What also emerges, of course, is a particular inflection of that myth, of necessity ideological, and in one way or another expressing a world view which excludes or relegates to insignificance other versions of reality" (1994, 167). As the BMW Museum positions itself with respect to the past and the future, mediated in terms of the "present" of its exhibition, Huyssen's notion of the museum as a site for creative forgetting and remembering assumes even greater importance, by shifting the emphasis to the role of the visitor (Huyssen 1995, 34–35). Silverstone also refers to this as "the 'curatorial' work of the visitor in which objects are reinscribed into a personal culture of memory and experience" (1994, 165).

The Vitra Design Museum: An Anthropology of Seating

The Vitra Design Museum employs very different curatorial strategies than we have observed at the BMW Museum. Opened in 1989, as a separate foundation established by the furniture manufacturer Vitra, the Vitra Design Museum (VDM) immediately distanced itself from traditional notions that corporate museums only document corporate histories and products (Von Vegesack 1993, 1). Vitra has an international reputation for manufacturing chairs by leading designers of the twentieth century (Charles and Ray Eames, George Nelson, and contemporary designs by Mario Bellini and Dieter Thiel). The VDM was in part founded to house Vitra CEO Rolf Fehlbaum's extensive collection of furniture and designs of major movements (Werkbund, Bauhaus, de Stijl) and designers (from Otto Wagner and Josef Hoffmann to Gerrit Rietveld, Charles and Ray Eames, and Robert Venturi). However, the concept evolved into much more than simply a "chair museum." Design became the conceptual focus for the museum and the Vitra Foundation.

A museum that makes design the centerpiece of its activities must also reflect this awareness in the museum structure, or "container" (Ritchie 1994). Like other contemporary museums, Vitra recognized the importance of communicating its image through the container of representational architecture. In keeping with its image as a cutting-edge manufacturer of contemporary furniture, Vitra engaged architect Frank Gehry to design his first museum in Europe (Von Vegesack 1993, 3). The collaboration with

Gehry had begun when Vitra produced a limited edition of his *Little Beaver* chair (Lawton 1994, 30). By choosing a high-profile architect, Vitra underscored its commitment to design and simultaneously attracted attention within the professional design community and the media that would promote the VDM. Vitra also showed its commitment to integrating design into the everyday culture of the workplace by commissioning Gehry to design a new factory. He suggested that Vitra take the process of diversity one step further by retaining a different architect for each new building within the corporate complex near Weil-am-Rhein, Germany. Through the interplay of multiple design perspectives, "corporate identity was . . . boldly replaced with corporate variety." Vitra's "corporate policy of stylistic pluralism" (Lawton 1994, 30, 34) draws attention to the multifaceted interactions of space, structure, and objects within the culture of the workplace. Unlike most corporations, Vitra has chosen to thematize the function of its own cultural production as a focus for its corporate cultural policy. Rather than simply instrumentalizing "design" as a promotional signifier, Vitra explores both the corporation's relations to those who produce design and design's function within the workplace. Simultaneously, the concept of design becomes the focus for the Foundation and the VDM, which in turn inform the corporation's production through interaction with design professionals and the public.

The VDM specifically aims to "stimulate consciousness of people towards their aesthetic environment" (Von Vegesack 1993, 1). Rather than using the museum primarily as an opportunity to present its own products, Vitra hopes to promote an awareness of individualized and collective interactions with everyday objects as a part of culture. This focuses on but is not limited to social interaction with furniture, interior design, and architecture:

> The primary task of the Museum continues to be the elucidation of the design process in all of its phases—from the birth of the idea through the manufacture and marketing of the completed product. And since furniture is not only perceived through an intellectual

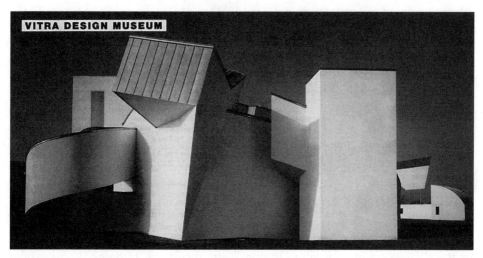

Figure 6.9. Vitra, designing spaces.

process, but also is experienced through sensual and physical contact, we do not present the collection purely through artworks enshrined on pedestals. So far as possible the visitor is given the opportunity for direct interaction with objects through installation of reproductions and demonstration models. (Von Vegesack 1993, 6)

By removing avant-garde designs from their "pedestals," the VDM attempts to "counteract these elitist tendencies" that make design synonymous with "styling" (Von Vegesack 1993, 1). This objective also relates to the museum's goal of demystifying the aura of works (e.g., chairs by Breuer or Eames) that have achieved the cultural status of collected art. The works' aura is heightened through their function as museum artifacts. In part, the VDM exhibitions attempt to explore this dialectic between the objects as museum artifacts of high modernist sophistication and their functions within mass production and consumption.

Vitra may illustrate a trend among many new corporate museums, relying less on presenting permanent collections and company history than on using the museum as a space for special exhibitions relating to the social and historical contexts of cultural production. Like other global museums, corporate museums, such as the VDM, function as cultural promoters by sending their own exhibitions on the road to public museums, thus expanding the communicative potential of the exhibition beyond the local site (in addition to the promotional value of sponsoring the exhibition). The corporate museum as host and recipient for traveling exhibitions also underscores its participation in, convergence with, and integration into global networks of museum administration and curatorship. Vitra views its participation within such global networks as a nonprofit activity. For example, the VDM offers one-year internships in design and architecture for students and professionals from eastern Europe, free consulting services on museum administration and marketing for eastern European museums, and workshops with leading design professionals.[32]

Traveling exhibitions prepared by the VDM include *The World of Charles and Ray Eames* (prepared in cooperation with the Library of Congress, Washington, D.C., 1997), *Frank Lloyd Wright: The Living City* (the first major European exhibition devoted to Wright's architecture and applied arts, 1998), *Luis Barragán* (an exhibition devoted to the Mexican architect's work and based on the Barragán archive acquired by Vitra in 1995). Thematically, the exhibitions relate to multiple and diverse representations of culture revolving around the changing functions of design as communication. This is particularly evident in the exhibition *Kindermöbel: The Material World of Childhood* (opened at the Kunsthal Rotterdam in 1997), which examined relationships between children and parents in Western, African, Asian, and Latin American cultures. The exhibition explores how these relationships are socially structured and represented through the historical and contemporary artifacts of children's furniture.

The exhibit *African Chairs* (1994) illuminates the symbolic significance of the chair by revealing its cultural meanings in non-Western cultures. In doing so, it provides

the viewer with new perspectives on the representative functions of the chair in every-day culture:

> In this pioneering survey, an entirely different tradition of sitting was displayed than that documented in the permanent collection. Westerners who can remember being forbidden to sit in "Father's chair" have at least a theoretical preparation for learning that, in some parts of Africa, Father's chair is deeply bound up with Father's soul. (Lawton 1994, 32)

As a cultural anthropology of "seating" practices, the exhibition makes visitors conscious of symbolic and communicative functions of the chair, functions related to language, space, and architecture. Moreover, it sensitizes them to the diverse uses of the chair as a mass-produced, utilitarian object or as a "functionless" object of art in their own (i.e., Western) culture. Here, Gehry's *Little Beaver* chair, in a limited edition of one hundred, and the corporate executive's leather-bound chair—a symbol of power and a fetish object—provide examples of such diverse uses presented in other VDM exhibitions. In assessing the collective contribution of this and other Vitra exhibitions, Lawton concludes,

> Evident in all these presentations is the way in which furniture echoes the society from which it emerges. As such its function is perhaps not so different from what was revealed in the African exhibition: social status is still defined by chairs . . . and our belief systems are echoed by what we sit on. Are our chairs functional or ornate? Are they made to last or to throw away? Do they require you to sit up straight or encourage you to lounge around? . . . Perhaps, most important, are they designed to fit us or do they require us to fit them? (1994, 34)

By providing "a terrain which offers multiple narratives of meaning" (Huyssen 1995, 34), *African Chairs* exemplifies exhibition strategies that illuminate (in a pedagogical sense) and stimulate what Silverstone refers to as the visitor's "'curatorial' work," which engages their own memories and experiences (Silverstone 1994, 165). Of course, the *African Chairs* exhibition could be seen as simply reinscribing the exotic. However, I argue that *African Chairs* engages the viewer in challenging this notion by demystifying cultural practices—for example, by creating an awareness that, through their representation as museum artifacts or collector's objects, Western chairs are inscribed within their own histories of the exotic and with their own representations of power and social relations.

Unlike the BMW Museum, Vitra has attempted to explore the multiple narratives of its own products and the corporation's implication within their social contexts of production and consumption (e.g., by using design to question the notion of a uniform corporate identity at its corporate headquarters). Undoubtedly, the automobile is more overtly linked to the symbols of power, leisure, and mobility of the twentieth century than is the chair, whose narratives are more "hidden" but nonetheless express these symbolic relations through their own histories. Within the BMW exhibitions

(*Zeithorizont* and *Isetta*), the automobile's narratives of highway accidents, urbaniza-
tion, environmental pollution, or automobile tourism remain unspoken or rela-
tivized within a past defined largely as nostalgia. For BMW, the automobile is repre-
sented through the temporal and spatial axes of lifestyle, collecting, mobility, leisure/
entertainment, and technological innovation. More importantly, it is not a matter of
simply comparing *what* is being exhibited, that is, "automobiles" versus "chairs," but
rather *how* and *why*, which reveals the politics of representation embedded in the ex-
hibitions. To a much greater extent than BMW, Vitra employs the multiple cultural
narratives and histories of design as a productive point of departure for its exhibition
practices and corporate cultural politics that are mediated through the museum and
foundation.

Thus, the Kunstmuseum Wolfsburg, the BMW Museum, and the Vitra Design
Museum demonstrate the process of institutional and functional convergence with re-
spect to corporate and public cultural politics. They also reflect the process of hy-
bridization by assuming private or public functions and expanding the scope of their
cultural offerings. Vitra is the most striking example of this process, since the corpora-
tion thematized its own involvement in the social contexts of design through exhibi-
tion practices that are not primarily oriented to public relations or promotional events
(unlike the BMW Museum or the Kunstmuseum Wolfsburg). Of course Vitra, like
other private and public institutions, is attentive to and dependent upon public
image. However, the museum's site, exhibitions, and image are not instrumentalized
as promotional vehicles. As a forum for design exhibitions and workshops rather than
as a promotional stage for corporate products and histories, Vitra may be an atypical
corporate museum or, as Vitra suggests, not a corporate museum at all.

Strictly in terms of promotional and administrative strategies, both the Guggen-
heim (with its global network of satellites) and the much smaller Kunstmuseum
Wolfsburg (an aggressively marketed, privatized public museum) have established
market-oriented positions very similar to those of global corporations. The Gug-
genheim has evolved into an especially significant hybrid museum. The SRGF and
Guggenheim Museum (New York) grew from a private foundation and museum into
a global entity and employed the logics of institutional (i.e., corporate) expansion into
overseas "markets" (e.g., by acquiring large collections, loaning them globally, and dis-
playing them in satellite museums) while also operating in modes similar to those of
public museums (e.g., fund-raising, education, and outreach).

The complex networks of interinstitutional cultural communication are illustrated
by the Guggenheim's curatorial strategies. In a distinct departure from its past pro-
grams, the Guggenheim's 1998 exhibition *The Art of the Motorcycle*, sponsored by
BMW, recontextualized similar themes of mobility as historical narrative that we
found manifest in the BMW Museum. Frank Gehry's minimal installation of the
motorcycles on upward-spiraling stainless steel resembled the chrome and steel of the
engine cylinders, providing a postmodern irony to Wright's modernist architecture
(Hyde 1998, 95). Despite a somewhat more critical edge to a "social history as seen

through the motorcycle" than we observed in the BMW Museum's *Isetta* exhibition, the final text concludes with praise (indistinguishable from an advertisement) for its sponsor's latest product as an environmentally friendly, ultimately "American" motorcycle, the R1200C designed by David Robb:

> On Robb's quiet and efficient machine, you can cruise at 55 mph while smelling the flowers. You can almost hear the birds singing. This is the soul of American motorcycling, even with a heart all BMW efficiency: shaft drive, a proven Boxer engine, and electronic engine management. The cruiser is the flipside of [designer Miquel] Galluzi's grunge Monster; it is the '90s turned green.[33]

James Hyde observes that in its praise of the motorcycle as an icon of freedom and rebellion, its more utilitarian uses (e.g., as police motorcycles) and modifications in other (non-Western) cultural contexts were absent, making the exhibition indistinguishable from "a tarted-up trade show" (1998, 96). As such, the exhibition set new attendance records and was also a significant marker in Krens's efforts to expand the Guggenheim's image from a site for avant-garde and modernist art to one that embraces popular culture. Yet it also seemed to be another missed opportunity for the museum to realize the full potential of the diversity of a popular culture that also contains critical or subversive moments by failing to integrate some of its broader cultural uses and to engage visitors in a consideration of them.

Although contemporary museum projects like the GMB or the Tate Modern (which opened in 2000) have exceeded projections for new visitors (the Tate Modern attracted a million visitors in the first six weeks alone), their contents and collections have been increasingly subordinated to image architecture and consuming the experience of visiting the site itself. Alice Rawsthorn, in the lifestyle magazine *Travel and Leisure,* addresses the "museum-as-theme-park" trend with some amazement in an article titled "Museum or Amusement Park?" She writes, "In the post-Bilbao era, flashy new museums are becoming adult theme parks. Is it the incredible art inside—or do the designer restaurants and the buildings themselves have something to do with it?"[34] The article also mentions Daniel Libeskind's Jewish Museum in Berlin, which may have already been relegated to the "attraction" category because of the success of its structure and apparent indecision regarding its collections.[35] Indeed, both economic and political pressures to get new audiences *into* new museums in the first place, so that they can then interact with exhibitions and collections, may be relegating contents and collections to secondary status, or at least shifting the emphasis of museum visits to other forms of visual and material consumption. In this respect, "the museum visit" has been gradually integrated into other forms of urban consumption. Or from a different perspective, the reconfiguration of museum spaces primarily in terms of experiential consumption has facilitated or encouraged visitors to approach the museum as they would other sites of consumption. Although such strategies undoubtedly attract new audiences and increase revenues, they also relativize the functional distinction of the museum within society, the process of sociocultural de-differentiation referred to earlier.

Like the Guggenheim, the Getty Museum and Getty Trust have expanded dramatically, in what may well represent a similar example of the private foundation's importance in contemporary cultural politics. The globalization of museum collections by major museums (such as the Guggenheim), the development of "museumlike" satellites (including museum branches in corporate headquarters), the importance of traveling exhibitions for most museums, and the standardization of administrative practices (in order to facilitate exchange procedures) all point to a globalization of the cultural politics of museums. In addition, international corporate consulting firms (functioning as "corporate cultural anthropologists") are examining the sociocultural environments of museums (e.g., employee interaction and cultural programing) in order to adapt them to corporate culture.[36] The convergence of corporate and museum structures have prepared the groundwork for this transfer. Finally, we should also remember that such interinstitutional relations are in most instances unequal and are based on the transfer of cultural and economic capital.

The Museum Visitor

Both Huyssen and Silverstone underscore the significance of the museum as a mass medium in terms of its potential for engaging the visitor through entertainment and information.[37] Unlike mass media such as television, however, museums operate simultaneously in the modes of the transitory and the material permanence of objects (Huyssen 1995, 33; Silverstone 1994, 162). Huyssen describes this relationship with respect to the museal gaze of the visitor:

> The gaze at the museal object may provide a sense of its opaque and impenetrable materiality as well as an anamnestic space within which the transitoriness and differentiality of human cultures can be grasped. Via the activity of memory, set in motion and nurtured by the contemporary museum in its broadest and most amorphous sense, the museal gaze expands the ever shrinking space of the (real) present in a culture of amnesia, planned obsolescence and ever more synchronic and timeless information flows, the hyperspace of the coming age of information highways. (1995, 34)

The potential of the museum as it relates to the visitor is based on a dialectic of remembering and forgetting. Silverstone describes this in terms of the artifact, of "the familiar made strange; the strange made familiar" and the "'curatorial' work of the visitor" which is embedded in memory (1994, 164, 165). For Huyssen, "the museum serves both as burial chamber of the past . . . and as site of possible resurrections, however mediated and contaminated in the eye of the beholder" (1995, 15). Hans-Peter Schwarz argues that even as museums integrate mass-media technologies as artifacts, unlike most electronic mass media they retain a subversive potential to confront visitors with the unexpected or alien (1996, 178–79).

If we choose to understand the potential of the museum as a mass medium, it is also an increasingly differentiated one, with distinct audiences and "programs." Thus, Huyssen emphasizes the importance of theorizing museums and exhibition cultures

that "can offer multiple narratives of meaning" (1995, 34). Certainly, the effectiveness of museums and their exhibitions are linked to how they engage the visitors as active participants in constructing the process of receiving the exhibition. In this regard, Silverstone concludes that

> the status of the object in the museum; the plausibility, persuasiveness and the offered pleasures of the museum's texts; the representation and articulation of space and time, all are . . . dependent on the involvement and competence of the receivers of the communication. The enormous amount of evaluative research in the museum is testimony . . . to the acceptance of this view—however, much of that evaluative work is premised on, at best, an inadequate view of the museum as a medium, and also on an inadequate view of the role of the visitor in contributing to, rather than simply receiving, the communication on offer. (1994, 174)

Tony Bennett also theorizes the perception of the visitor in constructing the meaning of the exhibition. Like Huyssen, Bennett develops the notion of the visitor's gaze, which he relates to the museum's own "politics of the invisible":

> If it is true . . . that they so arrange the field of the visible as to allow an apprehension of some further order of significance that cannot . . . be seen, the art museum is unique in simultaneously organizing a division between those who can and those [who] cannot see the invisible significances of the *"art"* to which it constantly beckons but never makes manifest. Far less freely and publicly available, . . . the aesthetic theories of modernism and postmodernism selectively mediate the relations between the visitor and the museum in providing . . . a means of reading the invisible grid of intertextual relations through which the works on display can be experienced as *"art."* (1995, 172)

Despite the "museum boom" and the "democratization of the museum" in the late 1970s, in the early 1980s critics pointed to exclusionary practices, mediated through exhibitions, that rendered women, minorities, and socially marginalized groups "invisible" (Bennett 1995, 172). The multiple "politics of the invisible" employed this awareness in redefining the objects and ends of museum practice. However, in constructing a new space for the expression of marginalized cultures, Bennett observes that these interventions need "to give careful consideration to the discursive forms and pedagogic props and devices that might be used to mediate those invisibles in such a way . . . as to be able, indeed, to give 'the eye' to those who cannot 'see'" (172). Thus, Bennett directs our attention to the complex questions of developing museum pedagogies that address viewers on multiple levels and that engage them in the process of constructing their own relations to the exhibits. Perhaps an even more critical question involves the extent to which audiences and communities can be involved in the process of cultural production rather than solely in terms of reception.[38]

As we have seen, much of the institutional practice of museums offers the *potential* to engage the visitor by integrating multiple narratives, some of them dissonant, into exhibition practice. The potential for changing the museum from outside is, as Huyssen

and Silverstone indicate, related to its success as a mass medium of cultural communication, information, and entertainment. Museums can only survive if they engage their audiences; museum visitors must, alternatively, assert their own collective interests. Rather than competing in the myriad and rapidly relativized offerings of the marketplace for experiences *(Erlebnismarkt),* cultural institutions that define themselves in terms of an alterity—which rejects the primacy of a market-oriented cultural politics *and* simultaneously engages visitors in creating spaces for redefined curatorial practices—may be more successful within the realm of a "postutopian cultural politics" (Schulze 1992). Similarly, museum pedagogies that inform and foster a critical dialogue and become a part of the museum's own institutional redefinition can contribute to creating such alternative spaces by "breaking down the walls," both from inside and from outside.

7. Cybersponsoring

Cultural sponsorships assume a pivotal role in linking notions of corporate innovation with artistic creativity. At the same time, they provide legitimacy for new product technologies within cultural institutions and at events. As a function of corporate cultural politics, we have seen that technology is embedded in sponsorships relating to (1) product promotion and consumption (e.g., BMW's "Art Cars"), (2) the organization and representation of social milieus and identities (e.g., product technologies at Ravestock), (3) the aesthetic mediation of events (e.g., visualization technologies used by the Bregenz Festival), (4) the representation of product histories as a filter for remembering and interpreting the past (e.g., BMW's *Isetta* exhibition), and (5) images of mobility, tourism, and space.

Although the dissemination of products or technologies constitutes a central objective of many sponsorships, it is not surprising that much of the growth in sponsoring has been in service-related industries (banking, insurance, and communications), for culture offers the potential for mediating immaterial goods. Thus, image transfer remains a primary objective for *product* sponsorships as well as for those that address the representation of corporate *images* and services within social contexts. Although product and image may be signified distinctly in various contexts, it is their fusion—both in promotion and in constructing spaces of contemporary culture and identity—that has become characteristic of postmodern culture (Wernick 1991, 181–82).

This fusion is epitomized by digital media. Facilitated by sophisticated hardware products, electronic technologies are creating new multidimensional, virtual spaces and communities, reconfiguring communication and how we conceptualize everyday life.[1] The expansion of these spaces also facilitates the further globalization of corporate cultural politics and transnational corporations in a cyberspace, which knows no geographical boundaries. Indeed, there seem to be few areas of social interaction untouched by electronic technologies or their effects. Obviously, cyberspace offers considerable potential for new forms of corporate colonization. However, I have also argued that the shifting contours of social interaction present opportunities for interventions that are not defined by corporate interests as well as apertures to interrogate and externalize such interests. In this regard, cyberspace is certainly no exception. It is

a highly contested terrain, both as a space for the expansion of corporate capital and interests and as one that threatens the very manner in which corporations conduct business and the security of their operations.

The following exploration of the relations among culture, technology, and corporate cultural politics can only tentatively indicate several emerging issues related to the globalization of corporate cultural politics and electronic communication. This discussion begins with the museum, continuing our investigation of its transformation and redefinition as a highly visible site of cultural representation. The emergence of the digital museum introduces a new dimension to the discussion of the museum as a mass medium (Huyssen 1995, Silverstone 1994) by making it a truly electronic medium with the potential to reach global audiences. New museum hybrids use electronic technologies in order to challenge existing models from "outside." Simultaneously, established museums are integrating digital technologies from within. Both processes reflect a fundamental reconfiguration of museums with respect to (1) how their contents are mediated to publics (e.g., through electronic storage and dissemination), (2) a heightened awareness of technology as a medium of artistic expression (i.e., the legitimacy of media art and online art), (3) the integration of information-management technologies into administrative and curatorial programs, and (4) new curatorial practices and modes of representation.[2] In particular, the electronic production and dissemination of museum contents (e.g., over the World Wide Web) has the potential to position it within the media marketplace as a cultural programmer. The way museums and sponsors create spaces (both "real" and "virtual") for artistic production, performance, and audience interactivity is crucial. This process relates to broader issues of community, access, public policy, and corporate cultural politics. Finally, I would like to consider the potential for engaging critical discourse on corporate cultural politics.

Meta-Museums: "Electronic Bauhaus" or R and D Parks for Cultural Software?

The emergence of new museum hybrids, "centers" conceptually based on art and technology, illustrates the significance of technology transfer from corporations to museums. These centers also reflect the museum's expanded function as a space for cultural and technological experimentation and development, which can be transferred to and adapted by corporations. Three centers have gained international attention as models for combining art and technology under one conceptual and administrative structure: the Ars Electronica Center (AEC) in Linz, Austria; the Zentrum für Kunst und Medientechnologie (ZKM) (Center for Art and Media Technology) in Karlsruhe, Germany; and the InterCommunication Center in Tokyo, Japan. To varying degrees, all three centers emerged from the interests of local cultural politics, economic development, higher education, and corporations. The AEC provides the most visible example of technology transfer from corporations to museums, but it also directs our attention to other models that function primarily as more commercial centers for research and development (e.g., the Institut für Neue Medien in Frankfurt am Main).[3]

The AEC is perhaps the best-known of the existing centers as a result of the Ars Electronica Festival for art and technology founded in 1979. The festival provided a forum for media artists and gained further international recognition among artists and museum curators through its annual Prix Ars Electronica (1987), sponsored by Austria's public television (ORF). Based on an initiative of the ORF program director for Upper Austria, Hannes Leopoldseder, the city of Linz agreed to fund and support the AEC as its wholly owned subsidiary.[4] Regional economic development and cultural politics were a key component of the AEC project from its conception and opening in 1996. Mayor Franz Dobusch underscored its function as a vehicle for technological and economic development:

> The Ars Electronica Center positively influences the innovative atmosphere in the economic region of Linz and promotes the interdisciplinary cooperation between industry, research, and art. It leads the way for the necessary process of catching up with technological development in our region and forms the basis for new social structures. The Ars Electronica Center is . . . a mediator for all questions regarding technological innovation and serves as a resource for interested parties from all sectors of the population.[5]

The AEC hybridizes the concept of the R and D park and combines it with the expanded institutional base of a museum, including studio and performance spaces for media artists and interactive installations—a central concept of the new media and art centers, as it is for science and technology museums (Mintz 1998, 23–24; Gradwohl and Feldman 1998, 185). Permanent exhibits at the AEC include a large three-dimensional virtual-reality installation, CAVE (Cave Automatic Virtual Environment), developed at the University of Chicago for exploring and transforming molecular structures; a Cyber City virtual-reality project with tools for city planning and architecture, in which visitors test various planning scenarios and their potential social or ecological consequences; the Knowledge Net electronic classroom, with facilities for distance learning and video conferencing; and an experiential SKY–Media Loft café (so-called *Erlebnis-Café*). Finally, the AEC's Museum of the Future reflects the conceptualization of space as a themed environment by combining entertainment, interactivity, consumption, and education, a process that has its historical roots in Disney's many attractions.[6]

In addition to its role in education (as a destination for school groups and a site for technology seminars), the AEC validates its role as a key participant in cultural politics by promoting itself as an "economic partner" and offering services to corporations in the region.[7] Although the AEC provides spaces for the development of "cultural software" that can be adapted by corporations in order to promote and package their products (e.g., the German direct-mail firm Quelle envisions a cooperative venture for presenting its products on the Internet), corporate transfer of hardware and capital *into* the center is, at present, the most tangible feature of this exchange. Technology transfer occurs within four primary modes: (1) promotional showcasing of corporate

products, services, and technologies; (2) sponsorships for special exhibitions and pro-grams (including funding, advertising, events, and materials); (3) hardware and soft-ware for museum administration, infrastructure, and information dissemination (e.g., servers and Web sites); and (4) hardware and software for permanent exhibitions and corporate products used by media artists.[8] These processes not only indicate the func-tion of meta-museums as experimental spaces for evaluating uses for new technolo-gies, they also relate to technology's broader uses in shaping the contexts of social rela-tions, such as forms of electronic consumption. It is, therefore, hardly a coincidence that the AEC's sponsors—Oracle, Digital, Microsoft, Siemens Nixdorf, and Silicon Graphics, among others—have recognized the potential of the arts and technology centers and "traditional" museums as sites for developing and assessing the cultural component of technological applications.

The meta-museum as a contested site for developing new forms of media use and interaction or as an experimental forum that could function to interrogate the rela-tions of media is reflected in sponsors' responses to the theme of the Ars Electronica Festival '98: "INFOWAR: information.macht.krieg." The festival, including a net symposium, interactive media, installations, CAVE, events, and performances, ad-dressed the expansion of multimedia information networks in cyberspace as forms of war, struggle, and power derived from information, encompassing "connecting issues ranging from hacker ethics to speculators' informationally generated acceleration of Asian financial markets" (Stocker and Schöpf 1998, 16).[9] Although the theoretical dis-courses around INFOWAR implicitly established the links between the emerging uses of networked communication as an instrument of power and repression, this narra-tive was largely rejected by the AEC's sponsors, who not only denied their own par-ticipation in shaping and directing electronic communication as a form of power (economic, political, or social), but also reduced the notion of INFOWAR to issues of corporate strategy, the social Darwinism of the free marketplace, or a war against those who would threaten corporate interests (i.e., hackers) and therefore the public good. This was, in part, exemplified by statements prefacing the INFOWAR catalog, such as those by Microsoft Austria's managing director Alexander Stüger:

> My hope is that the "Infowar" theme leads to a constructive debate on the subject of information without resorting to populist scaremongering about new information pos-sibilities. From an economic perspective, of course, employing information in the right way means competitive advantages for firms or national economies. I certainly would not categorize that as "war," but rather as "competition" (quoted in Stocker and Schöpf 1998, 12).

This, of course, obfuscates the interests of corporate politics, not to mention their im-plication in structuring electronic environments and social relations, one of the major themes of INFOWAR (Stocker and Schöpf 1998, 280). In this regard, Arthur and Marilouise Kroker discuss the "rhetoric machine" developed by Microsoft founder Bill Gates in his book *Business @ the Speed of Thought: Using a Digital Nervous System.* Gates establishes a digital ideology for a digitized future, an ideology that conflates

public and corporate interests in the form of "friction-free capitalism" (directly linking producers and consumers) and colonizes social spaces (health care, public policy, warfare, and education).[10]

In the corporations' statements on INFOWAR, we can also observe attempts to

Figure 7.1. Sponsors and partners for INFOWAR at the Ars Electronica Center.

establish and legitimize their own competing discourses related to and representations of technology, in part by disassociating their own institutional uses of information as economic, political, and ultimately military power from the realm of everyday social relations. Indeed, they have already understood and operationalized the rules of INFOWAR by establishing their own presence within the sites of communities, such as media arts projects (e.g., at the AEC itself) that interrogate the social uses of electronic art and technology. What better way to influence and participate in the structuring of media-art centers than to fund their development as a "partnership" that will lead to their (re-)configuration somewhere between R and D parks and themed environments?

Like the AEC, the Zentrum für Kunst und Medientechnologie was also initially funded by local governments (the City of Karlsruhe and later Baden-Württemberg) as part of a regional marketing and tourism plan; however, it has established a much more expansive museum project than the AEC and has deemphasized potential links to corporate R and D. The ZKM encompasses the Institute for Image Media, the Institute for Music and Acoustics, the Media Theater, the Media Museum, the Museum of Contemporary Art, and the Mediathek. The constituent museums and institutes within the center are designed to foster interaction among artistic production, experimentation, exhibition, collection, and documentation activities. Former director Heinrich Klotz invokes the tradition of Bauhaus as a project linked to modernity and the "creative connectivity between two contemporary social facts, art and technology" (quoted in Miles and Zavala 1994, 14). Klotz situates the contemporary relations of art and technology within a "second modernity" (following deconstruction and post-modernity), one that does not follow a linear, historical tradition of the historical avant-garde but allows a "pluralism of styles," approaches, and strategies, creating a new vocabulary for modernity (Klotz, Bredekamp, and Frohne 1997, 10–12). For Klotz, Frank Gehry's design for the Guggenheim Museum Bilbao is characteristic of the creative potential of this second modernity.[11] Moreover, he emphasizes the institutional role of the ZKM in opening spaces for art and social transformation within the social context of Germany:

> A place must be established in Germany in which the attempt is made to advance artistic and media technological issues and to anticipate for the future, a place in which the goal is a synthesis of the best creative forces in the arts and media technologies. ZKM aims at making multi-media *"Gesamtkunstwerks"* possible, as well as exploring special technologies, promoting the new, and equally well, providing critique of a blinded media euphoria. (Klotz 1995, 9)

A key function of this "Electronic Bauhaus" is to provide institutional legitimation for multimedia art (i.e., video, virtual-reality, or computer-based projects) within the museum. The ZKM does not function as a warehouse or depot (Grasskamp 1992, 94) for exhibiting media art. Rather, as Hans-Peter Schwarz underscores, its role is to represent the "effects and social functions of the media" in the museum (1997, 28). Schwarz calls for exhibition practices that invert the relations between the media ob-

jects on display and the audience in favor of interactive rather than passive reception (1997, 13). Yet he also warns that the danger of the interconnectedness of the media within a multimedia *"Gesamtkunstwerk"* (i.e., one combining multiple media and multiple modes of aesthetic representation), as well as the tendency of such works to contribute to an erasure of the boundaries between "aesthetic creation and reality," must be tempered by the museum's own "deconstruction of the myth of media technology" (1996, 180).

Some the most effective works of media art may be those that intersect with the contexts of everyday life and media use. Although media art by no means represents an integral or extensive part of most museum collections, it has already developed its own canon of classics (e.g., works by Paul Garrin, Marie-Jo Lafontaine, Bruce Nauman, Nam June Paik, Bill Viola, Wolf Vostell) through international shows, such as the *documenta* in Kassel, Germany; Ars Electronica in Linz, Austria; or the Venice Biennale (Galloway 1998, 46–47). The incremental legitimation of media art within the international art market has, of course, led to its historicization and commodification but has also created new institutional and imaginative spaces to investigate its own position within those processes.

One striking example of this intersection of media, art, and everyday life is the rapid rise of game culture (Grossberg 1994, 54) during the 1980s and 1990s, both as a cultural practice and as a mode of aesthetic mediation. In his installation *Welt der Spiele* (1994) at the ZKM, Friedemann Schindler appropriates the video game DOOM as the basis for involving "players" in a critical awareness of their interaction with game contents, thematizing violence and military imagery. Schindler destablizes the relations between game player and game by altering the environment within which the game is played. Players are seated in a dentist's chair similar to one used as an instrument of torture in the movie *Marathon Man*. While they play the game using a data helmet in order to follow the audio and visual game, their physical reactions are transmitted to video monitors placed at the base of the chair and are then observed by other visitors. Removed from the personalized space of everyday game-playing activity, the players become aware of their role as performers (game players) and objects of this performance. Schindler argues that "the structured interactivity—one of the characteristics of commercial video games—is broken here. The dual role of observer and participant, although analytically differentiated, is restored and the character of the interaction as an event is made conscious" (quoted in Schwarz 1997, 52).[12] Schindler's installation gained heightened significance after the school shootings at Columbine High School in Littleton, Colorado, where it was alleged that the violence in the video game DOOM contributed to the student assailants' behavior. Schindler has based his installation on pedagogical research, which he participated in, on the effects of video games like DOOM within youth culture. In this sense, Schindler's project, combined with his other projects that ask young game players to discuss their reactions to game playing and game culture, contributes to a critical pedagogy of media both within and outside the museum.

Mit Phantasie und Technik auf dem Weg zu neuen Erlebniswelten.

F&L CI 9/230

Bill Viola
"The Theater of Memory", 1985
Photo: Kira Perov and Squidds & Nunns
Collection: Newport Harbor Art Museum,
California

Bei der Mediale sind wir Partner eines Festivals, das künstlerische Vorstellungskraft und technische Entwicklung auf vielseitige und neuartige Weise verbindet. Die unter Mithilfe der Lufthansa Kulturförderung zustande gekommene Ausstellung „Feuer, Wasser, Erde, Luft – Die vier Elemente" vermittelt davon einen wirkungs- vollen Eindruck. Verbindungen zu schaffen und Grenzen zu überwinden, sehen auch wir als unsere schönste Aufgabe. Nicht nur in räumlicher Hinsicht. Schon seit vielen Jahren unterstützen wir Begegnungen im kulturellen Bereich. Wir wünschen allen Besuchern erlebnisreiche Stunden im Zeichen der Medien-Kunst.

 Lufthansa

Figure 7.2. Experiencing art and technology: Lufthansa sponsors the Hamburg Media Arts Festival (Mediale). *Text at top reads,* "With fantasy and technology, on the way to new worlds of experience."

Although this deconstruction of the relations of technology and culture is undoubtedly well represented in many of the individual works of media art exhibited at the ZKM, including Schindler's DOOM installation,[13] the integration of a critical analysis of media technologies into ZKM programming as a whole remains tenta-

tive.[14] Indeed, the way the centers for art and technology have developed institutional structures and discourses for representing their own roles in media technologies involves what Schwarz refers to as a paradoxical "mediatization of the media," that is, the transfer, representation, and mediation of mass media itself as the object of exhibitions for mass audiences (1997, 29).

This self-referential quality of the centers reflects their functions as meta-museums in at least two key respects.[15] The first involves their attempt to represent and mediate the discourses of their constituent museums, institutes, or programs for internal and external dissemination through networked communication and experimental projects among institutes, museums, and studios[16]—designed to create new modes of artistic production and interaction as well as communities in real or virtual space (e.g., media laboratories or Internet projects). A second significant feature defining meta-museums is their own adaptation of the technical and communicative characteristics of the technologies they exhibit and mediate. Like the electronic media they represent and employ, meta-museums conceptualize their activities as multidimensional, nonlinear, interactive, and networked. For example, Ursula Frohne refers to Friedrich Kittler's notion of the computer as a metaphor for reconceptualizing the museum:

> The museum itself can be considered both as a hybrid, as well as "universal storage medium" of temporal models and structures, which is comparable to the electronic storage units of a computer, ordering art works according to a museal plan, and opening up contemporary space for interpretation, by transforming its respective exhibition contexts into a new historical level. The relativization of the works as a result of time has the effect of counteracting the aestheticization of their temporality. (Frohne 1997, 49)

Yet I would argue that the works do not gain their immediacy primarily as a result of their *re*-presentation in infinite constellations and combinations, which would somehow inherently destabilize their privileged status as museal objects, but, rather, through the critical moment of interrogation and intervention by artists, curators, and audiences. The notion of "the computer as museum" leads to the meta-museum as a metaphorical structure that also assumes the logics associated with the new electronic media it represents. Such structures tend to position museum visitors as "components" of the technological hardware itself or as "users" within the network.[17]

Rather than reimaging themselves in terms of the logics of the media they employ and represent, I suggest that meta-museums integrate a more dialectical approach, which involves the deconstruction (Schwarz 1996, 180) and destabilization of the technologies they mediate. The art and technology centers must interrogate their multiple functions as institutions of technological legitimation, transfer, and critical inquiry. Whereas media *art* must first gain access into the museum in order to engage audiences in an exploration of technology's diverse narratives and social functions, curatorial strategies must provide contexts that problematize the relations between art and technology rather than allowing them to become extensions of entertainment based on the commercial uses of media.[18] By recognizing their role both in legitimizing *and* in

deconstructing media art, meta-museums can create a dynamic tension that can be used to explore their relations.

Virtual Museums

In some respects, meta-museums such as the AEC and ZKM now situate their role in the media-art terrain as a bridge between virtual and real space by displaying online art exhibitions (such as *Net_Condition*) within the museum. Although media art has gained increasing legitimacy within museum collections, it is the digitization and mediation of *existing* collections that holds even wider implications for fundamentally altering the role of all museums and the way their collections and exhibitions are received. During the 1990s, collection digitization (in CD-ROMs and online) was proceeding at an exponential rate, albeit at varying levels of technological sophistication.[19] Maxwell Anderson, director of the Whitney Museum of American Art, became one of the most visible advocates of digitizing the museum and integrating media art. Although Anderson recognizes that viewing exhibitions and collections online will not supplant the experience of viewing the original, he foresees an enormous potential for disseminating culture (e.g., on the Web) and expanding the mission of the museum in doing so. Part of this process involves altering the way museums contextualize and mediate artifacts. Anderson argues that virtual representation will re-create the origins and functions of artifacts, which have been removed from their original contexts, thereby expanding the viewer's understanding of the relationships between artifact and context. He envisions museums constructing virtual galleries with

> panel paintings reinserted into chapels, gargoyles reattached to cathedral walls, Roman portraits repositioned on bodies in simulated public buildings. The educational value of such three-dimensional imaging will be to breathe new life into works deprived of their original context, and will make the pilgrimage to our galleries all the more rewarding. (1997, 29)

Missing in this scenario, however, are the histories of how museum artifacts came to be in the museum in the first place and how they can now be magically returned to their original sites through a sort of virtual reinscription. How indeed will virtual exhibitions (re-)create the political and economic contexts of colonialism that facilitated and legitimized the acquisitions of many museum collections without creating new forms of mystification?[20]

There are also considerable economic incentives to disseminating culture online. Anderson theorizes that if 965,000 visitors paid to go to the Art Institute of Chicago's *Monet* exhibition, many more would be willing to pay user fees to (re-)visit the exhibition online. These fees could not only be used to defray exhibition costs, but they would also generate funds for other thematically linked exhibitions online (1997, 28). What Anderson envisions for exhibitions on the World Wide Web is much like pay-per-view television. With the convergence of television and Web technologies (e.g., WebTV), such exhibitions would be included as another form of programming

(Anderson 1997, 31). Similar types of programs (museum exhibitions, theater performances) could be packaged and promoted by museums and sponsors. Thus, Anderson argues, museums will be able to compete within the mass media marketplace, where "museum directors . . . have another expertise demanded of them: television producer":

> Through astute video programming on networked Web sites, museums need no longer accede to being marginalized because of the relentless onslaught of powerful commercial interests that have directed the audiovisual stimulation of the mass audience. With networked digital technology available through the cable box or through the air, it will be a battle of wits to get our multiple messages across, as well as to cajole audiences to communicate with each other through our museums by means of wireless keyboards and, soon enough, voice recognition systems. Which will require . . . a new kind of museum.(1997, 32)

In order to compete within the media marketplace of cable and WebTV, museum directors and curators will have to package their contents in appealing and salable formats. The relatively short history of marketing collections and exhibitions on CD-ROM indicates that the mass market is indeed limited to a relative few large-scale projects.[21] Museum programming will have to establish its own "difference" and profile to distinguish it from the proliferation of cultural offerings. Moreover, the visions of wired or virtual museums do not sufficiently address content. To the extent that diverse discourses are presented, will they be reduced to niche marketing? Many of the more creative projects in both traditional and new media will not be sufficiently commercial for mass marketing. And it is precisely these types of projects that, working against market rationales, may be economically feasible on the World Wide Web, although they will probably not generate significant amounts of income from user fees once most museums are offering an array of online exhibitions and artworks—not to mention those presented by individual artist-entrepreneurs, galleries, educational and arts institutions, or corporations. In fact, museums will be competing with other arts institutions online. Corporate museums or collaborative joint ventures between corporations and museums (e.g., between the Whitney and Intel or between the Brooklyn Academy of Music [BAM], the Guggenheim, and Lucent Technologies)[22] will create new spaces for corporate representation of culture and will be a dominant force within the media and online markets, which already reflect a high degree of concentration.

The museum as a mass medium, as a space for engaging wider audiences in a dialogue on diverse cultures and as a site of collective remembering and forgetting (Huyssen 1995, 19, 34), now assumes a new meaning and function as an electronic mass medium, globally linked through the Internet and disseminated in multiple formats. Once limited to the reproduction of its contents in catalogs, museums may employ digitization to expand their possibilities by introducing audio, visual, and interactive reproduction. From a media perspective, digitization does for the museum what audio and video reproduction has done for concerts and theater performances.

It also provides new products for reproducing the exhibition as a "performance event" within new contexts and markets (e.g., schools, homes, offices). The range of contexts and modes of reception is expanded exponentially, meanwhile widening the field of sensory interaction and reaching into everyday life. As the museum becomes a site for cultural production (e.g., artists' studios, interactive-exhibition projects) and performance, it can also reconfigure and reproduce those projects in multiple formats. Like the relationship between performance and reproduction, the desire to experience "live" is not eliminated. Live and recorded performances mutually reinforce one another. Yet the museum's evolution into a mass medium and the reproduction of its contents also integrate it into new networks of commodification that simultaneously relativize its collections and exhibitions. Although the museum has certainly been subject to the forces of the cultural marketplace, the extent to which it will be able to engage media technologies in order to create new spaces for the interrogation of society and culture, as well as the specific quality of this process, remains unclear.

Just as we differentiate between various types of museums and museum visitors in real space, we must also be conscious of the different functions and objectives of the emerging virtual museums (as sites of provocation, entertainment, consumption, education) and of the types of museum visitors in cyberspace. Virtual museums and online art might attract types of visitors different from those who are revisiting exhibitions in real museums. There is still much to be learned regarding who actually visits or interacts with online art and how they do so (Chadwick and Boverie 1999, 8). Sabine Fabo argues that virtual museums may lead to a reconsideration of notions of museal authenticity, in particular the imaginary and representational boundaries between what is considered material or real and works of virtual art, which also engage a sense of the imaginary (1999, 424). Certainly, the evolution of new museum hybrids that integrate both virtual and nonvirtual forms of exhibition and dissemination may be useful in developing new curatorial and representational strategies. However, I also argue that visitors will actually differentiate between the various contexts of reception. That is to say, they will visit the physical spaces of real museums (or hybrid meta-museums) for a kind of experience different from what they expect in their visits to virtual museums or environments through electronic networks. At present, the most interesting projects are those that do not simply replicate exhibitions in real space or function as forms of marketing and merchandising for collections but, rather, explore forms of mediation that are not possible in nonvirtual spaces (e.g., Walker Art Center's *Beyond Interface* exhibition).

Moreover, we must explore the manner in which a project's aesthetics, design, and accessibility within cyberspace structures visitors' interaction with the project, or potentially alters the work itself. Unlike artifacts stored and disseminated over the Internet, many online art projects utilizing hypermedia challenge the notion of "user-friendly" interaction through multiple interfaces, texts, and sites that defy rapid orientation and navigation. On the one hand, visitors are challenged through a sense of disorientation and the unexpected; on the other, they can also choose paths of inquiry and interaction within a range of options. This dynamic tension, which engages

visitors in a creative spectrum of challenges (zones of disorientation and rupture) as well as creative production and imagination (zones of interaction, response, or production), is what may characterize some of the more successful projects. These characteristics seem to make online art an effective medium for challenging established norms.

Although online art is by no means isolated from processes of appropriation and commodification, it does share some characteristics of conceptual art or site-specific installations, which are also characterized by their temporality in the spaces they occupy. In this sense, virtual, online art is even more difficult to "collect." Many media curators and directors, such as the AEC's Gerfried Stocker, clearly distinguish between "documentation" and "collection":

> We are only building documentations, not collections, because you can't collect the moment of happening. The most important thing in net art is the time-based process of exchange and communication. And you can't collect that, you can only document it. But I believe . . . that I would rather invest in production than collection. What is the role of the museum in net art? You can't support it by collecting it. As soon as you collect it, you damage it.[23]

Certainly, there is a fundamental difference between net or online art projects and museum collections that are digitized for electronic dissemination. The interactive dimension of online art does create an event character similar to that of performances and installations, and each visit to the site may be slightly different from the last. Nonetheless, successful online projects will probably be "collected" and stored online for future dissemination, as well as used for promotion or merchandising (to the extent that future technologies will be able to disseminate works produced with software that has become obsolete or to convert them into new formats). In any case, artistic production has moved to center stage in the conceptual development of meta-museums and media centers. By establishing the museum as a site of artistic production and collaboration (beyond the functions of acquisition, collection, documentation, and exhibition), both meta-museums and virtual museums are providing further impetus for reconfiguring the status of artists, curators, museum directors, and publics.

Artists, Engineers, and Audiences

Centers for art and technology, the emergence of virtual museums, and museum-corporate collaborations reflect a heightened awareness of the historical relations between cultural production and technology within institutional discourses. Certainly, the development of contemporary video and media art has involved varying degrees of collaboration among artists, engineers, and researchers, but in many cases the objective of the collaboration has been to deconstruct the cultural functions of technology itself.

Artists have appropriated technological hardware and software in order to interrogate and destabilize its representations and functions. Beginning in the 1960s, the Experiments in Art in Technology (EAT) program was an outgrowth of artist-engineer

collaborations that led to larger interdisciplinary projects exploring the social and cultural uses of new communications technologies (Klüver 1994, 218; Penny 1995, 65). A paradigmatic example of these early collaborations is the work of Billy Klüver, who gained permission from his employer, Bell Labs, to work with artists, beginning with Jean Tinguely and following with Robert Rauschenberg, Jasper Johns, Andy Warhol, and later, video artist Nam June Paik (Klüver 1994, 207–19). Tinguely's *Homage to New York* (1960), a machine that would destroy itself in front of a theater audience, was completed with the technical support provided by Klüver and his colleague Harold Hughes (Klüver 1994, 207–8). *Homage to New York* not only literally deconstructed the representation of urban technology, it did so as a performance installation, which challenged the permanence of museal art by foregrounding temporality through the process of self-destruction. As Klüver observes, an important outcome of the EAT (with more than six thousand members) during the 1960s and 1970s was its program to create a "training ground for larger-scale involvement in social issues for both the artist and the engineer" (1994, 218). Toward this end, many of the projects attempted to engage audiences (in different countries) in a critical awareness of their own uses of electronic communications technologies (216–17).

Hans-Peter Schwarz traces the history of media development through the incremental and cumulative interaction of artists (e.g., Robert Rauschenberg, with his early interactive art), engineers, and researchers. Schwarz argues that the conceptual development of many virtual-reality technologies had been prepared by the work of media artists, such as work by Dan Sandin, Tom DeFanti, and Gay Sayers under an NEA grant, followed by Tom Zimmerman's "data glove" as a conceptual model for NASA's production of a working prototype (Schwarz 1997, 63). Within music, the adaptation of electronic technologies for instruments and audio reproduction was even more integral, as musicians developed their own technical expertise (66). Whereas Schwarz cites the work of Myron Krueger *(Video Place),* filmmaker Morton Heilig *(Sensorama),* and Ivan Sutherland *(Scetchpad)* in order to document the extent to which virtual reality was a product of technical and artistic experimentation, Howard Rheingold's history of virtual reality (1991) presents a complicated and intricate narrative involving the pioneers of virtual reality (Krueger, Heilig, Sutherland) as well as U.S. Defense Department funding, NASA, R and D projects at Bell Labs, government-funded projects at universities (e.g., the Massachusetts Institute of Technology), and the commercial development of audiovisual technologies.

Simon Penny, who has been extensively involved in interactive media both as an artist and as a curator, emphasizes the importance of commercial and institutional forces at work in shaping the contexts in which media art is produced and disseminated:

> In the art world, discourses on the nature of the digital, cyberspace, virtual space, etc. have a peculiarly amnesiac quality about them. It is forgotten that the primary purpose of digital communications networks are, and always have been, strategic, military and commercial. . . . we forget that VR [virtual reality] and interactive interface research,

indeed basic computer research in general, have been almost exclusively military in origin. It is at least possible that this lineage has shaped the technology, confining its range of possibilities as an artistic medium. (1996, 127)

With the increasing convergence and hybridization of arts, education, and corporations, the interests of artists and researchers have become more complex. Much of the basic research in technology was driven and structured through government or defense industry funding in public and private research institutions.[24] Many of the new, smaller R and D centers, like the Institut für Neue Medien in Frankfurt am Main, combine commercial contract work with technology research and art projects and became corporate entities primarily as a result of privatization during the 1980s and 1990s. Undoubtedly, the artist-engineer dichotomy becomes more questionable as younger artists have technological training or become more technologically literate. This heightened awareness of new technologies can be strategically employed in a more extensive exploration of media within art and culture. Nonetheless, media artists must largely work within the institutional structures and communications networks that are, for the most part, developed and organized by commercial interests:

> In terms of corporate economics, VR serves the computer industry very well: it is intuitive (no learning curve, no consumer resistance), and it calls for unlimited computer power, thus fulfilling the industry's need for technological desire. The transference of libidinal desire onto fetish objects offers the promise of ecstasy but never finally consummates it, driving the consumer to the next purchase in an unending coitus interruptus. (Penny 1994, 247)

Penny's own work with virtual reality, and his analysis of its potential, suggests a more limited, strategic use in social critique, a use that becomes increasingly difficult as electronic technologies are embedded as a given within patterns of everyday life (1994, 247–48). Thus, a critical media consciousness must also integrate context-specific as well as broader theoretical and institutional analyses of existing and emerging technologies rather than foregrounding new electronic media solely in terms of their utopian or dystopian functions. Analyses of media art increasingly explore their contexts of production and reception (or the fusion of these contexts), as well as problematizing their positions within virtual spaces (Blackman 1998, 137).

Brandon

Virtual museums are using online, networked communication as a platform to investigate the mediation of social relations through technology. One of the most compelling online art projects, in terms of its exploration of the construction of identity within virtual space, is *Brandon: A One-Year Narrative Project in Installments* developed by filmmaker and artist Shu Lea Cheang for the Guggenheim Virtual Museum:

> BRANDON derives its title from Brandon/Teena Brandon of Nebraska, USA, a gender-crossing individual who was raped and murdered in 1993 after his female anatomy was

revealed. Cheang's project deploys Brandon into cyberspace through multi-layered narratives and images whose trajectory leads to issues of crime and punishment in the cross-section between real and virtual space. Conceived as a multi-artist/multi-author/multi-institutional collaboration, BRANDON will unfold over the course of the coming year [1998], with 4 interface[s] developed . . . for artists' participation and public intervention.[25]

Multiple-user spaces (chat rooms), a virtual MOO (multi-user object-oriented programming) court at Harvard (including experts on cyberlaw), and online symposia provided mediations of Brandon Teena that extended beyond the Guggenheim's BRANDON project itself. Linked installations in the *Theatrum Anatomicum* interface, developed by the Society for Old and New Media, Amsterdam (based on drawings of the original "theater" from 1773), problematize the relations of body, gender, crime, and medicine. The reconstruction of the amphitheater-like spectacles and its spectators reimages: "The operating table at the center where the body dissecting lessons were performed on executed criminals for medical society and selected viewers in the 17th century, is reconfigured into a net public interface."[26]

BRANDON
a one year narrative project in installments

BRANDON derives its title from Brandon/Teena Brandon of Nebraska, USA, a gender-crossing individual who was raped and murdered in 1993 after his female anatomy was revealed. Cheang's project deploys Brandon into cyberspace through multi-layered narratives and images whose trajectory leads to issues of crime and punishment in the cross-section between real and virtual space. Conceived as a multi-artist / multi-author / multi-institutional collaboration, BRANDON will unfold over the course of the coming year, with 4 interface developed (1996-1997) for artists' participation and public intervention:

bigdoll interface
roadtrip interface
mooplay interface
panopticon interface

During 1998-1999, guest curators will be invited to select other artists and writers to contribute additional uploads for each of these interfaces. BRANDON is launched with a netlink between Amsterdam's Theatrum Anatomicum and The Guggenheim Museum in Soho on June 30, 1998. Two netlinked forums, Theatrum Anatomicum interface, are developed with DeWaag Society for Old and New Media, Amsterdam.

The Brandon site is shown at regularly scheduled hours on Guggenheim Soho's videowall.

for information: Scott L. Gutterman, Director of Public Affairs, sgutterman@guggenheim.org

ever-processing with multi-author upload

concept/direction
Shu Lea Cheang

BRANDON is curated by Matthew Drutt Associate Curator for Research, Guggenheim Museum produced in association with Society for Old and New Media Caroline Nevejan and Suzanne Oxenaar / curators; Institute on the Arts and Civic Dialogue Anna Deavere Smith and Andrea Taylor / directors Banff Center for the Arts Sara Diamond / director of media arts

BRANDON is part of a broader program in the media arts being led by John G. Hanhardt, Senior Curator of Film and Media Arts at the Guggenheim Museum.

Funding for BRANDON has been made possible by grants from The Bohen Foundation, a Moving Image Installation and Interactive Media Fellowship from The Rockefeller Foundation, a Computer Arts Fellowship from the New York Foundation for the Arts, and in Holland, grants from The Mondriaan Foundation and the Ministry for Cultural Affairs. This project is supported, in part, with public funds from the New York City Department of Cultural Affairs Cultural Challenge Program. The project is being hosted by USWeb Los Angeles. Artist in residency provided by Woo Art International (New York) and Amsterdams Fonds voor de Kunst.

Figure 7.3. *Above,* BRANDON in virtual space: the Guggenheim's BRANDON Project. *Facing page,* engaging BRANDON in virtual space: the Web page from which one enters the bigdoll interface. BRANDON has been made possible by grants from The Bohen Foundation, The New York City Department of Cultural Affairs, a Moving Image Installation and Interactive Media Fellowship from The Rockefeller Foundation, a Computer Arts Fellowship from the New York Foundation for the Arts, and, in Holland, grants from The Mondriaan Foundation and the Ministry for Cultural Affairs. Copyright The Solomon R. Guggenheim Foundation, New York.

What I find particularly striking about the interfaces in BRANDON is the dynamic, creative spectrum of challenges (zones of disorientation and rupture) as well as of creative production and imagination (zones of interaction, response, or production). As visitors navigate the interfaces (bigdoll interface, roadtrip interface, mooplay interface, and panopticon interface), they explore multiple subject positions. These may include the virtual road trip in which the visitor, in part, assumes the role of Brandon, making stops along the way.[27] Other visitors to the road-trip interface may discover an autobiographical text written by a fictional driver who picks up Brandon hitchhiking. The driver-narrator relates this experience with Brandon, describing the ambivalence of his or her own identity and Brandon's attraction. When the narrator learns of Brandon's brutal murder, Brandon's rage becomes the narrator's own, shifting and alternating subject positions, in a trajectory approaching Brandon:

> i wasn't trying to start a revolution, i didn't ask to be sacrificed, his voice rising now. is this all my life was worth, to be used as a character in a tragedy of someone else's making? if this is my punishment, what was my crime? if I'm such a hero, where's my reward? and his gaze is burning me branding me forever.[28]

The dynamics of the driver-hitchhiker reminds us of our visit in the *Theatrum Anatomicum,* where the visitor as cyberspace driver-navigator assumes the spectatorial gaze of the voyeur. The observer-voyeur enters the "operating theater" of anatomy, where the instrumentalization of the body, as a function of medicine and science, converge in the spectacle of the amphitheater.[29] Although visitors may choose to enter or exit the interfaces or to navigate particular visual narratives, they are never completely in control, finding themselves drawn into an increasingly complex network of interrelationships in which the representation of Brandon as both a historical and fictional, "real and virtual," subject at once emerges and simultaneously becomes more fragmentary. In terms of its macronarratives, the navigation of the interfaces and links evokes the reinscription of Brandon in virtual and real (historical, fictional, juridical-administrative) spaces, created through the project itself, and in the imagination of the visitors.

Jennifer Terry points to the project's importance in terms of representing and interrogating Brandon's role within the formation of subcultural circles and identities, in particular "the sometimes conflictual, sometimes allied formations of transgender politics, lesbian-feminist politics, and butch identity politics."[30] This is also a key aspect of BRANDON's reception within the context of other media narratives on Brandon.[31] BRANDON seizes upon the aesthetic potential of digitized hypermedia (i.e., invoking multiple and simultaneous levels of narration reconfigured both by curators and by publics) to problematize the social construction of a stable identity in the real world. The project accomplishes this in part by making audiences aware of their acceptance of technologies and virtual spaces as sites for constructing social reality. The shifting interfaces of both documentation and fiction require visitors to respond interactively to these narratives, but also, more importantly, to probe and negotiate their conflicting voices. Thus, BRANDON facilitates an investigation of the way identities and their representations are constructed, communicated, and mediated by technology.

One way of assessing the impact of such projects will be to examine the way publics actually do respond to *and intervene* in the process of virtual representation. Many media curators recognize that the aesthetic strategies of digital exhibitions require "a new metaphor," providing different paths for navigating, exploring, and interacting with the resources of the site rather than structuring the exhibition in a primarily linear fashion (Gradwohl and Feldman 1998, 189). This also implies a changing role for media artists, who perform multiple roles as producers, programmers, collaborators, and facilitators.[32] Virtual projects on the scale of BRANDON must also be willing to risk a certain degree of danger or chaos from external and in some cases threatening voices in response to online art. At the same time, projects themselves can be interventions in virtual spaces. Robert Atkins observes that "on-line art is the most hybrid of all media; one in which production and distribution, economics, design and esthetics hopelessly—and intriguingly—intertwine" (1998, 89). Like media art presented in real spaces, virtual art must also work against itself, deconstruct its own rela-

tions, in order to reveal its own mechanisms and the way our reception and inter-action with existing technologies have already conditioned our expectations, and in doing so it will provoke interventions that question the boundaries and politics of real and virtual spaces.

Corporate Cultural Politics in Cyberspace

Technology transfer—from corporations to artists' virtual studios or to museums, as well as the transfer of "cultural software" from artists and museums back into corpo-rations—represents only one dimension of corporate interests in disseminating and commodifying electronic technologies. Moreover, the fusion of new modes of cultur-al production and dissemination that gradually erase boundaries between forms of digitized production and reception has by no means created an equal partnership of collaboration among artists, virtual museums, and commercial interests. Although cyberspace provides an aperture to interrogate corporate interests, it has become a highly commodified space, offering new sites for the representation and articulation of corporate politics. Corporate sponsors have simply applied their existing strategies of corporate cultural politics to their online operations, albeit with an exponentially greater potential for dissemination.

Corporate sponsorships of media art projects utilize the notion of image transfer within cyberspace by providing links to corporate Web sites. Whereas corporate names and logos in *print advertising* for sponsored projects (e.g., exhibitions or performances) rely on viewer associations with corporate image and product brands, the corporate logo embedded as a *digital link* transfers the visitor to an expansive array of corporate and product information with one click. Little is left to the imagination. In fact, cul-tural institutions are often required to include corporate URLs in both their print promotion and their Web site as one of many conditions of sponsorship. Ford Motor Company, for example, designates the precise wording that sponsored programs must use in acknowledging sponsorship and requires that it stand alone (i.e., not in con-junction with other text or acknowledgement of other sponsors): "To learn more about Ford Motor Company, [exhibition name] and other programs made possible by Ford Motor Company, visit *www.ford.com.*" In addition, museums or other spon-sored organizations are required to give Ford "on disk, graphic images to be placed on the Ford Web site representing the exhibition or program and the organization logo."[33] Thus, the museum's logo and the image of its exhibition provide a validation of the corporation's status as a cultural producer and promoter. In addition to finan-cial and product information, Web sites are platforms for promoting corporate inter-ests in public policy. Ford invites applications for support from

> groups or organizations designed to develop policies and programs on topics such as: labor practices, school curricula, and new market areas. Ford Motor Company Fund support is intended to help implement these new ideas and recommendations to better serve the needs of our changing population.[34]

Within the promotional discourse of community relations, communications technologies are represented as vehicles of economic access and democracy. Bell Atlantic promotes technology as "break[ing] the barrier between the haves and the have nots."[35] Apart from placing computers in schools to make students computer literate or supporting senior-citizen programs for computer literacy, Bell Atlantic funds museum projects linking schools with the museums. The Bell Atlantic Foundation is particularly involved in funding arts and community projects that will apply communications technologies to their programs. These sponsorships illustrate that the communications industry is concerned not only with disseminating information technologies but also, more significantly, with organizing how that communication is structured and occurs.

Although the Internet has frequently been considered a space for establishing utopian, virtual communities and forms of social interaction, there is no doubt that more dystopian scenarios, such as corporate efforts to structure access and forms of interaction within these spaces, are well underway. One of the ways the Internet is being structured as a site of consumption is through the "portal" sites providing access to a variety of additional services—essentially channeling user requests for information or entertainment along predetermined paths:

> Under the pretext of "more comfort" and "easier operation," it is really a matter of entangling the user in a comprehensive network of dependencies, which ultimately will have the objective of involving the use of as many products linked to this firm, whether browsers, e-mail clients, site or server. (Medosch 1998, 6)

User profiles and interactions are tracked in order to establish "branded communities," i.e., communities of people with similar patterns of use and consumption (Medosch 1998, 3–4). Thus, Internet use will increasingly be used for market research, recording visits to sites, purchasing patterns, or browsing activities. Personal interests, down to the most minute details, may not only be tracked but also channeled to specific forms of consumption (e.g., the burgeoning market in global cybersex).[36] Cultural institutions can determine the potential interests of audiences for virtual and real exhibitions by tracking use on their sites, and sponsors can use this data in assessing the effectiveness of cultural productions in accessing their target markets. In terms of Internet access, Medosch predicts a general trend toward uniformity, which is in part based on the increasing concentration of services within the hands of relatively few major global players, such as Microsoft and Disney (1998, 2, 4–8). Although it is unlikely that the Internet or its successors can become completely dominated by transnational communications corporations, individual users may have to become more resourceful in "navigating" and creating alternative spaces within cyberspace.

Moreover, the emergence of transnational corporations conducting much of their business in cyberspace (Pruitt and Barrett 1992, 408) poses a paradox for corporations that restrict sponsorships to sites where they maintain operations. The expansion of online consumption—and the elimination of wholesale and retail operations—transfers many, albeit not all, of these sites of exchange into cyberspace. Simultaneously, manu-

facturing and data-processing operations are increasingly subcontracted and shifted globally. If the corporation legitimizes sponsorships (cultural and social) through local "investments" in communities, how are those locales defined when corporate capital exchange occurs in cyberspace? Such contradictions will in all likelihood actually increase corporations' need to maintain forms of representation in real spaces (e.g., as global corporations have done in Berlin) in order to assert their legitimacy, as well as to protect their political and economic interests. Of course, themed environments (including new hybrids of the virtual and the real), which increasingly merge with other spaces of social interaction (e.g., education and culture), will continue to present site-specific opportunities for articulating corporate cultural politics.[37]

To what extent cyberspace can provide new spaces for fostering critical discourse in virtual communities is, at best, an open question. Based on Jürgen Habermas's notion of the public sphere, Howard Rheingold refers to the "commodification of public discourse" within the electronic media and, by extension, virtual communities. Indeed, he asserts that the notion that communications technologies are inherently democratic, rather than structured by economic and political interests, is a myth perpetuated by those interests:

> The great weakness of the idea of electronic democracy is that it can be more easily commodified than explained. The commercialization and commoditization of public discourse is only one of the grave problems posed by the increasing sophistication of communications media. The Net that is a marvelous lateral network can also be used as a kind of invisible yet inescapable cage. (Rheingold 1994, 289)

By facilitating the transfer of economic and cultural capital to media technologies and communications networks (increasingly controlled by transnational corporations), cyberspace may limit critical cultural practices by marginalizing other forms of site-specific, community-based culture in a more radical fashion than has occurred with the introduction of other media. Yet this development could also lead to a greater consciousness of place in constituting individual and collective identities and to the desire to participate in the construction of those places.

Finally, the convergence of cultural politics, based on the consensus of economic rationales—among corporations, foundations, arts institutions, and governments—further complicates communications policy issues. Artists and cultural institutions will have to negotiate many of the following issues with respect to electronic communication: (1) access, (2) diversity, (3) equity, (4) civic discourse, (5) freedom of expression, (6) privacy, and (7) copyright (Larson 1997, 119–25). Although the NEA recognizes the communicative potential of the Internet for museums and local cultural organizations, its report on the state of the arts at the outset of the twenty-first century, *American Canvas,* pointed to the marginalization of alternative cultural expression within U.S. communications policy. Indeed, nonprofit cultural organizations were largely denied a voice in the U.S. government's blueprint for communications policy for decades to come (i.e., in the Telecommunications Act of 1996) (Larson 1997, 114; Gaskin 1997, 214–19, 236–39). Citing the commercial development and concentration

of the cable industry, the NEA warned that local and national arts institutions will be at an economic and technological disadvantage unless they can form effective collaborations (Larson 1997, 114). In contrast to public broadcasting in the United States and Germany (where public television played a leading role), the development of the Internet is now being driven by commercial interests or public-private collaborations. And it is precisely this growing convergence, indeed fusion, of public, commercial, and nonprofit cultural programming and administration that will define the cultural landscape for the foreseeable future. As cyberlaw expert Lawrence Lessig points out in his book *Code and Other Laws of Cyberspace* (1999), the realm of cyberspace, and its increasing impact on everyday life, is an area that most governments are either unwilling or unable to regulate. Yet the consequences of coming to terms with fundamental regulatory issues will have a profound impact on the realities of public discourse, privacy, and democracy:

> We will watch as important aspects of privacy and free speech are erased by the emerging architecture of the panopticon, and we will speak, like modern Jeffersons, about nature making it so—forgetting that here, we are nature. We will in many domains of our social life come to see the Net as the product of something alien—something we cannot direct because we cannot direct anything. Something instead that we must simply accept, as it invades and transforms our lives. (Lessig 1999, 233)

The End of Sponsoring?

The expansion of corporate sponsorship in the United States, in Germany, and throughout much of the EU during the last two decades of the twentieth century reflects the growing significance of cultural programming as a function of corporate cultural politics. As we have seen, corporate funding in various forms has become indispensable for most large projects, accounting for roughly 70 percent of total costs for many museum exhibitions (*Museo Guggenheim Bilbao* 1997, chapter 6, page 3). The emergence and articulation of corporate cultural politics were increasingly visible as sponsorships, once defined primarily as philanthropy, became a part of the institutional networks of community relations, that is, as social sponsoring or forms of cause-related marketing. Many corporate-nonprofit "partnerships" now include both cultural and social sponsorships, or even merge them. For example, Philip Morris's "Arts against Hunger" campaign, referred to in chapter 1, offers discounted tickets to art museum exhibitions in return for contributions to local food drives. Such projects reflect public-policy discourse and a degree of consensus (within corporations and government) that define institutional legitimacy in terms of social issues and market acceptance.[38] In order to maintain institutional legitimacy and access funding, the NEA reports that a majority of LAAs now include collaborations with social agencies as part of their programs and funding requests (e.g., agencies for cultural and racial awareness, youth at risk, economic development, crime prevention, illiteracy, AIDS, environment, or substance abuse).[39]

Exhibition Sponsorship

Exhibition sponsorship at the Guggenheim Museum provides corporations with a unique opportunity to partner with one of the world's leading international museums. Through this program, corporate sponsors help enable the development and presentation of the finest in cultural programming. The Guggenheim's exhibition sponsorship program offers sponsors a flexible, multilevel engagement.

The Guggenheim works with its corporate sponsors to maximize benefits, including:

• prominent corporate acknowledgment
• special events
• acknowledgment on museum Web site
• acknowledgment in press and media campaigns
• licensing of museum image and artworks
• complimentary corporate membership with full member benefits.

For more information, contact:
Corporate Sponsorship
Solomon R. Guggenheim Museum
1071 Fifth Avenue
New York, NY 10128
(212) 355-6394
E-mail: sponsorship@guggenheim.org

Bottom: Pierre Auguste Renoir, *Woman with Parrot (La Femme à la perruche)*, 1871. Oil on canvas, 92.1 x 65.1 cm. Thannhauser Collection, Gift, Justin K. Thannhauser 78.2514 T68.

Figure 7.4. Guggenheim's Web site for sponsors. Copyright The Solomon R. Guggenheim Foundation, New York.

Obviously, corporations have vested interests in organizing the contexts of social relations locally (within and surrounding their sites of production) as well as globally. Yet they have also found that the public-policy arena is at times a volatile one. Public policy has come into conflict with specific forms of product promotion and consumption (e.g., tobacco, alcohol, environmental resources) and challenged the social relations of corporate power (e.g., with respect to affirmative action, sexual harassment, and diversity). Other more limited challenges, emanating from public-interest organizations, have exposed the underlying economic and social practices of corporate politics, such as labor practices in clothing manufacturing.[40] We have also seen that youth subcultures, a significant market for corporate products, images, and services, can also be a potential source of subversion of commercial products. This is most apparent in the growing resistance to brands and logos, as well as to the power of the Net. Naomi Klein has traced the contours of an emerging resistance to corporate globalization through the disparate agendas of numerous groups and subcultures:

> Ethical shareholders, culture jammers, street reclaimers, McUnion organizers, human-rights hacktivists, school-logo fighters and Internet corporate watchdogs are at the early stages of demanding a citizen-centered alternative to the international rule of the brands. That demand . . . is to build a resistance . . . that is as global, and as capable of coordinated action, as the multinational corporations it seeks to subvert. (1999, 445–46)

The coalescence of these interests was most visible in demonstrations against the World Trade Organization (WTO) in Seattle (1999), in Washington D.C. (2000), and in Genoa, Italy (2001). As a result of experience with the tobacco industry, among others, there is also a growing awareness of the power of other corporate sectors in the social relations of everyday life (e.g., agribusiness and developers of genetically modified products, the pharmaceutical and health care industries, or the media). Although years of sustained efforts by some organizations have shown tangible results, for example, in ethical investment policies for nonprofit investment funds, the degree to which more substantive *institutional* changes are occurring (in both public and corporate spheres) remains questionable.

The convergence of interests among corporate cultural production, nonprofit organizations, and public institutions has been a recurring theme of this study. Administrative, promotional, technological, and curatorial strategies of museums illustrate this convergence with respect to corporate cultural politics. Major museums have gradually assumed corporate structures in order to guarantee their fiscal stability. And the fact that many major corporate donors sit on museum boards or serve as museum trustees has undoubtedly contributed to this development (*Museo Guggenheim Bilbao* 1997, 6.3). Museum administrators increasingly operate in cultural as well as corporate environments. The Metropolitan Museum of Art, for example, named a former IBM executive as chief operating officer with the title of president reporting to the chief executive.[41] In Germany and the EU, the privatization of public institutions has also

fueled the growing dependence of museums, operas, and theaters on private and cor-
porate funding and led to new public-corporate models, such as the Kunstmuseum
Wolfsburg. Milan's La Scala opera was transformed from a state opera into a nonprofit
arts foundation in which private contributors (both individual donors and corporate
sponsors) provide up to 40 percent of the house's budget. La Scala donors have a voice
in the foundation; however, they must make a minimum contribution of $500,000.
Not surprisingly, many of the major donors and participants in the foundation are cor-
porations (particularly banks, electrical corporations, or fashion designers Armani and
Prada).[42] Italy is gradually adopting the U.S. model of cultural financing for most of its
opera houses and is attracting corporate funding in part by allowing a larger percentage
of donations to nonprofits as tax deductions. During the 1980s and 1990s, many cor-
porations transferred some sponsorship activities to foundations (e.g., Germany's
Lufthansa, which was also privatized). Others, like the Ford Motor Company Fund
(not affiliated with the Ford Foundation) date back to 1949.

Corporate administrative models are now setting the standard for many private
cultural foundations, which, through their funding guidelines, tend to favor "admin-
istrative-heavy" and "art-light" organizations, to the detriment of smaller, alternative,
artist-run programs (Atkins 1998, 59). The impact of private foundations as a funding
source in the United States, and their growing importance throughout the EU, is
underscored by the following statistics, which have contributed to what *American
Canvas* terms a "laissez-faire philanthropy that at times, appears to be more oligarchic
than democratic . . . [favoring] a comparatively small number of large flagship institu-
tions, located in a handful of cities, that dominate their fields, artistically as well as fi-
nancially" (Larson 1997, 156–57).

- Twenty-five foundations (approximately 0.07 percent of the total number) provide
 40 percent of all arts funding.

- Fifty arts organizations (approximately 1 percent of all grantees) receive 32 percent of
 the funding.

- Five states accounted for 65 percent of all arts funding awarded. (Larson 1997, 156)

Although Germany still maintains significant levels of public funding, the importance
of foundations and corporate sponsorships for new projects (museums and arts cen-
ters), as well as for museum acquisitions and exhibitions, is increasing dramatically and
will in all likelihood continue to do so in the coming decades (Heinrichs 1997, v–vi).[43]

In the United States, a significant percentage of donations to nonprofit cultural
and community organizations comes from individuals rather than corporations.
However, their interests are only represented through advisory boards, if at all. In con-
trast, wealthy donors can exert considerable influence, counterbalancing the voices of
individual donors, through a single large contribution, frequently augmented by sup-
port from the corporations they manage or own. Despite the best intentions to re-
spond to a diversity of voices, many local arts organizations remain largely within the

control of an elite group of more-affluent arts "patrons." The failure of many local arts groups to garner broad-based support for their programs has been attributed to their inability to fully embrace ethnic and socioeconomic diversity in their organizations.[44] Obviously, middle- and lower-income groups have not historically been a target market for fund-raisers. Similar trends are evident in Germany and the EU, where wealthy patrons who were once influential in museum foundations (i.e., Friends of the Museum) are now shifting support to their own corporate cultural programs, which have a higher visibility (Grasskamp 1998, 74–75).

I would argue that less-affluent donors (who may make modest individual donations but who account for a significant portion of funding when considered as a group) must attempt to assert their interests collectively, particularly within larger organizations, by demanding a greater voice in governance, administration, and programming. The collective articulation of these interests is admittedly difficult, given the often conflicting perspectives within memberships and communities. However, the organization of individual "small" donors presents a productive potential for communities to determine social and cultural agendas rather than allowing programs to be driven largely by monied and corporate interests.[45] In many instances, the total percentage of individual donations far outweighs corporate contributions, yet corporations (or foundations) can leverage their influence by providing a single funding block for special programs or acquisitions.[46] Obviously, a museum or symphony will be more concerned when a corporate sponsor or wealthy patron withdraws funding than when an individual donor does so. Yet an organized action by even 20 percent of the "average" donors would indeed evoke a response from the museum board or its director. Despite a system of cultural politics based largely on corporate and nonprofit organizations, individuals of lesser means can indeed assert their interests, but only through forms of collective participation that also leverage their joint capital. This process is a first step not only in gaining a voice within community affairs but also in establishing an environment for expanding its membership to more diverse publics— and in doing so, providing a broader, democratic, and more-inclusive participation in society and culture.

In Germany, where local civic and cultural organizations have played a less important role than in the United States, collective political action has taken the form of local citizen action groups, *Bürgerinitiativen* (usually focused on a particular issue). However, they have not, for the most part, provided funding for cultural or social programs. Many of the new models proposed for funding culture in Germany (and in many EU countries) are variations of government, corporate, and private models from the United States and the United Kingdom, including (1) combinations of public-private foundations or institutions, (2) institutional funding based on endowments to maintain continuity with additional funding for special projects derived from multiple sources (government, corporate, individual, foundation), (3) incentives for matching funds and "partnerships," (4) increased tax deductions for various forms of cultural programming (including donations, sponsoring, foundations), (5) improved

legal guarantees for nonprofit organizations, and (6) measures to promote expertise, with respect to funding and administration, in managing cultural institutions (Heinrichs 1997, 248–50). Here too, communities will have to articulate their own interests and participate in developing alternative models as new constellations for organizing and financing culture emerge.

Cultural and social programs *within* corporations, such as corporate art collections and arts programming, present another context within which communities may assert their interests. Corporations have only begun to recognize that such programs (e.g., "art in the workplace" programs) are rarely effective without employee participation in their conceptualization and implementation. Some initiatives, such as projects developed by artists Clegg and Guttman at the DG Bank or Vitra's Design Museum, may facilitate a greater consciousness of cultural spaces within the workplace (apart from "corporate culture") and their relations to other social spaces. Indeed, the two are inextricably linked. However, such tentative interventions will only be successful to the extent that corporate managements are interested in facilitating a dialogue—among and with employees—on the implications of culture and the workplace locally and on the role of corporations globally. This process implies not only an openness to conflicting voices but also a willingness to examine the corporations' own interests. Cultural production can play an important role in initiating and mediating such discussions. However, such programs must become more than just internal sponsorships—that is, another medium for corporate cultural politics and self-promotion linked with employee incentives (e.g., concert tickets, vacations, or products). To the extent that culture is allowed to become a catalyst for a critical dialogue in the workplace, such conceptual shifts (in the social organization of the workplace) would eventually lead to a different perception of how the corporation perceives its function within society.

Sponsoring has become a given, embedded in the sociocultural fabric, and an integral part of institutional survival for public and nonprofit institutions. An important indicator of its growth and legitimacy has been the significant increase of cultural and social programming within smaller and medium-sized firms (Business Committee for the Arts 1998, 9). Despite the ongoing waves of mergers in most business sectors, overall spending for sponsorships continues to increase, in part due to the higher levels of participation by medium-sized firms and the new high-tech corporations. No longer limited to multinational corporations, sponsorships have become a systemic feature of corporate cultural politics, operating both in local and global contexts. Although sponsoring's legitimacy is routinized and institutionally reinforced, its proliferation also exposes the extent to which corporations construct and organize everyday life.

Although challenges to corporate cultural programming—resulting from a shifting cultural terrain or forms of public resistance—may lead to the evolution of other forms of cultural programming (employing similar strategies) with new corporate designations, it is unlikely that they will signal an end to the *objectives* of cultural sponsorships or corporate cultural politics. If most institutionally sanctioned art becomes "sponsored" in one form or another, then the communicative potential of sponsoring

as an instrument of corporate promotion is relativized. I have suggested that one of the paradoxes of cultural programming is that corporations attempt to capture art as an auratic field in order to instrumentalize its symbolic power for corporate communication. However, the intensity and duration of art's communicative potential is undermined by the corporation's own interests in consumer and media culture. This means that cultural programming, if it is to be an effective instrument of communication, must operate on the boundaries between subcultures, the avant-garde, alternative culture, and promotional culture (Wernick 1991). I have also argued that this function of sponsorships explains much of the attraction and success of postmodern culture, that is, its dual roles as "complicity and critique" (Hutcheon 1991), for corporate sponsors. Yet, it is precisely at this intersection of the subversive and the promotional—also a significant dimension of event culture—that corporate interests and cultural politics become visible and vulnerable.

This heightened visibility provides an aperture for the interrogation of corporate cultural politics and social relations. The question becomes how such apertures can be employed to engage audiences in a consideration of their own positions within this process. We have seen that some artists have seized these strategic opportunities in order to destabilize corporate representation and organization of social spaces. Though many such projects remain tentative, they perform an important function by identifying and experimenting with strategies and modes of aesthetic communication that at once illuminate and undermine the representation of corporate interests. Site-specific works, such as those of Hans Haacke, facilitate this awareness by identifying and appropriating the social spaces in which culture and politics intersect and by then deconstructing them. In postunification Germany, the Parliament (Bundestag) has recognized the power of culture and its public representation, as evidenced by an unprecedented number of debates on cultural projects during the 1990s: Christo and Jeanne-Claude's *Wrapped Reichstag,* Peter Eisenman's Holocaust Memorial, or Haacke's installation for the Reichstag, *Der Bevölkerung.* In this regard, we should also not lose sight of the potential for alternative interventions in sponsored culture and for more diverse participation in cultural institutions at local or regional levels, while participating in organized actions and collaborations with other communities and interest groups at the macro levels (i.e., nationally and globally). Despite the significance of cyberspace, the material, real sites of cultural production, mediation, and reception remain a crucial dimension of cultural politics.

The fact that corporations have played a fundamental role in shaping the contexts of cultural production, distribution, and reception is not new. However, to a certain extent, sponsoring can only maintain its legitimacy by perpetuating the myth that corporations and culture operate within separate spheres, that is, that the intersection of culture and politics in the form of corporate cultural politics does not exist, or that corporate interests inherently work for the public good. Thus, sponsoring simultaneously reveals and belies (represses) the links between corporate and cultural production. The admission that they are intertwined, although by no means identical, would

ultimately lead to a legitimacy crisis by focusing attention on the corporation as a site of cultural production and mediation rather than deflecting this participation away from the corporation to other spaces.[47]

In this respect, the convergence of institutional interests (corporate, nonprofit/ foundation, and public) and their transformation into new hybrid organizations must also be considered in terms of their potential for public interventions and renegotiations, rather than allowing them to become sites for the colonization of cultural and nonprofit institutions—essentially coextensive with corporate space. The focus on culture, emanating from the corporation as well as from public policy, provides an opportunity for individuals and communities to "turn the tables" and interrogate the way corporations themselves produce culture and structure everyday life. At the outset of this book, I suggested that "full disclosure" (i.e., financial disclosure by sponsors, cultural institutions, and foundations related to sponsored projects) is a necessary first step in this process. Yet full disclosure alone will not lead to a true democratization of cultural institutions. This can only be approached as individuals and communities, including artists, assume a greater responsibility for and demand a voice in the institutions of culture. Thus, artists, cultural mediators, and publics must see their participation in cultural institutions of all kinds not merely in economic terms (e.g., as donations or funding objectives) but also as a form of empowerment that has implications beyond institutional sites (e.g., of the museum, symphony hall, or festival). Paradoxically, cultural production itself can perform a crucial role in this process by provoking audiences to interrogate and reconsider their own positions with respect to culture and in doing so contribute to a redefinition of private, public, and corporate spaces.

Notes

1. Full Disclosure

1. See Stuart Elliott, "Tired of Being a Villain, Philip Morris Works on Its Image," *New York Times,* 11 November 1999 (online; available: http://www.nytimes.com; 6 July 2001).

2. After a decade of debate (1989–1999) on the Holocaust Memorial, Peter Eisenman's proposal for a *Forest of Pillars,* along with a small *House of Information,* was approved by the German parliament. Although I not address the role of the Holocaust Memorial explicitly, it was a key part of the discourses surrounding German identity during the 1990s. See also the debate in the parliament on artist Hans Haacke's installation in a courtyard of the Reichstag, DER BEVÖLKERUNG (To the Population), referencing the inscription over the main entrance, which reads "DEM DEUTSCHEN VOLKE" (To the German people). Roger Cohen, "Poking Fun, Artfully, at a Heady German Word," *New York Times,* 31 March 2000.

3. Listings in the Europäische Sponsoring-Börse (ESB, European Sponsoring Exchange) (online; available: http://www.esb-online.com; 6 July, 2001) provide ample evidence that many aspects of cultural and social life in Germany (e.g., education in the new states) are increasingly supported through corporate donations.

4. Judith H. Dobrzynski, "Ford Devotes $40 Million More to Art," *New York Times,* 3 May 2000 (online; available: http://www.nytimes.com; 3 May 2000).

5. For example, Paul G. Allen, cofounder of Microsoft, established six charitable foundations, including the Allen Foundation for the Arts and the Experience Music Project Foundation, which funded the Experience Music Project building in Seattle, designed by Frank Gehry. See Paul G. Allen Foundation Web site: http://www.paulallen.com/foundations/main.asp (6 July 2001).

6. "Intel Chips In for Whitney Show," *Art in America,* November 1998, 52. See also the Intel Corporation Web site: http://www.intel.com/pressroom/archive/releases/CO092498.HTM; 9 September 2001. Corporate expenditures for all event sponsorships (including sports) had already exceeded $3 billion by the mid-1990s (Schreiber 1994, 1).

7. "NEA Gives Final Grants for 2000," *Art in America,* July 2000, 128. Congressional reorganization of the NEA in 1996 required that individual artists apply for grants through their local arts organizations, thereby creating greater administrative control and bureaucratization (Siegel 1996, 168).

8. Cultural institutions face a number of issues regarding partnerships with social organizations, issues ranging from appropriate selection criteria for partners to the types of programs that should be offered to administrative costs. Indeed, most larger cultural institutions (museums, symphonies) already maintain programs for community education and outreach. Will

new programs dilute their institutional mission and focus? Will they indeed increase the perception of "legitimacy," and will this lead to greater funding or support?

9. My view regarding the legitimization of social programming and corporate sponsorship is also argued by George Yúdice (1999, 17, 32).

10. I will also examine how the interests of corporations and cultural institutions are converging as the latter have adapted corporate administrative procedures, promotional strategies, and technologies. However, this does not mean they are equal partners.

11. There was extensive domestic and international media coverage of *Sensation*. See, for example, Stephanie Cash, "Art under Siege in New York: 'Sensation' Battle Erupts in Brooklyn," *Art in America*, November 1999, 37–41; David Barstow, "Brooklyn Museum Recruited Donors Who Stood to Gain," *New York Times*, 31 October 1999 (online; available: http://www.nytimes.com; 31 October, 1999). Michael Kimmelman, "In the End, the 'Sensation' Is More in the Money," *New York Times*, 3 November 1999; Lynn Macritchie, "Ofili's Glittering Icons," *Art in America*, January 2000, 96–101.

12. See Barstow, "Brooklyn Museum Recruited Donors Who Stood To Gain."

13. Quoted in Carol Vogel, "Australian Museum Cancels Controversial Art Show," *New York Times*, 1 December 1999 (online; available at: http://www.nytimes.com; 1 December 1999).

14. Rolf Zwirner, "Wo bleibt der Wertekanon? Das Museum als Spielplatz fremder Interessen: Wenn Sammler dominieren," *Die Welt*, 2 February 1999 (online; available: http://www.welt.de; 10 March 1999).

15. See Barstow, "Brooklyn Museum Recruited Donors Who Stood To Gain."

16. Vera Graaf, "Enthüllungen: Skandal um Brooklyn Museum," *Süddeutsche Zeitung*, 8 December 1999 (online; available: http://www.sueddeutsche.de; 8 December 1999).

17. Marion Leske, "Warum Saatchi immer gewinnt: Geschlossenes Erfolgssystem. Der Londoner Händler und Sammler spannt die Kunstszene für sich ein," *Die Welt*, 16 November 1998 (online; available: http://www.welt.de; 8 December 1999).

18. Cited in Thomas Veser, "Raus aus dem Reservat! Eine Berlelsmann-Tagung sucht nach einem neuen Rollenverständnis von Stiftungen," *Berliner Tagesspiegel*, 19 July 2000; see also http://www.bertelsmann-stiftung.de; 6 July 2001.

19. See Herbert Muschamp, "Where Ego Sashays in Style," *New York Times* (weekend edition), 20 October 2000.

20. Roberta Smith comments, "Nearly 250 of the 450 ensembles date from 1995, another 160 from 1990 to 1994. If Mr. Armani is so desperate to be seen as an artist, he should have allowed himself to be treated as one. That would have meant taking a back seat to the curators who, one hopes, would have selected a smaller show, included earlier designs and his work for other labels, and emphasized his development with a chronological installation. As it is, once you've looked at all the bead work, the show reduces to an exceptional Robert Wilson installation." See Roberta Smith, "Memo to Art Museums: Don't Give Up on Art," *New York Times*, 3 December 2000.

21. Smith, "Memo to Art Museums."

22. See Brian Wallis, *Hans Haacke: Unfinished Business* (New York: New Museum of Contemporary Art, 1986).

23. See, for example, *Black's Law Dictionary: Definitions of the Terms and Phrases of American and English Jurisprudence, Ancient and Modern*, 4th ed. (St. Paul, Minn.: West Publishing, 1986), 51.

24. See Roger Cohen, "Poking Fun, Artfully, at the Heady German Word," *New York Times*, 21 March 2000.

25. Matthias Arning: "Appelle der früheren Zwangsarbeiter treffen auf Ignoranz,"

Frankfurter Rundschau, 25 February 2001 (online; available: http://www.fr-aktuell.de; 25 February 2001). See also, "Contributions Slow for Nazi Fund," *New York Times,* 28 May 2000 (online; available: http://www.nytimes.com; 28 May 2000).

26. "Intel Chips In for Whitney Show," 152.

27. See Rudolf von Thadden, "Deutschland ist eine Nation westlichen Typs geworden," *Frankfurter Rundschau,* 10 June 2000 (online; available: http://www.fr-aktuell.de; 10 June 2000).

28. I would argue that Europe (or other nations) may not be as willing to embrace U.S. leadership in public-policy development as Friedman suggests, particularly in health or environmental issues—as the widespread public rejection of genetically modified food products (including those from the United States) illustrates. Nor are Europeans willing to accept unconditionally the United States, "at its best," as a "spiritual value and role model" (Friedman 2000, 474).

2. Corporate Cultural Politics

1. The example of the Kunstmuseum Wolfsburg, financed largely through funding by the Holler Stiftung, is discussed in chapter 6. Regarding changes in tax laws and donations to culture, see "Bedingungen für Mäzene verbessert: Bundestag verabschiedet neues Stiftungsgesetz," *Das Parlament* 2000, 30 March 2000 (online; available: http://www.das-parlament.de; 27 April 2000).

2. The collective interests of individual donors are underrepresented because they are not institutionally organized (see chapter 7).

3. See, for example, public reaction in Germany to Shell's announcement that the drilling platform *Brent Spar* would be sunk. The reaction included boycotts of Shell gas stations and products by politically conservative, moderate, and liberal Germans concerned about environmental issues and ultimately led to the corporation's reconsideration of its plan and subsequently to a public relations campaign designed to position Shell as socially responsible. Ulrich Beck, "Der grüne Spaltpilz," *Frankfurter Allgemeine Zeitung,* 8–9 July 1995; Heidi Blattmann, "Brent Spar: Ein Erfolg für die Umwelt?" *Kulturchronik* 5 (1995); Ursula Ott, "Gute Tat ist teuer," *Die Woche,* 24 November 1995.

4. In its sponsorship guidelines, Ford Motor Company requires use of its logo and a credit line in all materials and also reserves the right to use the sponsorship in its own promotional information. Ford has the right to approve and reject all images for catalog covers and exhibition advertising. Such images must be consonant with the corporate identity: "Consultation with Ford Motor Company is requested to define images and/or graphics created for a cohesive marketing effort in regards to posters, invitations, advertising copy, etc." At the opening of some events, Ford reserves the right to display vehicles at the entrance to the organization. See "Ford Motor Company Sponsorship Guidelines" Ford Fund annual report, 4 December 1998 (online; available: http://www.ford.com/corporate-info/culture/find/guidecorpcon.html; 4 December 1998).

5. I will use the term "community" to refer to larger social groups that may encompass or cut across subcultures and milieus (e.g., with respect to ethnicity or geography). The existence of community frequently implies social integration, coherence, and cohesion. It can also be a force for the containment of social conflict, rather than a basis for democratic social action. Sarah Thornton suggests that subcultures, in comparison to communities, tend to express struggles over territory, place, and space, particularly within urban communities, even threatening established notions of neighborhood (1997, 2). I use "community" primarily in reference to constructing shared interests and empowerment. Here, David Morley and Kevin

Robins refer to the work of Eileen and Stephen Yeo in arguing that "it is 'community made *by* people *for* themselves'" (1995, 182; see also Eileen and Stephen Yeo, "On the Uses of 'Community': From Owenism to the Present," in *New Views of Co-operation,* ed. Stephen Yeo [London: Routledge, 1988], 230–31; and Berman 1992, 274–76). The distinction between community interests organized by corporations or institutional political interests primarily from outside communities versus those that develop out of discourses that articulate competing interests from within communities, and attempts to implement those interests through community-based and community-directed initiatives, is a key one. On a different plane, "community" also refers to regional and national entities as well as the construction of virtual communities (Morley and Robins 1995, 182–88, 132–33)

6. With regard to public policy and corporate interest, see Larson 1997, 54–55.

7. John McCormick, "Take a BMW for a Spin To Help Cancer Fund-Raiser," *Des Moines Register,* 14 June 1997.

8. In partial response to media criticism of sponsoring, fifty major German and multinational corporations (e.g., DaimlerChrysler, Volkswagen, and Hoechst, as well as the German subsidiaries of IBM and Sony) established a "Working Group on Cultural Sponsoring" in 1998 to create a "Code of Conduct" that (1) asked other corporations to increase long-term sponsoring programs to offset government budget cuts, (2) established the responsibilities and expectations of corporations and the sponsored, and (3) stated that corporations should not infringe on the autonomy of artists and cultural institutions, but that the cultural community should recognize sponsoring "not [as] disinterested philanthropy but a business strategy to bolster firms' public images." See "Major Corporations Issue Sponsoring Guidelines," *The Week in Germany,* 16 October 1998, 4.

9. This institutional convergence of museum and corporation is reinforced by corporate leaders who chair museum boards, such as Leonard Lauder, CEO of Estée Lauder Co., who chaired the Whitney Museum's board. Philip Morris's headquarters also house a branch of the Whitney (Roth 1989, 362).

10. The ultimate fate of many of these studio spaces after corporate projects are completed (and promotional funds are exhausted) is at best uncertain.

11. Oren Yiftachel has shown that urban and regional planning has been utilized as a means of territorial, procedural, and socioeconomic control by (1) spatially containing minorities, (2) limiting minority access to decision-making and procedural processes, and (3) privileging the economic and social interests of dominant groups in terms of land-development politics (Yifchatel 1995, 220–21; see also Watson and Gibson 1995a, 258).

12. For a discussion of the role of leading postmodern architects engaged by Disney (Robert A. M. Stern, Michael Graves, Charles Moore, Helmut Jahn, Arata Isozaki, and Frank Gehry), see Waldrep 1995, 208–21.

13. Gerhard Matzig, "Die Retorte im Gesicht der Stadt," *Süddeutsche Zeitung,* 30 September 1998, 12. In the development of the two largest projects (i.e., by Daimler and Sony), Matzig sees an attempt to infuse the new Berlin Republic with the mythology and urbanity of fin de siècle Berlin.

14. Part of Ford's rationale in choosing city-center locations was to reach tourists and suburbanites attending theater performances. Theaters in New York and Chicago were designed "to enhance its image in the community and to increase access to the arts. Ford chose to sponsor theater because it is a major market for women and young people, who make up a large percentage of Ford customers. As part of this sponsorship, Ford was able to showcase its vehicles in the theaters' lobbies and the Company name appeared on tickets for productions and in media advertisements." See "BCA News Excerpts," 30 November 1998 (online; available: http://www.bcainc.org; 30 November 1998).

15. Similarly, the proliferation of casino-entertainment complexes (beginning in Atlantic City, N.J.) marked the expansion of themed environments beyond Las Vegas. Although ostensibly promoting economic development, many casino projects accelerated economic and social displacement by offering cheap real estate, tax abatements, low-paying jobs, and the outflow of corporate revenues, rather than promoting a balanced economic base and economic infrastructure.

16. With regard to the analysis of postmodern architecture, see also Jameson 1997, 239–46; Charles Jenks, *Language of Postmodern Architecture* (London: Academy, 1978).

17. For agency information, see Strahlendorf 1992. The ESB provides an online exchange at http://www.esb.online.com; 9 September 2001.

18. Deutsche Aerospace public relations publication "Visionen."

19. "BMW Public Relations Information," 1992.

20. BMW, "Kultur und Wirtschaft," 5.

21. Ibid., 9.

22. Corporate case studies are provided in management literature on sponsoring. See Bettina Becker 1994; Bruhn 1991; Grüßer 1992; Rauhe and Demmer 1994; Schreiber 1994.

23. Of course, all of the outward signs of the two firms were also merged (e.g., business cards, stationery, and logos). Even a funeral wreath for a postmerger Daimler-Benz employee included the new DaimlerChrysler logo. See Karl-Heinz Büschemann, "Aber es bleibt bei vier Rädern," *Süddeutsche Zeitung,* 18 November 1998.

24. *In Search of Excellence* also provided considerable reinforcement for the "total quality management" philosophy, which, in the United States, was transferred from the corporate sector to universities and nonprofit organizations. See also Terrence E. Deal and Allan A. Kennedy, *Corporate Cultures: The Rights and Rituals of Corporate Life* (New York: Perseus, 2000); Thomas J. Peters and Robert H. Waterman, *In Search of Excellence: Lessons from America's Best-Run Companies* (New York: Harper and Row, 1982).

25. Timothy Brennan has argued that the transnationals still remain very much bound to national economic, social, cultural, and political interests (1997, 161–62).

26. With regard to Höhler's role as one of the leading German marketing experts and her own self-promotion in management seminars, see Herbert Riehl-Heyse, "Warum Sieger leise lächeln: Beobachtungen bei einem Seminar für Führungskräfte," *Süddeutsche Zeitung,* 28 October 1992.

27. The German automobile industry claimed that a speed limit would result in industry job losses. According to opinion polls, the German public is about equally divided regarding speed limits on the Autobahn. See "Deutsche Autokonzerne gegen Tempolimit," *Süddeutsche Zeitung,* 12 October 1998.

28. BMW, "Kultur und Wirtschaft," 4.

29. The *International Directory of Corporate Art Collections* lists over 1,250 corporate collections internationally.

30. Regarding economic analyses of art collecting, see Heilbrun and Gray 1993, 149–68.

31. Frank Nicolaus, "Mit Kunst floriert auch das Geschäft," *ART,* March 1990, 90–91 (cited in Bettina Becker 1994, 67–69).

32. See John Fiske with regard to forms of resistance within popular culture as "selective, not wholesale—progressive, not radical" (1992, 214).

33. Ralf Dahrendorf, "'Das ist ein Hammer,'" *Der Spiegel,* 11 May 1998, 110.

34. For descriptions of these projects, see Bourdieu and Haacke 1995, 96, 30, 120; Buchloh 1997, 413–15. A discussion of Haacke's work during the 1980s is included in Luke 1992, 152–68; Deustche 1998, 109–58, 159–92.

35. Grasskamp 1995, 145; Lacy 1996, 226; Deutsche 1998, 159–92.

36. Haacke specifically references the links to National Socialism within the context of Venice (Bourdieu and Haacke 1995, 125–44).

37. German industry's German Holocaust Fund, established to compensate victims of slave labor, also assumed a significant function within foreign and cultural policy in order to validate corporate legitimacy (but also to forestall litigation in foreign courts and the portrayal of negative images of major corporations). See "Contributions Slow for Nazi Fund," *New York Times,* 28 May 2000 (online; available: www.nytimes.com; 28 May 2000).

3. Redefining Culture, *Absolutly*

1. James Twitchell (1996) argues that "Adcult" has become synonymous and coterminous with culture, or at least, contemporary mass culture. "Adcult" also assumes that audiences or communities can be theorized primarily as niche markets or subcultures of consumption, and it accepts the premise of consumer culture as culture, without fully exploring examples of resistance or disruption in greater depth.

2. See chapter 2, note 3.

3. Like Schulze, Scott Lash has investigated the process of cultural de-differentiation (between high and popular culture) as a specific characteristic of postmodern culture (Lash 1991, 11–13). Yet as Lash, Schulze, Douglas Kellner, and other critics observe, de-differentiation does not imply a reductive homogenization of culture.

4. A pathbreaking analysis of the discursive strategies of advertising was provided in Williamson 1995.

5. "Eavesdropping" is used without evoking the negative reactions associated with "listening in" on telephone party lines (connections shared by multiple customers). In this sense, it has quaint or antiquated allusions, unlike "wiretapping," which is a more serious invasion of privacy.

6. In particular, see Roberta Smith, "High and Low Culture Meet on a One-Way Street," *New York Times,* 5 October 1998.

7. Danto sees three historical developments: First, fin de siècle artists entered the field of publicity (e.g., Henri Toulouse-Lautrec and the artists of the art nouveau style), which contributed to the erasure of the boundary between high and applied art. Second, during the 1950s, advertising and promotion appropriated art, in a purely instrumental fashion, as a prop or aesthetic style in order to market images and commodities. On the other hand, artists perceived the relationship between art and advertising as "disjunctive." Finally, artists appropriate certain elements of advertising style or create counterfeits in order to destabilize the relationship between the two (1993, 152–55).

8. In his review of the Guggenheim's 1998 exhibition *The Art of the Motorcycle* (sponsored by BMW), James Hyde refers to the *High and Low* exhibition as only minimally incorporating a treatment of popular culture, whereas the Guggenheim marked a distinct shift in "museological perspective" by dedicating itself exclusively to the popular culture of the motorcycle (1998, 95). However, *The Art of the Motorcycle* failed to incorporate a more critical representation the motorcycle's function in diverse cultural contexts. (See my discussion of the Guggenheim in chapter 6.)

9. In another program engaging images of popular culture from the 1960s to 1990s, AT&T (in collaboration with the Rock and Roll Hall of Fame and Museum) sponsored a Covers Tour of 250 cover photographs from *Rolling Stone.* See the advertisement in *Rolling Stone,* 22 January 1998, 63.

10. Susanne Wegerhoff (of American Express) writes, "The members' certainty of belonging to a privileged group with a cultivated enjoyment of life ensures the exclusivity of events such as the Frank Sinatra concert" (Wegerhoff 1992b, 54).

11. Andrew Wernick writes, "The displacement of live performance by recording, of auratic culture by the mechanically reproduced, has led to a countervailing nostalgia for the living, the authentic, and the original" (1991, 115). Yet Wernick also observes that the audience anticipates a rendition of the recorded version, which has become the "authentic" version (116).

12. Wernick employs the term "promotional culture" to analyze contemporary culture with respect to common modes of communication and, more specifically, signification: "A promotional message is a complex of significations which at once represents (moves in place of), advocates (moves on behalf of), and anticipates (moves ahead of) the circulating entity or entities to which it refers" (1991, 182).

13. Donaher was referring to a new ad campaign for Crystall Vodka, where he was also employing visual strategies similar to those used in the Absolut campaign (Lubow 1994, 68).

14. Other Absolut themes included cities; holidays; fashion; "themed-art," that is, artists who employed similar styles; artistic media, for example, sculpture; flavors; spectaculars; Eurocities; film and literature; "tailor-made" advertisements, that is, designed for niche magazines; "topicality," that is, tied to media events, news (Lewis 1996, viii).

15. See chapter 2 for information on BMW's "Art Cars." With respect to best-sellers, Werner Faulstich has identified the interaction of aesthetic innovation and schematization as central characteristics of international best-sellers (e.g., the James Bond books, *Airport, The Godfather, Love Story*); see Werner Faulstich, *Innovation und Schema: Medienästhetische Untersuchungen* (Wiesbaden: Otto Harrassowitz, 1987).

16. Roux's investment in the artwork itself was minimal. On average, he paid about $5,000 for the rights to a painting and never exceeded the price of the original Warhol (Brown 1991, 129). By the early 1990s, he had commissioned work by more than three hundred artists and spent approximately $400,000 a year on paintings—a bargain considering that the total ad budget for Absolut was about $15 million several years later (Brown 1991, 129; Tilsner 1994, 95).

17. As Roux himself admitted, the campaign was indeed advertising. Its objectives were not oriented to any sort of continuous, long-term support of specific artists or their projects, or related to the historical ideal of selfless patronage.

18. In Canada, Vin & Sprit threatened to sue *Adbusters* magazine (21,000 circulation) for running a parody of the Absolut advertisements; the parody questioned the effects of alcohol consumption. Subsequently, however, Absolut's TBWA advertising agency stated, "Any exposure for us is great exposure for Absolut." See Barry Brown, "Magazine's Parody Makes Marketer Absolut-ely Mad," *Advertising Age*, 27 July 1992, 3, 42.

19. Joe DiSabato, president of Rivendell Marketing (a major representative for gay media publications), explained that most advertising and marketing executives have been reluctant to place advertising in gay publications because they fear responses from antigay groups. Advertisers like Absolut (or Saab, Suzuki, or ITT Sheraton) are exceptions (Johnson 1991, 31).

20. In the United States, corporations refer to sponsorships for social causes or nonprofit organizations as "cause-related sponsorships." In Germany, they are designated "social sponsoring and social marketing." Unlike corporate philanthropy, social sponsoring is directly tied to marketing objectives. Corporate sponsorships, or "cause-related marketing," programs, which donate a specific percentage of sales to a nonprofit organization, are linked to a return-on-investment that is measured in product recognition and sales. (American Express was one of the first major corporations to employ this strategy.) Schreiber states that "these events are not driven by foundations that are removed somewhere in the corporation. Corporate cause-related sponsorship is now a mainstream marketing activity that serves a strategic, marketing function within the corporation" (1994, 13).

21. See discussions of Benetton court cases in the EU: "Textilhersteller muss sittenwidrige

Werbung einstellen," *Deutschland Nachrichten,* 14 July 1995, 5; "Wie jedermann," *Der Spiegel,* 10 July 1995, 108.

22. Although Benetton's Web site includes some negative responses from consumers regarding its advertising, this is overshadowed by the overwhelmingly promotional content. See United Colors of Benetton (Web site; available: http://www.benetton.com; 3 December 1996).

23. For information on Generation Y and clothing, see Sharon R. King, "Marketing Fashion for the Gen Y Buyer," *New York Times,* 28 August 1999 (online; available: http://www. nytimes.com; 28 August 1999). Benetton's agreement with Sears was terminated after Sears received complaints on Benetton advertising using a death-row inmate in the United States.

24. See also Haacke's installation *Dyeing for Benetton* (1994) (Haacke 1995, 228).

25. This is particularly the case with respect to clothing manufacturing. Labor policies of corporations operating in Latin America were highlighted in the U.S. media when it became known that a line of clothing promoted by television celebrity Kathie Lee Gifford (for Walmart) was being manufactured by children working in inhumane conditions. Similar cases (involving The Gap, Liz Claiborne, and the Walt Disney Company) were documented by the National Labor Committee (NLC; a nonprofit labor and human rights advocacy group). As a result, the NLC established agreements with The Gap and Gifford/Walmart in 1995 and 1996 to monitor corporate accountability. See National Labor Committee, "Executive Summary," 10 November 1998 (online; available: http://www.nlcnet.org; 10 November 1998).

26. See Deborah Stead, "Corporations, Classrooms, and Commercialism: Some Say Business Has Gone Too Far," *New York Times,* Education Life Section 4A, 5 January 1997, 30–33, 41–47; Jacobson and Mazur 1995, 35.

27. This convergence between nonprofit, educational, and cultural institutions, on the one hand, with commercial or corporate institutions, on the other, is illustrated by Disney, which organizes one-week educational programs for high school students at its theme parks.

28. For a general overview of these developments with respect to identity, see Konrad H. Jarausch, ed., *Reconfiguring German Identities* (Oxford: Berghahn Books, 1997).

29. See Giovanni Di Lorenzo, "Die intellektuelle Feuerwehr," *Der Spiegel,* 8 February 1993, 210–11; *München—Eine Stadt sagt nein: Die Lichterkette. Eine Dokumentation* (Munich: Süddeutsche Zeitung, 1992).

30. Within the publishing industry, there has been a significant interest in fiction and nonfiction written by migrant authors in Germany. *Migrantenliteratur* is a well-established market niche, particularly for smaller and medium-sized publishers.

31. Ursula Ott, "Gute Tat ist teuer," *Die Woche,* 24 November 1995, 35.

32. See projects listed under "Social Sponsoring" in the ESB, http://www.esb-online.com.

33. With respect to the depiction of "foreigners," especially Japanese, in U.S. advertisements, see O'Barr 1994, 73–101, 157–98.

34. Advertisement for Mecklenburg–West Pomerania in *Der Spiegel,* 20 July 1998, 12.

35. For example, the court case over Binder Optik's use of sunglasses and a parrot in an advertisement stating its support for endangered species. See "Sponsoring-Urteil bestätigt: Keine Werbung mit Artenschutz—Verfassungsbeschwerde möglich," ESB, 17 February 1997, (online; available: http://www.esb-online.com; 6 July 2001).

36. See *Philip Morris Companies Incorporated Corporate Contribution Guidelines,* 2–11.

37. Ibid., 13.

38. There was, however, one notable exception: Formula One auto racing. Without sponsorships from multinational corporations (more than $790 million a year) in the tobacco, automotive, oil, and consumer products industries (e.g., Philip Morris, Ford, Shell, Foster's Beer, and Benetton), designed to reach auto-racing fans (particularly younger males), experts believed Formula One would move to Asia and simply beam back racing with tobacco advertise-

ments over cable. The combination of corporate, media, and powerful consumer interest in Formula One left this area of promotion untouched for an indefinite period of time. See Barry Meier, "A Controversy on Tobacco Road: Do Smoking and Speed Mix?" *New York Times,* 4 December 1997; Edmund L. Andrews, "European Officials Agree To Ban on Most Tobacco Ads by 2006," *New York Times,* 5 December 1997.

39. Philip Morris Companies Inc., *1996 Annual Report* (New York: Philip Morris Companies, 1996), 4.

40. Philip Morris Companies Inc., *1997 Annual Report* (New York: Philip Morris Companies, 1997), 22–24.

41. See chapter 1, note 1.

42. Philip Morris Companies Inc., *1996 Annual Report,* 4.

43. *Philip Morris Companies Incorporated Corporate Contribution Guidelines,* 10.

44. Information related to the sponsorship of the exhibition is taken from a Philip Morris and Milwaukee Art Museum press release: "Milwaukee Art Museum Presents First Major Exhibition of Latin American Women Artists. Sponsored by Philip Morris Companies Inc. with additional support from the National Endowment for the Arts" (March 1995). The "Sponsor Statement" is also included in the bilingual exhibition catalog (Biller 1995).

45. Philip Morris and MAM press release, 1; Biller 1995, 5.

46. Philip Morris and MAM press release, 2–3.

47. Ibid., 3.

48. In his preface to the catalog, MAM director Russell Bowman referred to the importance of mounting exhibitions that are culturally inclusive, that is, that also address women and minorities and in this case the large percentage of people "with Latin American roots" in the Chicago–Milwaukee–Green Bay corridor (Biller 1995, 4).

49. In manufacturing-based consumer-product businesses (e.g., those owned by Philip Morris and its subsidiaries Kraft, Miller Brewing, and recently Nabisco), labor relations with minority communities in urban centers can become a critical element in local corporate politics. See Lena Williams, "Companies Capitalizing on Worker Diversity," *New York Times,* 15 December 1992; Taylor Cox Jr., *Cultural Diversity in Organizations* (San Francisco: Berrett-Koehker, 1993). Under the category "Corporate Citizenship," Philip Morris's *Annual Reports* refer to contributions to diversity, for example, through sponsorship of educational training, a "diversity vendor program" that encourages purchases from businesses owned by women and minorities, and human resources (i.e., personnel) policies "committed to diversity, in keeping with our need to attract, retain and develop a workforce as diverse as the products we sell." See Philip Morris Companies Inc., *1995 Annual Report,* 50.

50. Philip Morris and MAM press release, 4.

51. Curator Geraldine Biller refers parenthetically to the significance of the North American Free Trade Agreement (NAFTA) but does not directly address the relationship between economic interests and their promotion via the vehicle of cultural exchange (1995, 19). Through projects such as *Latin American Women Artists,* Biller hopes to overcome the hegemonic discourses at the centers of economic power. Biller addresses the tension between the mainstream and oppositional Latino art in situating her own role as curator and the status of the MAM: "First, I am admittedly and unapologetically a *gringa,* organizing this exhibition for a mainstream museum in the heartland of the United States" (1995, 19).

4. Sponsoring Lifestyle

1. This reference to the Civil War photographer Mathew Brady was also applied to another leading celebrity photographer, Richard Avedon.

2. In Europe, the exhibition premiered in Munich and subsequently traveled to Hamburg, Paris, Madrid, Edinburgh, and London. Throughout this chapter, I will distinguish between the "Portraits" advertisements and the *Photographs* exhibition and catalog. Some of the photographs in the exhibitions and the catalog were also advertisements for The Gap or American Express. Most appeared originally in *Rolling Stone* or *Vanity Fair*. In any case, many of the photographs functioned in multiple contexts, for example, as promotional magazine covers, as advertisements, and as art photography at international exhibitions and in the catalog.

3. Celebrity and fashion photographer Richard Avedon experimented with appropriating the tabloid style of photography in some of his early work.

4. The original version read, "Bezahlen Sie einfach mit Ihrem guten Namen"; the final version is rendered more direct by omitting the word *"einfach"* ("simply"): "Pay with your good name."

5. In this regard, we will also see that Leibovitz's photographs function, at least tentatively, to neutralize images of social hierarchy by demystifying the celebrity persona through visual strategies of postmodern irony and self-parody (e.g., Pavarotti with a pitchfork).

6. See American Express advertising brochure on the exhibition *Annie Leibovitz: Photographs, 1970–1990* at the MSM.

7. This voluminous report (approximately the size of a telephone book for a medium to large city) includes print-media reports (copies of newspaper and magazine reviews, circulation statistics) as well as synopses of electronic-media coverage (e.g., length of review or report, television station or program, and number of viewers or listeners). Such studies provide evidence that corporations involved in sponsorships are also very interested in measuring the impact of sponsored programs, in terms of both public relations and product recognition—a fact that American Express and most other corporations openly admit. By offering free admission to the *Photographs* exhibitions to cardholders, American Express was also able to measure the response to the free offer in its advertising among members (and indirectly assess the effectiveness of the advertising). (In order to gain free admission, cardholders had to show their card; an imprint was made of the card so that the actual number of cardholders visiting the exhibition was documented.) The documentation was "the result of thirty-four exclusive interviews arranged for Annie Leibovitz, the press conference held on January 29th, 1992 (which was attended by an impressive 172 reporters, photographers and film teams) as well as two press mailings and intensive press work" (ABC/EUROCOM 1992, n.p.).

8. Marie Waldburg, "Warum Wim Wenders auf Annies Fotos steht," *Abendzeitung*, 30 January 1992.

9. Claus Heinrich Meyer, "Es kommt Geld, es kommen Leute," *Süddeutsche Zeitung*, 31 January 1992; "Von Geblitzten und Abgeblitzten," *Süddeutsche Zeitung*, 30 January 1992.

10. Meyer's "Es kommt Geld, es kommen Leute" was among the more critical.

11. The role of audiences at rock concerts represents a similar process, which combines performance and reception. Members of the audience interact (singing, dancing, diving into the audience) in a performance mode (i.e., for their own enjoyment and sensual gratification or for the entertainment of other participants) and in a receptive mode (i.e., while listening and viewing the on-stage performance). However, the celebrities who perform for the press at a VIP event and the audiences who perform for each other at concerts accumulate very different kinds of cultural capital. Celebrities acquire additional cultural capital through the mass-media recognition, which can be transformed into economic capital. On the other hand, the audiences who attend rock concerts, for example, derive primarily forms of self-gratification or enjoyment and secondarily a degree of cultural capital based on the level of prestige, significance, or distinction that they and their milieu associate with the attendance of that particular event,

that is, of "being there." Unlike the celebrities, all of whose public appearances can be transformed into media events that cumulatively yield economic capital, the "noncelebrity" audience cannot accumulate economic capital as either spectators or performers at events.

12. ABC/EUROCOM, Appendix 2.

13. American Express, "Portraits: Eine ungewöhnliche Anzeigen Kampagne" (Portraits: An Unusual Advertising Campaign). Press release.

14. Harley-Davidson has opened its own museum at the factory in York, Pennsylvania, and has registered more than 78,000 visitors each year.

15. *The Art of the Motorcycle* (online exhibition; available: http://www.guggenheim.org).

16. American Express, "American Express Targets United Kingdom's Younger Market with the Launch of Blue Card," 23 May 1998 (online; available: http://www.americanexpress.com; 30 November 1998).

17. This was reported by Germany's Federal Labor Office (Bundesanstalt für Arbeit) in 1993 and reported in an essay "Jeder Fünfte ein Künstler?" *Süddeutsche Zeitung,* 21 February 1993.

18. American Express press release, "Portraits," 24 September 1992.

19. Ibid.

20. Ibid.

21. The photo of Hanna Schygulla as Maria Braun appeared on the front cover of the German photography and trade magazine *Fotodesign + Technik: Das creative Magazin für Fotodesign und die Technik moderner Bildaufzeichnungs- und Verarbeitungsverfahren,* March 1992.

22. With regard to advertising's recirculation of cultural images, see Wernick 1991, 25.

23. Leibovitz's photograph of corporate consultant Gertrud Höhler is much more "typical" in this regard.

24. This form of self-parody may simply reinforce the "playful" quality of the celebrity persona, that is, the quality of not taking oneself too seriously. Indeed, the staged quality of most of Leibovitz's photographs is one aspect of her aesthetics that she has mentioned in interviews (Sischy 1991/92, 10).

25. The cigarette as a symbol of commodification within the context of the Economic Miracle and within U.S.-German economic and cultural transfer plays a significant role in several key scenes in the movie, most notably in the following: (1) Maria Braun lights her cigarette on the stove's gas jet, which is left on and subsequently leads to the explosion in the final scene of the film. (2) Maria's husband, Hermann, returns unexpectedly after the war to find Maria and Bill (an African American GI) in the bedroom; Hermann is distracted from Maria and Bill when he sees a pack of cigarettes and rushes across the room to get one. (3) Maria barters with her mother, exchanging a pack of cigarettes, which she had received from an apologetic GI, for her mother's broach.

26. Fassbinder and Wenders utilize American culture to thematize the cultural colonization of Germany during the postwar era and to question the construction of a national identity vis-à-vis the United States. Wenders and the New German Filmmakers were self-consciously aware of Germany's turn to American culture because of its "profound mistrust of sounds and images about itself" (Morley and Robins 1995, 96; Silberman 1995, 214).

27. Leibovitz considers 1970 a particularly significant year in her career, as she began work for *Rolling Stone* that year (Sischy 1991/92, 8).

28. Hutcheon writes, "His self-consciousness about the act of representing in both writing and photography undoes the mimetic assumptions of transparency that underpin the realist project, while refusing as well the anti-representationalism of modernist and late modernist abstraction and textuality. *Roland Barthes by Roland Barthes* manages to de-naturalize both the

'copying' apparatus of photography and the realist reflecting mirror of narrative, while still ac-
knowledging—and exploiting—their shared power of inscription and construction" (1991, 41).

29. Leibovitz 1991/92, 51, 231n; see also Leibovitz 1991.

30. The theme "photographer as photographed" is repeated in Leibovitz's photograph of
photographer Richard Avedon hiding behind a large studio camera (1976) (Leibovitz 1991/92,
104).

31. The photo of John Lennon taken shortly before his death has achieved cult status and
was used for the front cover of the *Photographs* catalog. Ingrid Sischy discusses the significance
of the body in Leibovitz's work (in particular in the John Lennon and Yoko Ono photo)
(Sischy 1991/92, 9). See also the photo of Yoko Ono entitled *Strawberry Fields*, taken the fol-
lowing year, 1981 (Leibovitz 1991/92, 116–17).

32. Leibovitz completed a series of twenty female celebrity photos for a $52-million ad-
vertising campaign (for the National Fluid Milk Processor Promotion Board), including por-
traits of Lauren Bacall and supermodels Naomi Campbell and Christy Brinkley, each wearing
a white milk mustache. Dottie Enrico, "Celebrity Milk Mustaches," *USA Today*, 10 January
1995; Schulberg 1998, xiv–xvi.

33. *Swimming Dancers* is the German title of the photo entitled *Dancers* (Leibovitz
1991/92, 231, 218–19).

34. Many of Leibovitz's own comments on photography (e.g., documentary photography
as a construct) can be seen within the context of and have been informed by Susan Sontag's
book *On Photography* (1989). See also McRobbie 1995, 77–95.

35. Douglas Kellner discusses Stallone in relationship to the reception of his Rambo char-
acter as a "polysemic cultural construct which can be appropriated by opposing sides in politi-
cal debate and struggle" (1995, 74).

36. However, in a later interview, Leibovitz also refers to the inherent tension in photo-
graphing these different subjects: "I can't first shoot Arnold Schwarzenegger and then come back
and shoot the woman going through garbage" (quoted in Meyhöfer 1997, 17). Her heightened
consciousness of such contradictions in her own work is in part attributed to her friend and
collaborator Susan Sontag. Leibovitz has only begun to introduce such contradictions as a pro-
ductive force in her own recent projects.

37. Anja Schäfer, "Annie Leibovitz Exklusiv: Die Helden des Golfkriegs," *Männer Vogue*,
February 1992.

38. Ibid.

39. The photos included H. Norman Schwarzkopf (commander of allied forces), Colin
Powell (chairman, Joint Chiefs of Staff), Javier Perez de Cuellar (U.N. secretary-general), Peter
Arnett (CNN news correspondent, Baghdad), Saud Nasir Al-Sabah (Kuwait's ambassador to
the United States), a Stealth bomber, Major Joe Bouley (Stealth bomber pilot), Isaac Stern
(violinist), and Jacqueline Phillips Guibord (police officer in Utah, posed with a shotgun and
badge in the Leibovitz photo; an earlier photo of Guibord, not by Leibovitz, modeling
Wrangler jeans became a pinup for the U.S. troops in the Gulf).

40. Schäfer, "Annie Leibovitz Exklusiv," 127.

41. Ibid., 128.

42. Texts accompanying photographs are more common for Leibovitz's photographs in
magazines *(Vanity Fair, The New Yorker, Life)* than for her work for advertising or art photog-
raphy appearing in catalogs or exhibitions. Leibovitz is certainly aware of the relations between
text and image in postmodern culture and references this in her own parody of postmodern
photography (in a photo of television monitors in an electronics store with photographer
Barbara Kruger appearing on multiple screens partially covered with sale signs) (Leibovitz
1991/92, 211; on text and image, see McRobbie 1995, 91).

43. The placcs (e.g., the Berlin Wall, or Baghdad Hotel's swimming pool) offer a guide-post for visual orientation as well as a more elaborate range of symbolic associations. With regard to the relationship between symbol and index, see Gottdiener 1995, 67–68, 71.

44. This aspect of Arnett's interview with Saddam Hussein was debated in the U.S. media.

45. *The New Yorker,* 29 January 1996, 69–77.

46. Deborah Scaperoth, "Looks Are Deceiving," letter to the editor, *The New Yorker,* 18 March 1996, 2.

47. The information in this section is based on Bill Goldstein's interview with Leibovitz on an extensive Web site at the *New York Times* online edition, established to promote the book (online; available: http://www.nytimes.com/library/photos/leibovitz/interview.html; 9 September 2000). In the interview, Leibovitz comments on the pivotal role of the "Show-girls" series, which she developed toward the end of the *Women* book project.

5. Sponsoring Events

1. The project, which was formally called *Wrapped Reichstag, Berlin, 1971–95,* was developed by Christo and Jeanne-Claude. References to Christo do not imply the exclusion of Jeanne-Claude from the project. In certain cases, they may refer to a quote by Christo alone.

2. Here Tschumi refers to John Rajchman's work on Foucault; Tschumi 1994, 256.

3. Hal Espen writes, "To be sure, this widespread misapprehension that Woodstock was anticommercial rather than unsuccessfully commercial has, paradoxically, become one of the most appealing, and salable, aspects of the Woodstock mystique" (1994, 73); on the significance of the film *Woodstock* within the context of the 1960s, see Kellner 1995, 104–6.

4. However, they have accepted forms of sponsorship or patronage for some smaller projects. See Gabi Szöppan, "Journal: Christo," *Kritik* 2 (1995): 2.

5. Benjamin referred to the aesthetic qualities of film as a new medium; however, postmodern film raises the possibility of employing commodified images of "shock" (e.g., stock scenes from the horror genre, violence, brutality) in order to destabilize these genres.

6. There is extensive literature on the event. Some of the more influential discussions include Daniel Boorstin, *The Image; or, What Happened to the American Dream* (London: Weidenfeld and Nicholson, 1961). (Wernick points out that Boorstin's analysis of pseudo-events and the importance of the image predates Jean Baudrillard's work, which has received much wider reception; Wernick 1991, 185–88.) See Debord 1995; Laura Mulvey, "Visual Pleasure and Narrative Cinema," in *Popular Television and Film,* ed. Tony Bennett (London: BFI, 1981), 206–15. The journal *Theory and Event* explores political thought and contemporary events.

7. Texaco Press Information, "Behind the Scenes with Texaco and the Met," 30 November 1998 (online; available: http://www.texaco.com).

8. Schulze notes that the significance of the body in the process of experiencing has been relegated to "lower" forms of enjoyment in sociological research or analyzed primarily in terms of cognition and communication, for example, by Pierre Bourdieu and Umberto Eco (Schulze 1992, 106). Schulze's analysis provides additional qualitative and quantitative sociological evidence with respect to the signification of the body as a site of constructing identity and experience, evidence that augments extensive research within cultural and feminist studies.

9. Perhaps one of the most visible events of what was once considered to be a signifier of high culture is the opera festival. Bayreuth is associated with European society and culture in the grand tradition of the nineteenth century. Yet as Marc Weiner observed, adaptations and televised performances of Wagner's *Ring* (including those of other venues, such as the Metropolitan Opera in New York) have reached more demographically diverse audiences. Adaptations

and their subsequent reception, at least tentatively, challenged the representation of cultural and ethnic identities. See Marc Weiner, *Richard Wagner and the Anti-Semitic Imagination* (Lincoln: University of Nebraska Press, 1995), 17.

10. Conductor and festival director Justus Frantz, Carl Hermann Schleifer (then secretary of finance for the State of Schleswig-Holstein), and businessman Ulrich Urban were the driving forces behind the conceptual development of the festival, reflecting the "new partnerships" between culture, politics, and commerce.

11. See Frank-Olaf Brauerhoch's discussion of the professionalization of street-fair and festival culture in various districts of Frankfurt. As part of the city's cultural politics, these events were designed, in part, to include "foreign" residents of the city; however, this participation situated them as spectators for the established groups that dominated the events (Brauerhoch 1993, 113–15).

12. Willnauer had been opposed to the "Schleswig-Holstein model" while he was in Salzburg. Now he was being brought in to tighten the management. Werner Burkhardt, "Wolken sind überall," *Süddeutsche Zeitung*, 27 June 1995.

13. See Bregenzer Festspiele Web site: http://www.bregenzerfestspiele.com; 9 September 2001.

14. With respect to the relationship between the dramaturgical special effects in Bregenz and Pountney's direction, see Thomas Thieringer, "*Nabucco* im Käfig," *Süddeutsche Zeitung*, 23 July 1993.

15. Thieringer, in "*Nabucco* im Käfig," notes that when Austria's president, Thomas Klestil, for example, appeared in Bregenz, there was no public applause. The response was considered a result of the negative image of the office after revelations of Kurt Waldheim's activities during National Socialism.

16. This is based on an American Express advertisement in the *Süddeutsche Zeitung*, 10 September 1992. Of course, American Express also offered its customary VIP packages to accompany the event for cardholders, as well as "cultural tourism" packages.

17. Peter Buchka, "Benutzen statt gucken: Die neue Sommerattraktion. Open-air-Kino," *Süddeutsche Zeitung*, 26 July 1995.

18. Ibid.

19. Roger Thiede and Stefan Wimmer, "Die 89er: Eine umkämpfte Generation," *Focus* 28 (1995): 134; Henkel and Wolff 1996, 102–9.

20. The performative aspect of dance culture is taken out of the clubs into the street and back again.

21. For an extensive discussion of the intersection of fashion, youth subculture, and the media (including digital "wearables"), see Birgit Richard, "Die oberflächlichen Hüllen des Selbst: Mode als ästhetisch-medialer Komplex," *Kunstforum* 141 (1998): 49–93; Tracy Skelton and Gill Valentine, *Cool Places: Geographies of Youth Cultures* (London: Routledge, 1997). An archive of fashion dealing with rave, techno, and house within youth culture is located at the Johann Wolfgang Goethe-Universität Frankfurt's *Institut für Kunstpädagogik*, directed by Birgit Richard. Information on the research and artifacts can be accessed online at http://www.uni-frankfurt.de/f609/kunstpaed/indexweb/jka.htm; 9 September 2001.

22. "Tanzen für den Frieden," *Der Spiegel*, 3 July 1995, 103.

23. "Vergeßt alle Systeme," *Der Spiegel*, 14 August 1995, 154–60.

24. Regarding Generation Y, the successor to Generation X, as consumer group, see Sharon R. King, "Marketing Fashion for the Gen Y Buyer," *New York Times*, 28 August 1999 (online; available: http://www.nytimes.com).

25. This strategy of creating "sensational" or "bad" publicity (e.g., for the tabloids) that

will arouse moral indignation among some and titillation among others was probably perfect-
ed by Hollywood.

26. Grossberg develops Will Straw's definitions of scenes with respect to music and dance
(Grossberg 1994, 46, 58n10).

27. Weinberg emphasizes the concept of "youthfulness" as an appealing orientation that
cuts across social milieus and is employed in marketing experiences (1992, 21).

28. Philip Morris, "Light American Minister," advertisement, 1992.

29. For obvious reasons, sponsors refrain from addressing volatile or violent youth sub-
cultures (e.g., skinheads, neo-Nazis) unless the styles of a particular subculture are adapted by
other subcultures that are considered socially legitimate (e.g., punk fashion). See Ilka Piepgras,
"Kundschafter der Nacht: Weil Marketing-Experten die Jugend kaum noch verstehen, schicken
sie Spione in die Partyszene," *Berliner Zeitung,* 13 September 1995.

30. Piepgras, "Kundschafter der Nacht."

31. Schulze refers to four main strategies utilized by the commercial and nonprofit insti-
tutions of cultural production: schematization, the production of distinctive images or pro-
files, variation, and suggestion (1992, 425).

32. See Gottdiener's discussion of the signification of punk (1995, 243–52).

33. Kellner points out that much of the image of the original Woodstock had been re-
duced to style through its promotion in movies such as *Woodstock* and *Easy Rider* (1995,
104–6). One must question to what extent Woodstock '94 adapted and modified these vestiges
of Woodstock style in retro fashion, that is, in dress and music.

34. Kevin Goldman, "Woodstock '94 Signs Up Pepsi, Häagen-Dazs, and the Wiz," *Wall
Street Journal,* 21 June 1994.

35. The notion of rock classics was most visibly institutionalized through the Rock and
Roll Hall of Fame and Museum, originally conceived in 1983 in New York and opened in 1994
as a museum complex in Cleveland. The museum documents and promotes popular music.

36. Jeff Rowlands, senior vice president, PolyGram Diversified Ventures, coproducer of
Woodstock '94, "Ravestock at Woodstock," 18 July 1996 (online; available: http://www.
Woodstock-94.com; 18 July 1996).

37. Scotto/DEA, "Ravestock at Woodstock."

38. With respect to product placement at rock concerts and in video clips, see Kohlen-
berg 1994, 45–47; Rau 1994, 243–53.

39. "Woodstock '94 Unveils the Surreal Field," 18 July 1996 (online; available: http://
www.Woodstock-94.com; 18 July 1996).

40. For example, the Mall of America in Bloomington, Minnesota, which includes the
theme park Camp Snoopy as well as multiple entertainment venues such as Planet Hollywood.

41. Patrica Leigh Brown, "Step Right Up: Let an Architect Thrill You," *New York Times,*
19 February 1998.

42. See also syndicated columns appearing in regional newspapers; for example, see Neal
Karlen, "Festival Wasn't a Revolution, It Was a Marketing Key," *Des Moines Register,* 11 August
1994 (*New York Times* syndication); Frank Rich, "Woodstock '94: Made for the Age of
Overkill," *Des Moines Register,* 18 July 1994 (*New York Times* syndication).

43. To what extent the violence at Woodstock '99 resulted from the event's commerciali-
zation is of course difficult to ascertain, particularly given more-widespread violence (rioting)
at many public venues (including college campuses) during the 1980s and 1990s. Regarding
violence during the summer of 1999, see Jenny Eliscu, "Riots Erupt at Dave Matthews Band
Shows," *Rolling Stone,* 16 September 1999, 41. In any case, the relations among youth sub-
cultures, events, and violence warrant further investigation. Most of the research in this area

currently focuses on media (e.g., video and television) rather than event culture. (See also chapter 7 regarding video games and violence.)

44. I am not referring here to events organized by political parties, labor unions, or other sociopolitical organizations.

45. As of this writing, Live Aid (raised $56 million) and Farm Aid ($15 million) have been the most financially successful events. There are also a number of ongoing concert events that raise money on an annual basis (e.g., Tibetan Freedom Concerts). Mega-events are also increasingly disseminated on the Internet. For example, NetAid—Webcast from Giants Stadium, New Jersey; Wembley Stadium, London; and the Opera House, Geneva—was sponsored by the data communications firm Cisco Systems and the consulting firm KPMG in 1999 as part of the United Nations Development Programme to fight poverty.

46. The activities of SiN and SMF are reported in Josefine Köhn, "Ein Funke ist übergesprungen," *Süddeutsche Zeitung*, 11 December 1998.

47. With respect to the representation of Berlin, see Klaus Hartung, "So viel Übergang war nie," *Die Zeit*, 16 June 1995.

48. This strategy is similar to Haacke's work (Bourdieu and Haacke 1995, 95).

49. For a detailed chronology of the project, see Michael S. Cullen: "Chronologie des Reichstag-Projekts (1971–1993)" (Baal-Teshuva 1993, 30–40).

50. See the documentation of speeches in Baal-Teshuva 1993, 40ff. For a cross-section of cultural commentary in the press, see Werner Spies, "Meister der Vergänglichkeit," *Frankfurter Allgemeine Zeitung*, 23 December 1993; Petra Kipphoff, "Die Politik kann einpacken," *Die Zeit*, 18 February 1994; Frank Schirrmacher, "Den Reichstag verpacken?" *Frankfurter Allgemeine Zeitung*, 23 February 1994.

51. Here, see Andreas Huyssen, "Monumental Seduction," *New German Critique* 69 (1996): 187; Huyssen 1995, 249–60. The debate over the Holocaust Memorial in Berlin and over Cultural Minister Michael Naumann's reappraisal of the Kohl government's plans for it assumed a significant position in postunification cultural politics.

52. Christo and Jeanne-Claude have financed approximated $130 million for their projects through similar sales of project-related artwork. See Jutta Lehmer, "Die Kunst der Finanzierung," *Berliner Zeitung*, 1 July 1995 (online; available: http://www.berlinonline.de; 1 July 1995).

53. Prominent government politicians (e.g., Rita Süssmuth, president of the Bundestag) did appear in an information tent next to the Reichstag to meet with the public. See "Politiker plädieren für Verlängerung," *Berliner Zeitung*, 29 June 1995 (online; available: http://www.berlinonline.de; 1 July 1995). In May 1995, *Stern* magazine attempted to place one of four diorama pavilions on panoramas of "Berlin 2005" within the excluded line of sight of the *Wrapped Reichstag*; however, the "rotunda" was moved to another location subsequent to a court order. Teja Fiedler, "Jetzt fürchten sie nur noch den Wind," *Stern* (25) 1995: 166; "Chronik einer Staatsaktion," *Berliner Zeitung*, 1 July 1995 (online; available: http://www.berlinonline.de; 1 July 1995).

54. "Politiker plädieren für Verlängerung."

55. "Kultur, Kommerz, und Außenpolitik: Ungewohnte Perspektiven, neue Kooperationen," symposium sponsored by the Börsenverein des Deutschen Buchhandels, Frankfurt/M., 15 January 1996.

56. Jürgen Habermas, "Modernity versus Postmodernity," *New German Critique* 22 (1981): 12 (cited in Enssle and Macdonald 1997, 16, 21n47).

57. Schulze points to forms of suggestion and autosuggestion as strategies of organizing and structuring experiences (and the relations between products and their images) both for producers and the consumers of experiences (1992, 436, 443).

6. The Sponsored Museum; or, The Museum as Sponsor

1. As of this writing, plans are underway for another Guggenheim in New York City, to be designed by Frank Gehry. Also MASS MOCA, a former warehouse transformed into a museum space for contemporary art (conceived by Thomas Krens before he assumed directorship of the Guggenheim), will display works from the Guggenheim collections. See Martin Filler, "The Museum Game," *The New Yorker,* 17 April 2000, 97–105. In a postmodern gesture of self-referentiality, the Guggenheim (New York) presented an exhibition entitled *The Global Guggenheim: Selections from the Extended Collection* (2001).

2. See Eva Larrauri, "El Museo Guggenheim de Bilbao desvela el contenido de su colección permanente," *El País,* 4 October 1997 (online; available: http://www.elpais.es; 4 October 1997).

3. See Filler, "The Museum Game," regarding these plans. Regarding the initial success of the GMB, see also http://www.guggenheim-bilbao.es/ingles/historia/contenido.htm.

4. For a discussion of the "Guggenheim phenomenon" from the perspective of museum directors, corporate leaders, and cultural mediators in Germany, see Hoffmann 1999.

5. See Guggenheim Museum, "Museum History," 20 January 1999 (online; available: http://www.guggenheim.org/berlin/history/his_main_info.html; also see www.deutsche-guggenheim-berlin.de/info/index.htm; 20 January 1999).

6. For discussion of the historical status of *Unter den Linden,* see Laurenz Demps, "Das Zentrum: Unter den Linden, Wilhelmstraße, Gendarmenmarkt," in *Berlin: Eine Ortsbesichtigung. Kultur—Geschichte—Architektur* (Berlin: Transit, 1996).

7. According to Ulf Brychcy, the banks and hotels have asked police to patrol the Pariser Platz for street vendors or other unwanted "visitors" who might disturb the upscale guests who frequent the Adlon or the Dresdner Bank. As Berlin's "front parlor" *(Gute Stube),* designed to show off the city center, the Pariser Platz is increasingly reserved for special events (e.g., film festivals). See Ulf Brychcy, "Gute Stube: Verschlossen. Am Pariser Platz empfängt die Stadt ihre Gäste—nur die willkommenen natürlich," *Süddeutsche Zeitung,* 22 July 1998.

8. Guggenheim Museum Web site (online; available: http://www.deutsche-guggenheim-berlin.de; 31 July 2001).

9. See Guggenheim's "Web Partners" (online; available: http://www.guggenheim.org).

10. See Guggenheim Museum Web site (online; available: http://www.guggenheim.org). Matthew Barney is known for his videos, installations, and performances, particularly those that deal with the body, medicine, and sports. His cycle of movies *(Cremaster)* was widely reviewed in the international art scene, and the Guggenheim planned a major retrospective of the series for 2001. See Christian Kämmerling, "'Mein Kopf ist wie ein Cockpit,'" *Süddeutsche Zeitung Magazin,* 13 November 1998, 34–40.

11. See the promotional brochure "Willkommen bei uns in Wolfsburg," VW AG Public Relations. "Kraft-durch-Freude" was a designation for National Socialist mass organizations.

12. Under National Socialism, Volkswagen, much like other state-run industries, relied on non-German prisoners and forced laborers to power the war machine.

13. VW Press Information, "Wolfsburg auf dem Weg zur Urbanität."

14. *Deutschland Nachrichten,* 27 May 1994, 7.

15. Jürgen Schow was chief legal counsel for VW AG at the time the Kunststiftung Volkswagen was established (Schow 1994, 104–5).

16. Wolfgang Guthardt, director of cultural affairs of the City of Wolfsburg, *Italienischer Sommer in Wolfsburg,* brochure.

17. The closest the official program came to engaging Italians who lived and worked in Wolfsburg was a small photography exhibit portraying everyday life at the German-Italian elementary school in Wolfsburg *(Italienischer Sommer in Wolfsburg).*

18. "Let's Spend the Night Together: Volkswagen und die Rolling Stones," interview with Jennifer Hurshell, *Indigo Stadtmagazin*, July/August 1995, 12–13.

19. See "Let's Spend the Night Together," 13.

20. Anne Mikus identifies 169 corporate museums in Germany (1997, 211).

21. See the museum brochure *Erlebniswelt BMW Museum—The BMW Museum Experience,* BMW Museum.

22. Ibid., 15.

23. Bill Munn, "It's More Than a Trip down Memory Lane," *AUTO Magazine,* November 1994, 23–25, here 24–25; see also BMW AG München, "Zeithorizont: Eine Führung durch das BMW Museum," September 1993; Horst Mönnich, *BMW: Eine deutsche Geschichte* (Munich: Piper, 1991).

24. Recognizing that its AutoMuseum was rather obsolete, in 2000 Volkswagen opened a new $420-million high-tech theme park, Autostadt, including a luxury hotel and attractions. Autostadt can also be seen within the broader context of Wolfsburg's attempts to position itself as a regional center of tourism. This also includes the new Science Center designed by the internationally acclaimed architect Zaha Hadid. See "Zaha Hadid gewinnt Wettbewerb in Wolftsburg," *Frankfurter Rundschau,* 17 February 2000 (online; available: http://www.fr-aktuel.de; 17 February 2000); Steven Komarow, "VW Park Pampers Buyers," *USA Today,* 11 July 2000.

25. BMW's later development of its own section for cultural programs *(Kulturreferat)* confirmed the significance of participating in cultural politics at the regional, national, and international levels (see chapter 2).

26. *Erlebniswelt BMW Museum,* 4.

27. BMW AG Presse, "BMW Museum: Zeithorizont," no. 4 (1991): 6.

28. Ibid., 20–23.

29. BMW AG Presse, "BMW Isetta: Die Knutschkugel wird 40," 1995: 2–4.

30. The Grand Prix for children (sponsored by the Rosso Bianco Collection of sports cars in Aschaffenburg) was integrated into social sponsorships for educating children on traffic safety (supported by the Automobile Club of Germany) and encouraged them to gather donations in automobile-shaped containers for MUKO (Mukoviszidose-Hilfe). See BMW AG Presse, "Isetta: Kinder-Grand-Prix," 1995: 2.

31. BMW AG Presse, "BMW Isetta: Zeitzeuge der 50er Jahre," 1995.

32. While such programs might be considered part of administrative globalization, in the case of Vitra they do not seem to involve attempts to promote the corporation's own products or interests; rather, they are based on design and Vitra's own strategies of alternative modes of curatorial development, which are not reduced to product mediation.

33. See Guggenheim Web site (online; available: http://www.guggenheim.org/motorcycl/1993-1998.html). For information on how Thomas Krens expanded the mission of the Guggenheim, see Carol Lutfy, "China Comes to the Guggenheim," *ARTnews,* March 1998, 144–45.

34. Alice Rawsthorn, "Museum or Amusement Park?" *Travel and Leisure,* October 2000, 147–52.

35. See Henryk M. Broder, "Kirche ohne Fenster," *Der Spiegel,* 7 August 2000, 164–69.

36. McKinsey has examined the function of museums as cultural mediators (e.g., at the Stuttgart Staatsgalerie). See Christian Marquart, "Der Kundige ist König," *Süddeutsche Zeitung,* 21 July 1998.

37. Both theorists recognize that there are, of course, significant structural and functional differences between museums and mass media and also are conscious of the role of electronic media in museums. Silverstone 1994, 175n7; Huyssen 1995, 32.

38. Projects developed by artists Clegg and Guttmann within corporate and public spaces provide some tentative possibilities in this direction (see chapter 2).

7. Cybersponsoring

1. Howard Rheingold, referring to William Gibson, defines cyberspace as "the name some people use for the conceptual space where words, human relationships, data, wealth, and power are manifested by people using CMC [computer-mediated communications] technology" (1994, 5).

2. Here it is important to distinguish between three basic forms of production or mediation: (1) the digitization of existing works or collections for distribution on CD-ROM or online; (2) media-art installations in museums (e.g., art utilizing video, computer, or virtual reality technologies); and (3) online projects developed specifically for the World Wide Web or Internet (Atkins 1999, 89).

3. There are also new centers emerging, such as Museum 540 (New York) and the Beecher Center for the Electronic Arts (Youngstown, Ohio). Museum 540 is attempting to develop media programs without the commercial interests driving much of the new technology. See Matthew Mirapaul, "Groundbreaking Developments in Electronic Art," *New York Times,* 24 December 1998 (online; available: http://www.nytimes.com; 24 December 1998).

4. Ars Electronica Center, 9 January 1999 (online; available: http://www.aec.at; 9 January 1999).

5. Ibid.

6. The promotion of "educational outreach" has become a particularly important element in validating the democratization of the museum and in maintaining institutional legitimacy. In this respect, science and technology museums and specialized programming by entertainment and media corporations play an important role in the process of representing the relations of technology and society and constructing narratives for education and technology. With regard to themed environments and Disney's pedagogies and corporate politics, see Henry A. Giroux, *The Mouse That Roared: Disney and the End of Innocence* (Lanham, Md.: Rowman & Littlefield, 1999).

7. The following statement from the AEC Web site is indicative of the center's role in promoting corporate interests: "As a permanent studio for innovation, it is a competent partner with professional know-how. In cooperation with corporate industries like Voest Alpine MCE, the development of new simulation methods, training, or product presentation are given particular importance. Wolfgang Modera, Managing Director, sees the considerable interest of industry to be predicated on the notion that artistic consideration of technology within the AEC releases a potential which is frequently hidden within the 'standardized' regime of technology. And it is precisely as a result of this fact that many technicians and engineers have received valuable innovations for their companies as a result of the 'open character' of the Ars Electronica Center" (AEC Web site [online; available: http://www.aec.at]).

8. Each corporate page at the AEC includes a promotional statement defining and legitimizing the corporate role in technology, culture, and the AEC; a corporate profile; and a summary of corporate technologies and services. Technology corporations represent the majority of sponsors: Hewlitt-Packard Austria, Digital Equipment Austria, Gericom, Siemens Nixdorf Austria, Silicon Graphics, Ericcson, and Oracle. Hewlitt-Packard provides the AEC video server, video-on-demand in the media center, and printers for the administrative offices. Oracle supplies software for AEC information and administrative systems. In addition to sponsoring the Prix Ars Electronica, Siemens Nixdorf donates hardware for ticketing systems and information-management systems for data searches. Ericcson installed an in-house

asynchronous transfer mode (ATM) network for digital information transmission. The Sky–Media Loft virtual reality installation uses Gericom notebook computers. And in the foyer of the AEC, the Pro Cash Installation sponsored by the Creditanstalt presents an interactive electronic currency market.

9. Given the title of the festival, its siting in Linz is also somewhat ironic. Linz was to be Hitler's metropolis of the future for National Socialism.

10. Arthur and Marilouise Kroker, "Digital Ideology: E-Theory (1)," review of *Business @ The Speed of Thought: Using a Digital Nervous System,* by Bill Gates, *CTHEORY,* 1999 (online; available: http://www.ctheory.com; 9 September 2001), 5.

11. Although museums employ notions of modernity, their actual practices reflect postmodern culture, that is, cultural and sociological de-differentiation (Lash 1991). Indeed, much of media art itself is a postmodern phenomenon. Institutionally, the centers for art and technology, as meta-museums, blur and de-differentiate the modernist conception of the museum (e.g., representation and filtering of high culture). The museum as an experimental studio for artistic production and events, as well as a site for entertainment, is a distinctive feature of this process.

12. Museums are encouraged to use the aesthetics of games for their interactive CD-ROMs. See Lee Rosenbaum, "Art Lovers Cool to Lures of CD-ROM's," *New York Times,* 23 July 1998 (online; available: http://www.nytimes.com; 23 July 1998).

13. For references to DOOM in the U.S. media, see, among others, Timothy Egan, "The Trouble with Looking for Signs of Trouble," *New York Times,* 25 April 1999 (online; available: http://www.nytimes.com). The pedagogical basis of Schindler's installation at the ZKM in Karlsruhe may be found in Friedemann Schindler and Jens Wiemken, "DOOM Is Invading My Dreams: Warum ein Gewaltspiel Kultstatus erlangte," in *Handbuch Medien: Computerspiele Bundeszentrale für politische Bildung,* ed. J. Fritz and W. Fehr, 1997 (online; available: http://salon-digital.zkm.de/~snp/referate/doom.htm; 5 May 1999).

14. The ZKM attempts to examine media art within the broader contexts and histories of technological development, providing a certain structure to exhibitions, without, however, invoking "fictional, linear histories of technology" (Schwarz 1997, 32). Schwarz relates this aspect to the need for museums to develop installations, displays, and presentations that are appropriate to media art (1997, 13, 29).

15. George MacDonald and Stephen Alsford use the term "meta-museum" primarily in reference to digitization projects rather than to the formation of new museum concepts integrating projects for art and technology (1997, 272–73).

16. These include cooperative agreements with other centers or museums, such as the ZKM's collaboration with the Guggenheim's Virtual Museum project.

17. For example, visitors using the chip cards at the "Log-In Gateway" at the AEC.

18. In many respects, the new media centers combining museums under one conceptual roof are not radically different from mega-museums, like the Metropolitan Museum of Art or the Louvre, that house their own departments and collections extensive enough to form a museum within a museum. Although the new museum centers claim to serve similar functions (documentation, archiving, representation, and exhibition), what distinguishes them from the Met or the Louvre is their emphasis on the museum as a site of cultural production (e.g., artist studios and labs) as well as of mediation and reception.

19. A variety of nonprofit organizations and consortia—such as the Art Museum Image Consortium (AMICO), the Museum Informatics Project (MIP) at the University of California, Berkeley, or the Museum Educational Site Licensing Project (MESL) (supported in part by the Getty Information Institute)—developed technical and administrative support for

the digitization and dissemination of collections and archives. More than any other factor, collection digitization and online dissemination promise to reconfigure contemporary museum practices.

20. Some curators have argued that using media and the World Wide Web for historical reconstruction of cultures can potentially "redress somewhat . . . [the] colonialist and migratory trends over the last two centuries result[ing] in the fragmentation and even annihilation of many of the world's cultures, a process from which museums have been among the beneficiaries" (MacDonald and Alsford 1997, 274). Yet this argument once again positions the museum as a patron that grants access to privileged culture to those from whom it has been taken—creating new barriers to access through capital investment in technology—rather than uncovering and interrogating the relations between the objects of museal representation and the function of the museum itself.

21. There are also significant costs associated with some new technologies, such as the higher bandwith required for high-resolution, full-motion video, which may make it difficult for smaller organizations to gain access to technology (Sherwood 1997, 141).

22. Matthew Mirapaul, "Columbia, Guggenheim, and BAM Consider New Media-Arts Program," *New York Times,* 12 August 1999 (online; available: http://www.nytimes.com; 12 August 1999).

23. Quoted in Mark Tribe, "Burning under the Fingernails: Interview with Gerfried Stocker," *Rhizome,* 7 September 1999 (online; available: http://www.rhizome.org; 7 September 1999).

24. With regard to the origins of the Internet in ARPANET (the U.S. Defense Department's Advanced Research Projects Agency Network), Rheingold writes, "The fundamental technical idea on which ARPANET was based came from RAND, the think tank in Santa Monica that did a lot of work with top-secret thermonuclear war scenarios; ARPANET grew out of an older RAND scheme for a communication, command, and control network that could survive nuclear attack by having no central control" (1994, 7).

25. See the BRANDON Project at the Guggenheim Web site: http://www.brandon.guggenheim.org; 20 September 1998.

26. Ibid.

27. See Jennifer Terry's remarks as a participant in a panel discussion on BRANDON: Guggenheim Museum Soho, 20 September 1998 (online; available: http://www.brandon.guggenheim.org; 20 September 1998).

28. Text composed by Fiona McGregor for BRANDON road-trip interface (online; available: http://www.brandon.guggenheim.org).

29. The intersection of the spectacle, of the sensational, with sexuality, violence, and gender identity are further thematized in the introductory "bigdoll" interface.

30. Terry's commentary on BRANDON.

31. A number of other media dealt with the history and reception of BRANDON both prior to and following Cheang's project. Although these treatments have led to a greater awareness of transgender issues, they also (inevitably) involved some degree of sensationalism and promotion, ranging, for example, from the novelization *(All S/he Wanted),* to television documentaries *(Investigative Reports),* to the *Jerry Springer Show* (at the most extreme); see, for example, *GLAAD Alert,* "Two Thumbs Up: Roger Ebert Talks about Drag," 24 September 1998 (online; available: http://glaad.org; 24 September 1998). Following an internationally acclaimed documentary, *The Brandon Teena Story* (1998) by Susan Muska and Greta Olafsdottir, Kimberly Peirce's film on Brandon, *Boys Don't Cry* (1999), received overwhelmingly positive reviews from the mainstream and queer media, as well as several Oscars in 2000. However,

entertainment media (e.g., *Premiere* movie magazine) reconfigured the image of Brandon as a cult celebrity through its promotional framing of actress Hilary Swank (who played the role of Brandon). See Robert Abele, "Hilary Swank: The Actress Breaks Out with a Dramatic Turn as a Gender-Bending Teen," *Premiere,* November 1999, 46.

32. With respect to new roles of media artists as curators, see Aurora Lovelock, "Curating on the Edge of Chaos, Curating the Net," *Cached* 5, ICA London, 23 June 1998 (online; available: http://www.rhizome.org).

33. Ford Motor Company, Ford Fund annual report (online; available: http://www.ford.com/; 10 May 1998).

34. Ibid. One of the most visible forms of social sponsorships used for corporate product promotion throughout the 1980s and 1990s was donations of computers and hardware to schools, universities, and other institutions.

35. Susan Kong, "Q&A: Jane Mayer. Distributing Grants to Nonprofit Groups," *New York Times,* Long Island Weekly Desk, 3 May 1998 (online; available: http://www.nytimes.com).

36. Rachel Baker discusses the "Cyberhostess" currently available at the WWW.PDFtm (Wood 1998, 206–11). With regard to the "Corporate Virtual Workspace," Steve Pruitt and Tom Barrett predict, "No longer limited to statistical studies or contrived product prototype trials, a company will maintain a real-time data base of customer demands as they try out and respond to specific products" (1992, 405–6).

37. Small and medium-sized corporations are also becoming more involved in sponsorships as forms of technology and culture merge.

38. This has become increasingly true in Germany as well as in the United States (Schulze 1992, 528–29).

39. NEA reports that 100 percent of LAAs "in the 50 largest U.S. cities use the arts to address community development issues, an increase from 88 percent in 1994 and approximately 20 percent in 1986" (Larson 1997, 84–86).

40. With respect to the textile industry, see the activities of the NLC (discussed in chapter 3) at http://www.nlcnet.org.

41. Although Philippe de Montebello actually became the Met's chief executive while remaining director, technically speaking, he had been subordinate to the former chief executive William H. Luers. David E. McKinney of IBM assumed the position of president. See Judith Dobrzynski, "A Diplomatic Look back at a Met Career," *New York Times,* 7 January 1999.

42. Henning Klüver, "Don Giovanni trägt Armani," *Süddeutsche Zeitung,* 9 December 1998.

43. Christoph Wiedemann, "Zwischen Party-Dekoration und Wertschöpfung," *Süddeutsche Zeitung,* 27 January 1999.

44. Judith Miller, "Bleak Study on the Arts Brings Outcry," *New York Times,* 20 October 1997.

45. Universities in the United States provide one example of wealthy donors' and corporate interests' considerable influence in shifting programmatic emphases by establishing new institutes and programs and by providing infrastructure for them through building projects. With respect to research and technology, see Norman E. Bowie, *University-Business Partnerships* (Lanham, Md.: Rowman and Littlefield, 1994).

46. Of the $9 billion per annum in arts contributions, approximately $1 billion comes from corporations. This does not include corporate marketing budgets for sponsorships (Business Committee for the Arts 1998, 4, 15). Nor do these numbers include the dollar value of individual contributions based on the type of organization. I have argued that despite the relatively low proportion of corporate contributions among total contributions, corporate par-

ticipation nevertheless has a significant effect, not only because it is strategically deployed within promotional campaigns that have a broader multiple effect and can also support certain types of programs, but also because individuals seldom pool their capital resources. Even among those corporations that consider their support to cultural sponsorships to be "noncommercial," the majority integrate their donations into business strategies (Business Committee for the Arts 1998, 27).

47. Rosalyn Deutsche has argued that the notion that there is a clear differentiation of spatial boundaries and their representation (in this case, between public and private, or between corporate and cultural spaces) restricts a fuller analysis of social space. Thus, the acceptance of existing spatial boundaries as legitimate "deter[s] us from investigating the real political struggles inherent in the production of *all* spaces and from enlarging the field of struggles to make many different kinds of spaces public" (1998, 374–75n121).

Bibliography

The following references include books and articles cited in the text. Other sources, including newspaper articles, cited in notes are not included here. All translations from sources with German titles, including quotations, are my own. I have also included texts that were useful in my analyses.

ABC/EUROCOM, comp. 1992. *Final Media Report: Annie Leibovitz Exhibition.* Frankfurt/M.: ABC/EUROCOM.

Anderson, Maxwell L. 1997. "Introduction." In *The Wired Museum: Emerging Technology and Changing Paradigms,* ed. Katherine Jones-Garmil, 11–32. Washington, D.C.: American Association of Museums.

Anna, Susanne, ed. 1997. *Standort Deutschland: Ein interdisziplinärer Diskurs zur deutschen Situation. Symposium und Ausstellung.* Heidelberg: Edition Braus.

Atkins, Robert. 1998. "On Edge: Alternative Spaces Today." *Art in America,* November, 57–59.

———. 1999. "State of the (On-line) Art." *Art in America,* April, 89–95.

Ayub, Ivonne. 1993. "Skepsis bei ai gegenüber Aktionen des Social Sponsoring." In *Social Sponsoring und Social Marketing: Praxisberichte über das "neue Product Mitgefühl,"* ed. Thomas Leif and Ullrich Galle, 66–69. Cologne: Bund Verlag.

Baal-Teshuva, Jacob, ed. 1993. *Christo, Der Reichstag, und urbane Projekte.* Trans. Wolfgang Himmelberg and Dagmar Lutz. Munich: Prestel.

Baca, Judith F. 1996. "Whose Monument Where? Public Art in a Many-Cultured Society." In *Mapping the Terrain: New Genre Public Art,* ed. Suzanne Lacy, 131–38. Seattle, Wash.: Bay Press.

Barber, Benjamin R. 1996. *Jihad versus McWorld: How Globalism and Tribalism Are Reshaping the World.* New York: Ballantine.

Barrett, Terry. 1994. *Criticizing Art. Understanding the Contemporary.* Mountain View, Calif.: Mayfield.

Baudrillard, Jean. 1997. "America." In *Rethinking Architecture: A Reader in Cultural Theory,* ed. Neil Leach, 218–24. London: Routledge.

Beck, Ulrich. 1998. *Was ist Globalisierung? Irrtümer des Globalismus—Antworten auf Globalisierung.* Edition Zweite Moderne, ed. Ulrich Beck. Frankfurt/M.: Suhrkamp.

Becker, Bettina M. 1994. *Unternehmen zwischen Sponsoring und Mäzenatentum: Motive, Chancen, und Grenzen unternehmerischen Kunstengagements.* Frankfurt/M.: Campus.

Becker, Carol, ed. 1994. *The Subversive Imagination: Artists, Society, and Social Responsibility.* New York: Routledge.

Bender, Gretchen, and Timothy Druckrey, eds. 1994. *Culture on the Brink: Ideologies of*

 Technology. Dia Center for the Arts. Discussions in Contemporary Culture, 9. Seattle, Wash.: Bay Press.

Benedikt, Michael, ed. 1992. *Cyberspace: First Steps.* Cambridge: MIT Press.

Bennett, Tony. 1995. *The Birth of the Museum: History, Theory, Politics.* Culture: Policies and Politics. London: Routledge.

Berman, Russell A. 1992. "Popular Culture, Political Culture, Public Culture." In *Culture and Democracy: Social and Ethical Issues in Public Support for the Arts and Humanities,* ed. Andrew Buchwalter, 261–76. Boulder, Colo.: Westview.

Best, Steven, and Douglas Kellner, eds. 1991. *Postmodern Theory: Critical Interrogations.* New York: Guilford.

Biller, Geraldine P., curator. 1995. *Latin American Women Artists: 1915–1995/Artistas Latinoamericanas.* Exhibition and catalogue. Milwaukee, Wisc.: Milwaukee Art Museum.

Blackman, Lisa. 1998. "Culture, Technology, and Subjectivity: An 'Ethical' Analysis." In *The Virtual Embodied: Presence/Practice/Technology,* ed. John Wood, 132–46. London: Routledge.

BMW Art Car Collection: Automobile Art. 1991. Munich: BMW.

———. 1993. Munich: BMW.

Bolton, Richard, ed. 1992. *Culture Wars: Documents from the Recent Controversies in the Arts.* New York: New Press.

Borja-Villel, Manuel J., ed. 1995. *The End(s) of the Museum/El límits del museu.* Barcelona: Fundació Antoni Tàpies.

Bosetti, Petra. 1997. "Journal: Kulturpolitik. Museumsdirektoren auf Kundenfang. Techno und Kunst vor der Tür sollen neue Besucher locken." *Art,* June, 122–23.

Bourdieu, Pierre, and Hans Haacke. 1995. *Free Exchange.* Stanford, Calif.: Stanford University Press.

Bradley, Kim. 1995. "Guggenheim Bilbao Taking Shape." *Art in America,* February, 27.

———. 1997. "The Deal of the Century." *Art in America,* July, 48–55, 105–6.

Brantl, Sabine, comp. 1997. *Haus der Kunst, 1937–1997: Eine historische Dokumentation.* Munich: Haus der Kunst.

Brauerhoch, Frank-Olaf. 1993. *Das Museum und die Stadt.* Münster: Westfälisches Dampfboot.

Brennan, Timothy. 1997. *At Home in the World: Cosmopolitanism Now.* Cambridge, Mass.: Harvard University Press.

Brock, Bazon. 1992. "Kultur durch Kommunikation: Wirtschaft als Kulturfaktor." In *Produktkulturen: Dynamik und Bedeutungswandel des Konsums,* ed. Reinhard Eisendle and Elfie Miklautz, 23–39. Frankfurt/M.: Campus.

Brown, Christie. 1991. "Absolutely Ingenious." *Forbes,* 15 April, 128–29.

Bruhn, Manfred. 1991. *Sponsoring: Unternehmen als Mäzene und Sponsoren.* 2nd ed. Frankfurt/M.: Frankfurter Allgemeine Zeitung/Gabler.

Bruhn, Manfred, and H. Dieter Dahlhoff. 1989. *Kulturförderung—Kultursponsoring: Zukunftsperspektiven der Unternehmenskommunikation.* Frankfurt/M.: Frankfurter Allgemeine Zeitung/Gabler.

Buchloh, Benjamin H. D. 1997. "Hans Haacke: The Historical 'Sublime.'" In *German Art from Beckmann to Richter: Images of a Divided Country,* ed. Eckhart Gillen, 413–15. Cologne: DuMont.

Buchwalter, Andrew, ed. 1992. *Culture and Democracy: Social and Ethical Issues in Public Support for the Arts and Humanities.* Boulder, Colo.: Westview.

Burgin, Victor. 1986. *The End of Art Theory: Criticism and Postmodernity. Communications and Culture.* Atlantic Highlands, N.J.: Humanities.

Business Committee for the Arts, ed. 1998. *1998 National Survey: Business Support to the Arts.* New York: BCA and Roper Starch Worldwide.

Bußmann, Klaus, and Florian Matzner, eds. 1993. *Hans Haacke: Bodenlos.* Ostfildern bei Stuttgart: Edition Cantz.

Byrnes, William J. 1993. *Management and the Arts.* Boston: Focal, 1993.

"Carillon Importers: The Art of 'Absolut' Marketing." 1992. *Sales and Marketing Management,* August, 44.

Casey, J. Burton. 1986. *The Arts and Business: Partners in Economic Growth.* Executive Viewpoints. New York: BCA.

Chadwick, John, and Patricia Boverie. 1999. "A Survey of Characteristics and Patterns of Behavior in Visitors to a Museum Web Site." *Archives & Museum Informatics* (Museums and the Web 1999). Online; available: http://www.archi.muse.com; 16 September 1999.

Conroy, Marianne. 1998. "Discount Dreams: Factory Outlet Malls, Consumption, and the Performance of Middle-Class Identity." *Social Text* 16.1: 63–83.

Cowell, Alan. 1997. "New U.S. Sector in Berlin: Little Guggenheim Branch." *New York Times* 7 November.

Crimp, Douglas, with photographs by Louise Lawler. 1993. *On the Museum's Ruins.* Cambridge: MIT Press.

Cubitt, Sean. 1991. *Timeshift: On Video Culture.* Comedia, ed. David Morley. London: Routledge.

Cullen, Michael S. 1993. "Chronologie des Reichstag-Projekts (1971–1993)." In *Christo, der Reichstag, und urbane Projekte,* ed. Jacob Baal-Teshuva, trans. Wolfgang Himmelberg and Dagmar Lutz, 30–40. Munich: Prestel.

Danto, Arthur C. 1993. *Beyond the Brillo Box: The Visual Arts in Post-Historical Perspective.* New York: Noonday.

Davis, Susan G. 1997. *Spectacular Nature: Corporate Culture and the Sea World Experience.* Berkeley and Los Angeles: University of California Press.

Debord, Guy. 1995. *The Society of the Spectacle.* Trans. Donald Nicholson-Smith. New York: Zone.

Deitsch, Jeffrey, ed. 1993. *Post Human.* Exhibition and catalogue. Hamburg: Deichtorhallen-Ausstellungs-GmbH.

Deutsche, Rosalyn. 1998. *Evictions: Art and Spatial Politics.* Graham Foundation/MIT Press Series in Contemporary Architectural Discourse. Cambridge: MIT Press.

Diamonstein, Barbaralee, ed. 1994. *Inside the Art World: Artists, Directors, Curators, Collectors, Dealers. Conversations with Barbaralee Diamonstein.* New York: Rizzoli.

Dischinger, Nicola. 1992. *Kultur, Macht, Image: Frankfurter Banken als Sponsoren.* Schriftenreihe des Instituts für Kulturanthropologie und Europäische Ethnologie der Universität Frankfurt am Main, 40. Frankfurt/M.: Institut für Kulturanthropologie und Europäische Ethnologie der Universität Frankfurt am Main.

Dumrath, Carla. 1992. "Social Sponsoring als gesellschaftliche Verantwortung: McDonald's und die 'Ronald McDonald' Kinderhilfe." In *Jahrbuch Sponsoring 92,* ed. Peter Strahlendorf, 31–36. Düsseldorf: Econ.

Econ Werbeannual 1992 für Deutschland, Österreich, und die Schweiz. 1992. Düsseldorf: Econ.

Eisendle, Reinhard, and Elfie Miklautz, eds. 1992. *Produktkulturen: Dynamik und Bedeutungswandel des Konsums.* Frankfurt/M.: Campus.

Elsaesser, Thomas. 1989. *New German Cinema: A History.* New Brunswick, N.J.: Rutgers University Press.

Enssle, Manfred J., and Bradley J. Macdonald. 1997. "The Wrapped Reichstag, 1995: Art, Dialogic Communities, and Everyday Life." *Theory and Event* 1.4: 1–21.

Erben, Klaus-Michael. 1992. "Kultursponsoring im ländlichen Raum: Das Förderkonzept der

IBM Deutschland." In *Kulturpolitik und Kultursponsoring,* ed. Christian Stolorz and Stefan Schmalhaus, 63–74. Wirtschaft und Politik im Dialog, ed. Rainer Frey and Christian Stolorz, 1. Münster: Lit.

Espen, Hal. 1994. "The Woodstock Wars." *The New Yorker,* 15 August, 70–74.

Ewen, Stuart. 1977. *Captains of Consciousness: Advertising and the Social Roots of the Consumer Culture.* New York: McGraw-Hill.

Fabo, Sabine. 1999. "Vom imaginären zu digitalen Museum." In *Konfigurationen: Zwischen Kunst und Medien,* ed. Sigrid Schade and Georg Christoph Tholen, 413–25. Munich: Wilhelm Fink Verlag.

Feldmann, Bernd. 1992. "Festspiele und Sponsoren." In *Jahrbuch Sponsoring 92,* ed. Peter Strahlendorf, 81–88. Düsseldorf: Econ.

Fischer, Volker, ed. 1988. *Design heute: Maßstäbe. Formgebung zwischen Industrie und Kunst-Stück.* Munich: Prestel.

Fiske, John. 1989. *Understanding Popular Culture.* Boston: Unwin Hyman.

———. 1992. *Reading the Popular.* London: Routledge.

Fohrbeck, Karla. 1989. *Renaissance der Mäzene? Interessenvielfalt in der privaten Kulturfinanzierung. Studien zur Kulturpolitik.* Bundesministerium des Innern. Cologne: DuMont.

Fohrbeck, Karla, and Andreas Johannes Wiesand. 1989. *Private Kulturförderung in der Bundesrepublik Deutschland.* Bonn: Inter Nationes.

Foster, Hal. 1996. *The Return of the Real: The Avant-Garde at the End of the Century.* An October Book. Cambridge: MIT Press.

Freeman, Laurie. 1998. "As Events Grow, So Does Skepticism." *Advertising Age* 8: S12–S13.

Freitag, René. 1998. "Not a Museum, Not a Media Centre, but Both and More: The ZKM in Karlsruhe." *Deutschland,* February, 47–49.

Friede, Claus. 1998. "Claus Friede im Gespräch mit Clegg & Guttmann." In *Clegg and Guttmann: Museum for the Workplace,* ed. Luminita Sabau, 11–17. Alltägliches: Kunst am Arbeitsplatz, DG 1. Regensburg: Lindinger und Schmid.

Friedman, Thomas L. 2000. *The Lexus and the Olive Tree.* New York: Anchor.

Frohne, Ursula. 1997. "Motive der Zeit" In *Kunst der Gegenwart: Museum für Neue Kunst,* ed. Heinrich Kotz, Horst Bredekamp, and Ursula Frohne, 38–50. ZKM, Zentrum für Kunst und Medientechnologie Karlsruhe. Munich: Prestel.

Fry, Susan L. 1991. "Reaching Hispanic Publics with Special Events." *Public Relations Journal,* February, 12–13, 30.

Galloway, David. 1998. "Digital Bauhaus." *Art in America,* June, 45–47.

Garofalo, Reebee. 1992. "Understanding Mega-Events: If We Are the World, Then How Do We Change It?" In *Technoculture,* ed. Constance Penley and Andrew Ross, 247–70. Cultural Politics, 3. Minneapolis: University of Minnesota Press.

Gaskin, James E. 1997. *Corporate Politics and the Internet.* Upper Saddle River, N.J.: Prentice Hall.

Gelder, Ken, and Sarah Thornton, eds. 1997. *The Subcultures Reader.* London: Routledge.

Gillen, Eckhart, ed. 1997. *German Art from Beckmann to Richter: Images of a Divided Country.* Cologne: DuMont.

Giroux, Henry A. 1994. "Benetton's 'World without Borders': Buying Social Change." In *The Subversive Imagination: Artists, Society, and Social Responsibility,* ed. Carol Becker, 187–207. New York: Routledge.

Goldberger, Paul. 1997. "The Politics of Building." *The New Yorker,* 13 October, 48–53.

Goldstein, Bill. 1999. "Annie Leibovitz on 'Women,' and Her Career." *New York Times* 9 November, http://www.nytimes.com/library/photos/leibovitz/interview.html.

Gordon, Avery. 1995. "The Work of Corporate Culture: Diversity Management." *Social Text* 13.3: 3–30.

Gottdiener, M. 1995. *Postmodern Semiotics: Material Culture and the Forms of Postmodern Life.* Oxford: Blackwell.

Gradwohl, Judith, and Gene Feldman. 1998. "Going Electronic: A Case Study of 'Ocean Planet' and Its On-Line Counterpart." In *The Virtual and the Real: Media in the Museum,* ed. Selma Thomas and Ann Mintz, 173–90. Washington, D.C.: American Association of Museums.

Graf, Christof. 1996. *Event-Marketing: Konzeption und Organisation in der Pop Musik.* Wiesbaden: Deutscher Universitäts Verlag.

Graham, Dan. 1995. "Two-Way Mirror Cylinder inside Cube and Video Salon: Rooftop Park for Dia Center for the Arts (1991)." In *The End(s) of the Museum/El límits del museu,* ed. Manuel J. Borja-Villel, 126–32. Barcelona: Fundació Antoni Tàpies.

Grasskamp, Walter. 1992. *Die unästhetische Demokratie: Kunst in der Marktgesellschaft.* Beck'sche Reihe, 475. Munich: Beck.

———. 1995. *Der lange Marsch durch die Illusionen: Über Kunst und Politik.* Beck'sche Reihe, 1110. Munich: Beck.

———. 1998. *Kunst und Geld: Szenen einer Mischehe.* Beck'sche Reihe, 1258. Munich: Beck.

Greenberg, Reesa, Bruce W. Ferguson, and Sandy Nairne, eds. 1996. *Thinking about Exhibitions.* London: Routledge.

Grossberg, Lawrence. 1994. "Is Anybody Listening? Does Anybody Care? On 'The State of Rock.'" In *Microphone Friends: Youth Music and Youth Culture,* ed. Andrew Ross and Tricia Rose, 41–58. New York: Routledge.

Grüßer, Birgit. 1992. *Handbuch Kultursponsoring: Ideen und Beispiele aus der Praxis.* Hannover: Schlütersche.

Haacke, Hans. 1995. *Obra Social.* Barcelona: Fundació Antoni Tàpies.

Hackelsberger, Christoph. 1994. "Finding the Centre: Wolfsburg and Its Kunstmuseum." In *Kunstmuseum Wolfsburg: Architekten Schweger + Partner,* 40–42. Berlin: Ernst und Sohn.

Haenlein, Carl. 1994. "Architecture Art Museum: Texts on the Planning Process for the Wolfsburg Kunstmuseum (Art Museum)." In *Kunstmuseum Wolfsburg: Architekten Schweger + Partner,* 21–30. Berlin: Ernst und Sohn.

Hanhardt, John G. 1995. "Acts of Enclosure: Touring the Ideological Space of the Art Museum." In *The End(s) of the Museum/El límits del museu,* ed. Manuel J. Borja-Villel, 31–47. Barcelona: Fundació Antoni Tàpies.

Hannerz, Ulf. 1996. *Transnational Connections: Culture, People, Places.* Comedia, ed. David Morley. London: Routledge.

Hardenberg, Irene von. 1998. "The Covert Seducers: Germany's Most Creative Advertising Agencies." *Deutschland,* October, 47–49.

Harris, Melissa. 1993. "Annie Leibovitz." *Aperture,* Fall, 4–13.

Harris, Thomas L. 1993. *The Marketer's Guide to Public Relations: How Today's Top Companies Are Using the New PR To Gain a Competitive Edge.* Wiley Series on Business Strategy, ed. William A. Cohen. New York: Wiley.

Hebidge, Dick. 1994. *Subculture: The Meaning of Style.* London: Routledge.

Heilbrun, James, and Charles M. Gray. 1993. *The Economics of Art and Culture: An American Perspective.* Cambridge: Cambridge University Press.

Heinrichs, Werner. 1994. "Kommunale Kulturarbeit." In *Kulturmanagement: Theorie und Praxis einer professionellen Kunst,* ed. Hermann Rauhe and Christine Demmer, 343–50. Berlin: Walter de Gruyter.

————. 1997. *Kulturpolitik und Kulturfinanzierung: Strategien und Modelle für eine politische Neuorientierung der Kulturfinanzierung.* Munich: Beck.

Hendrickson, Matt. 1999. "Woodstock: What Went Wrong." *Rolling Stone,* 16 September, 35–41.

Henkel, Olivia, and Karsten Wolff. 1996. *Berlin Underground: Techno und HipHop zwischen Mythos und Ausverkauf.* Berlin: FAB.

Heyman, I. Michael. 1998. "Museums and Marketing." *Smithsonian,* January, 11.

Hitters, Erik. 1996. *Patronen van patronage: Mecenaat, protectoraat en markt in de kunstwereld.* Utrecht: Uitgeverij Jan van Arkel.

Hoffmann, Hilmar, ed. 1999. *Das Guggenheim Prinzip.* Cologne: DuMont.

Hoffmann, Hilmar, and Dieter Kramer. 1994. "Kulturämter und -behörden." In *Kulturmanagement: Theorie und Praxis einer professionellen Kunst,* ed. Hermann Rauhe and Christine Demmer, 351–64. Berlin: Walter de Gruyter.

Hummel, Marlies. 1993. "Quantitative Aspekte privater Kulturförderung." In *Kulturförderung: Mehr als Sponsoring,* ed. Rupert Graf Strachwitz and Stefan Toepler, 57–69. Wiesbaden: Gabler.

Hutcheon, Linda. 1991. *The Politics of Postmodernism.* New Accents, ed. Terence Hawkes. London: Routledge.

Hutter, Michael. 1994. "Stichwort: Kulturökonomik." In *Kulturmanagement: Theorie und Praxis einer professionellen Kunst,* ed. Hermann Rauhe and Christine Demmer, 57–71. Berlin: Walter de Gruyter.

Huyssen, Andreas. 1995. *Twilight Memories: Marking Time in a Culture of Amnesia.* New York: Routledge.

Hyde, James. 1998. "'The Art of the Motorcycle' at the Guggenheim." *Art in America,* December, 95–96.

Info Box: Der Katalog. 1996. Berlin: Nishen.

Jacobson, Linda, ed. 1992. *CyberArts: Exploring Art and Technology.* San Francisco: Miller Freeman.

Jacobson, Michael F., and Laurie Ann Mazur. 1995. *Marketing Madness: A Survival Guide for a Consumer Society.* Boulder, Colo.: Westview.

Jameson, Fredric. 1997. "The Cultural Logic of Late Capitalism" In *Rethinking Architecture: A Reader in Cultural Theory,* ed. Neil Leach, 236–47. London: Routledge.

Jedlicka, Judith A. 1989. Foreword to *The BCA Report: A New Look at Business Support to the Arts in the U.S.* New York: BCA and Research Forecasts.

Johnson, Bradley. 1991. "Gay Press Gains Few National Ads." *Advertising Age,* 8 July, 31.

Jones-Garmil, Katherine, ed. 1997. *The Wired Museum: Emerging Technology and Changing Paradigms.* Washington, D.C.: American Association of Museums.

Jordan, Glenn, and Chris Weedon. 1995. *Cultural Politics: Class, Gender, Race, and the Postmodern World.* Oxford: Blackwell.

Kanner, Bernice. 1988. "Annie in Adland." *New York,* 14 March, 24–28.

Karp, Ivan, and Seven D. Lavine, eds. 1991. *Exhibiting Cultures: The Poetics and Politics of Museum Display.* Washington, D.C.: Smithsonian Institution Press.

Kellner, Douglas. 1995. *Media Culture: Culture Studies, Identity, and Politics between the Modern and the Postmodern.* London: Routledge.

Kimmelman, Michael. 1997. "Giant Guggenheim in Spain May Upstage Its Contents." *New York Times,* 20 October.

Kinkel, Klaus. 1996. "Kultur, Kommerz, und Außenpolitik: Ungewohnte Perspektiven, neue Kooperationen." Ein Symposium im Kaisersaal des Frankfurter Römer. Frankfurt/M.: Börsenverein des Deutschen Buchhandels e.V.

Klein, Hans-Joachim. 1990. *Der gläserne Besucher: Publikumsstrukturen einer Museums-landschaft.* Berliner Schriften zur Museumskunde, 8. Berlin: Staatliche Museen Preußischer Kulturbesitz.

Klein, Naomi. 1999. *No Logo.* New York: Picador.

Kleinert, Matthias. 1994. "Kulturelle Öffentlichkeitsarbeit in Unternehmen." In *Kultur-management: Theorie und Praxis einer professionellen Kunst,* ed. Hermann Rauhe and Christine Demmer, 387–90. Berlin: Walter de Gruyter.

Klotz, Heinrich, ed. 1995. *Das Zentrum für Kunst und Medientechnologie Karlsruhe.* 2nd ed. Karlsruhe: Zentrum für Kunst und Medientechnologie.

Klotz, Heinrich, Horst Bredekamp, and Ursula Frohne. 1997. *Kunst der Gegenwart: Museum für Neue Kunst.* ZKM, Zentrum für Kunst und Medientechnologie Karlsruhe. Munich: Prestel.

Klüver, Billy. 1994. "Artists, Engineers, and Collaboration." In *Culture on the Brink: Ideologies of Technology,* ed. Gretchen Bender and Timothy Druckrey, 207–19. Dia Center for the Arts. Discussions in Contemporary Culture, 9. Seattle, Wash: Bay Press.

Kohlenberg, Markus. 1994. *Musiksponsoring: Grundlagen—Strategien—Beispiele.* Wiesbaden: Deutscher Universitäts Verlag.

Kolker, Robert Phillip, and Peter Beicken. 1993. *The Films of Wim Wenders: Cinema as Vision and Desire.* Cambridge Film Classics, ed. Raymond Carney. Cambridge: Cambridge University Press.

Kössner, Brigitte. 1998. *Kunstsponsoring II: Neue Trends und Entwicklungen.* Vienna: Signum.

Kruger, Barbara. 1990. "What's High, What's Low—and Who Cares?" *New York Times,* 9 September.

Kunstmuseum Wolfsburg: Architekten Schweger + Partner. 1994. Berlin: Ernst und Sohn.

Kursbuch Jugendkultur: Stile, Szenen, und Identitäten vor der Jahrtausendwende, comp. 1997. SpoKK (Arbeitsgruppe für Symbolische Politik, Kultur, und Kommunikation). Mannheim: Bollmann.

Lacayo, Richard. 1991. "Shadows and Eye Candy." *Time,* 30 September, 72–74.

Lachmeyer, Herbert. 1992. "Geschmackseliten und Identitätsdesign." In *Produktkulturen: Dynamik und Bedeutungswandel des Konsums,* ed. Reinhard Eisendle and Elfie Miklautz, 41–49. Frankfurt/M.: Campus.

Lacy, Suzanne, ed. 1996. *Mapping the Terrain: New Genre Public Art.* Seattle, Wash.: Bay Press.

Larson, Gary O. 1997. *American Canvas: An Arts Legacy for Our Communities.* Washington, D.C.: National Endowment for the Arts.

Lash, Scott. 1991. *Sociology of Postmodernism.* International Library of Sociology, ed. John Urry. London: Routledge.

Lawton, Michael. 1994. "Sitting Pretty at the Vitra Design Museum." In *German-American Cultural Review* (Inter Nationes), Winter, 30–35.

Leach, Neil, ed. 1997. *Rethinking Architecture: A Reader in Cultural Theory.* London: Routledge.

Leibovitz, Annie. 1991. *Photographs: Annie Leibovitz, 1970–1990.* New York: HarperCollins.

———. 1991/92. *Photographien: 1970–1990. Annie Leibovitz.* Trans. Dirk van Gunsteren. Munich: Schirmer/Mosel.

Leibovitz, Annie, and Susan Sontag. 1999. *Women.* New York: Random House.

Leif, Thomas, and Ullrich Galle, eds. 1993. *Social Sponsoring und Social Marketing: Praxisberichte über das "neue Produkt Mitgefühl."* Cologne: Bund Verlag.

Lessig, Lawrence. 1999. *Code and Other Laws of Cyberspace.* New York: Basic Books.

Lewis, Richard W. 1996. *Absolut Book: The Absolut Vodka Advertising Story.* Boston: Journey Editions.

Lingner, Michael. 1998. "Kunst als Medium der Selbstbestimmung." In *Clegg and Guttmann: Museum for the Workplace,* ed. Luminita Sabau, 80–89. Alltägliches: Kunst am Arbeitsplatz, DG 1. Regensburg: Lindinger und Schmid.

Loock, Friedrich, ed. 1991. *Kulturmanagement: Kein Privileg der Musen.* Wiesbaden: Gabler.

Lubow, Arthur. 1994. "This Vodka Has Legs." *The New Yorker,* 12 September, 62–83.

Luke, Timothy W. 1992. *Shows of Force: Power, Politics, and Ideology in Art Exhibitions.* Durham, N.C.: Duke University Press.

MacDonald, George F. and Stephen Alsford. 1997. "Conclusion: Toward the Meta-Museum." In *The Wired Museum: Emerging Technology and Changing Paradigms,* ed. Katherine Jones-Garmil, 267–78. Washington, D.C.: American Association of Museums.

McRobbie, Angela. 1995. *Postmodernism and Popular Culture.* London: Routledge.

Medosch, Armin. 1998. "Browser Fast Food: Wie die Portal-Strategien das Web verändern." *Telepolis,* on-line edition, 23 June.

Meyer, Stephen. 1988. "Craftsmanship Has Its Privileges." *Advertising Age,* Creative Supplement, 4 January, 11–14, 19.

Meyhöfer, Annette. 1997. "True Moments." In *Annie Leibovitz Photographs: 1968–1997,* ed. Werner Funk, 14–22. Stern Bibliothek der Photographie. Hamburg: Gruner and Jahr.

Mikus, Anne. 1997. *Firmenmuseen in der Bundesrepubik: Schnittstelle zwischen Kultur und Wirtschaft.* Berliner Schriften zur Museumskunde, 12. Opladen: Leske und Budrich.

Miles, Roger, and Lauro Zavala, eds. 1994. *Towards the Museum of the Future: New European Perspectives.* London: Routledge.

Milward, John. 1994. "The Big Business behind Woodstock 94: Field of Dreams." *Rolling Stone,* 11 August, 36–37.

Mintz, Ann. 1998. "Media and Museums: A Museum Perspective." In *The Virtual and the Real: Media in the Museum,* ed. Selma Thomas and Ann Mintz, 19–34. Washington, D.C.: American Association of Museums.

Morley, David, and Kevin Robins. 1995. *Spaces of Identity: Global Media, Electronic Land-scapes, and Cultural Boundaries.* London: Routledge.

Muschamp, Herbert. 1997. "The Miracle in Bilbao." *New York Times Magazine,* 7 September, 54–59, 72, 82.

Museo Guggenheim Bilbao/Guggenheim Museum Bilbao. 1997. New York: Solomon R. Guggenheim Foundation.

Newhouse, Victoria. 1998. *Towards a New Museum.* New York: Monacelli.

Nicolaus, Frank. 1990. "Mit Kunst floriert auch das Geschäft." *Art,* March, 90–91.

O'Barr, William M. 1994. *Culture and the Ad: Exploring Otherness in the World of Advertising.* Institutional Structures of Feeling, eds. George Marcus et al. Boulder, Colo.: Westview.

Ohmann, Richard, ed. 1996. *Making and Selling Culture.* Hanover, N.H.: Wesleyan University Press.

Penley, Constance, and Andrew Ross, eds. 1992. *Technoculture.* Cultural Politics, 3. Minneapolis: University of Minnesota Press.

Penny, Simon. 1994. "Virtual Reality as the Completion of the Enlightenment Project." In *Culture on the Brink: Ideologies of Technology,* ed. Gretchen Bender and Timothy Druckrey, 231–64. Dia Center for the Arts. Discussions in Contemporary Culture, 9. Seattle, Wash.: Bay Press.

———. 1996. "Realities of the Virtual." In *Perspektiven der Medienkunst/Media Art Perspectives,* ed. Hans-Peter Schwarz and Jeffrey Shaw, 127–34. Edition ZKM, Heinrich Klotz. Karlsruhe and Ostfildern: ZKM/Cantz.

———, ed. 1995. *Critical Issues in Electronic Media.* SUNY Series in Film History and Theory, ed. Maureen Turim. Albany: State University of New York Press.

Philip Morris and the Arts: 35 Year Report. 1993. New York: Philip Morris Companies, Inc.

"Politically Correct Patrons." 1992. *Economist,* 20 June, 89–90.

Project on Disney. 1995. *Inside the Mouse: Work and Play at Disney World.* Post-Contemporary Interventions, ed. Stanley Fish and Fredric Jameson. Durham, N.C.: Duke University Press.

Pruitt, Steve, and Tom Barrett. 1992. "Corporate Virtual Workspace." In *Cyberspace: First Steps,* ed. Michael Benedikt, 383–409. Cambridge: MIT Press.

Ramírez, Mari Carmen. 1996. "Brokering Identities: Art Curators and the Politics of Cultural Representation." In *Thinking about Exhibitions,* ed. Reesa Greenberg, Bruce W. Ferguson, and Sandy Nairne, 21–38. London: Routledge.

Rau, Fritz. 1994. "Konzerte und Festivals (Pop, Rock, Jazz)." In *Kulturmanagement: Theorie und Praxis einer professionellen Kunst,* ed. Hermann Rauhe and Christine Demmer, 243–53. Berlin: Walter de Gruyter.

Rauhe, Hermann, and Christine Demmer, eds. 1994. *Kulturmanagement: Theorie und Praxis einer professionellen Kunst.* Berlin: Walter de Gruyter.

Rectanus, Mark W. 1994. "Kulturförderung und Kultursponsoring: Positionen zwischen Kulturpolitik und Marktwirtschaft." *Internationales Archiv für Sozialgeschichte der deutschen Literatur* 19.1: 75–94.

Rheingold, Howard. 1991. *Virtual Reality.* New York: Touchstone.

———. 1994. *The Virtual Community: Homesteading on the Electronic Frontier.* New York: Harper Perennial.

Rheuban, Joyce, ed. 1986. *The Marriage of Maria Braun.* Rutgers Films in Print Series, 4. New Brunswick, N.J.: Rutgers University Press.

Ritchie, Ian. 1994. "An Architect's View of Recent Developments in European Museums." In *Towards the Museum of the Future: New European Perspectives,* ed. Roger Miles and Lauro Zavala, 7–30. London: Routledge.

Rockefeller, David. 1966. *Culture and the Corporation.* Founding Address, Business Committee for the Arts, Inc. New York: BCA.

Römer, Stefan. 1992. "Zur Soziologie der künstlerischen Strategie: Ein Interview mit Hans Haacke." *Texte zur Kunst* 2.8: 51–65.

———. 1996. "Die Autonomie der Kunst oder die Kunst der Autonomen." *Kritik: Zeitgenössische Kunst in München* 1: 54–59.

Ross, Andrew, and Tricia Rose, eds. 1994. *Microphone Friends: Youth Music and Youth Culture.* New York: Routledge.

Roth, Peter. 1989. *Kultur Sponsoring: Meinungen, Chancen und Probleme, Konzepte, Beispiele.* Landsberg am Lech: Moderne Industrie.

Sabau, Luminita, ed. 1998. *Clegg and Guttmann: Museum for the Workplace.* Alltägliches: Kunst am Arbeitsplatz, DG 1. Regensburg: Lindinger und Schmid.

Schnibben, Cordt. 1992. "Die Reklame Republik." *Spiegel,* 21 December, 114–28.

Schiff, Stephen. 1996. "Showgirls: Portfolio by Annie Leibovitz." *The New Yorker,* 29 January, 69–77.

Schow, Jürgen. 1994. "Die Grundlagen: Zwei Stiftungen." In *Kunstmuseum Wolfsburg: Architekten Schweger + Partner,* 104–5. Berlin: Ernst und Sohn.

Schreiber, Alfred L., with Barry Lenson. 1994. *Lifestyle and Event Marketing: Building the New Customer Partnership.* New York: McGraw-Hill.

Schulberg, Jay. 1998. *The Milk Mustache Book.* New York: Ballantine.

Schulze, Gerhard. 1992. *Die Erlebnisgesellschaft: Kultursoziologie der Gegenwart.* Frankfurt/M.: Campus.

Schwarz, Hans-Peter. 1996. "The Digital Museum: Multimedia Image Terror or Chance to

Redefine the Museum?" In *Perspektiven der Medienkunst/Media Art Perspectives,* ed. Hans-Peter Schwarz and Jeffrey Shaw, 175–82. Edition ZKM, Heinrich Klotz. Karlsruhe and Ostfildern: ZKM/Cantz.

———. 1997. *Medien-Kunst-Geschichte. Medienmuseum.* ZKM, Zentrum für Kunst und Medientechnologie Karlsruhe. Munich: Prestel.

Schwarz, Hans-Peter, and Jeffrey Shaw, eds. 1996. *Perspektiven der Medienkunst/Media Art Perspectives.* Edition ZKM. Heinrich Klotz. Karlsruhe and Ostfildern: ZKM/Cantz.

Sherwood, Lyn Elliot. 1997. "Moving from Experiment to Reality: Choices for Cultural Heritage Institutions and Their Governments." In *The Wired Museum: Emerging Technology and Changing Paradigms,* ed. Katherine Jones-Garmil, 129–50. Washington, D.C.: American Association of Museums.

Siebenhaar, Klaus. 1992. *Kultur und Management: Positionen—Tendenzen—Perspektiven.* Berlin: Nicolaische Verlagsbuchhandlung, 1992.

Siegel, Lee. 1996. "How Not To Save the NEA," *ARTnews,* June, 168.

Silberman, Marc. 1995. *German Cinema: Texts in Context.* Contemporary Film and Television, ed. Patricia B. Erens. Detroit, Mich.: Wayne State University Press.

Silverstone, Roger. 1994. "The Medium Is the Museum: On Objects and Logics in Times and Spaces." In *Towards the Museum of the Future,* ed. Roger Miles and Lauro Zavala, 161–75. London: Routledge.

Sischy, Ingrid. 1991/92. "[Annie Leibovitz:] Ein Gespräch mit Ingrid Sischy." In Annie Leibovitz, *Photographien: 1970–1990. Annie Liebovitz,* trans. Dirk van Gunsteren, 7–12. Munich: Schirmer/Mosel.

Snedcof, Harold R. 1985. *Cultural Facilities in Mixed-Use Development.* Washington, D.C.: Urban Land Institute.

Solomon-Godeau, Abigail. 1991. *Photography at the Dock.* Minneapolis: University of Minnesota Press.

Sontag, Susan. 1989. *On Photography.* New York: Anchor/Doubleday.

Stemmle, Dieter. 1993. "Das neue Produkt Mitgefühl; oder, Austausch statt Almosen." In *Social Sponsoring und Social Marketing: Praxisberichte über das "neue Product Mitgefühl,"* ed. Thomas Leif and Ullrich Galle, 23–35. Cologne: Bund Verlag.

Stocker, Gerfried, and Christine Schöpf, eds. 1998. *Information, Macht, Krieg.* Vienna: Springer.

Stolorz, Christian. 1992. "Zur unternehmenspolitischen Zielsetzung von Sponsoring." In *Kulturpolitik und Kultursponsoring,* ed. Christian Stolorz and Stefan Schmalhaus, 52–62. Wirtschaft und Politik im Dialog, ed. Rainer Frey and Christian Stolorz, 1. Münster: Lit.

Stolorz, Christian, and Stefan Schmalhaus, eds. 1992. *Kulturpolitik und Kultursponsoring.* Wirtschaft und Politik im Dialog, ed. Rainer Frey und Christian Stolorz, 1. Münster: Lit.

Stolz, Hans-Georg. 1993. "Die Kampagne des UNHCR." In *Social Sponsoring und Social Marketing: Praxisberichte über das "neue Product Mitgefühl,"* ed. Thomas Leif und Ullrich Galle, 56–65. Cologne: Bund Verlag.

Storey, John. 1996. *Cultural Studies and the Study of Popular Culture: Theories and Methods.* Athens: University of Georgia Press.

Strachwitz, Rupert Graf, and Stefan Toepler, eds. 1993. *Kulturförderung: Mehr als Sponsoring.* Wiesbaden: Gabler.

Strahlendorf, Peter, ed. 1992. *Jahrbuch Sponsoring 92.* Düsseldorf: Econ.

Thomas, Selma, and Ann Mintz, eds. 1998. *The Virtual and the Real: Media in the Museum.* Washington, D.C.: American Association of Museums.

Thornton, Sarah. 1994. "Moral Panic, the Media, and British Rave Culture." In *Microphone Friends: Youth Music and Youth Culture,* ed. Andrew Ross and Tricia Rose, 176–92. New York: Routledge.

———. 1997. "General Introduction." In *The Subcultures Reader,* ed. Ken Gelder and Sarah Thornton, 1–7. London: Routledge.

Tilsner, Julie. 1994. "Skol, Dude: Spirits Get Hip. Vodka and Scotch Importers Are Targeting Twentysomethings." *Business Week,* 30 May, 95–96.

Toepler, Stefan. 1999. "Presentation for 'Reassessment of Support for Art Organizations: Organizations and the Future,'" *NEA Explore,* 14 May, http://www.arts.endow.gov/explore/Colloquia/future.html.

Tschumi, Bernard. 1994. *Architecture and Disjunction.* Cambridge: MIT Press.

Twitchell, James B. 1996. *Adcult USA: The Triumph of Advertising in American Culture.* New York: Columbia University Press.

Umbach, Klaus. 1995. "O Mensch am See." *Spiegel,* 17 July, 158–59.

Urry, John. 1995. *Consuming Places.* International Library of Sociology, ed. John Urry. London: Routledge.

Van Biema, David. 1994. "The Eye of Annie Leibovitz." *Life,* April, 46–54.

Varnedoe, Kirk, and Adam Gopnik. 1990. *High and Low: Modern Art and Popular Culture.* Catalogue and exhibition. New York: Museum of Modern Art.

Venturi, Robert, Denise Scott Brown, and Steven Izenour. 1997. *Learning from Las Vegas: The Forgotten Symbolism of Architectural Form.* Rev. ed. Cambridge: MIT Press.

Vergo, Peter. 1991. *The New Museology.* London: Reaktion Books.

Virilio, Paul. 1997. "The Overexposed City." In *Rethinking Architecture: A Reader in Cultural Theory,* ed. Neil Leach, 380–90. London: Routledge.

Vitali, Christoph. 1997. Foreword to *Haus der Kunst, 1937–1997: Eine historische Dokumentation,* comp. Sabine Brantl, 5. Munich: Haus der Kunst.

Von Vegesack, Alexander. 1993. "The Vitra Design Museum." Press release. Originally published in Alexander Von Vegesack. *Vitra Design Museum,* ed. Yuko Futagawa. Tokyo: GA Design Center, 1993.

Waldrep, Shelton. 1995. "Monuments to Walt." In Project on Disney, *Inside the Mouse: Work and Play at Disney World,* 199–229. Post-Contemporary Interventions, ed. Stanley Fish and Fredric Jameson. Durham, N.C.: Duke University Press.

Wallis, Brian, ed. 1984. *Art after Modernism: Rethinking Representation.* The New Museum of Contemporary Art, New York. Documentary Sources in Contemporary Art. Boston: Godine.

Waters, Malcolm. 1996. *Globalization.* Key Ideas, ed. Peter Hamilton. London: Routledge.

Watson, Sophie, and Katherine Gibson. 1995a. "Postmodern Politics and Planning: A Postscript." In *Postmodern Cities and Spaces,* ed. Sophie Watson and Katherine Gibson, 254–64. Oxford: Blackwell.

———, eds. 1995b. *Postmodern Cities and Spaces.* Oxford: Blackwell.

Wegerhoff, Susanne. 1991. "Die Kunst zu fördern, heißt mit Interessen leben—Anmerkungen zum Kultursponsoring im Kommunikationskonzept von American Express." *Bank und Markt+Technik* 20.

———. 1992a. "Die Kunst zu fördern, heißt mit Interessen leben: Zur Sponsoring Strategie von American Express." Marketing conference "Sponsoring" 7–8 September 1992 Frankfurt/M., 1–6.

———. 1992b. "Sponsoring im Kunst- und Kulturbereich." In *Jahrbuch Sponsoring 92,* ed. Peter Strahlendorf, 48–57. Düsseldorf: Econ.

Weinberg, Peter. 1992. *Erlebnismarketing*. Munich: Vahlen.

Weissman, George. 1988. *Lively Arts, Lively Cities: The Arts in Economic Development*. Executive Viewpoints. New York: BCA.

Wernick, Andrew. 1991. *Promotional Culture: Advertising, Ideology, and Symbolic Expression*. Theory, Culture, and Society, ed. Mike Featherstone. London: Sage.

Wever, Ulrich A. 1992. *Unternehmenskultur in der Praxis: Erfahrungen eines Insiders bei zwei Spitzenunternehmen*. Frankfurt/M.: Campus.

Wiesand, Andreas J. 1994. "Vom Kulturstaat zum Sponsor? Trends und Konflikte der Kulturpolitik und -finanzierung in Deutschland." In *Kulturmanagement: Theorie und Praxis einer professionellen Kunst*, ed. Hermann Rauhe and Christine Demmer, 27–43. Berlin: Walter de Gruyter.

Williamson, Judith. 1995. *Decoding Advertisements: Ideology and Meaning in Advertising*. 4th ed. London: Marion Boyars.

Willis, Susan. 1995. "Public Use/Private State." In Project on Disney, *Inside the Mouse: Work and Play at Disney World*, 180–98. Post-Contemporary Interventions, ed. Stanley Fish and Fredric Jameson. Durham, N.C.: Duke University Press.

Wolf, Silvia. 1993. "'Kunst für alle': Die Zigarette West als offizieller Sponsor der DOCUMENTA IX." In *Kulturförderung: Mehr als Sponsoring*, ed. Rupert Graf Strachwitz and Stefan Toepler, 365–73. Wiesbaden: Gabler.

Wood, John, ed. 1998. *The Virtual Embodied: Presence/Practice/Technology*. London: Routledge.

Yanagi, Masaihiko. 1993. "Interview mit Christo." In *Christo, Der Reichstag, und urbane Projekte*, ed. Jacob Baal-Teshuva, trans. Wolfgang Himmelberg and Dagmar Lutz, 21–29. Munich: Prestel.

Yiftachel, Oren. 1995. "The Dark Side of Modernism: Planning as Control of an Ethnic Minority." In *Postmodern Cities and Spaces*, ed. Sophie Watson and Katherine Gibson, 216–42. Oxford: Blackwell.

Yúdice, George. 1999. "The Privatization of Culture." *Social Text* 17.2: 17–34.

Zipf, Michael. 1997. "More Than Conventional Sponsoring: Art Stands To Profit Most from the Partnership between the Guggenheim Museum and Hugo Boss." *Deutschland*, June, 36–37.

Mark W. Rectanus is professor of German at Iowa State University. He has held appointments as a research fellow of the Alexander von Humboldt Foundation in Munich, Germany, and as a visiting professor at Ohio State University. He is the author of four books; his research focuses on the publishing industry and literary marketplace, cultural politics, and museums.

DATE DUE